Chiang Yee and His Circle

Chiang Yee and His Circle

Chinese Artistic and Intellectual Life in Britain, 1930–1950

Edited by Paul Bevan, Anne Witchard, and Da Zheng

Hong Kong University Press
The University of Hong Kong
Pokfulam Road
Hong Kong
https://hkupress.hku.hk

© 2022 Hong Kong University Press

ISBN 978-988-8754-13-7 (*Hardback*)

All rights reserved. No portion of this publication may be reproduced or transmitted in any form or by any means, electronic or mechanical, including photocopying, recording, or any information storage or retrieval system, without prior permission in writing from the publisher.

British Library Cataloguing-in-Publication Data
A catalogue record for this book is available from the British Library.

10 9 8 7 6 5 4 3 2 1

Printed and bound by Hang Tai Printing Co., Ltd. in Hong Kong, China

Contents

Foreword by Yi-Fu Tuan	vii
List of Illustrations	ix
Acknowledgements	xi
Note on Copyright	xiii
Notes on Romanisation and References	xiv
List of Contributors	xv
Editors' Introduction: *Chiang Yee and His Circle: Chinese Artistic and Intellectual Life in Britain, 1930–1950*	1

Part One: Chiang Yee

1.	Chiang Yee's Hampstead *Paul Bevan*	11
2.	Chiang Yee as Art History *Craig Clunas*	18
3.	Being Chiang Yee: Feeling, Difference, and Storytelling *Sarah Cheang*	37
4.	Chiang Yee and British Ballet *Anne Witchard*	51
5.	The Silent Traveller at Home *Da Zheng*	71
6.	Chiang Yee in Wartime *Paul French*	89

Part Two: Chiang Yee's Circle

7.	Navigating British Publishing and Finding an Anglophone Readership: Five Chinese Writers *Tessa Thorniley*	107

8. Chiang Yee and the Hsiungs: Solidarity, Conviviality, and the Economy of Racial Representation 128
Diana Yeh

9. Shih-I Hsiung and Anglo-Chinese Films: 'An Interesting Experiment' 142
Paul Bevan

10. A 'Chinese Shelley' in 1930s Britain: Wang Lixi's Transnational Activism and Transcultural Lyricism 158
Ke Ren

11. Mahjong in Maida Vale 181
Frances Wood

Glossary of Chinese names 197

Selected Bibliography 199

Index 209

Foreword

I was a young patient recovering from a hernia operation at the children's hospital. There was a knock at the door and in walked the Chinese consul's wife with two books, her gifts to me: they were *The Bridge of Heaven* and *The Silent Traveller in London*. A friend of my parents, she knew me well. She knew I was fond of reading and that I took a course in painting at my school. Propped up on my hospital bed, I found *The Bridge of Heaven* heavy going and not the sort of adventure story I liked to read, but I was very impressed by the delicate watercolours in the Silent Traveller book, so contrary to the thick paint I liked to slap on canvas as a boy artist.

The scenario I just sketched occurred in 1943, in Sydney, Australia, where my father was the Chinese consul general.

Five years later, I sought admission to the University of Oxford. Unfortunately, I knew neither Latin nor Greek—the classics—a requirement for entry. Father asked the famous playwright and novelist Shih-I Hsiung to help. He did and I was admitted, translating Confucius and Mencius in place of Plato and Cicero. As an Oxford undergraduate, I lived with the Hsiung family at Iffley Turn House, which Mr. Hsiung ('Uncle' Hsiung to me, since he was my father's friend) rented and was later purchased by the famous novelist Graham Greene. I know it is tiresome of me to keep saying 'famous', but it cannot be helped. At the time I lived in Iffley Turn House, Uncle Hsiung's reputation, based on his play *Lady Precious Stream*, was at its height, reinforced by the novel *The Bridge of Heaven*. Chinese intellectuals and artists flocked to Iffley Turn House where they enjoyed Mrs. Hsiung's hospitality and one another's lively conversation. Alas, as an unsophisticated teenager, I wasn't fully aware that I lived on an island of Chinese intellectual and artistic efflorescence. My immaturity and ignorance meant that I didn't seek to participate or even make a point of remembering who's who in the distinguished gathering—with one exception. One day, in walked a man who seemed to be tall and large for a Chinese and he was introduced to me as Chiang Yee, author/artist of the Silent Traveller series. As people milled around the table laden with food, Uncle Hsiung said he would ask Vivien Leigh whether she would consider playing Lady Precious Stream while others dropped names with which I was for the most part unfamiliar, except George Bernard Shaw, who was very supportive of the expatriate Chinese literati and even

wondered whether the English language would, in the course of time, acquire a faint jasmine flavour as a result of their work.

The multi-authored study you are about to read describes in detail a remarkable movement at the time of the Second World War, first in London, then in Oxford and Cambridge—remarkable because the innovators and creators were Chinese rather than English. I lack the scholarship to add anything to the scholars' account, but then I enjoy one advantage they do not have—I was there, I touched the hem of an important but neglected chapter in the West's own literary and aesthetic history.

Yi-Fu Tuan

Yi-Fu Tuan, born in 1930 in Tianjin, China, was the J. K. Wright and Vilas Research Professor at the University of Wisconsin-Madison until his retirement in 1998. He is the author of twenty-three books, including *The Historical Geography of China* and *Coming Home to China*. Both have been translated into Chinese.

Illustrations

Cover: 'Umbrellas under Big Ben' from *The Silent Traveller in London* (1938)

Figure 0.1: Chiang Yee reading in his residence in the 1930s 4

Figure 1.1: Map of bombings in the Borough of Hampstead 16

Figure 2.1: Chiang Yee, *The Chinese Eye* (1935), Plate XII, superimposed on *Zhongguo minghuaji* 32

Figure 2.2: Chiang Yee, *The Chinese Eye* (1935), Plate IV 34

Figure 3.1: Chiang Yee, 'Charlie Chan and Myself' from *The Silent Traveller in Oxford* (1944) 42

Figure 3.2: Chiang Yee, 'Hair Raid' from *The Silent Traveller in Oxford* (1944) 47

Figure 4.1: *The Birds* (1942) set design by Chiang Yee (see colour plates after p. 70)

Figure 4.2: *The Birds* (1942), Cuckoo (Gordon Hamilton) and Two Cheeky Sparrows (Margaret Dale and Joan Sheldon) 66

Figure 4.3: *The Birds* (1942), Hen and Sparrows (Moyra Fraser, Margaret Dale, and Joan Sheldon) 67

Figure 4.4: *The Birds* (1942), Nightingale (Beryl Grey) 68

Figure 4.5: *The Birds* (1942), Nightingale costume design by Chiang Yee (see colour plates after p. 70)

Figure 5.1: The front cover of *A Chinese Childhood* (1940) (see colour plates after p. 70)

Figure 5.2: *Budai Monk*, painting, ca. 1934 79

Figure 5.3: 'Up the Lu Mountain' from *A Chinese Childhood* (1940) 84

Figure 6.1: 'Sleeping in a Gas Mask' from *The Silent Traveller in War Time* (1939) (see colour plates after p. 70)

Figure 6.2: An illustration by Chiang Yee from M. P. Lee's *Chinese Cookery: A Hundred Practical Recipes* (1943) 98

Figure 6.3: 'Is He Mr. Winston Churchill?' from *The Silent Traveller in War Time* (1939) 100

Figure 10.1: Wang Lixi. The inscription reads: 'Wang Lixi, 1938, in Belfast.' 174

Acknowledgements

First, as editors we would like to offer our profound gratitude to the family of Chiang Yee, in particular San Edwards and Sudi Chiang for their support with the project. Warm thanks also go to Professor Yi Fu-Tuan for kindly writing the foreword to the book.

We thank all contributors to this volume for taking time out from their busy schedules to write their chapters, and, in doing so, providing such a wide range of varied and complementary new scholarship to the field of Chinese diaspora studies. A symposium, 'The Silent Traveller: Chiang Yee in Britain, 1933–55', which took place at the Ashmolean Museum in June 2019, was the springboard for this volume and we would like to thank everyone at the museum who made this possible, in particular Felicitas von Droste zu Hülshoff, for her hard work behind the scenes. We are especially grateful to the University of Westminster for kindly providing the funding that made it possible. Eda Forbes, Secretary of the Oxfordshire Blue Plaques Board, was also vital to the success of the day in her capacity as organiser of the erection of the commemorative memorial plaque that was unveiled later in the day at Chiang Yee's former Oxford residence. Special thanks also to the families and the descendants of the artists and intellectuals who appear in Frances Wood's chapter.

Others who have helped with queries of all sorts include: Clementine Cowl, executive director, Royal Ballet Benevolent Fund; Jane Fowler, archivist at The Royal Opera House; Jane Pritchard, Curator of Dance, Theatre and Performance at the Victoria and Albert Museum; Simon Sladen, Curator of Modern and Contemporary Performance, Department of Theatre and Performance at the Victoria and Albert Museum; and Paula Jin, who assisted with Chinese-language queries in Chapter 7.

In addition, we would like to thank the following libraries for their assistance: The Library of the School of Oriental and African Studies and Senate House Library of the University of London; the Bodleian Library, K. B. Chen China Centre Library, and Sackler Library at the University of Oxford; The British Library; the Guildhall Library, City of London; the Victoria and Albert Theatre and Performance Archives; and the Royal Opera House Archives.

We are grateful to San Edwards for granting us permission to use images of Chiang Yee, and to the Victoria and Albert Museum, London, for allowing us to reproduce artwork relating to him that is housed in their collection. We also thank Keith Millar and the John Hewitt Society for permission to reproduce the photograph of Wang Lixi in Chapter 10.

Thanks also go to Peter Daniell, Kenneth Yung, and the team at Hong Kong University Press and two anonymous referees for their helpful comments.

Finally, we thank our families and friends for their support and encouragement as we worked on this book.

Note on Copyright

Every effort has been made to trace and contact copyright holders and to obtain the required permissions for the use of copyright material prior to publication. However, in some cases this has not been possible. Sincere apologies are offered for any inadvertent errors or omissions. If notified, all effort will be made to correct any such errors at the earliest opportunity.

Notes on Romanisation and References

The Hanyu Pinyin system of romanisation has been used throughout, except in self-contained quotations and with the names of a number of figures who are best known by certain spellings, such as Chiang Yee and Shih-I Hsiung as well as commonly known names such as Chiang Kai-shek and Sun Yat-sen.

In the case of Chinese magazines and books that were published with both Chinese- and foreign-language titles, the original foreign-language title appears in quotation marks, for example '*Modern Miscellany*'.

Words and phrases that appeared in an original Chinese text in English, or other European languages, are written in bold, for example **Hampstead** in chapter one.

When there is no page number at all in the original this will be indicated in the footnotes by n.p. (no page number). Likewise, when there are no birth and death dates available for individuals mentioned in the text, n.d. (no dates) is used.

There is a glossary of Chinese names at the end of the book which provides the Chinese characters together with the Pinyin and/or Wade-Giles spellings.

Contributors

(In alphabetical order)

Paul Bevan (co-editor)
Paul Bevan is Departmental Lecturer in Modern Chinese Literature and Culture at the University of Oxford. From 2018 to 2020 he worked as Christensen Fellow in Chinese Painting at the Ashmolean Museum and his research focusses equally on the visual arts and literature. Paul's primary research interests concern the impact of Western art and literature on China during the Republican period (1912–1949), particularly with regard to periodicals and magazines. His first book, *A Modern Miscellany: Shanghai Cartoon Artists, Shao Xunmei's Circle and the Travels of Jack Chen, 1926–1938* (2015), was hailed as 'a major contribution to modern Chinese studies'; his second book, *'Intoxicating Shanghai': Modern Art and Literature in Pictorial Magazines during Shanghai's Jazz Age*, was published in 2020.

Sarah Cheang
Sarah Cheang is Head of Programme in History of Design at the Royal College of Art, London. Her research centres on transnational fashion, ethnicity, material culture, and the body from the nineteenth century to the present day, on which she has published widely. Her work on Chinese material culture in Britain spans consideration of ceramics, fashion and textiles, wallpapers, furniture, and dogs. She is an active member of the Research Collective for Decolonizing Fashion, and the OPEN research initiative.

Craig Clunas
Craig Clunas is Professor Emeritus of the History of Art at the University of Oxford, and the author of numerous works on Chinese art and culture, particularly of the late imperial and modern periods. His most recent book is *Chinese Painting and its Audiences* (2017).

Paul French
Paul French was born in London, educated there and in Glasgow, and lived and worked in Shanghai for many years. He is the author of the books *Midnight in Peking* and *City of Devils: A Shanghai Noir*, both currently being developed for television.

He is also the author of the *Audible Original Murders of Old China* as well as regular contributor to the *South China Morning Post* magazine.

Ke Ren
Ke Ren is Assistant Professor of Chinese/East Asian History at the College of the Holy Cross (Massachusetts). He specializes in the cultural and intellectual history of modern China, Sino-Western exchanges, cosmopolitanism, and transnational movements. He is working on a book manuscript entitled *Fin-de-Siècle Diplomat: Chen Jitong and Cosmopolitanism in the Late Qing World*. He is also researching the history of Chinese participation in transnational anti-fascist and peace movements in the Global Second World War.

Tessa Thorniley
Tessa Thorniley is an independent researcher whose work focuses on writers of Chinese heritage who have lived and worked in Britain. She is currently conducting research for the British Chinese Studies Network (BCSN). She completed her doctoral studies at Westminster University where she also taught seminars in contemporary Chinese literature and society. Prior to her doctorate she spent seven years living and working as a freelance journalist in China.

Anne Witchard (co-editor)
Anne Witchard is Reader in English Literature and Cultural Studies at the University of Westminster. She is the author of *Thomas Burke's Dark Chinoiserie: Limehouse Nights and the Queer Spell of Chinatown* (2007), *Lao She in London* (2012), and *England's Yellow Peril: Sinophobia and the Great War* (2014). She is editor, with Lawrence Philips, of *London Gothic: Place, Space and the Gothic Imagination* (2010) and *Modernism and British Chinoiserie* (2015).

Frances Wood
Frances Wood is the retired Curator of the Chinese Collections in the British Library. She has written a number of books on China including *The Blue Guide to China* (2002), *No Dogs and Not Many Chinese: Treaty Port life in China, 1843–1943* (1998), *The Lure of China: Writers on China from Marco Polo to J. G. Ballard* (2009), and *Great Books of China* (2017).

Diana Yeh
Diana Yeh is Associate Dean of Equality, Diversity and Inclusion in the School of Arts and Social Sciences, City, University of London, and Senior Lecturer in Sociology, Culture, and the Creative Industries in the Department of Sociology. She is author of *The Happy Hsiungs: Performing China and the Struggle for Modernity* (2014) about the playwright S. I. Hsiung, and co-editor of *Contesting British Chinese Culture* (2018). She is currently principal investigator of two projects: (1) 'Responding to

COVID-19 Anti-Asian Racial Violence through Community Care, Solidarity and Resistance', funded by Resourcing Racial Justice and the SASS Higher Education Innovation Fund; and (2) 'Becoming East and Southeast Asian: Race, Ethnicity and Youth Politics of Belonging', funded by the British Academy/Leverhulme.

Da Zheng (co-editor)
Da Zheng is Professor Emeritus of English at Suffolk University, Boston. He has published articles on American Literature, Asian American literature, and diaspora studies. He is the author of *Chiang Yee: Silent Traveller from the East – a Cultural Biography* (2010) and *Shih-I Hsiung: A Glorious Showman* (2020).

Editors' Introduction

Chiang Yee and His Circle: Chinese Artistic and Intellectual Life in Britain, 1930–1950

In the 1930s, writer, poet, and painter Chiang Yee (1903–1977) was one of a small group of Chinese writers and artists who made their homes in what was then the Borough of Hampstead in Northwest London. At the time, this neighbourhood was largely inhabited by a multicultural community of artists, writers, musicians, philosophers, and critics, a number of whom had fled Nazi persecution in Europe. Many of these intellectuals lived in Hampstead well into the 1980s and 1990s, making it one of the most vibrant artistic areas in London over a period of several decades.

It was in Hampstead, on the second floor of a large Victorian house, that Chiang Yee shared a flat with Shih-I and Dymia Hsiung (Xiong Shiyi and Cai Daimei). Their circle of friends and neighbours included the married couple Wang Lixi (Shelley Wang) and Lu Jingqing, both of whom were writers and poets; Tsui Chi, a historian and writer; Hsiao Ch'ien (Xiao Qian), essayist, translator, and newspaper reporter; and the future literary translator Yang Hsien-I (Yang Xianyi), who visited London at weekends while studying at the University of Oxford. Together with their friends and families, this group comprised an important social and intellectual network of Chinese writers and artists in London during the 1930s. Later, especially after the outbreak of war, they scattered across London and to other parts of the country—notably to Oxford and Cambridge—but continued to interact and were actively involved in cultural and political activities in both the UK and China. The chapters in this collection go some way towards telling a story about the Chinese in England that up until now has received scant consideration. Although certainly not the most ostentatious part of London during the pre-war period, Hampstead, where Chiang Yee and Shih-I Hsiung made their home in the 1930s, was in striking contrast to the well-documented Limehouse district, where most of London's Chinese residents lived at the time. By uncovering this understudied aspect of British cultural history, this volume will help create a more balanced and nuanced picture of London's Chinese population and their artistic and intellectual contributions.

The subject of the Chinese in Britain has come a considerable way in just a short time, both in terms of scholarship and general attention. As recently as 1993 Colin Holmes's essay 'The Chinese Connection' was pretty much the only work on

the subject.[1] Holmes's aim was chiefly to examine the manifestations of a disproportionate animosity directed towards the Chinese in Britain in the first decade of the twentieth century. Britain's first Chinese residents were seamen who settled in the dockside neighbourhoods of London, Cardiff, and Liverpool. Despite the fact that the Chinese were statistically just a very small group—comprising only 480 out of a total of 15,246 foreign workers (UK census 1911)—Holmes demonstrated that small groups can come under hostile scrutiny when they become linked to issues of national economic or social concern. While the cheapness of Chinese labour provoked localised anger, this was exacerbated with the outbreak of the First World War, when claims of illicit sexual relations, illegal gambling, and recreational drug use were mobilised in the service of a general dynamics of racial hostility. Late nineteenth-century notions of a 'Yellow Peril' were revitalised and the dissemination of anti-Chinese sentiment in the daily press was pervasive. Holmes emphasises the role of popular culture in this, examining the interplay of the daily press, literary potboilers, and lurid films with police and government reports, a potent brew that filtered into a popular consciousness in which the Chinese presence, tiny though it was, loomed large. London's Chinatown in the Limehouse docks became a byword for vice, exoticised by Thomas Burke's bestselling *Limehouse Nights: Tales of Chinatown* (1916) and demonised in Sax Rohmer's tales of the evil mastermind Dr. Fu Manchu.

Chiang Yee arrived in the UK in 1933. Two years earlier, the 1931 UK census had recorded 1,934 Chinese living in England and Wales. Popular perceptions of Chinese people continued to be based on sensationalist press stories while caricatured stereotypes in novels and films had become firmly established. In unpicking the workings of this anti-Chinese discourse, 'The Chinese Connection' mapped out a terrain of future scholarship on the Chinese in Britain which continues to develop and broaden. Publications such as Christopher Frayling's *The Yellow Peril: Dr. Fu Manchu and the Rise of Chinaphobia* (2014) and Phil Baker and Antony Clayton's edited collection *Lord of Strange Deaths: The Fiendish World of Sax Rohmer* (2015) have thoroughly excavated the popular 'Yellow Perilism' of pulp exotica. The pernicious impact of popular cultural representation of the Chinese found its most detailed account in Robert Bickers's *Britain in China: Community, Culture and Colonialism, 1900–49* (1999). While Bickers's work is a study of British incursion in China, the first chapter, 'China in Britain, and in the British Imagination', is concerned with how the colonial mindset was informed by its mental baggage. Bickers details the films, plays, and fiction, both for children and adults, in which the cruelty

1. Colin Holmes, 'The Chinese Connection', in *Outsiders and Outcasts: Essays in Honour of William J. Fishman*, ed. Geoffrey Alderman and Colin Holmes (London: Duckworth, 1993), 71–93. This essay incorporated Holmes's previous attention to the Chinese in *John Bull's Island: Immigration and British Society, 1871–1971* (London: Macmillan Education, 1988). It also built on an earlier article by J. P. May, 'The Chinese in Britain, 1860–1914', that Holmes had published a decade before in his edited volume *Immigrants and Minorities in British Society* (London: Allen and Unwin, 1978). The essay remains a foundational source for the wide range of studies that have come since.

and wickedness of 'China and the Chinese—and the Chinese in Britain too—were represented to the extent that those pleading for improvements in relations between Chinese and Britons routinely joked about it'.[2] Two significant works have explored the 'facts', as far as they can be gleaned, of London's early Chinatown in relation to the fantasies it engendered. John Seed's article 'Limehouse Blues: Looking for Chinatown in the London Docks, 1900–1940' (2006), utilises census and other data to assess the discrepancy between exotic reportage and drab reality, while Sacha Auerbach's *Race, Law, and 'The Chinese Puzzle' in Imperial Britain* (2009) examines the manner in which derogatory media representation influenced the treatment of Chinese immigrants in the British judicial system and how the reports of these legal judgments, in turn, reinforced the ways in which the Chinese were depicted in the British media.

With *The Chinese in Britain, 1800–Present: Economy, Transnationalism, Identity* (2007), Gregor Benton and E. T. Gomez published the first comprehensive study of the long history of Chinese migration to Britain. Most significantly, Benton and Gomez revised accounts that treated all Chinese emigrants as one unified diaspora. The Chinese in Britain are a highly diverse group, divided by points of origin, reasons for leaving their homeland, and linguistic, ethnic, and class differences. Studies of individual Chinese in Britain include Da Zheng's comprehensive biographies, *Chiang Yee: The Silent Traveller from the East* (2010) and *Shih-I Hsiung: A Glorious Showman* (2020), as well as Anne Witchard's *Lao She in London* (2012) and Diana Yeh's study of Shih-I and Dymia Hsiung, *The Happy Hsiungs: Performing China and the Struggle for Modernity* (2014). Further developments in the history of the Chinese in Britain were prompted by the centenary of the First World War. A series of Penguin Specials were published in 2014 to commemorate the involvement of China in the war, the consequences of its aftermath, and the neglected contribution of the Chinese Labour Corps.[3]

In a welcome counterpoint to the more familiar negative narrative, a growing body of work looks at the cultural impact of the Sino-British encounter in the early twentieth century, exploring the ways in which the visual iconography of China constituted a precursor of literary and visual modernism. Studies which include Patricia Laurence's *Lily Briscoe's Chinese Eyes: Bloomsbury, Modernism and China* (2003), Eugenia Zuroski Jenkins's *A Taste for China: English Subjectivity and the Prehistory of Orientalism* (2013), Ross Forman's *China and the Victorian Imagination: Empires Entwined* (2013), Elizabeth Chang's *Britain's Chinese Eye: Literature, Empire, and Aesthetics in Nineteenth-Century Britain* (2010), and Anne Witchard's edited collection *British Modernism and Chinoiserie* (2015) demonstrate the ways in which

2. Robert Bickers, *Britain in China: Community, Culture and Colonialism, 1900–49* (Manchester: Manchester University Press, 1999), 27.
3. Including Mark O'Neill, *The Chinese Labour Corps: The Forgotten Chinese Labourers of the First World War* (Melbourne, VIC: Penguin Group Australia, 2014); and Anne Witchard, *England's Yellow Peril: Sinophobia and the Great War* (Melbourne, VIC: Penguin Group Australia, 2014).

exposure to a Chinese aesthetic primed British sensibilities for the developments of a European avant-garde. Heralding this reformation of Western aesthetics, in the first decade of the twentieth century, Laurence Binyon, Keeper of East Asian Prints and Drawings at the British Museum, sought to explicate to non-specialist audiences the spiritual and unifying role of art, central to the communal traditions of China and East Asia. Binyon's diagnosis of a bankrupt contemporary culture chimed with the modernists' preoccupation with the reintegration of art and life. Through pioneering works such as *Painting in the Far East* (1908) and *Flight of the Dragon* (1911), his regular newspaper column in the *The Saturday Review*, and a series of landmark international exhibitions, Binyon argued that the philosophies which lay behind East Asian art had much to teach the twentieth-century West.

The 1930s saw a further development. Chiang Yee's publications on Chinese art and culture, along with his lectures broadcast on the BBC, marked a period in which Chinese artists and writers began to communicate information and ideas about their cultural heritage directly. Their work pushed back in various ways against the prejudices and stereotypes about their country and its people that they had encountered. This marked a significant shift in perspective, one that in the years before the Second World War was beginning to be welcomed by influential, often leftist, magazine editors, critics, and book publishers. Chiang's Silent Traveller series, with

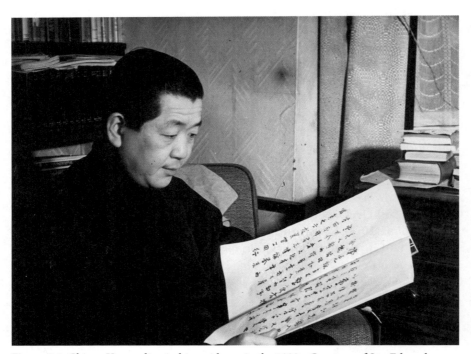

Figure 0.1: Chiang Yee reading in his residence in the 1930s. Courtesy of San Edwards.

its alternative presentation of Britain, was an innovative attempt to synthesise two diverse cultures at a time when the Yellow Peril discourse persisted as an influence in the collective British consciousness.

Chiang Yee and His Circle: Chinese Artistic and Intellectual Life in Britain, 1930–1950 is a volume that addresses aspects of the life and work of Chiang Yee, but it is equally, and importantly, about the Chinese intellectual community in Hampstead, the network that sustained him both professionally and personally. Exiled for different reasons but all highly educated, the small group of Chinese men and women who settled in the Hampstead area would play an important role in reshaping conceptions about China in Britain, interacting with London's cultural elites and engaging in political anti-fascist activism. Theirs was a world of literary and artistic interconnectedness and wartime co-operation that is only now beginning to be explored in scholarship. In considering their lives and achievements this volume seeks to demonstrate just how important their unique contributions were to intellectual and sociocultural life in Britain during the three decades spanned by the research. It is our hope that it will stimulate scholarly interest in the field and lead to more discussion and further discoveries about the Chinese in Britain during the twentieth century and beyond.

In summer 2019, an audience of around a hundred academics, sinologists, art lovers, curious locals, international participants, and some descendants of Chiang Yee who still live in the UK gathered at the Ashmolean Museum, Oxford, for a symposium organised by Anne Witchard of the University of Westminster. It was convened to celebrate Chiang's life and work and to mark the occasion of the erection of an English Heritage 'blue plaque' in commemoration of his residency in Oxford. This book, which includes revised papers presented at the symposium, as well as some additional contributions, was inspired by that event.

The book is divided into two parts. Part One, 'Chiang Yee', contains six chapters and begins with a contribution by Paul Bevan that sets the scene for all that follows. Bevan's introductory chapter takes the form of a brief survey of artistic life in the Borough of Hampstead during the 1930s—the modernist architecture that was appearing at the time and the eclectic groups of people who were attracted to the area: modernist painters and sculptors, members of the Bauhaus, and artists inspired by left-wing politics and Soviet Socialist Realism. Bevan draws professional and social connections between painters, sculptors, writers, and designers—many of whom were refugees or émigrés—and their Chinese neighbours. The extent of these connections gives us a sense of the socio-geographical importance of Hampstead to its Chinese residents before they were forced to relocate in the 1940s as a result of the damage caused by the London Blitz.

The remaining five chapters in Part One focus more or less directly on the life and work of Chiang Yee. Craig Clunas's contribution places Chiang's writings on the arts of China in the context of their time, and looks at the development of his thought over the course of his career. *The Chinese Eye: An Interpretation of Chinese*

Painting (1935) and *Chinese Calligraphy: An Introduction to Its Aesthetic and Technique* (1938) presented themselves as 'authentic' presentations of Chinese aesthetic principles by a Chinese author, contrasted with the existing literature on these subjects by Westerners. Clunas submits that a close reading of these texts reveals them to be part of a complicated process of the circulation of ideas about art in the first part of the twentieth century, when 'purely Western' and 'purely Chinese' ideas were enmeshed in a network of mutual appropriation. In her chapter, Sarah Cheang explores how the persona of the Silent Traveller created by Chiang Yee steered clear of making controversial remarks, although he had strong feelings about Chinese politics, racism, and how Chinese people were regarded in Britain and America; he could be an 'Angry Traveller'. Cheang maintains that emotions, whether difficult or joyous, do not fit smoothly into linear narratives, and make memory an unreliable witness to history; historians themselves may have a personal interest in the subjects they study. Embracing the fragmented, the personal, the emotional, and the misremembered, Cheang presents a series of moments about Chinese physical presence. She asks: What was it to be a 'Silent Traveller'? How can we understand the things in that 'silence' that couldn't be said?

As discussed by Anne Witchard, Chiang Yee was involved in the theatre, in addition to his many books, his art, and his poetry, and was at the heart of the wartime revival of ballet in Britain. In 1942, Chiang Yee was commissioned to design sets and costumes for the new ballet *The Birds*, which subsequently won many glowing reviews from critics. This overlooked episode in his career has much to tell us about his artistic versatility and his wider significance for British cultural life. Following this, in Da Zheng's contribution we step back in time to Chiang Yee's early years, and look at his book *A Chinese Childhood*, published in 1940. Zheng shows that behind this peaceful narrative of childhood life lay sorrowful feelings and emotions. Exiled in England, Chiang was tormented with anxiety and worry while working on the book. Da Zheng maintains that by writing this book, the author attempted to reconstruct a home that no longer existed, yet a home that could take him away from the pain and anxiety of a life of exile in a foreign land. Finally, Paul French looks at Chiang Yee's work during World War Two. Chiang's various contributions to war-related propaganda speak both of his position in British society at the time and his attempts to draw parallels between the twin struggles of Britain and China against the Axis powers. Chiang's *The Silent Traveller in War Time* (1939) sought to portray British resolution in the face of war. Critically, as argued by French, it also serves as an early example of propaganda work, documenting the wartime experience of solidarity, laughter in the face of adversity, and the 'Blitz spirit' under the threat of gas attacks and evacuation.

The five chapters in Part Two, 'Chiang Yee's Circle', introduce some of the Chinese writers, artists, and friends with whom Chiang associated during his time in the UK. Tessa Thorniley's chapter considers the period during and shortly after the war, when Chinese writers in Britain were enjoying something of a heyday. At

this time, a number of publishers who were sympathetic towards China helped them to find new readers and achieve a measure of literary acclaim. The chapter traces the rise to prominence of Chiang Yee, Hsiao Ch'ien, Chun-chan Yeh, Lo Hsiao Chien (Kenneth Lo, 1913–1995) and Tsui Chi, and their individual relationships with influential publishers. Diana Yeh's contribution to the volume examines Chiang Yee's relationship with the Hsiungs, who, she maintains, were probably the most famous Chinese couple living in Britain during the 1930s. In discussing the major role that the Hsiungs, and Shih-I Hsiung in particular, played in both Chiang's career and personal life, she highlights how their relationship was one of mutuality, solidarity, and conviviality as diasporic Chinese writers in Britain. However, as she further expounds, this fruitful friendship was also impacted severely by the economy of racial representation at the time, which admitted only a few Chinese artists or writers to visibility. She discusses how, by pitching them as competitors against one another, this economy ruptured solidarities and collective resistance, and eventually tore apart their fragile bonds and those of their wider circle of diasporic Chinese writers.

Another little-known aspect of the life of Shih-I Hsiung is introduced by Paul Bevan, who explores his role as a screenwriter, specifically his collaboration with the showman Lai Foun. A simple but fundamental question is posed in this chapter: should Shih-I Hsiung's *Lady Precious Stream* be seen as an example of serious drama—as it was often said to be at the time—or as the author's own contribution to the populist, Orientalist world of Fu Manchu and other sensationalist films and novels about China, as it was recognised to be by a number of Hsiung's compatriots who were active in his homeland during the 1930s? Ren Ke's chapter focusses on the Chinese writer and political activist Wang Lixi, who landed himself in political exile in England for opposing Chiang Kai-shek's Nationalist Party (Kuomintang) regime. Adopting the English name Shelley Wang, he joined fellow Jiangxi natives Chiang Yee and Shih-I Hsiung to form a trio of displaced Chinese writers in London. The most politically engaged of the group, Wang Lixi travelled widely to gather support for China's War of Resistance against Japan and became a key participant in transnational anti-fascist movements. At the same time, he established close relationships with British leftist writers and publishers. These connections resulted in a series of transcultural literary moments, such as the publication of Wang's writings in *Left Review*, public salons in Dorset and Ulster, and the reading of Wang's poems on the BBC. Finally, taking the discussion into the 1950s, Frances Wood uses an oral history approach to introduce Shih-I Hsiung's family, which formed part of the small group of Chinese who settled in North London, exiled for different reasons but all highly educated and determined to preserve something of a Chinese lifestyle in unpromising surroundings. By the 1950s, Wood tells us, there were writers, painters, and ex-diplomats getting together for games of mahjong and cooking rather competitively! Their life in Hampstead is recalled through the memories of the second generation.

Part One: Chiang Yee

1
Chiang Yee's Hampstead

Paul Bevan

Although certainly not the most well-to-do part of London during the pre-war period, Hampstead, where Chiang Yee and Shih-I Hsiung made their home in the 1930s, was in striking contrast to the impoverished Limehouse area where most of London's Chinese residents lived at the time. Their flat in Upper Park Road was situated in the heart of what was arguably the most vibrant artistic area of London. Herbert Read (1893–1968), art critic, poet, and theorist, lived just around the corner at 3 Mall Studios, having moved there in 1934 with his wife 'Ludo' (Margaret Ludwig) from a flat belonging to Henry Moore (1898–1986) on nearby Parkhill Road.[1] This was an area inhabited by several modernist painters and sculptors, a group which Read later described with fondness:

> Living and working together in Hampstead, as closely and intimately as artists of Florence and Siena had lived and worked in the Quattrocento . . . Within this inner group that worked within five minutes' walking distance of each other in Hampstead I do not remember any quarrels, any jealousy or spitefulness. It was a 'nest' of gentle artists . . . a spontaneous association of men and women drawn together by common sympathies, shared seriousness and some kind of group criticism.[2]

This 'nest of gentle artists', a phrase Read would use on more than one occasion to describe the group, included Ben Nicholson (1894–1982), Barbara Hepworth (1903–1975), and Henry Moore.[3] In the years that followed, the area saw the fruits of this intellectual and artistic confluence, with the appearance of several modernist buildings of real architectural significance, a reflection of the district's progressive stance in the world of the arts. Not far from the 'nest', at 13 Downshire Hill, was one example, built in 1936 by Michael and Charlotte Bunney. By 1939, just around the

1. Charles Darwent, *Mondrian in London: How British Art Nearly Became Modern* (London: Double-Barrelled Books, 2012), 28; Caroline Maclean, *Circles and Squares: The Lives and Art of the Hampstead Modernists* (London: Bloomsbury, 2020), 117.
2. Quoted in Maclean, *Circles and Squares*, 132–33; Christopher Wade, ed., *The Streets of Belsize* (London: Camden History Society, 1991), 33. See also Herbert Read, *Art in Britain, 1930–40: Centred around Axis, Circle, Unit One* (London: Marlborough Fine Art, 1965); Herbert Read, 'A Nest of Gentle Artists', *Apollo* 77, no. 7 (September 1962): 536–40.
3. See also Read, 'A Nest of Gentle Artists', 536–42.

corner, at 1–3 Willow Road, Ernő Goldfinger's contribution stood, facing directly onto Hampstead Heath, a favourite place at this time for Chiang Yee to take his daily walk. According to *A Silent Traveller in London*, he would stroll round the grounds of Kenwood House on Hampstead Heath at least twice a week and, depending on the route he chose to take on the day, would have frequently passed Goldfinger's house.[4] Perhaps closest of all to the 'nest' was the Isokon Building, built on Lawn Road in 1933–1934, just two minutes' walk from both 50 Upper Park Road and the English modernist enclave.[5] The Chinese émigrés lived in close proximity to a number of refugees from Europe. Among the residents of the Isokon flats were artists and designers formerly attached to the Bauhaus, who came to London to escape Nazi persecution.[6] Walter Gropius (1883–1969) was resident from 1934 to 1937 and his colleagues Marcel Breuer (1902–1981) and László Moholy-Nagy (1895–1946) both lived there when they first arrived in London in 1935.[7] All three Bauhaus designers were central to the work of the Isokon Furniture Company (run by Jack Pritchard), while at the same time working for a number of other pioneering companies. Gropius was given the title 'Controller of Design' of Pritchard's company and Breuer took over that role when Gropius emigrated to the US in March 1937; Moholy-Nagy joined Gropius there just three months later, while Breuer was the third of the 'Bauhausler' trio to emigrate to the US, departing England in December of that year.[8] The Isobar, the dining club and bar Breuer designed for the Isokon, was a favourite meeting place for the local artistic community, including artists from the 'nest'.[9]

Photomontage artist John Heartfield (Helmut Herzfeld, 1891–1968), who had no direct links to the Bauhaus, lived on nearby Downshire Hill from 1938, after suffering the indignity of being temporarily interned as an 'enemy alien'.[10] English artist Roland Penrose (1900–1984) was his neighbour on the same road for a number of years and it was from there that he established the British Surrealist Group. By the time war broke out the photographer Lee Miller had joined him there and they were

4. See Chiang Yee, *The Silent Traveller in War Time* (London: Country Life, 1939), 113; Chiang Yee, *The Silent Traveller in London* (London: Country Life, 1938), 29. Goldfinger's house is now a National Trust property open to the public, see https://www.nationaltrust.org.uk/2-willow-road. Accessed 2 September 2021.
5. Built by Jack and Rosemary 'Molly' Pritchard and designed by the architect Wells Coates. See Leyla Daybelge and Magnus Englund, *Isokon and the Bauhaus in Britain* (London: Batsford, 2019).
6. Darwent, *Mondrian in London*, 26.
7. Daybelge and Englund, *Isokon and the Bauhaus in Britain*, 80–93.
8. Daybelge and Englund, *Isokon and the Bauhaus in Britain*, 106. Their time at the Isokon is celebrated by an English Heritage 'blue plaque'.
9. Darwent, *Mondrian in London*, 26; Daybelge and Englund, *Isokon and the Bauhaus in Britain*, 157–63. These included the Ukrainian former Weimar Bauhaus master Naum Slutzky (1984–1965), who lived in the Isokon flats for some time, and his old friend the Russian Constructivist Naum Gabo (1890–1977), who had taught at Weimar Bauhaus's successor in Dessau, and now lodged close by to the flats at 11 Lawn Road.
10. He was released after just six weeks due to ill health. Anna Schultz, 'John Heartfield: A Political Artist's Exile in London', in *Burning Bright: Essays in Honour of David Bindman*, ed. Diana Dethloff et al. (London: UCL Press, 2015), 254.

married later in the 1940s.[11] From Downshire Hill, in the summer of 1936, Penrose organised the International Surrealist Exhibition in collaboration with Herbert Read, which was mounted at the New Burlington Galleries in London's Mayfair. The previous year, in February and March, the prominent Shanghai painter Liu Haisu had organised the 'Exhibition of Modern Chinese Painting' at the same venue and was a guest at Hsiung and Chiang's Upper Park Road flat while he was in London.[12]

Down the road from Downshire Hill, opposite Belsize Park underground station on Haverstock Hill, was a new parade of shops and flats, Hillfield Mansions, built in 1934 by Hillfield Estates in the latest utilitarian style. Photographer Bill Brandt (1904–1983) made his home at 58 Hillfield Mansions from the mid-1930s, while his brother, Rolf Brandt (1906–1986), a follower of both Surrealism and Bauhaus design, was also on the long list of artists resident at the Isokon flats.[13] The Haverstock Hill Odeon, which opened on 29 September 1934, was the focal point of the Hillfield complex.[14] This would become a favourite haunt for Piet Mondrian (1872–1944), the Dutch artist who made London his home from 1938 to 1940, living at 60 Parkhill Road, not far from Herbert Read's home and those of Henry Moore and Barbara Hepworth, off what is now Tasker Road.[15]

These modernist figures were not the only artists living in the area. In 1933 the Artists' International Association (AIA) was formed. This was an eclectic group of individuals whose slogan, 'Radical in Politics, Conservative in Art', saw the production of art largely inspired by Soviet Socialist Realism, as championed by art historian Anthony Blunt (1907–1983).[16] Blunt's link to Chinese art in the 1930s was through Trinidadian-born left-wing journalist Jack Chen (1908–1995), who in 1937 mounted an exhibition in Charlotte Street in Central London for which Blunt wrote a glowing review in *The Spectator*.[17] At this time Blunt was a great follower of Socialist Realism, but not all artists involved in the AIA were necessarily devoted to this political brand of art. Amongst the well-known names associated with this group at one time or another were the portraitist Augustus John (1878–1961); expressionist painter Oskar Kokoschka (1886–1980), who lived on nearby

11. Maclean, *Circles and Squares*, 156. Commemorative 'blue plaques' have been erected at Heartfield's former residence, 47 Downshire Hill—actually the house of the German painter Fred Uhlman (1901–1985)—and that of Penrose and Miller at 21 Downshire Hill.
12. Da Zheng, *Chiang Yee: The Silent Traveller from the East – a Cultural Biography* (New Brunswick, NJ: Rutgers University Press, 2010), 59.
13. Paul Delany, *Bill Brandt: A Life* (Stanford, CA: Stanford University Press, 2004), 119; Daybelge and Englund, *Isokon and the Bauhaus in Britain*, 80. For more on Rolf Brandt see https://www.englandgallery.com/artists/artist_bio/?mainId=78. Accessed 2 September 2021.
14. The first film to be shown at the Odeon Haverstock Hill was *Chu Chin Chow*, starring George Robey and Anna May Wong. http://cinematreasures.org/theaters/15082. Accessed 31 December 2020.
15. Darwent, *Mondrian in London*, 58–59.
16. For more on the AIA see Robert Radford, *Art for a Purpose: The Artists' International Association, 1933–1953* (Winchester: Winchester School of Art Press, 1987); Christine Lindey, *Art for All: British Socially Committed Art from the 1930s to the Cold War* (London: Artery Publications, 2018), 29–34, 177–80.
17. See Paul Bevan, *A Modern Miscellany: Shanghai Cartoon Artists, Shao Xunmei's Circle and the Travels of Jack Chen, 1926–1938* (Leiden: Brill, 2015), 204–13.

King Henry's Road; and cartoonist David Low (1891–1963), whose studio on Heath Street was just round the corner from Hampstead underground station. Chiang Yee was himself a one-time member of the AIA. Even though his political and artistic aims may not have been in full accord with those propounded by the association, the AIA did raise money for aid to the wars in Spain and Abyssinia, two conflicts about which Chiang expressed great concern in his writings.[18] This organisation was also, in some small way, engaged in raising money for aid to China at the time of its war with Japan (1937–1945), a role that was taken up in a rather more focussed manner by the China Campaign Committee, one of several groups for which Wang Lixi, Hsiao Ch'ien, and Shih-I Hsiung worked, together with their colleagues H. D. Liem (Liem Ham-Djang)[19] and Jack Chen (another one-time resident of the Hampstead area and a member of both the AIA and the China Campaign Committee).[20]

According to the members' register of the AIA (now in the Tate Gallery Archive), a significant number of its members lived right in the heart of the 'nest' and the vast majority in the London postcode districts of NW3 and NW1, that is, Hampstead, Belsize Park, and Chalk Farm.[21] Henry Moore, in addition to being a major figure in the Hampstead modernist circles, was a member of the AIA, but the figure who seems to have been the strongest link between all the different artistic groups in Hampstead—the Chinese intellectuals, Moore's modernist clique, the Bauhaus group, and the Socialist Realists—was Herbert Read.

By the late 1930s Read was even well known in China, to both the Chinese- and English-speaking communities. His 1933 book *Art Now* had been published in Shanghai in 1935, translated into Chinese by the influential writer Shi Zhecun (1905–2003), and the following year an essay written by Read, 'An Approach to Modern Art', appeared in the Shanghai-published English-language periodical *T'ien Hsia Monthly*.[22] His poetry, too, could be found in Chinese translation. In 1938 his 'Bombing Casualties: Spain' appeared in the Shanghai-published magazine

18. Chiang, *The Silent Traveller in War Time*, 1–2.
19. Liem Ham-Djang later became London correspondent of the Chinese Central News Agency: 'Mr. H. D. Liem, the first Chinese journalist to "cover" the British capital, who is the London correspondent of the Chinese Central News Agency, addressed the China Campaign Committee luncheon yesterday, on Japan's aims in the Pacific.' 'Japan's Aim in the Pacific: Chinese View of Thai Fighting', *The Straits Times*, 23 January 1941, 10.
20. See Arthur Clegg, *Aid China, 1937–1949: A Memoir of a Forgotten Campaign* (Beijing: Xinshijie chubanshe, 1989), 18–19, 35. For more on Jack Chen see Bevan, *A Modern Miscellany*, 192, 203–4.
21. Names and addresses listed in the AIA register include the following: E. Kapp, 2 Steele's Studios, Haverstock Hill; Naum Slutzky, 31 Lawn Road; Nancy Sharp, 30 Upper Park Road; Leila Leigh, 38 Upper Park Road. 38 Upper Park Road was also the address of William Coldstream (1908–1987) from 1930 to 1941, and W. H. Auden lodged there in 1934. Many of the entries in this list include the addresses of those who lived within ten minutes' walk of Upper Park Road: Helena M. Clarke, 23c Belsize Park Gardens; Helen Kapp, 44 Belsize Park Gardens; Morris Kestelman, 27 Belsize Park Gardens; F. D. Klingender, 45 Downshire Hill; James B. Lane, 37 Belsize Square; Mary Martin, 54 Belsize Park, all in the postcode NW3; and Lord Methuen, 6 Primrose Hill Studios, Fitzroy Road, NW1. See 'Ledger Book Recording Payment of Ledger Fees', Artists' International Association, London, Tate Gallery Archive, TGA 7043/11/1.
22. Herbert Read, 'An Approach to Modern Art', *T'ien Hsia Monthly* 4, no. 4 (April 1937): 329–41; Herbert Read, *Art Now* (London: Faber and Faber, 1933); Li De 里德 [Herbert Read], *Jinri zhi yishu* 今日之藝術 ['Art now'], trans. Shi Zhecun 施蟄存 (Shanghai: Shangwu yinshuguan, 1935).

'*Candid Comment*' (*Ziyoutan* 自由譚), translated by the magazine's publisher, Shao Xunmei.[23] In London, Read not only lived a stone's throw away from the Chinese artists but was, by all accounts, a personal friend of Chiang Yee.[24] Even though Chiang's account of Read in *The Silent Traveller in London* gives the impression that they were rather distant friends, by 1937 Read had already written a preface to Chiang's *The Silent Traveller: A Chinese Artist in Lakeland* (the first of his Silent Traveller books), in which he deemed Chiang to be 'a master of the art of landscape painting'.[25] Two decades later, Read would continue his hands-on support of Chiang Yee's work by writing another preface for the second edition of his book *Chinese Calligraphy*, just before Chiang left England for the US in 1955.[26] Read had clearly read the book when it first came out in 1938, as he wrote in his preface that at the time he had seen an 'analogy' between the aesthetic of Chinese calligraphy and that of Western abstract art.[27]

Chinese Calligraphy was written at a time when Chiang had physically moved further into the heart of the territory of the English modernist clique, as by then he had taken up lodgings at 56 Parkhill Road. There he lived until 1940, when he was bombed-out during the London Blitz, after which time he lived for a short while with Hsiao Ch'ien before moving to Oxford.[28] Hsiao left an account of his own experiences of the bombing in Hampstead.

> Just as I finished dinner the sirens sounded again. The area where I live, **Hampstead**, is the highest part of London. A siren in the city centre, as usual, sounded first. This distant sound – light and graceful – was like a herd boy playing a flute riding on the back of his ox. Following this, each district answered in turn, the closer it got the louder it became, until it was like a great church organ. As it began to sound close around us, the noise became such that it could awaken the dead, yet it also signified a mocking irony: after the Far East and Spain it was now London's turn.[29]

23. Hebotuo • Lüde 赫勃脫・呂德 [Herbert Read], 'Hongzha can'an: Xibanya' 轟炸慘案：西班牙 [Bombing casualties: Spain], trans. Zhong Guoren 鐘國仁 [Shao Xunmei 邵洵美], *Ziyoutan* 自由譚 ['Candid comment'] 1, no. 1 (1 September 1938): 40.
24. Chiang, *The Silent Traveller in London*, 257–58.
25. Chiang Yee, *The Silent Traveller: A Chinese Artist in Lakeland* (London: Country Life, 1937). See also Anna Wu, 'The Silent Traveller: Chiang Yee in Britain, 1933–55', *V&A Online Journal* 4 (Summer 2012), http://www.vam.ac.uk/content/journals/research-journal/issue-no.-4-summer-2012/the-silent-traveller-chiang-yee-in-britain-1933-55. Accessed 15 April 2020.
26. Chiang Yee, *Chinese Calligraphy: An Introduction to its Aesthetic and Technique*, 2nd ed. (London: Methuen, 1954). In the first edition of 1938 (also published by Methuen) the preface was written by Lin Sen 林森 (1868–1943), then President of the Chinese government. For the second edition (1954) Herbert Read supplied a new preface.
27. Herbert Read, preface to *Chinese Calligraphy* by Chiang Yee, viii.
28. Zheng, *Chiang Yee*, 115. The Victorian house that once stood at 56 Parkhill Road is no longer there. In its place is a more recent building, which stands next to number 60 (Piet Mondrian's former residence). There is no number 58.
29. Fu Guangming 傅光明, ed., *Xiao Qian wenji* 蕭乾文集 [Collected works of Xiao Qian] (Hangzhou: Zhejiang wenyi chubanshe, 1998), 2:272.

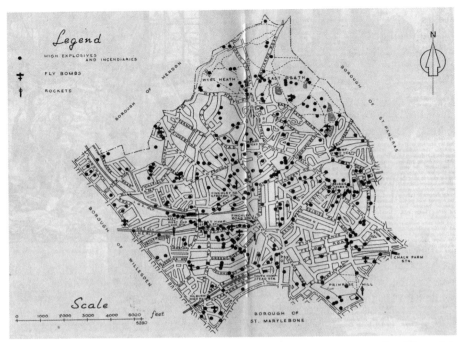

Figure 1.1: Map of bombings in the Borough of Hampstead from *Hampstead at War*, originally published by Hampstead Borough Council, ca. 1946.

During the London bombing, Bill Brandt took photographs of the air-raid shelters in Belsize Park underground station, just a couple of minutes' walk from his home, and it was on these station platforms that Henry Moore began to draw his 'Shelter Drawings'.[30] Soon afterwards, Moore and his wife Irina were forced to move out of their Parkhill Road flat as a result of the air raids, as was their neighbour Piet Mondrian. He transferred to temporary lodgings in Belsize Grove, round the corner from his beloved Odeon Cinema on Haverstock Hill, before leaving England for good towards the end of September.[31] Two months later the Odeon took a direct hit, suffering severe bomb damage, and remained closed until it was finally renovated in 1954.[32]

The Blitz affected all who lived in the immediate area. 50 Upper Park Road, together with the row of once grand Victorian houses of which it was a part, suffered irreparable damage, having been hit by the first bomb to land on the Borough

30. Andrew Causey, *The Drawings of Henry Moore* (Farnham: Lund Humphries, 2010), 104. See also Ann Garrould, *Henry Moore: Drawings* (London: Thames and Hudson, 1988), 84–97.
31. Darwent, *Mondrian in London*, 86.
32. Mark Aston, *The Cinemas of Camden* (London: London Borough of Camden, 1997), 54–55. See also 'Odeon Haverstock Hill', Cinema Treasures, http://cinematreasures.org/theaters/15082. Accessed 31 December 2020.

of Hampstead on 9 September 1940, and was subsequently pulled down. On the site it once occupied there now stands a block of forty-six council flats and maisonettes. This substantial building, Barn Field, erected on Upper Park Road in 1947–1948, shortly after the end of the war, lies back-to-back with its mirror image, Wood Field, which in turn faces straight onto Parkhill Road. They are now both Grade II listed buildings and architecturally important in their own right as striking examples of post-war social housing. Wood Field is situated directly opposite the houses that were once home to Chiang Yee, Piet Mondrian, and the 'nest of gentle artists'.[33]

33. The four-storey blocks of flats, built between 1947 and 1949, have been designated Grade II listed buildings since December 2000 (English Heritage Building ID: 486927). Barn Field on Upper Park Road and Wood Field on Parkhill Road are now the responsibility of Camden Council. See 'Barn Field: A Grade II Listed Building in Gospel Oak, Camden', British Listed Buildings, http://www.britishlistedbuildings.co.uk/en-486927-barn-field-greater-london-authority. Accessed 31 December 2020.

2
Chiang Yee as Art History

Craig Clunas

In August of 1933, readers of the Shanghai newspaper *Shishi xinbao* 時事新報 ('China Times') might have glanced at a brief story with the headline 'Praise for Chiang Yee's Paintings of Buddha', which opens, 'The former county magistrate of Jiujiang, Chiang Yee, is famous for painting the Buddha, and having a desire to deepen his practice, last month he travelled to London to engage in scholarly research'.[1] They would have learned too that he had taken three of his paintings of the Buddha to London with him, where they had been exhibited and praised. Just over a year later, in November of 1934, they would have received further news of the same artist's achievements in foreign parts, under the headline 'Chiang Yee, Student in England, Takes Part in International Painting Exhibition'. The exhibition in question sounds like an impressively important event, one organised by the 'British Ministry of Education', with ambassadors of all the nations represented in London serving on its committee. Three works by Chiang Yee were exhibited: *Lushan zhi song* 廬山之松 (Pines of Lushan), *Xihu zhi liu* 西湖之柳 (Willows of West Lake), and *Huanggang zhi zhu* 黃崗之竹 (Bamboos of Huanggang).[2] And later in the same month they would have read of the success on the London stage of the drama *Lady Precious Stream*, its published script accompanied by illustrations from the pens of Chiang Yee and the famous artist Xu Beihong (1895–1953).[3] These three newspaper accounts remind us that, before he was 'The Silent Traveller', the author of well-received and popular transcultural commentary, Chiang Yee came to public notice as a figure involved in the *visual* arts, a position which was principally cemented by his first book, *The Chinese Eye: An Interpretation of Chinese Painting* (1935), and then by *Chinese Calligraphy: An Introduction to its Aesthetic and Technique* (1938). Indeed, it was the first of these two books (titled in Chinese on the cover simply *Zhongguo hua*, 'Chinese Painting') which formed the centrepiece of the longest account of Chiang Yee's activities ever to appear in the press in China itself, when

1. *Shishi xinbao* 時事新報, 23 August 1933, 11, accessed via the database 'Late Qing and Republican Era Chinese Newspapers', https://gpa.eastview.com/crl/lqrcn/. Accessed 5 November 2020.
2. *Shishi xinbao*, 19 November 1934, 6.
3. *Shishi xinbao*, 26 November 1934, 11.

in February 1936 *The China Times* carried the following extensive encomium under the headline 'Mr. Chiang Yee's Glory' (*Jiang Yi jun zhi rongyu* 蔣彝君之榮譽):

> Despatch from London: The Chinese overseas student Chiang Yee, who has been studying local government for three years, and is long versed in calligraphy and painting [*su shan shuhua* 素擅書畫] has exhibited a number of Chinese paintings in exhibitions, eliciting great interest and praise from the London public. Mr. Chiang composed the book *Chinese Painting* in English, in order to introduce our nation's art of painting, and this has sold out on first publication, with a reprint shortly to sell out, and a third edition to come. Most recently he has written another book on 'China's Great Mountains and Rivers' [*Zhongguo mingshan da chuan* 中國名山大川], publication of which is imminent. Since the opening of the London exhibition of Chinese art, British appreciation for our art has elicited deep interest, and Mr. Chiang has been invited to many places to lecture on Chinese art, making him extremely busy in responding. And, beginning with this term, London University have specially invited Mr. Chiang to lecture for six weeks on the methods of Chinese calligraphy and painting, beginning on 12 February, the numbers of those registering being extremely buoyant. On 20 January Mr. Chiang's solo exhibition of painting opened, to an unceasing flow of visitors; it will be extended to the end of February, and Gaumont, Britain's largest cinema company, have shot an educational news film, showing how to paint a Chinese painting and write Chinese characters; the work has already been completed, it will be shown in all of London's cinemas in the middle of February, and subsequently sent everywhere. Due to this Mr. Chiang's face will be known by everyone. Also, a recent painting of English landscape by Mr. Chiang has been bought by an Englishman, and there is talk of an exhibition at the British Museum.
>
> Mr. Chiang's *zi* is Zhongya, he is originally from Jiujiang in Jiangxi, and is a graduate of Southeastern University. He has served as county magistrate in Jiujiang, Shangrao, Wuhu, and Dangtu counties, but being unable to express his aims and ambitions he left office to go to Britain, applying himself with utmost diligence to his studies. Held in high esteem by that country's world of learning, he has become much talked about, and his achievements are remarkable.[4]

The fact that by this date he was teaching at the School of Oriental Studies, and no longer actively pursuing his studies at the London School of Economics, reduces the chances that Chiang himself was the source for these stories, though this cannot be ruled out. However, such contemporary accounts also introduce a number of issues which need to be addressed if we are to accurately take the measure of Chiang Yee's place as a cultural figure in Britain, and if the nature of those achievements is to be accurately gauged in the context of writing on the art of China during his lifetime. Before the professionalisation of 'art history' as a discipline, when canons and standards remained very much the object of negotiation between varied claimants to authority and to cultural capital, the challenges faced by a transnational subject like Chiang Yee were of a very particular kind. How he negotiated them, using

4. *Shishi xinbao*, 23 February 1936, 7.

both the strengths and weaknesses of his position as an immigrant, is instructive in helping us understand the wider flows of information and power in which both individuals and discourses (such as 'Chinese art' itself) were embedded, particularly in the context of 'a political economy of racial representation, where only a limited number of Chinese artists or writers were admitted to visibility'.[5]

Let us start with the issue of Chiang Yee being 'famous for painting the Buddha'. This brings us at once up against the issue of his status as a painter prior to his departure from China on 20 May 1933. Chiang Yee was prominent enough to be one of the relatively few Chinese men or women named in the passenger list of the liner *André Lebon*, published in the English-language Shanghai press.[6] This public visibility however owed nothing at all to any artistic achievements, rather to his status as (until very recently) a successful functionary of the Republican government, one with family connections going right to the very top of the Nationalist Party hierarchy. Whatever later success he enjoyed, he had no presence whatsoever in the vibrant and extensive art world of China in the 1920s and 1930s, marked by a proliferation of publications, societies, advertisements, exhibitions, polemics, and coverage in China's voracious print media.[7] His several early appearances in the newspapers over the course of the 1920s and early 1930s relate either to his matriculation at Southeastern University (Dongnan daxue 東南大學), or to his career as a county magistrate in various parts of his native Jiangxi province.[8] So, his 'fame' as a painter of Buddhist images was not in any sense more than local, or even familial. More pertinently, there is no trace of these Buddhist images being displayed in London, or of their survival in any public collection, and there is indeed limited reference in the contemporary published literature by and about Chiang Yee of any commitment to Buddhist practice or belief. The History and Teachings of the Different Buddhist Schools in China' did initially form the topic of his abortive doctoral thesis at London's School of Oriental Studies, for which he registered in August 1936, but within months he had jettisoned this in favour of the subject of Chinese calligraphy.[9] On his own religious beliefs his works are indeed largely silent. This underlines the issue that, given the fact that he effectively disap-

5. Diana Yeh, *The Happy Hsiungs: Performing China and the Struggle for Modernity* (Hong Kong: Hong Kong University Press, 2014), 88.
6. *The China Press*, 21 May 1933, 5, accessed via the database 'ProQuest Historical Newspaper: Chinese Newspapers Collection', https://search.proquest.com/hnpchinesecollection. Accessed 5 November 2020.
7. On which see Liu Ruikuan 劉瑞寬, *Zhongguo meishu de xiandaihua: meishu qikan yu meizhan huodong de fenxi* 中國美術的現代化: 美術期刊與美展活動的分析 [The modernisation of Chinese art: A study of art journals and art exhibitions] (Beijing: Shenghuo, Dushu, Xinzhi, Sanlian shudian, 2008); Pedith Pui Chan, *The Making of a Modern Art World: Institutionalisation and Legitimisation of* Guohua *in Republican Shanghai* (Leiden: Brill, 2017).
8. His matriculation is recorded in *Shishi xinbao*, 5 September 1921, 2. For an example of his political activities, when 'bandits' burned the school and various shops in Dangtu, see *Shishi xinbao*, 21 April 1930, 6.
9. And in the 1950s he considered but did not execute a major translation project involving Buddhist texts. See Da Zheng, *Chiang Yee: The Silent Traveller from the East — a Cultural Biography* (New Brunswick, NJ: Rutgers University Press, 2010), 70, 74, 181, 191. See also Da Zheng's essay in this volume for an alternative interpretation of this aspect of Chiang Yee's life.

pears from the written record in Chinese after his moment of glory in 1936, we are today almost entirely dependent on Chiang's various autobiographical writings for an understanding of his training and his career. Certain inconsistencies in these, whether due to lapses of memory with the passage of time, or a certain tendency to coat the past in a rosy glow of success, mean that it is necessary to be cautious in accepting Chiang's own accounts purely at face value, and to try and triangulate them with what we can gain from other sources, as well as from the wider historical context. The aim is not to 'debunk' Chiang Yee, but rather to situate him more believably in a context of contingency and practice, which may not have had at the time the inevitability it later acquired in print.

An exhibition of Chiang Yee's painting at the British Museum in 1936 was never a likely possibility, and there is no sign that he ever actually wrote another book on 'China's Great Mountains and Rivers', but otherwise the success commemorated in the 1936 newspaper article is, with due allowances, accurate. His 1935 book *The Chinese Eye* was a considerable hit, both commercially and critically, and there is no doubt that without it the opportunities presented to him by the publication of the first Silent Traveller book in 1937 might never have come along. To an extent, it was born out of Chiang Yee's great skill for being in the right place at the right time, just as the impending major International Exhibition of Chinese Art, held at the Royal Academy of Arts from 28 November 1935 to 7 March 1936, created an urgent demand among London publishers for works on this topic of fashionable interest. Alan White, director of Methuen, was not only already the British publisher of the works of Pearl Buck (1892–1973), the American author of numerous novels about China, and of the 1935 hit *The Maker of Heavenly Trousers* by Daniele Varè (1880–1956), he was acquainted with Shih-I Hsiung, author of the West End hit *Lady Precious Stream* and at that point the landlord of his fellow Jiangxi provincial Chiang Yee. Chiang might not have been a major player in the Chinese art world, but he *was* more than competent as a painter in the *guohua* 國畫 (national painting) mode of picturing, and indeed had shown his work in London on two verifiable occasions since his arrival. The first of these (referred to in the November 1934 newspaper story quoted above) was an exhibition of paintings of trees from around the world, mounted by 'The Men of the Trees', an early ecological organisation whose exhibition does not appear to have troubled the London art press.[10] The second London exhibition in which Chiang's work was featured was a much more significant, and widely noticed, affair, the Exhibition of Modern Chinese Painting held in one of London's prestigiously situated Mayfair private galleries, the New Burlington Galleries, from 21 February to 12 March 1935. This was an event bankrolled by the Chinese government, prominently supported by its ambassador in London, Guo Taiqi (1888–1952), and curated by one of the most prominent and successful artists

10. It *is* mentioned in the scientific journal *Nature* 105, (22 June 1935): 1031.

of the time, Liu Haisu (1896–1994).[11] Arriving in London in January 1935, having organised prior shows of the same material in various German centres, Liu lodged with Shih-I Hsiung, hence under the same roof as Chiang Yee, a man whom he may never have met before and who was unlikely to have been viewed as a major figure of the art world in which Liu was himself so big and energetic a presence. However, in one of a series of newspaper articles through which Liu made sure the Chinese public knew just how successful (and busy) he had been in Europe in the years 1933–1934, Liu Haisu lists Chiang Yee as one of the Chinese members of the organising committee for the show, along with such luminaries as the president of the Academia Sinica, Cai Yuanpei (1868–1940), and Ye Gongchuo (1881–1968), renowned artist as well as minister of transport in the Republican government.[12] He included ten of Chiang's works (possibly including the mysterious Buddhist images?) in the New Burlington Galleries exhibition, and he records Chiang as lecturing in conjunction with the exhibition, along with himself and the distinguished English poet, curator, and scholar of Chinese art Laurence Binyon (1869–1943); the title of Chiang's lecture was 'Chinese Characters and Painting' (*Zhongguo wenzi yu huihua* 中國文字與繪畫), while Liu himself talked on 'Chinese Painting and the Six Laws'.[13] Liu appears to have remained in London when the Exhibition of Modern Chinese Painting closed (he did not accompany it to its next venue in Prague), and returned to China at some point in 1935. The exact articulation of his interactions with Chiang Yee as he wrote *The Chinese Eye*, which was published on 21 November 1935, exactly one week before the opening of the great Royal Academy exhibition, cannot now be recovered. But as we shall see they left a deep impact on Chiang, a writer who was at this precise point addressing the nature of 'Chinese painting' in print for the first time, and in a language not his own.

By his own account Chiang was nervous about his command of written English, and had to be reassured by his publisher.[14] Crucial to the success of the project was the major input of Innes Jackson (later Innes Herdan, 1912–2008), then a recent Oxford graduate whose commitment to Chinese culture had led her to the language classes Chiang taught at London University's School of Oriental Studies for the first

11. On this and related exhibitions see Shelagh Vainker, 'Exhibitions of Modern Chinese Painting in Europe, 1933–1935', in *Chinese Painting and the Twentieth Century: Creativity in the Aftermath of Tradition*, ed. Cao Yiqiang and Fan Jingzhong (Hangzhou: Zhejiang Art Publishers, 1997), 554–61; Shelagh Vainker, 'Chinese Painting in London, 1935', in *Shanghai Modern, 1919–1945*, ed. Jo-Anne Birnie Danzker, Ken Lum, and Zheng Shengtian (Ostfildern-Ruit: Hatje Cantz Verlag, 2004), 118–23; Michaela Pejčochová, 'Exhibitions of Chinese Painting in Europe in the Interwar Period: The Role of Liu Haisu as Artistic Ambassador', in *The Reception of Chinese Art Across Cultures*, ed. Michelle Ying-Ling Huang (Newcastle-upon-Tyne: Cambridge Scholars Publishing, 2014), 179–99; Michelle Ying-Ling Huang, 'Introducing the Art of Modern China: Trends in Exhibiting Modern Chinese Painting in Britain, c. 1930–1980', *Journal of the History of Collections* 31, no. 2 (2019): 383–401.
12. 'Liu Haisu baogao Ou you jingguo (si)' 劉海粟報告歐遊經過(四), *Shenbao* 申報, 3 July 1935, 14.
13. 'Liu Haisu baogao Ou you jingguo', 12. The 'Six Laws' will be returned to below.
14. Chiang Yee, *China Revisited, after Forty-Two Years* (New York: W. W. Norton, 1977), 37.

time in the academic year 1935–1936.¹⁵ Herdan lived long enough to express to Chiang Yee's biographer her disappointment that she had been denied the status of a co-author, so significant was her contribution, which went far beyond merely polishing the English (she was, for example, the source of the title of the work).¹⁶ Given the degree of her input, it would be very valuable to know more about what she had been reading on the subject before she effectively became the book's co-author. But crucial to the marketing strategy of the book, and to the performance of an 'authentically Chinese' identity which it embodied, was the idea that this represented a pure and true 'native' understanding of Chinese art, in marked contrast to 'Western critics whose conceptions, though valuable, would certainly give an interpretation quite different from that of Chinese artists'.¹⁷ Its pervasive rhetorical strategy is a differentiation between 'we/us' (the Chinese) and what is 'ours', and 'you', the Westerner. There was therefore no space for the unmixed testimony of the 'native informant' to be contaminated by contact with 'the West', although as we shall see this is far from being the only way in which Chiang's work can in fact be most effectively thought of as a 'co-production', something which arises out of the mutual entanglement of 'East' and 'West', at the very point when it insists on their separateness, indeed strives to interpellate Chinese and Western subjects, to bring them into being. But in fact, as Diana Yeh has remarked of the work of Shih-I Hsiung, Chiang Yee also, 'far from merely reproducing or expressing a fixed 'Chinese' identity or culture ... drew upon a range of already globalized artistic and literary ideas, concepts and languages, encountered prior to and following transnational migration, for specific audiences'.¹⁸ It is perhaps worth pausing to remember that this commitment to a total separation of East and West was widespread among a range of geographically distributed authors. Laurence Binyon's review of *The Chinese Eye* for instance happily asserts, 'here we are shown the Chinese painter's outlook from within. The differences between this outlook and that of the European mind are great indeed'.¹⁹

The Chinese Eye is marked by a degree of inaccuracy about Chinese names and other words, which Innes Jackson (and certainly not Chiang's editor, Alan White) would have been equipped to spot. A number of these erroneous transcriptions can be put down to Chiang Yee's origins in Jiangxi province, where the dialect of spoken Mandarin has a well-known tendency to swap round the consonants 'l' and 'n'. So, the Song dynasty painter Liu Songnian (1174–1224) appears as 'Liu Sung-Lian' (Liu Sung-nien in correct Wade-Giles romanisation), and the Chinese name of the

15. Irini Antoniades, 'Obituary: Innes Herdan (1912–2008)', *The Guardian*, 18 June 2008. https://www.theguardian.com/theguardian/2008/jun/18/2. Accessed 6 November 2020.
16. Zheng, *Chiang Yee*, 62.
17. These are the words of Shih-I Hsiung, in his preface to *The Chinese Eye: An Interpretation of Chinese Painting*, by Chiang Yee (London: Methuen, 1935), ix.
18. Yeh, *Happy Hsiungs*, 8.
19. Laurence Binyon, review of *The Chinese Eye: An Interpretation of Chinese Painting* by Chiang Yee, *Journal of the Royal Asiatic Society of Great Britain and Ireland* (1 January 1937): 165–66.

famous court Jesuit Giuseppe Castiglione (1688–1766) is rendered as 'Nan Shih-Lin' instead of Lang Shining 郎世寧 (Wade-Giles: Lang Shih-ning).[20] We perhaps get a glimpse of the author's personal life experience in his claim that, 'Since we adopted Western systems of education, painting has been taught in schools as a part of the curriculum. There are four prominent names connected with this movement for universal and scientific instruction in art: the late Li Mei-An, Chi Pei-Shih, who holds the Professorship of art at Peiping, Yu Péon [sic], Professor at Nanking, and Liu Hai-Su, Professor at Shanghai.'[21] Qi Baishi (1864–1957), Xu Beihong, and Liu Haisu are all canonical figures today, but 'the late Li Mei-an' might be less familiar (certainly to the art market). He is Li Ruiqing (1867–1920), best remembered today for his role in the promotion of art education in the reformed education institutions of the very late Qing.[22] He was also the president of Southeastern University, where Chiang Yee majored in chemistry. And he was a noted figure of the Buddhist revival taking place in Chiang's youth: was he an influence on his pupil Chiang Yee, who remembered him here alongside three of the most famous painters alive at the time? In fact, it might be pertinent to consider for a moment the role of the newly founded (in 1921) Southeastern University as the place in which Chiang Yee received his intellectual formation. At the precise period when he studied there, Southeastern was the bastion of a revived cultural conservatism, centred around the journal *'The Critical Review'* (*Xueheng* 學恆); in addition, China's most famous society for the writing of poetry in the classical *ci* 詞 ('song-lyric') mode flourished there under the leadership of the poet and academic Wu Mei (1884–1938).[23] Whether Chiang, a keen poet in classical Chinese, took part in its activities is unknown, but we should not assume he was unaware of them. One little-noticed vignette of Chiang's years spent in this milieu of a considered classical revival (in fact to call it simply 'conservative' seems wrong) is his later confession that as a student there he studied the *guqin*, the musical instrument of the zither family that was the symbol *par excellence* of a conscious neo-literati subjectivity.[24] The China of Chiang Yee's youth, far from being a monoglossal space where 'the Chinese' all spoke with one voice (or, by extension, saw with one eye), was rather, as Michel Hockx has put it, somewhere where 'no one side . . . had a clear advantage in the competition for control over resources and aesthetic tastes'.[25] Many of the 'facts' around painting at this time are polemical positions, some of which Chiang Yee must have known were not incon-

20. Chiang Yee, *Chinese Eye*, 156, 157. This weakness was spotted by at least one reviewer; see William King, 'Chinese Art', *The Spectator*, 20 December 1935, 1036–37.
21. Chiang Yee, *Chinese Eye*, 60.
22. Lü Peng 呂澎, *Zhongguo yishu biannianshi* 中國藝術編年史 ['A History of Chinese Art year by year from the year 1900 to 2010'] (Beijing: Zhongguo qingnian chubanshe, 2012), 63.
23. Shengqing Wu, *Modern Archaics: Continuity and Innovation in the Chinese Lyric Tradition, 1900–1937*, Harvard-Yenching Institute Monograph Series 88 (Cambridge, MA: Harvard University Press, 2013), 254–63.
24. Chiang Yee, review of *Foundations of Chinese Musical Art* by J. H. Levis, *The Journal of the Royal Asiatic Society of Great Britain and Ireland* (1 January 1938): 145–48.
25. Michel Hockx, *Questions of Style: Literary Societies and Literary Journals in Modern China, 1911–1937* (Leiden: Brill, 2003), 221; quoted in Wu, *Modern Archaics*, 262.

testable. For example, the oft-repeated claim that real Chinese painters did not work to order or accept payment for their work, but painted only as inspiration struck, or as gifts for friends, is certainly empirically false for the past.[26] But it is even more false for the China of Chiang Yee's first thirty years, when newspapers were filled with the published pricelists of painters in the *guohua* manner, including the most revered and most prestigious ones.[27]

A close reading of *The Chinese Eye* can only reinforce the interpretation that, while rhetorically it exists in an ethnographic present of an essentially timeless 'Chinese painting', in practice it is very much an artefact of its era, reflecting specific debates and interventions which swirled around the topic of painting in Chiang Yee's lifetime. These debates have to be understood in a transnational framework, one in which not only flows of texts and ideas but also flows of objects and images took place very much *not* in a unidirectional way, but in a continuous circuit, a sort of 'echo chamber' whereby ideas were mutually amplified as they passed between locations and languages.[28] Precisely because Chiang Yee had *not* (whatever later constructions might assert) been intimately involved in the art world of the early Chinese Republic, his understanding of what '*Zhongguo hua*' was and was not is all the more deeply dependent on the noises coming out of this transnational conversation.

Crucial to the performed identity which is embodied in the idea of the 'Chinese eye' is the claim that this is being done for the first time, that the native informant has never before been afforded a hearing. It is perfectly true to say that 'prior to the Burlington exhibition almost all literature on the subject of Chinese art in English had been written by Western authors with few contributions by native Chinese experts'.[29] But for the claim of priority to be sustained it is necessary (both for the Chinese author *and* his English audience) to 'forget' any precursors who may actually have existed. In the case of the visual arts, as we shall see, one of the most prominent of these precursors was Liu Haisu himself, who published an essay, 'Aims of the Chinese Painters', in one of Britain's leading art periodicals in the summer of 1935, that is, before the publication of Chiang's book.[30] But there were others, reaching back into the nineteenth century. For example, the forgotten figure of Chen Jitong (1851–1907), a successful diplomat of the Qing empire and the first Chinese Francophone author, whose hugely successful books about Chinese life were translated from French to English; one of these explicitly included a section on 'painters',

26. James Cahill, *The Painter's Practice: How Artists Lived and Worked in Traditional China* (New York: Columbia University Press, 1994).
27. Craig Clunas, 'Reading a Painter's Price List in Republican Shanghai', *Source: Notes in the History of Art* 35, no. 1/2 (Fall–Winter 2016): 22–31.
28. This theme is treated more fully in Craig Clunas, *The Echo Chamber: Transnational Chinese Painting, 1897–1935* (Beijing: OCAT Institute, forthcoming).
29. Anna Wu, 'The Silent Traveller: Chiang Yee in Britain, 1933–35', *V and A Online Journal* 4 (Summer 2012), http://www.vam.ac.uk/content/journals/research-journal/issue-no.-4-summer-2012/the-silent-traveller-chiang-yee-in-britain-1933-55/. Accessed 2 November 2020.
30. Liu Hai-Su, 'Aims of the Chinese Painters', *The Studio* 109 (1935): 240–50.

which, in addition to translations of two works on painting by the Tang dynasty poet Du Fu (712–770), stated such 'facts' as the essentially amateur nature of all Chinese painters.[31] Rather like Chiang Yee, at least until very recently, 'Chen's extraordinary literary success in the West was and has remained almost totally unknown to the Chinese public.'[32]

If we analyse the contents of *The Chinese Eye*, to what extent are they in fact significantly at odds with the views of 'Western critics [who] . . . would certainly give an interpretation quite different from that of Chinese artists'? The plethora of books about Chinese art produced by publishers seeking to take advantage of the surge of interest around the International Exhibition of Chinese Art gives us a number of points of comparison (and indeed Chiang Yee's work was frequently reviewed in the context of a collective notice of several titles). We can profitably compare Chiang's work with something like *A Background to Chinese Painting* by Roger Soame Jenyns.[33] Jenyns (1904–1976) had served in the Hong Kong Civil Service from 1926 to 1931, the year in which he joined the British Museum as a curator; he and Chiang (born in 1903) were therefore close contemporaries. Unlike some of the leading figures of the previous generation (most notably Laurence Binyon), Jenyns had some command of the Chinese language, from his days as a colonial administrator. Both of their books present themselves as aimed at the 'general reader', they both specifically eschew claims of academic expertise. Chiang's structure involves nine chapters; an 'Introduction' is followed by 'Historical Sketch', 'Painting and Philosophy', 'Painting and Literature', 'Inscriptions', 'Painting Subjects', 'The Essentials', 'The Instruments', and 'Species of Painting'. Jenyns's work takes a seven-chapter form, these being 'A General Survey', 'The Influence of Religion', 'The Relation to Calligraphy', 'The Patronage of the Throne', 'The Choice of Materials and Technique', 'The Treatment of Landscape and the Human Figure', and 'The Use of Bird, Flower and Animal Motives'. Both are more or less equally dismissive of painting in China which does not meet their criteria for being 'Chinese painting', with Jenyns commenting that, 'there has been a tendency in the last few years among Chinese painters to study European art in Paris. About 1926 Shanghai was full of Chinese versions of Cézanne, and since then there have been Chinese artists who have deserted their native styles to plunge into the problems of the most modern European art', while Chiang complains that 'nowadays, many of our modern painters make strenuous efforts to coalesce Eastern and Western ideals, but their small sparks have not caught fire!'[34]

31. Tcheng-Ki-Tong, *Chin-Chin; or, The Chinaman at Home*, trans. R. H. Sherard (Fairford: Echo Library, 2019), 71.
32. Catherine Vance Yeh, 'The Life-Style of Four *Wenren* in Late Qing Shanghai', *Harvard Journal of Asiatic Studies* 57, no. 2 (1997): 436.
33. Roger Soame Jenyns published under the name Soame Jenyns. See Soame Jenyns, *A Background to Chinese Painting* (London: Sidgwick and Jackson, 1935).
34. Jenyns, *Background to Chinese Painting*, 22; Chiang Yee, *Chinese Eye*, 61.

Perhaps one area where a difference, of emphasis at least, can be discerned relates to these two authors' attitudes towards the so-called 'Six Laws' (*liu fa* 六法) of the sixth-century art theorist and intellectual Xie He, (his exact dates are in fact unknown), and in particular the first and most enigmatic criterion, *qiyun shengdong* 氣韻生動. To start with the English author, Jenyns states baldly that 'all art criticism in China is based on six principles laid down by Hsieh Ho who lived AD 479–501'.[35] He says of *qiyun shengdong*, 'This is the most important of the six. Giles translated it [as] "rhythmic vitality" and Okakura "the life movement of the spirit through the rhythm of things"'.[36] Jenyns asserts, 'the six principles may not strike us as very conclusive, but the Chinese have woven round them a wealth of philosophical subtleties', and he goes on: 'But as Waley says, "each age and class has made its attempt to define artistic beauty, has produced its convenient phrase and grown tired of it. Who shall say Hsieh Ho's formula is any more nebulous than the rest"'.[37] The three scholars he cites here are Herbert Giles (1845–1935), Okakura Kakuzō 岡倉覚三 (1862–1913), and Arthur Waley (1889–1966), all of whom had made contributions to what was by 1935 a considerable literature in English on the 'Six Laws' of Xie He.[38] Following Waley, like himself at one point a British Museum curator, Jenyns is mildly sceptical about the explanatory power of these ancient formulae. But by contrast Chiang Yee doubles down on the central concepts of 'rhythm' and 'rhythmic vitality': the latter term has no less than eleven entries in the index of *The Chinese Eye*, making it one of the most pervasive concepts in his entire book.[39] He introduces the two concepts with these words:

> The 'Six Principles [Chiang's rendering of the Six Laws] of Painting' were formulated by his [Xie He's] penetrating mind. They represent the standards against which any painting should be measured, and so satisfactory are they to the Chinese that they have remained to the present day, unaltered, unsupplemented, almost uncriticised. . . . There has been some discussion as to the best English translation: it is remarkably difficult to find an equivalent in a foreign tongue, since the inspiration and technique of which they are the judges are themselves alien. Here is the simple version: Rhythmic Vitality, Structure and Brushwork, Modelling after Object, Adaptation with Colouring, Careful Placing and Composition, Following and Copying.[40]

Elsewhere he comments that 'Hsieh Ho said that to capture the "Rhythmic Vitality" of any object was the painter's pre-occupation, implying that all things in the Universe were possessed of life.' He calls 'rhythmic vitality' 'the most vital part of all

35. Jenyns, *Background to Chinese Painting*, 136.
36. Jenyns, *Background to Chinese Painting*, 137.
37. Jenyns, *Background to Chinese Painting*, 139.
38. The relevant works are Herbert Giles, *An Introduction to the History of Chinese Pictorial Art* (Shanghai: Kelly and Walsh, 1905); Kakasu Okakura, *The Ideals of the East with Special Reference to the Art of Japan* (London: J. Murray, 1903); Arthur Waley, *An Introduction to the Study of Chinese Painting* (London: Ernest Benn, 1923).
39. Chiang Yee, *Chinese Eye*, 239.
40. Chiang Yee, *Chinese Eye*, 32–33.

in our paintings . . . the sole aim of painters . . . the sum of the other five "principles of painting".'[41] There can be no doubt, indeed Chiang Yee makes it explicit, that his views on the topic draw heavily on those of his more famous (in China) contemporary, and recent housemate, Liu Haisu. He quotes directly Liu's interpretation of 'the Chinese expression "Chi-Yung Shen-tung" as the combination of two ideas— "Rhythmic harmony—Life's motion,"' and he goes on to cite Liu Haisu extensively, from the introduction to the Exhibition of Modern Chinese Painting.[42] He owes to Liu the conclusion that *qiyun shengdong* is the 'sum' of the other five laws, a position which is in no way sustained by a reading of the original text (even if it was normative by the early twentieth century). We can also see Chiang's appropriation of Liu's particular interpretations when he writes that 'Hsieh Ho, our fifth-century art critic, while emphasising "Rhythmic Vitality" as the first essential of a great work of art, was careful to point out that "Touch" and command over the "skeleton" or basic outline were the most important means to this end'.[43] It is the word 'Touch' that is the giveaway here. In 1931 Liu Haisu had published *'The Theory of the Six Laws in Chinese Painting'* (*Zhongguo huihuashang de liufa lun* 中國繪畫上的六法論), its preface dated 24 April 1931 and attributed to 'Liu Haisu in the Latin Quarter [*Lading qu* 臘丁區], Paris'. It therefore stakes its claim as a text written in Chinese, by a Chinese author, but crucially in Paris, still widely accepted as the 'capital' of the art world. At least one scholar has argued that Liu was not himself the author of this book, and that it was rather ghostwritten for him by his younger colleague Teng Gu (1904–1941).[44] At exactly the same time as Chiang Yee was establishing himself in London, and toying with the idea of a doctoral thesis, Teng Gu was knuckling down to *his* Berlin University PhD on early Chinese painting theory, publishing in 1934–1935 a lengthy and impressively scholarly two-part article in German, essentially the material of his dissertation, entitled 'Chinese Painting Theory in the Tang and Song Period'.[45] Teng is therefore another figure who needs to be 'forgotten' in order for Chiang's priority to be sustained. Whoever wrote *'The Theory of the Six Laws in Chinese Painting'*, be it Liu Haisu or Teng Gu, it is clearly the source of Chiang's notion of 'Touch', since somewhat idiosyncratically this is the very word it uses to render the second of Xie He's six formulae, the canonical *gufa yongbi* 骨法用筆 (Chiang's 'Structure and Brushwork'). In Liu's (or Teng's) book the word 'Touch' is actually written in English, in the Latin script, a common practice in Republican-era scholarly or even literary writing, if a practice which necessarily

41. Chiang Yee, *Chinese Eye*, 105, 186.
42. Chiang Yee, *Chinese Eye*, 186.
43. Chiang Yee, *Chinese Eye*, 176.
44. Jane Zheng, *The Modernization of Chinese Art: The Shanghai Art College, 1913–1937* (Leuven: Leuven University Press, 2016), 288.
45. Ku Teng, 'Chinesische Malkunsttheorie in der T'ang und Sungzeit I', *Ostasiatische Zeitschrift*, N.F. 10 (1934), 155–75; Ku Teng, 'Chinesische Malkunsttheorie in der T'ang und Sungzeit II', *Ostasiatische Zeitschrift* N.F. 11 (1935), 28–57.

excluded the majority of the population not versed in foreign languages.[46] But what situates Liu's interpretation even more firmly in the realm of the transnational is his citing of perhaps the most famous formula of the great Victorian critic Walter Pater (1839–1894), when he talks of *qiyun shengdong*:

> If we use a foreign word to replace it, we can use the word '**Rhythm**', which is already very suitable. The English critic **Pater**, in his imperishable work entitled *The Renaissance*, has said 'all art constantly aspires towards the condition of music' [*yiqie yishu, dou qingxiang yinyue de zhuangtai* 一切藝術，都傾向音樂的狀態]. Thus rhythm is not only the condition of music, it is a sort of condition of all art. Once we understand this, the basic meaning of Xie He's *qiyun shengdong* is then easy to understand.[47]

The centrality of 'rhythm' thus appears here *not* as something essentially 'Chinese', but as something which goes back to a range of existing interpretations in English, all appearing within a very narrow timeframe. It was in the year of Chiang Yee's birth, 1903, that Okakura Kakuzō—in his book *The Ideals of the East: With Special Reference to the Art of Japan*—produced the first rendering in English of the term *qiyun shengdong*. Writing in Calcutta, in close collaboration with the Irish convert to Hinduism Sister Nivedita (born Margaret Elizabeth Noble, 1867–1911), his rendering bears the strong impression not only of the philosophical and religious milieu of the Bengali renaissance in which he was working, but also of the ideas of Herbert Spencer (1820–1903), perhaps the most influential of Western thinkers in the Meiji Japan of Okakura's youth. So significant was Nivedita's contribution that some scholars at least have viewed *The Ideals of the East* as effectively a 'co-production' between her and Okakura, prefiguring the same gendered division of labour which has already been noted in the case of Chiang Yee and Innes Jackson.[48] Laurence Binyon's adoption of this English translation, and his subsequent modification of it, in collaboration with Herbert Giles, to the snappier 'rhythmic vitality', owes much to the vitalist philosophy of Henri Bergson (1859–1941), whose influence in Britain was it its height in the years leading up to the First World War. These English translations found their way in turn back to China, where the Western enthusiasm for a non-mimetic Chinese art infused with 'life-force' was in turn seized upon by Chinese writers arguing for a 'vital' Eastern civilisation as the counterpoint to a mechanistic, anti-humanist, and dying 'West'.[49] The German vitalist philosopher

46. Liu Haisu 劉海粟, *Zhongguo huihua shang de liu fa lun* 中國繪畫上的六法論 [The Theory of the Six Laws of Chinese painting] (Shanghai: Zhonghua shuju, 1936), 16a–16b.
47. Liu Haisu, *Zhongguo huihua shang de liu fa lun*, 25a–25b.
48. Inaga Shigemi, 'Okakura Kakuzō's Nostalgic Journey to India and the Invention of Asia', in *Nostalgic Journeys: Literary Pilgrimages Between Japan and the West*, ed. Susan Fisher (Vancouver, BC: Institute of Asian Research, University of British Columbia, 2001), 119–32; Rustom Bharucha, *Another Asia: Rabindranath Tagore and Okakura Tenshin* (New Delhi: Oxford University Press, 2006), 35.
49. Ku Ming (Kevin) Chang, '"Ceaseless Generation": Republican China's Rediscovery and Expansion of Domestic Vitalism', *Asia Major*, 3rd ser., vol. 30, no. 2 (2017): 101–31. For more on this topic see Clunas, *The Echo Chamber*.

and scientist Hans Driesch (1867–1941) was in China lecturing extensively at the precise point that the budding scientist Chiang Yee studied chemistry in the very particular setting of Southeastern University, cauldron of *guoxue* 國學 (national studies) enthusiasm. It might be pertinent to point out that any idea of 'rhythm', the concept so dear to Liu Haisu and by extension to Chiang Yee, as forming a satisfactory translation of *qiyun shengdong* was later comprehensively rubbished by another Chinese student who was studying in Britain as he wrote (though there is no evidence that they knew each other), the polymath and novelist Qian Zhongshu (1910–1998). 'Rhythmic vitality', as a translation of *qiyun shengdong*, was to be a particular target of Qian Zhongshu's erudite derision.[50] But the key point to grasp here is that the prominence of this idea is only comprehensible in the context of transnational flows of ideas, whereby Chinese writers are grappling in English with a concept introduced by a Japanese scholar steeped in Herbert Spencer, one who is in turn interpreted via Bergson by a British disciple of Walter Pater. When Pater is invoked, in turn, by Liu Haisu (and we can surely imagine Chiang Yee being familiar with his book on the 'Six Laws'), some sort of loop is closed, a loop across which interpretation can flow in a never-ceasing circuit. This is not a simple 'transmission' of 'Chinese theory' to 'the West'.[51] Far from being a simple outpouring of indigenous essence, *The Chinese Eye* is itself rather an artefact born out of transnational interpretative acts.

The book however contains more than just words, and it is perhaps in examining its twenty-four illustrations that we can best see a very distinctive cultural politics at work, particularly if we compare them to the forty-three collotype illustrations in Jenyns's competitor volume. What is immediately striking is that there is *no* overlap between their selections in terms of actual paintings, and almost no overlap even in terms of the artists featured, with only five artists common to both selections. Jenyns's illustrations, perhaps not surprisingly, draw heavily on institutional collections, with the British Museum as the single biggest source, providing thirteen of the forty-three (twelve come from 'The National Collection, Peiping' and others from the Museum of Fine Arts, Boston, and the Freer Gallery). *None* of Chiang Yee's twenty-four pictures comes from a collection outside China, perhaps raising the possibility that the 'Chinese eye' requires looking upon objects remaining in a Chinese space. But, in fact, Chiang Yee's (somewhat idiosyncratic) choice of illustrations (the lack of locations for which was picked up on by more than one reviewer) begins to make sense only when one realises that they are almost all drawn directly from the same published source, the bilingual work '*Famous Chinese Paintings Collected by Ping Teng Ke*' (*Zhongguo minghuaji* 中國名畫集) (Figure

50. Qian Zhongshu 錢鍾書, *Guan zhui bian* 管錐編 [Limited views] (Beijing: Zhonghua shuju, 1986), 4:1354.
51. Shao Hong 邵宏, 'Xie He "Liu fa" ji "qiyun" xichuan kaoshi' 謝赫 '六法' 及 '氣韻' 西傳考釋 [The 'Six Laws' of Xie He and the transmission of 'qiyun' to the West], *Wenyi yanjiu* 文藝研究 (June 2006): 112–22.

2.1).⁵² This collotype publication had a complicated history as a part work, before being issued in two volumes in 1930 by the Youzheng shuju 有正書局 (Youzheng publishing house), one of many outlets for the energies of the remarkable entrepreneur and veteran anti-Qing activist Di Baoxian (1873–1941).⁵³ Di and his publishing house had been at the forefront of the wave of collotype publishing of China's artistic heritage, both pictorial and poetic, which underpinned much activity on the 'national studies' wing of early twentieth-century cultural debates.⁵⁴ But far from being a 'pure' Chinese space, *Famous Chinese Paintings Collected by Ping Teng Ke* is very much a transnational one, with its captions in both English and Chinese, its biography of Di Baoxian in two languages, and its bilingual advertisements for other Youzheng publications, priced in pounds sterling and hence very specifically aimed at a 'Western' audience.

It would be interesting to know if Chiang Yee had brought the work with him, or borrowed it from his landlord Shih-I Hsiung, who definitely had a sideline as a dealer in Chinese art, or from another source (there was no copy in the library of his employer, the School of Oriental Studies). But there can be no doubt that this collection was the immediate source of his pictures, not least because of the very obscure nature of some of them, which are published in no other source, but because he draws on the English-language titles printed in the collection in such a way that his borrowing cannot have been coincidental. For example, one figure painting signed Gu Yuncheng (n.d.), depicting a lady asleep at her desk, is titled in the earlier book somewhat curiously as 'Hors de Combat', and this is the very title adopted by Chiang Yee for this work, which appears as Plate IV in *The Chinese Eye* (Figure 2.2); this is not the only case of such direct lifting.⁵⁵ The obscurity of the works is explained partly by the fact that Di Baoxian's publication is based principally on his own family collection, a very distinguished one to be sure, containing a number of pictures still regarded as masterpieces, but also one in which works

52. *Zhongguo minghuaji* 中國名畫集 ['Famous Chinese paintings collected by Ping Teng Ke'], 2 vols. (Shanghai: Youzheng shuju, 1930). Collating the copy of this work held in the Sackler Library, University of Oxford, shows seventeen out of twenty-four illustrations in *The Chinese Eye* have it as their immediate source. The other seven illustrations may also derive ultimately from the same work, given its very complicated history as a part-work, and the consequent variety between surviving copies. Reviewers noting lack of locations include King. See William King, 'Chinese Art', 1036–37.
53. 'The Context of *Famous Chinese Paintings*', Mywoodprints.free.fr, http://mywoodprints.free.fr/famous_chinese_painters/fca_context.html. Accessed 7 November 2020. For justification for Di's birth and death dates adopted here, which are given variously in different sources, see Richard Vinograd, 'Patrimonies in Press: Art Publishing, Cultural Politics, and Canon Construction in the Career of Di Baoxian', in *The Role of Japan in Modern Chinese Art*, ed. Joshua A. Fogel (Berkeley: University of California Press, 2012), 245–72.
54. Yujen Liu, 'Second Only to the Original: Rhetoric and Practice in the Photographic Reproduction of Art in Early Twentieth-Century China', *Art History* 37, no. 1 (2014): 69–95. For the Youzheng shuju production of volumes of *ci* poetry see Wu, *Modern Archaics*, 84.
55. The Chinese title given in *Zhongguo minghuaji* (which is unpaginated) is '*Ming Gu Yuncheng juan yin tu*' 明顧雲程倦吟圖. No painter of this name appears in the online 'Index to Ming Dynasty Paintings', https://library.harvard.edu/collections/index-ming-dynasty-chinese-paintings. Accessed 7 November 2020. The dates of the Ming politician Gu Yuncheng (1535–1608) seem far too early for a work in this style, but it may be he is being claimed here by Di Baoxian as the artist.

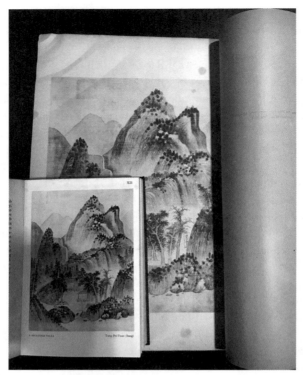

Figure 2.1: Chiang Yee, *The Chinese Eye* (London, 1935), Plate XII, superimposed on *Zhongguo minghuaji*, 2 vols (Shanghai, 1930).

by minor artists, or with what would now appear to be dubious attributions, are prominent; 'Hors de Combat' is one of the former category, just as Chiang's Plate I, attributed optimistically to the Tang master Wang Wei (699–759), belongs to the latter.[56] But perhaps more important is a recognition that in the 1930s the canon of 'Chinese painting' remained very much still a subject of negotiation. As Richard Vinograd has observed, Di Baoxian 'was operating within a highly dynamic and unstable environment of cultural authority', one in which, 'for most of the period 1908–1930, the environment of weak or incompletely developed art institutions meant that artistic canons could not be viewed as fixed and static things ready to be deployed for various contexts and purposes, but rather should be seen as the emerging products of typically dynamic and contentious processes of formation'.[57] While rhetorically *The Chinese Eye* suggests stable and agreed canons and criteria,

56. James Cahill, incorporating the work of Osvald Sirén and Ellen Johnston Laing, lists this as a 'much later work'; *An Index of Early Chinese Painters and Paintings: T'ang, Sung and Yüan* (Berkeley: University of California Press, 1980), 18.
57. Vinograd, 'Patrimonies in Press', 259.

its author's choice of illustrations displays only too clearly the way in which no singular view was possible. And, indeed, to go further, the treatment of illustrations is one place where *The Chinese Eye* subverts its own stated purpose most significantly. Liu Yu-jen has shown how early collotype reproduction of artworks, including that undertaken by Di Baoxian, explicitly sought to reproduce practices of viewing and connoisseurship standard in late Qing China, making them 'not different from the original', in the marketing phrase.[58] This meant a prominent role for colophons and inscriptions, for paratexts of all kinds, seen as in no way superfluous or extraneous to 'the picture'. Modern museum and publishing practices now tend to exclude such material, but in something like '*Famous Chinese Paintings Collected by Ping Teng Ke*' the surrounding textual matter is very much part of what the eye, Chinese or otherwise, sees as the pages are turned. Chiang Yee certainly acknowledges through a whole chapter the importance of inscriptions on painting, making a point of discussing one such example, an 'inscription by a fine artist and gentleman, Ti Ping-Tzu, written on a figure painting by "Old Lotus" Chěn (Plate VI)'. 'Ti Ping-tzu' (Di Pingzi 狄平子) is Di Baoxian himself, raising the intriguing possibility of some prior connection between him and Chiang Yee, a possibility only strengthened by the fact that the colophon in question relates to an exchange between Di and Li Ruiqing, president of Chiang Yee's alma mater and already mentioned as one of the four luminaries Chiang lists as central figures of modern Chinese art. Both Di Baoxian and Li Ruiqing were prominent figures of the Buddhist revival, giving tantalising hints as to now-lost networks of patronage and support which Chiang Yee might have drawn on prior to his departure 'in haste' from China.[59] But despite his attention to this example, in general *The Chinese Eye* arguably flouts the conventions of the 'Chinese eye'—if such a concept has any real meaning—by trimming off a number of the inscriptions which Di Baoxian's publication carefully includes; 'Hors de Combat' is one good example of this, with significant loss of text at both the top and bottom of the image.

Following the success of *The Chinese Eye* with the British reading public, Chiang Yee continued to produce writing on the visual arts alongside the Silent Traveller series that is the source of his enduring fame; but it is probably fair to say that with the professionalisation of art history his standing in that field became increasingly marginalised. Even before he arrived in Britain the first tentative steps towards the presence in higher education there of teaching on Chinese art took place, with the appointment to the Courtauld Institute of Art of Walter Perceval Yetts (1878–1957), an ex-colonial doctor and writer on Chinese bronzes and other antiquarian topics.[60] It is perhaps telling that, in his avid search for patronage among the great and good

58. Liu, 'Second Only to the Original', 80.
59. The suddenness of departure is supported by Chiang Yee in *China Revisited*, 35.
60. On Yetts, whose antiquarian preferences effectively shut him out from any engagement with the 'art world', see Craig Clunas, 'Oriental Antiquities/Far Eastern Art', *positions: east asia cultures critique* 2, no. 2 (Fall 1994): 341.

"HORS DE COMBAT" Ku Yün-Cheng (Ming)

Figure 2.2: Chiang Yee, *The Chinese Eye* (London, 1935), Plate IV.

of British Chinese studies, Chiang Yee never seems to have interacted with Yetts, whose name does not appear anywhere in writings by him, or in his biography. The years 1935–1936 were perhaps the highpoint of his visibility as a writer on the visual arts, when he for instance reviewed in two separate periodicals the same catalogue of the Chinese painting collection of his friend A. W. Bahr (1877–1959).[61] He also reviewed the paintings in the Royal Academy exhibition alongside his friend W. W. Winkworth (1897–1951).[62] But his putative doctoral thesis on Chinese calligraphy was abandoned. There are a number of reasons for this, including the loss of the

61. Chiang Yee, 'Early Chinese Painting: Nature as Viewed through the Eyes of the East', *Country Life* 84, (26 November 1938): lxii; Chiang Yee, 'A Collection of Chinese Paintings', *The Burlington Magazine for Connoisseurs* 73, no. 429 (December 1938): 236, 262–64.
62. W. W. Winkworth and Chiang Yee, 'The Paintings', *The Burlington Magazine for Connoisseurs* 68, no. 394 (January 1936): 30–31, 34–36, 39. In this instance, Winkworth was more generous to Chiang than the latter had been to Innes Jackson. Note here too the passing reference to 'the venerable collector and artist, Mr. Ti Ping-Tzu', a name Winkworth can only have got from Chiang Yee, strengthening the possibility of at least some acquaintance between them.

influential support of Reginald Johnson on the occasion of the latter's retirement, and the non-renewal of Chiang Yee's School of Oriental Studies teaching contract by Johnson's successor, Evangeline Dora Edwards (1888–1957) (partly on the grounds of that non-standard Jiangxi accent). One also wonders about Chiang's possible awareness of a doctoral thesis written in Paris on the very same topic of Chinese calligraphy by Yang Yuxun (1895–1947).[63] His own book on the topic, though it went on to become a much-cited work in the post-war period, did not immediately replicate the popular success of *The Chinese Eye*, the original edition additionally receiving a rather supercilious and patronising review in *The Burlington Magazine*.[64]

The visual arts remained central to Chiang Yee's self-image throughout his life, even as it was the Silent Traveller books which brought him a measure of acclaim. In 1956, by which time he was living in the US, he was invited to deliver the prestigious Phi Beta Kappa Oration at Harvard University, and chose to lecture on the topic of 'The Chinese Painter'. Twenty years after he first addressed the topic, this is still an abstract and a timeless figure, and the lecture is noteworthy for its lack of reference to much in the way of specific painters or paintings. Speaking in the very depths of the Cold War (and as China's actual painters were about to face the storm of the 1957 Anti-Rightist Movement), Chiang insisted that, 'What I want to stress is the spirit which, as I have said, is ageless, boundaryless, and eternal.'[65] This type of overview, this confident inhabiting of the native informant's subjectivity, would only come under greater and greater pressure as 'Chinese art' normalised itself in the academy, above all in the US, often in the hands of scholars who combined origins in China with formal training in the new disciplinary protocols of art history. Chu-tsing Li (1920–2014, graduate of Nanjing University), Wai-kam Ho (1924–2005, graduate of Lingnan University), and Wen C. Fong (1930–2018, born in Shanghai) all established themselves in major teaching and museum posts in the US at precisely this time, to be joined by such figures as Michael Sullivan (1916–2013) and James Cahill (1926–2014). This was a generation of scholars marked out by the possession of doctoral degrees in the field of Chinese art, who published detailed investigations into specific periods, themes, and artists. All of them eschewed the broad definitional sweep which characterizes Chiang Yee's work. It is therefore not a little poignant that the last brief pieces of art historical writing, published by Chiang in the year before his death, are necessarily forced to accord with this new disciplinary paradigm, appearing as they do in the monumental *Dictionary of Ming Biography*,

63. Yang Yu-hsun, *La calligraphie chinoise depuis les Han* (Paris: Librairie Orientaliste Paul Geuthner, 1937). My thanks to Eirik Welo for identification of this figure, who served the Japanese puppet regime of Wang Jingwei and died in prison after the Second World War.
64. Chiang Yee recalls that 'it had little sale on publication'. Chiang, *China Revisited*, 42. The review was published under the pseudonym 'S. J.', and it seems highly likely that the initials conceal none other than Jenyns. See S. J., review of *Chinese Calligraphy*, by Chiang Yee, *The Burlington Magazine* 73, no. 425 (August 1938): 90. The 1956 reprint with its enthusiastic preface by the English art historian Herbert Read comparing calligraphy to abstract art attracted more notice, and this was the second of Chiang's works to be translated into Chinese in the 1980s, by Da Zheng and Qianshen Bai.
65. Chiang Yee, 'The Chinese Painter', *Daedalus* 86, no. 3 (May 1957): 250.

1368–1644 (1976). Chiang is here one of no fewer than 125 authors, responsible for the biographical entries on just two painters of the Ming, Lu Zhi (1496–1576) and Lü Ji (ca. 1477–?); Chu-tsing Li is much more prominent across the work as a writer on Ming artists, as indeed is James Cahill. Chiang was most probably allotted these two entries by his boss at Columbia University, the intellectual historian and member of the *Dictionary of Ming Biography* steering committee William Theodore de Bary (1919–2017), with whom he 'could not get along well'.[66] Certainly there is no sign anywhere else in his writings that either of these two rather different artists (one an elite literatus, one a court professional) were of any particular interest to him. The secondary scholarship he draws on here is noteworthy. There is reference to the writing of Xu Bangda (1911–2012), probably the most distinguished connoisseur of the People's Republic of China after 1949, revealing that Chiang did keep up with scholarly writing in Chinese. But there is also reference to what were by the 1970s extremely venerable pieces of Western writing, going all the way back to the early twentieth-century works of Herbert Giles and Arthur Waley, presumably the very sort of people his one-time friend Shih-I Hsiung had in mind forty years before when he wrote of 'Western critics whose conceptions, though valuable, would certainly give an interpretation quite different from that of Chinese artists'.[67] Chiang Yee's biographical accounts of both Ming painters are unremarkable, except perhaps for the fact that he goes out of his way to note the exhibition histories of both of them, stressing of both Lu and Lü that their work had been among those works included in the 1935–1936 'International Exhibition of Chinese Art' at the Royal Academy.[68] Was this a recollection, conscious or not, of his hour of glory, his moment of triumph, when it was he who had briefly embodied the authority to speak and be heard on the subject of Chinese painting? By the time his words were published, the Silent Traveller was back in his native Jiangxi after some forty years, and soon to be silent forever.

66. Zheng, *Chiang Yee*, 218.
67. Chiang Yee, *Chinese Eye*, ix.
68. Chiang Yee, 'Lu Chih', in *Dictionary of Ming Biography, 1368–1644*, ed. L. Carrington Goodrich and Chaoying Fang (New York: Columbia University Press, 1976), 1:960–61; Chiang Yee, 'Lü Chi', in *Dictionary of Ming Biography*, 1:1005–6.

3
Being Chiang Yee
Feeling, Difference, and Storytelling

Sarah Cheang

> I am certainly not attempting to please learned scholars! I remember once talking with a lady who told me she would never write a book on 'oddments' for the sake of amusement, for no scholar would do that kind of thing!
>
> —Chiang Yee[1]

Following Chiang Yee's example of perhaps not pleasing learned scholars, this chapter presents a liberal selection of humorous 'oddments' from *The Silent Traveller in London* and *The Silent Traveller in Oxford* which I hope the reader will relish and enjoy. I write, however, with a serious intent: that of creating space to think about what Chiang Yee can tell us about the experiences of Chinese men in Britain and America, the embodied and emotional side of life, and the composite nature of all histories. In the same way as Chiang Yee proposed the 'oddment'—the slice of life—as a way to counter particular cultural hierarchies of knowledge, this chapter explores what it is to be perceived as a cultural 'oddment', and how this might relate to Chiang Yee's lived experiences of being Chinese in Oxford.

Reading Chiang Yee is an unforgettable experience. My first encounter was with *The Silent Traveller in London*, and one passage stayed with me more than any other. This was the comical assertion that Chinese men are always much shorter than English policemen, with consequences for both Chinese masculine confidence and sartorial dignity:

> As I am taller than most Chinese here, my fellow-countrymen always nickname me "policeman" whenever I go among them. Inspired by this, I used to approach the admirable London "Bobby" for comparison. But I always withdrew again hastily as soon as I came up close – he would be towering above me. On many occasions I go out with Mr. S. I. Hsiung, the playwright, who is rather short, and he always warns me to beware of his hat falling off when he looks up to ask the policeman something![2]

I remember reading this passage and being utterly struck by this highly embodied description of encounters between Chinese and English masculinities. Being a

1. Chiang Yee, *The Silent Traveller in London* (London: Country Life, 1945), xii–xiii.
2. Chiang, *The Silent Traveller in London*, 208.

woman of mixed Chinese/English heritage, I am fairly short myself, and so I could very easily relate to the idea of Hsiung, with his head thrown back, gazing up at an unbending policeman. In 1930s London, when hats were an ordinary and expected item of fashion, hats and hatlessness would have been an area of social anxiety when in public. Within Chiang Yee's humorous anecdote is the embarrassment of a wardrobe malfunction, turned into a body malfunction, turned into a 'racial' malfunction. He describes the friendly English 'Bobby' as an intimidating figure, who he wanted to approach, but could not. This vignette of Chiang Yee's made such a vivid, or felt, impression on me that, in my memory of the passage, I thought that there had been an accompanying illustration. Going back to the book some years later, I was astonished to find no little line drawing of Hsiung looking up, his hat rolling away, or Chiang Yee curiously sidling up to the policeman at a safe distance. Instead, I found an image of a very different scene: a befuddled 'Bobby' surrounded by dancing locals on Jubilee night.[3]

All authors are capable of making mistakes and can choose to either capitalise or guard against the tricks that memory plays, and the ways that life experiences often colour our appreciation of the 'facts'. I cannot think about Chiang Yee without experiencing resonances with my own family history, and the times when I and other family members have found ourselves being Chinese or embodying China in Britain. I especially think about my father and my grandfather, who were also Chinese travellers in twentieth-century Britain.[4] Emotions, whether difficult or joyous, do not fit smoothly into linear narratives, whether these take the form of stories, official histories, or academic essays. Embracing the irrational and the embodied, rather than struggling or shying away from it, can be an experimental strategy.[5] Can we arrive at a deeper understanding of Chiang Yee's work and experiences by focussing on how he connected with others, in the living, sensing moment, across time and across cultures, simply through his physical presence? What can we learn from thinking about how he may have experienced his own physical presence? What was it to be a 'Silent Traveller', and how can we get at everything in that 'silence' that wasn't being said?

Understanding Misunderstandings

Historian Saul Friedländer argues that there is a continuum between personal and public memory. He writes of a 'twilight zone between history and memory' and

3. Chiang, *The Silent Traveller in London*, Plate XIa, facing 208.
4. My grandfather, Chang Koon Cheang, studied history at Cambridge University between 1929 and 1931 although he did not graduate and instead returned to Shanghai to marry. In 1958, my father, Min Yin Cheang, was also sent to the UK to study, but then chose to settle permanently on the south coast of England.
5. Walter Mignolo and Rolando Vazquez, 'Decolonial Aesthesis: Colonial Wounds/Decolonial Healings', *Social Text Online* (15 July 2013): 2–13, http://socialtextjournal.org/periscope_article/decolonial-aesthesis-colonial-woundsdecolonial-healings/.

dares us to enter it.[6] In Friedländer's work on his own personal positioning in relation to histories of the Holocaust, he confronts two scholarly taboos. The first is giving the historian a personal voice and position in allowing that a historian might have a personal relationship to the subject that they study, and an emotional vested interest. The second is engaging with the potentially unreliable memories of eyewitness survivors of traumatic events. Friedländer encourages us to deepen rather than deny the historian's role as a storyteller, and to engage more with the way in which historical events were understood by eyewitnesses as they unfolded. I find this really useful when trying to make sense of what I find in the Silent Traveller books.

The persona of the Silent Traveller created by Chiang Yee steered clear of controversial remarks, although we know that he had strong feelings about Chinese politics and about how Chinese people were regarded in Britain and America. How should we address the areas of difference and overlap between the lived experiences of Chiang Yee the author and the narrative accounts of life in England created through the character of the Silent Traveller? In what ways are areas of slippage useful and important, both for readers and historians and for Chiang Yee himself? We can picture the Silent Traveller walking slowly and meditatively, focussing on simple things while experiencing nostalgic recollections, making Chinese aesthetic, social, or historical associations, or merely recording personal experiences and responses to everyday situations. But Chiang Yee himself was not always a silent traveller, and while being a Chinese eye and a Chinese brain at large in England, Chiang Yee also has much to say about being a Chinese body.

In fact, *Silent Traveller in Oxford* contains a number of statements on the problem of thinking in terms of 'race', and many wry references to how being perceived as physically Chinese affected Chiang Yee. The use of humour, and the charming, mild-mannered politeness of Chiang Yee's writing and drawing, should not discount the more disquieting aspects of these lived experiences, seen in lines such as these: 'I remembered having heard that Trinity is now the only college which does not admit Orientals. My flat face could not be disguised, so I passed on without entering to avoid misunderstandings.'[7]

What does the word 'misunderstandings' contain here? Though he moved in highly privileged and intellectual circles, there were places that Chiang understood only too well were off limits to him because of 'race' and racism. There were situations where being Chinese meant being the uncomfortable target of curious eyes, causing an internal emotional response. 'Misunderstandings', what are these? A mismatch between Chiang Yee's internal sense of self and the way he felt others perceived him as a representative of the Chinese 'race' while travelling and residing

6. Saul Friedländer, 'Trauma, Transference and "Working Through" in Writing the History of the "Shoah"', *History and Memory* 4, no. 1 (Spring–Summer 1992): 39–59; James E. Young, 'Between History and Memory: The Uncanny Voices of Historian and Survivor', in 'Passing into History: Nazism and the Holocaust beyond Memory – in Honor of Saul Friedlander on His Sixty-Fifth Birthday', ed. Gulie Ne'eman, special issue, *History and Memory* 9, nos. 1/2 (Fall 1997): 47–58.
7. Chiang Yee, *The Silent Traveller in Oxford*, 3rd ed. (London: Methuen, 1946), 17.

in England? I use the term 'race' here to denote a Western school of thought, honed and given credence through the rise of anthropology in the nineteenth century, that grouped people according to a specific set of physical characteristics (primarily skin and eye colour, hair type, and facial features). Western concepts of 'race' were used to rank human beings in a hierarchy that placed white people of Northern European descent at the top.[8] This was done in part by directly linking biological characteristics with cultural practices and histories, and then proposing that racial groups were differentiated by innate differences in abilities and temperament. This 'science' of 'race' was developed in thoroughly racist social contexts, and although it is now completely rejected within anthropology, this was the main way that racial difference was understood in the time of the Silent Traveller, and it still underpins racist attitudes today.

In his stories and illustrations, Chiang Yee displays great *tact*. This is a word I have chosen for its meanings of skill and sensitivity. It has its roots in matters of touch but it also reminds me of the word 'tacit' and implications of a knowing silence and matters that are implied but not stated. This chapter is for any reader who has ever wondered what it was like for Chiang Yee to *be* the Silent Traveller. But I write especially for anyone who has ever recognised, in Chiang Yee's works, a shared experience of what it is like to be Chinese in England. As novelist and activist Elif Shafak succinctly puts it: 'Stories bring us together, untold stories keep us apart.'[9]

Being the 'Honourable' Chiang Yee

Chiang Yee's Oxford was that of the Second World War and the Second Sino-Japanese War. His London flat had been destroyed by bombing, and news from back home in China was filled with the horror, violence, and tragedy of both civil war and the Japanese occupation. In *The Silent Traveller in Oxford*, in a chapter called 'Honourable Pussy Cat', Chiang Yee tells of an incident on a bus that happened during this time:

> One summer evening while it was still light I was travelling on the top of a 'bus to Carfax. In front of me were four schoolgirls talking noisily, one of whom, a child of eleven or twelve, kept turning round to look at me. Then she would say something to her companions who would look round too. I could not hear what they were saying, but no doubt they were interested in my face being flat and strange. When we reached Carfax the girls alighted in front of me. No sooner had I stepped off than one of them shouted "Charlie Chan!" and the others followed suit. I presumed

8. Michael Banton, *Racial Theories*, 2nd ed. (Cambridge: Cambridge University Press, 1998); Christine Bolt, *Victorian Attitudes to Race* (London: Routledge and Kegan Paul, 1971); Stephen Jay Gould, *The Mismeasure of Man* (London: Penguin Books, 1997).
9. Elif Shafak, *How to Stay Sane in an Age of Division* (London: Wellcome Collection, 2020), 9.

they recognized me as a fellow-countryman of Charlie Chan, so I smiled my thanks, and most of the passengers smiled too.

A few weeks later I was walking along Abingdon Road to visit a friend. Before reaching Lake Street I met a group of girls and boys coming from the swimming-pool. Suddenly one of them exclaimed "Charlie Chan!" and then "Look! Charlie Chan in Oxford!" I wanted to stop and ask them what they meant, but they had gone. When I reached my friend's house I told him that I was now known as "Charlie Chan". He smiled, and after scrutinizing me in silence said, "You do look like Charlie Chan, you know," and we both laughed.[10]

In his story, it is soon clear why the Silent Traveller was suddenly receiving this particular attention. The American film *Charlie Chan in Panama* (1940) was playing in Oxford, its leading character the eponymous fictional Chinese American police detective from Honolulu. Chiang Yee tells that he therefore went to the cinema to make his own comparison. In his accompanying illustration (Figure 3.1), he created a visual rendering of the fictional Chan and the fictionalised Chiang Yee side by side. Details of dress show Chan wearing an American suit and tie, while Chiang Yee places himself in a more traditional Chinese collar and side-fastening garment, suggestive of a long scholar's robe (*changpao*).[11] It is highly unlikely he would actually have worn such a robe on the streets of Oxford. Indeed, while Chiang Yee made use of artistic license to place himself in a more Chinese social envelope, his written reflections seem truer to life, and are focussed on the body itself. He reached the following conclusion:

> He [Charlie Chan] proved to have a face as flat as mine, but his broad cheeks and forehead made his face square, while mine is more rectangular. I could imagine however, that in profile, had I his moustache, we should look pretty much alike, and I was not surprised at the children's mistake.[12]

The American Charlie Chan films made between 1929 and 1949 are examples of what is termed 'Yellowface', the practice of white actors and performers playing Chinese and Japanese roles. In films, from Richard Barthelmess playing Cheng in *Broken Blossoms* (1919, dir. D. W. Griffith) and Boris Karloff as Fu Manchu (*The Mask of Fu Manchu* [1932], dir. Charles Brabin) to Flora Robson as Empress Dowager Cixi (*55 Days in Peking* [1963], dir. Samuel Bronston), white actors in 'Yellowface' have simulated Chinese body language and voices, and makeup artists have been praised for their abilities to create Chinese bodies.[13] Chiang Yee's comparison, in life and in the line drawing above, was between his own face, and that

10. Chiang, *The Silent Traveller in Oxford*, 78.
11. In nineteenth-century China, the *changpao* was associated with men of the non-labouring classes. In early Republican China, it offered an alternative fashion to the Western business suit, which could be seen as being linked to Western imperialism. Antonia Finnane, *Changing Clothes in China: Fashion, History, Nation* (London: Hurst, 2007), 177–78.
12. Chiang, *The Silent Traveller in Oxford*, 79.
13. For an account of how to 'turn occidentals into orientals [*sic*]' see Cecil Holland, 'Orientals Made to Order', *American Cinematographer* (December 1932): 16, 48.

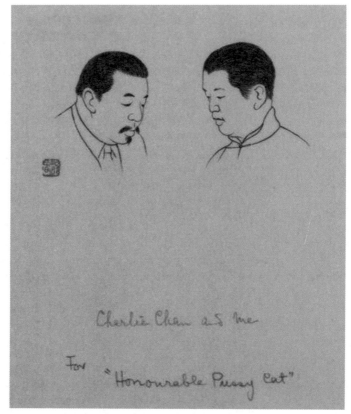

Figure 3.1: Chiang Yee, 'Charlie Chan and Myself', original drawing as reproduced in *The Silent Traveller in Oxford* (1944). Courtesy of the Victoria and Albert Museum, London.

of European American actor Sidney Toler, who played Charlie Chan in twenty-two films.[14] Beyond costume and makeup, Yellowface performances typically included a soft and low manner of speaking with halting intonation, walking with a shuffling gait and a stoop (in some instances almost bent double), holding the hands behind the back, or together in front within the sleeves. Dialogue frequently makes use of the idea of mysterious and ancient Chinese proverbs that could be real or invented.

The character of Charlie Chan—wise, kind, and heroic, and commanding respect—was intended as a positive portrayal of Chinese men, in contrast to fictional villains such as Fu Manchu, and seem to have been well-received by audiences

14. In the Twentieth Century Fox/Monogram film series, the actors who have played Chan are Warner Oland, Manuel Arbó, Sidney Toler, Roland Winters, Ross Martin, and Peter Ustinov. The character of Chan was not played by an actor of Chinese heritage until Chinese American veteran actor Keye Luke (Lu Xiqi 陸錫麒) was cast as the voice of Chan for the 1972 animated television series *The Amazing Chan and the Chan Clan*. Keye Luke had also appeared regularly on screen in the role of Chan's son in nine films between 1935 and 1949.

in China.[15] Chinese Americans, however, have testified to the damaging effects of Yellowface and the general stereotyping of Chinese characters in popular films of the twentieth century.[16] For example, Bill Chu recalls that when he was growing up in Los Angeles and Philadelphia in the 1950s, he and his younger brother were subjected to racial taunts inspired by the fictional Confucian quotations featured in the Charlie Chan films.[17] In 2003, Fox Movie Channel was forced to reconsider its Charlie Chan season after protests from activist organisations. Richard Konda, director of Asian American civil rights organisation the Asian Law Alliance, stated, 'the movies were racist in the 1930s and they are still racist in 2003'.[18] In 1940s Oxford, Charlie Chan was widely understood and appreciated by audiences as a positive portrayal of Chinese American masculinities (both the traditional Chan and his Americanised son). And yet, misunderstandings, and the sense of being misunderstood, would still occur.

Embracing an 'and/and' methodology is useful here. Where thinking in terms of either/or results in the need to determine correct or incorrect facts, histories and realities, an and/and approach means that contradictory information can be allowed to stand.[19] It enables us to engage with the shifts of emotional energy that are involved in constructing and maintaining a sense of self in the world, especially when under duress, and allows for the existence of conflicting emotions, memories, and meanings.[20] Whether or not the figure of Charlie Chan provided a positive role model, the spectacle of his Chineseness played into and constructed stereotypes that provided a language and available sign system for the singling out of Chinese people in Europe and America. It is important to ask the question, what was it *like* for Chiang Yee to sit in that cinema in Oxford watching Charlie Chan? He writes:

> I was deep in thought and not really attending to the film when the audience burst into laughter. I looked at the screen. Charlie Chan's son had followed his father after dark to search a large house and was disturbed by something jumping from a height. He told his father it was a pussy cat, but Charlie Chan corrected him, saying '*Honourable* Pussy Cat'. The audience was apparently laughing at the idea of addressing a cat as "honourable", and I laughed too.[21]

15. Yunte Huang, *Charlie Chan: The Untold Story of the Honorable Detective and His Rendezvous with American History* (New York: W. W. Norton, 2010), 247–58. The fictional character of Charlie Chan, calm and tolerant of racism, has been seen as exemplifying the notion of Chinese Americans as a 'model' ethnic minority, as an explanation for his popularity alongside and perhaps still within discourses of the 'Yellow Peril'. William Wu, *The Yellow Peril: Chinese Americans in American Fiction, 1850–1940* (Hamden, CT: Archon Books, 1982), 181–82.
16. Frank H. Wu, *Yellow: Race in America beyond Black and White* (New York: Basic Books, 2002), 1–5.
17. Pradnya Joshi, 'A Charlie Chan Film Stirs an Old Controversy', *The New York Times*, 7 March 2010, https://www.nytimes.com/2010/03/08/business/media/08chan.html. Accessed 22 November 2020.
18. 'Charlie Chan Season Shelved after Race Row', *The Guardian*, 3 July 2003, https://www.theguardian.com/film/2003/jul/03/news. Accessed June 2019.
19. Arturo Escobar, *Pluriversal Politics: The Real and the Possible* (Durham: Duke University Press, 2020).
20. Sarah Cheang and Shehnaz Suterwalla, 'Decolonizing the Curriculum: Transformation, Emotion and Positionality in Teaching', *Fashion Theory* 24, no. 6 (2020): 879–900.
21. Chiang, *The Silent Traveller in Oxford*, 79.

Chiang Yee twins this anecdote with other uses of the word 'honourable' within an English context, by quickly moving on to how he was hearing the word used frequently as a form of address during formal debates in Oxford. A stereotype of fictional Chinese speech is shifted, and he presents us with a new, re-digested stereotype. It is the Charlie Chan idiom, reframed. In Chiang Yee's telling, while audiences laughed at Charlie Chan's quaint use of language, a silent traveller-turned-cinemagoer, a watcher in the dark, was laughing at the idea of Chan encouraging his son to address a cat as 'honourable' as if the cat were a speaker at an Oxford debate or a member of Parliament.

But let us revisit this moment one more time by comparing the story Chiang Yee tells with the images and sounds fixed into the celluloid itself. In the film, the scene in question actually unfolds like this: Charlie Chan and his son are searching a dark house. Chan's son, who, in an earlier scene, had had a frightening encounter in the dark with a monkey, sees something moving and warns his father to watch out for a monkey. Instead, however, a cat runs past. The son exclaims, 'That was no monkey!' His father supports this with the affirming observation, 'Honourable Pussy Cat'.

We could speculate that Chiang Yee, who perhaps was not following the film closely and had drifted off into reverie, watched this scene and misinterpreted what he saw as a Chinese father correcting his modern, Americanised son. And we could also speculate that Chiang Yee reauthored the memory to fit the theme that he wanted to develop for the Silent Traveller as he wrote his book about Oxford. Indeed, the notion of titling a cat 'honourable' is central to the crafting of the entire chapter, which focussed next on a story of seeing the Chinese ambassador Wellington Koo (1888–1985) participating in a debate. Speaker after speaker warmly praised the ambassador and all the people of China for their continued resistance to Japanese invasion.

Chiang Yee, again a silent member of an Oxford audience, writes of this moment: 'Becoming suddenly self-conscious about my racial identity with the people being so praised, I shifted in my seat, as if in acknowledgement. My feelings however were far from being unmixed gratification.' He explains that he was wondering whether China deserved this praise. How well was China doing? And what were the weaknesses as well as the strengths of modern China? He continues, 'I cannot help recalling that in China's unregenerate days, during the beginning of the Revolution, when praise of her was rare, there did in fact exist among her people many time-honoured virtues that are now all too often conspicuous by their absence'.[22] He reflects on China as a very young nation that could have serious and dangerous faults, and observes that parents need to guide their children. Interwoven in this discourse of the old guiding the young are reflections on the tragedy of all the lives being lost in China. Themes of parental wisdom, the folly of youth, and the disjuncture between

22. Chiang, *The Silent Traveller in Oxford*, 82.

traditional and modern China swirl in a tempestuous inner dialogue, mixing with the awful traumas of war and separation from homeland and surfacing ultimately in a story of finding oneself painfully conflicted on suddenly having to be *consciously* Chinese.

The story continues:

> Then followed a number of speakers. What struck me most was the frequent repetition of such phrases as "Honourable gentlemen of this side and of that side", and "Honourable members of this house". I was astonished at the exaggerated gesture of the speakers in saying these words. The mention of the word "honourable" reminded me so vividly of "Charlie Chan in Panama" and the Honourable Pussy Cat that I rather lost the thread of the debate.[23]

Ultimately, the trip to the cinema so coloured the Silent Traveller's experience of the Oxford Union debate, with the presence of Wellington Koo appearing as Charlie Chan, and the new Chinese nation as his modern son—that he was not even listening in the end, just as, in the cinema, he had not always been watching. And so, the chapter finishes with these last remarks:

> I must not close this chapter without mentioning a stout speaker . . . He was most impressive when he said "My President, Sir" or "Honourable Gentlemen, sir" as though blowing out a candle. With his head bent forward over his notes he might have been Charlie Chan bowing to the Honourable Pussy Cat, for I could not see his face clearly from my gallery seat. I laughed to myself and murmured: "Here *is* Charlie Chan, Charlie Chan in Oxford." After all, Charlie Chan was a westerner. I still smile when I think of that occasion.[24]

And so, Chiang Yee brings us back to the blending of historical record and personal experience, hard facts caught on celluloid and soft memories held in the mind and shaped by the heart. The truth of the Silent Traveller's account is exactly in this murky land between autobiography, documentary, memory, and storytelling. As Patricia DeRocher reminds us:

> experiences are always both "real" and "constructed," at once referring to actual, outward, objective events, but always necessarily filtered through our subjective lens as embodied objects, and further shaped by language and available social narratives as we attempt to convey our experiences to others. While experiences refer outwardly to actual events in the world, experience itself is always a narratively crafted account of the event – interpreted within, processed within.[25]

Pain and discomfort, mistakes and confusion are what make *The Silent Traveller in Oxford* of real value when trying to understand what it meant for Chiang Yee to

23. Chiang, *The Silent Traveller in Oxford*, 83.
24. Chiang, *The Silent Traveller in Oxford*, 84.
25. Patricia DeRocher, *Transnational Testimonios: The Politics of Collective Knowledge Production* (Seattle: University of Washington Press, 2018), 30.

be Charlie Chan, a racialized body in Oxford, and his hopes for a more harmonious, cosmopolitan future. In the chapter 'It is New to Me', he muses on the way that the University of Oxford's historic buildings and use of traditional robes are animated by the presence of modern humanity in a mixing of old and new. Included among the new was his 'own flat face from modern China, blending harmoniously with the ancient buildings'.[26] Stories of how he managed that body from modern China during his years in Oxford provide further evidence of how Chiang Yee used the ambiguity inherent in a misunderstanding to leave a more truthful record of mid-twentieth-century Chinese experiences in England.

'Hair Raid': Encounters at the Barber Shop

My father always used to cut his own hair, laying sheets of newspaper carefully across the bathroom floor to catch the thick black tufts as they fell. He explained that English barbers did not know how to cut Chinese hair—one experience had been enough. Reading Chiang Yee, however, I wonder what else might have been in the mix, where bodily experiences connect and separate us, and public displays of the primary signifiers of race take on a frightening resonance.

In the chapter 'Hair Raid', Chiang Yee describes the Silent Traveller's own visit to the barbers in Oxford, and draws himself surrounded by the tufts of his own hair (Figure 3.2). Perhaps significantly, he mentions that he only ever patronised one particular barber shop, inconveniently located two bus rides away.[27] Chief among its benefits was that it was a small shop, away from the city centre, run by a barber whose deafness reduced conversation to a minimum. One might say he was in search of privacy. Once in the barber's chair, however, not only the hair but also the haircut was in danger of being cut short:

> While I was having my hair cut, four children, towels and bathing costumes over their arms, dashed into the shop. Just then the siren sounded, and the children one after the other shouted out, 'Hair raid! Hair raid!' until the barber told them to be quiet. The siren sounded familiar to my ears after the London blitzes, and I wondered whether it was familiar to the youngsters, or whether they were joking at my thick black hair falling to the ground in such big quantities. After all, it *was* a hair raid, and I felt not at all uncomfortable at being laughed at.[28]

Hair colour and texture is one of the primary signifiers of 'race', along with skin and eye colour and facial features.[29] A highly visible part of the human body, easily covered or exposed, cut, dressed, and treated, hair is very widely used by all human cultures to signal many different forms of social identity. Hair is also highly

26. Chiang, *The Silent Traveller in Oxford*, 67–68.
27. Chiang, *The Silent Traveller in Oxford*, 98.
28. Chiang, *The Silent Traveller in Oxford*, 102.
29. Sarah Cheang, 'Roots: Hair and Race', in *Hair: Styling, Culture and Fashion*, ed. Geraldine Biddle-Perry and Sarah Cheang (Oxford: Berg, 2008), 27–42.

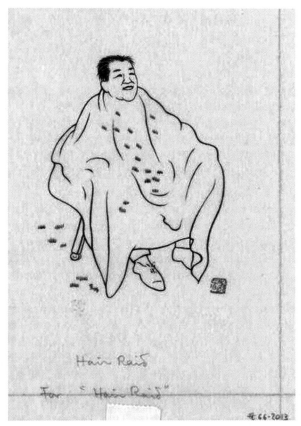

Figure 3.2: Chiang Yee, 'Hair Raid', original drawing as reproduced in *The Silent Traveller in Oxford* (1944). Courtesy of the Victoria and Albert Museum, London.

personal, a natural part of the body that grows continually and must be constantly managed in order to fit in or create an effect. It is not surprising, therefore, that hair is an important vehicle for social and personal meanings.[30]

In 'Hair Raid', Chiang Yee appears very comfortable with being an unfamiliar body in England. He is at home with his difference. We could speculate that the children in his anecdote who ran into the shop either knew or were related to the barber, and often shouted out 'hair raid' at the sound of the siren to taunt the barber or merely for their own amusement. That the Silent Traveller was left wondering if it had been the conspicuousness of his black hair that had caused their actions—that *his* moment was experienced as being about his hair—points to a lack of access to

30. Susan J. Vincent, *Hair: An Illustrated History* (London: Bloomsbury, 2018); Geraldine Biddle-Perry, and Sarah Cheang, 'Hair', in *Berg Encyclopedia of World Dress and Fashion: Global Perspectives*, edited by Joanne B. Eicher and Phyllis G. Tortora (Oxford: Berg, 2010), accessed 28 September 2021, http://dx.doi.org/10.2752/BEWDF/EDch10311

what is often termed 'white privilege'. Whether or not he felt uncomfortable at the joke, the Silent Traveller could not discount the feeling of being an alien body. As if to underline this point, Chiang Yee writes that, shortly before, on arrival at the barber's shop:

> A kindly-looking old lady was sitting near the door waiting for her husband. Smilingly she asked me whether I had come from Pennyfield. 'No,' I answered, 'I have come from London.' She seemed surprised at my answer, and I remembered then that Pennyfield was where the famous Limehouse, or Chinatown, is situated. The old woman apparently lived near there and knew or had seen many of my compatriots. She might even have a lot to tell me. She looked so unsatisfied with my reply that I hurriedly added that I had quite often been to Pennyfield.[31]

There are worlds of experiences in this short paragraph. The friendly intentions of the woman in talking to the Silent Traveller, connecting with him because he was physically recognisable as a 'Chinese', or, using his Chineseness as the connective tissue between two strangers. Her seeking out of fellow Londoners in Oxford and her assumption that any Chinese man in 1940s England must be part of the Chinese community of London's quasi-mythical East End Chinatown.[32] The implication that having lived near/known/seen Chinese people in London was enough to create common ground with the Silent Traveller. The pressure that the Silent Traveller felt to satisfy these preconceptions. His apparent sensitivity and politeness that resulted in his actively seeking some way to support the misunderstanding, perhaps to mitigate against the kind of social embarrassment that dissuaded Chinese travellers from visiting Trinity College, as we have seen. Here, possession of an 'Oriental' body rendered the Silent Traveller a member of a diasporic community, rather than an excluded foreigner, however that body was still understood as out of place.

An Exile and a Refugee

Where do you look for role models, allegiances and belonging, when abroad? In the course of his book about Oxford, Chiang Yee brings his Silent Traveller into comparison, companionship and connection with Chinese friends and ambassadors, Charlie Chan, London 'East Enders', the Chinese nation (both new and old), and all people in possession of a 'flat face' and black hair. During the inter-war period, many urban-exploration genre writings included a visit to London's 'Chinatown', which at that time centred on two short streets in the East End where small numbers of Asian seamen had taken up residence. These accounts of the Chinese in Britain by non-Chinese 'travellers' blend touristic voyeurism with a pseudo-anthropology of

31. Chiang, *The Silent Traveller in Oxford*, 101–2.
32. Anne Witchard, *Thomas Burke's Dark Chinoiserie: Limehouse Nights and the Queer Spell of Chinatown* (Farnham: Ashgate, 2009).

social, physical, and racial types for an implied white, middle-class readership.[33] In comparison, Chiang Yee did not bring his readers to the East End, even in *The Silent Traveller in London*. In fact, the closest the Silent Traveller ventures to 'Chinatown' is in the abstract, in an encounter at the barber's shop in Oxford, and via an awkward misunderstanding.

Chiang Yee mixed in cosmopolitan and elite circles.[34] However, he carried an extraordinary awareness of the need to explain himself and his presence, as a modern intrusion into British space, and sometimes even an anguished one. For all his urbane, intellectual, and well-connected ramblings (both physical and lyrical), when reflecting on a visit to Queen's College, he described himself/the Silent Traveller as 'an exile and refugee in Oxford', left behind in England while other Chinese friends and acquaintances had moved on.[35] A story within a story within a story, Chiang Yee relates how his friend Ke-chin had shown him a room said to be haunted by the ghost of a young man who had been murdered. Later, dreaming that he was back there, the Silent Traveller encounters the ghost himself. In an emotional one-way dialogue (the ghost remains silent), Chiang Yee writes the following:

> "I wonder," said I, "if you would care to come in for a rest and a chat? It must be depressing to have a lot to say and no one to listen to it. Please forgive me for referring in any way to your tragedy, but I am a Chinese who has come from a far country and would like to hear all you may have to say. If you would care to confide in me I might be able to give you the sympathy you need . . . Naturally you think yourself misunderstood by the general public. You have refused to discuss or argue the matter, because you were deprived of the right of doing so. The only thing they know is that they are frightened of you. *I* can understand your grief, and why you are so unhappy, but who else will trouble to sympathise with you? If you heard their remarks about your appearances here, intended as they are as a joke or to frighten someone, you would be most depressed to realize how you are misunderstood. But one is often misunderstood in life, and you must make the best of it. Confucius once said: "he who does not feel unhappy when he is misunderstood by others – is he not a gentleman?"[36]

I find this passage immensely moving. Through the figure of the Silent Traveller, trying his best to communicate and find companionship with a spirit conjured by a dreaming subconscious, Chiang Yee gives voice to his own sense of isolation, feelings of having a disruptive alien appearance, and the social rightness—the gentlemanly behaviour—of smoothing over and philosophising away any damaging effects to the psyche. A dignified silence reigns. And, rather than drawing on a fear

33. See, for example, Stephen Graham, *London Nights: Studies and Sketches of London at Night* (London: John Lane, 1925); H. V. Morton, *H. V. Morton's London* (London: Methuen, 1940).
34. Examples of his many acquaintances include Reginald Johnston, Stewart Lockhart, Laurence Binyon, and Kenneth Clark. Da Zheng, *Chiang Yee: The Silent Traveller from the East – a Cultural Biography* (New Brunswick, NJ: Rutgers University Press, 2010).
35. Chiang, *The Silent Traveller in Oxford*, 106.
36. Chiang, *The Silent Traveller in Oxford*, 107.

of ghosts as harmful entities, common in Chinese traditions, Chiang Yee chooses at this point to humanise, not demonise, the ghost.

'Why should people be separated by terms of race or nation?' Chiang Yee asks at the end of *The Silent Traveller in London*.[37] It is a theme that he also uses to end *The Silent Traveller in Oxford*, this time tinged with the messiness of lived experience. In an earlier chapter, in which he watches the ducks in University Park, he says with some force, 'If only I could one day see the different names of races and nations disappear from the vocabulary of mankind! Let each one of us be just a member of the *human* race, as the ducks and water-hens are of the bird race, living happily together.'[38] At the end of his book, however, referencing the doubts about his Chinese appearance that had prevented the Silent Traveller from venturing into the grounds of Trinity College, he declares:

> If you intend to study in Oxford, you had better find out which college you would like to enter – if you can reach the required standard . . . I may as well warn you now that no matter how much you may admire Trinity, you will be wasting your time trying to enter it.

Then, in a list of points to bear in mind for Chinese visitors to Oxford, he brings us back the episode in the barbers, playful folding micro- and meta-geographies, with one last joke on the final page: 'your flat face will always identify you as an "East Ender".[39]

Misunderstandings, uncomfortable or amusing, have been at the heart of this chapter, inspired by the Silent Traveller's combination of humour and diplomacy in confronting the everyday of cultural division. Chiang Yee captures so much of the historical moment as lived experience, precisely because he retains the multi-layered complexity of subjective reality, rather than pursuing a more conventional narrative, purged of 'oddments'. In wartime Britain, confronted with the horrors of the present, reassurance could always be found in the stability of ancient buildings and traditions that Chiang Yee presented as appealing to both Chinese and British sensibilities. His work can be seen as bridge-building between nations in pursuit of global racial harmony, in which cultural difference is constantly morphing into cultural similarity. Experiences of difference, however, embodied and deeply felt, and the effects of trauma and unhappiness on the laying down of narrative accounts, are also here to be listened to, even if, like ghosts, they are the stories within the stories.

37. Chiang, *The Silent Traveller in London*, 263.
38. Chiang, *The Silent Traveller in Oxford*, 95.
39. Chiang, *The Silent Traveller in Oxford*, 183.

4
Chiang Yee and British Ballet

Anne Witchard

> I gained nothing in terms of money, but I thus became the first Chinese to do stage design in the West.
>
> —Chiang Yee[1]

Chiang Yee's contribution to the art of ballet is little remembered today, maybe because, as things turned out, it was to be a one-off. But it is an episode that has much to tell us, not only about his artistic versatility, but also about his significance as a Chinese artist to British cultural life. In the late summer of 1942, by now well known as an artist and author, Chiang was requested by Constant Lambert (1905–1951), musical director of the recently formed Sadler's Wells company, to design the sets and costumes for a new ballet, *The Birds*. British ballet as a national art form was then very much in its infancy.

As Karen Eliot observes in her reassessment of this period, *Albion's Dance: British Ballet During the Second World War*, critics in the post-war decades were inclined to present a distinctly British ballet as having ascended, phoenix-like, fully fledged from the ashes of adversity.[2] There was a tendency to skirt over the unglamorous war years and their privations, which had in fact confirmed the vitality of many small companies, in particular of Ninette de Valois's Sadler's Wells, formerly Vic-Wells, which in 1946 would become the resident ballet company of the Royal Opera House (receiving its royal charter in 1956).[3] Chiang's account of his own contribution to British ballet's wartime development is, in characteristically modest style, also rather underplayed, given just a couple of pages in *The Silent Traveller in Oxford* (1944).

Constant Lambert's commissioning of Chiang attests to a sincere cultural engagement with Chinese artforms during the inter-war years. Lambert was central to the artistic zeitgeist of the period—a musical prodigy, he was mentored by the Sitwells (Edith [1887–1964], Osbert [1892–1969], and Sacheverell [1897–1988])

1. Quoted in Da Zheng, *Chiang Yee: The Silent Traveller from the East – a Cultural Biography* (New Brunswick, NJ: Rutgers University Press, 2010), 162.
2. Karen Eliot, *Albion's Dance: British Ballet During the Second World War* (Oxford: Oxford University Press, 2018).
3. See Alexander Bland, *The Royal Ballet: The First Fifty Years* (Garden City, NY: Doubleday, 1981).

and close friends included composers William Walton (1902–1983) and Lord Berners (1883–1950), and writers and aesthetes Anthony Powell (1905–2000), Harold Acton (1904–1994), and Cecil Beaton (1904–1980). When considering the emergence of a British national ballet it is important to recognise that Lambert's role in establishing it was key. At the age of nineteen, he had the distinction of being the first British composer from whom Sergei Diaghilev commissioned a ballet score, for *Romeo and Juliet* (1926).[4] In the wake of Diaghilev's demise, Lambert was one of the founding triumvirate—with de Valois and dancer Frederick Ashton—at Sadler's Wells, where, following Diaghilev's influence, the tradition was maintained of working with the most innovative of fine artists rather than theatre designers, among them Duncan Grant and Vanessa Bell, Edward Burra, E. McKnight Kauffer, André Derain, and Rex Whistler (Whistler's *The Rake's Progress* was on the bill with *The Birds*).[5] Altogether, Chiang was in distinguished company.

Lambert would receive numerous accolades upon his untimely death, just short of his forty-sixth birthday. Among them, de Valois mourned his loss as 'our only hope of an English Diaghilev', while Powell memorialised his friend as the composer Hugh Moreland in *Casanova's Chinese Restaurant* (1960), the fifth in his twelve-novel sequence, 'A Dance to the Music of Time' (1951–1975).[6] The novel's 'grotesquely hybrid name', as the blurb for the 1964 Penguin edition describes it, in fact provides an esoteric clue, a poignant testament to what Lambert's biographer Stephen Lloyd describes as the composer's 'Chinese phase'.[7] Lambert was something of a sinophile, as we shall see. His engagement of Chiang as stage designer for *The Birds* can be seen in relation to certain transcultural negotiations with 'Chineseness' on the British stage, cinema screen, and concert platform that were formative to Lambert's artistic development in the pre-war years, and concomitantly, I suggest, to the influence of Diaghilev's persistent attempts at presenting Hans Christian Andersen's chinoiserie tale, *The Emperor's Nightingale* (1843), in his pursuit of the ultimate *Gesamtkunstwerk* (a collaborative synthesis of choreographer, composer, and scenic artist).

Friday the Thirteenth, November 1942

The penultimate chapter of *The Silent Traveller in Oxford* is entitled 'Friday the Thirteenth' and begins as a discourse on the global universality of certain superstitions, brought to bear on the local frustrations of erratic train schedules.[8] Removed from his Hampstead home to Oxford on account of the Blitz, Chiang reflects on

4. Diaghilev's only other British commission was Lord Berners's *The Triumph of Neptune* (1926).
5. See Rupert Martin, ed., *Artists Design for Dance, 1909–1984* (Bristol: Arnolfini Gallery, 1984).
6. Ninette de Valois, *Come Dance with Me: A Memoir* (Cleveland, OH: World Publishing, 1957), 118.
7. Anthony Powell, *Casanova's Chinese Restaurant* (Harmondsworth: Penguin Books, 1964); Stephen Lloyd, *Constant Lambert: Beyond the Rio Grande* (Woodbridge: Boydell Press, 2014), 530.
8. Chiang Yee, *The Silent Traveller in Oxford* (London: Methuen, 1944), 169.

the woes of his London commute given the inadequacies of the railway system, patently due to the exigencies of wartime rather than because, as an old lady repeatedly remarks: 'To-day is Friday the thirteenth—that's what it is'.[9] Having been commissioned to design 'the décor and costumes for a Sadler's Wells ballet called *The Birds*' he explains: 'There seemed perpetually to be some detail or other for which my attendance was required—some costumes had been finished and were to be fitted, or certain materials that I had chosen had proved unobtainable and others must be selected. And always the matter was urgent. No time to be lost'.[10] Intricate feathered dance costumes required frequent journeys back to London, invariably at short notice.

The Birds was a comic ballet intended to showcase the talents of the company's up-and-coming young ballerinas Moyra Fraser and fifteen-year-old Beryl Grey (b. 1927).[11] It was staged by the Australian dancer Robert Helpmann (1909–1986), the company's leading man and, after Ashton was called up for military service, its chief choreographer. The musical inspiration was a 1928 orchestration by Italian musicologist Ottorino Resphigi—assembled from pieces by various seventeenth- and eighteenth-century composers that imitate bird sounds—respectively a Dove, Hen, Nightingale and Cuckoo—music that represents not just birdsong but the sound of their movements such as fluttering wings or scratching feet. The story or 'action' of Helpmann's ballet was as follows: the handsome Dove (Alexis Rassine) falls in love with the lyrical Nightingale (Beryl Grey) and the comical Hen (Moyra Fraser) who has fallen for the Dove, attempts to charm him by trying to impersonate the Nightingale. Meanwhile the arrogant Cuckoo (Gordon Hamilton) dons the plumage of the Dove and tries to gain the favour of the Nightingale. The two imposters, Hen and Cuckoo are a laughing stock for a pair of cheeky Sparrows (Margaret Dale and Joan Sheldon) and the chorus of attendant Doves (Anne Lascelles, Moira Shearer, Pauline Clayden, and Lorna Mossford). All ends happily with the nuptials of the Nightingale and the Dove.

Chiang, we learn, managed to get to his rendezvous at the Soho studio of costumier Matilda Etches just about on time, despite the ominous date.[12] Helpmann was already there, erroneously attempting to 'put on his head the tail-piece of the male dove's costume, which was fan-like and looked, on him, like a Red Indian's feathered head-dress'.[13] Chiang was struck anew by Helpmann's distinctive 'big round eyes', recalling that 'once I almost disbelieved him when he complained of

9. Chiang, *The Silent Traveller in Oxford*, 172.
10. Chiang, *The Silent Traveller in Oxford*, 169–70.
11. Beryl Grey would be the first ballerina from the West to be invited to dance in Mao's China in 1964. She worked with the Peking Ballet Company, then directed by Dai Ailian. See Beryl Grey, *Through the Bamboo Curtain* (London: Collins, 1965), 40.
12. Muriel Matilda Etches (1898–1974), a film, ballet, and opera costumier, was also a well-known couturier sticking out the war years in her Frith Street atelier despite the falling bombs. As 'an interpreter of the costume sketches of others she worked selflessly with . . . enthusiasm and sensitivity'. Cecil Beaton, 'Matilda Etches – Gifted Designer', *The Times*, 26 April 1974, 20.
13. Chiang, *The Silent Traveller in Oxford*, 172.

being tired after travelling all night from Manchester to London because his eyes were so wide-open and round'.[14] Here we get a glimpse of the legendary wartime stamina that propelled the fledgling Sadler's Wells company into such fond national regard. Despite the testing conditions of food rationing, bombing raids, conscription, and the long, blacked-out train travel endured on provincial tours, Sadler's Wells nurtured leading dancers who would become famous all over the world. Beryl Grey remembered her excitement that day and the novel 'satisfaction of being fitted for my very own costume, designed on me'.[15] Chiang was understandably apprehensive, especially when fitting Moyra Fraser for her costume as the Hen:

> I had been anxious about the execution of the elaborate hen costume, for the hen is an important character in the ballet, and her costume had to be perfect in every detail. Very little had been accomplished at that time, but when I looked at the broad smile on Moyra Fraser's face and at her quickened humorous steps executed to see how the roughly-made part of the costume would fit the movements, I was confident that she would make the finished costume most attractive on the stage.[16]

As well as Helpmann and Etches, Chiang tells us, Madame de Valois herself was there to help adjust each fitting: 'The founder of the Sadler's Wells ballet and its very busy director, she compelled my great admiration for the hard work she put in to make the new ballet successful. She even helped with the sewing of costumes!'[17] Back in 1931, when de Valois started up her company, 'one had to be a blind patriot to talk of British ballet', the dance critic Arnold Haskell noted of her stubborn ambition.[18] Unlikely as it might seem, the Second World War was to prove the hothouse in which the seedling of a native British ballet was to flourish.[19]

Until the arrival in London of Sergei Diaghilev's groundbreaking Ballets Russes in 1910, ballet on the British stage had been an amateur affair. The effect of the Ballets Russes was to raise the status of ballet in Britain from a rather risqué music hall entertainment to a respectable art form. As Eliot notes, 'the events that plummeted Britain into another world conflict' might well have resulted in the 'stagnation of this carefully nurtured but still youthful and fragile form'.[20] On the contrary, a wave of wartime patriotism swelled London audiences as soldiers on leave joined Bloomsbury aesthetes and regular balletomanes. 'One of the theatrical phenomena of wartime London, and especially since the blitz began, has been the astonishing vitality and popularity of ballet,' commented *The Tatler and Bystander*.[21] Arts-funding bodies (such as the Council for the Encouragement of Music and the Arts

14. Chiang, *The Silent Traveller in Oxford*, 173.
15. Beryl Grey, *For the Love of Dance: My Autobiography* (London: Oberon Books, 2017), 30.
16. Chiang, *The Silent Traveller in Oxford*, 174.
17. Chiang, *The Silent Traveller in Oxford*, 174.
18. Arnold Haskell, *Ballet* (Harmondsworth: Penguin Books, 1945), 121.
19. Bland, *The Royal Ballet*, 71.
20. Karen Eliot, 'Starved for Beauty: British Ballet and Public Morale During the Second World War', *Dance Chronicle* 31, no. 2 (2008): 175.
21. *The Tatler and Bystander*, 12 March 1941; cited in Eliot, 'Starved for Beauty', 180.

and Entertainments National Service Association) as well as critics appreciated that ballet might enable wartime audiences to transcend the grimness of their daily lives with 'infusions of aesthetic beauty', so the morale-boosting benefits of ballet were extended to the nation at large as government-sponsored tours took metropolitan ballet troupes to town halls and military outposts across the country.[22] In a broadcast of the BBC Forces Programme, Helpmann spoke about dancing 'for troops in garrison theatres and for audiences of munition and other war workers in the provinces' and how they 'took to it like ducks to water'.[23] Meanwhile, George Bernard Shaw welcomed the resurgence of interest in ballet and lobbied for the exemption of male dancers from military service: 'One of the most astonishing artistic developments in the theatre of our time has been the rebirth of the high art ballet at Sadler's Wells Theatre. We thought it had died with Diaghilev'.[24] Shaw credited radio programming with improving 'the minds and tastes of soldiers since the last war' and argued that if male ballet dancers were called up 'the soldier on leave will find nothing to recreate him . . . except the rubbish that wireless has taught him to despise'.[25] Music critic Edwin Evans noticed approvingly that choreographers were responding to new populist audiences by collaborating with artists from other disciplines to create new works: 'unlike the concert world, they are not relying exclusively on the repertoire'.[26] Nevertheless, Eliot observes of this surge of choreographic creativity that there was a distinct turn during wartime 'toward what was familiar and cherished'.[27] Lambert's notion for *The Birds* to be given a Chinese design can be seen in light of this as an homage to Diaghilev's various treatments between 1914 and 1925 of *Le Rossignol* (The Nightingale, 1914), based on Andersen's well-loved fairy tale.[28]

Diaghilev's Ballets Russes and Chinoiserie Ballet

Diaghilev's particular genius had been for the creative administration of music and art. For six years he was editor-in-chief of *World of Art* (*Mir iskusstva*) the magazine he founded in 1899 with artists Alexandre Benois and Leon Bakst. The *miriskusniki* favoured an ornamental aesthetic. They revered traditional Russian folk art, Italian *commedia dell'arte*, and the rococo chinoiserie of Jean-Antoine Watteau.[29]

22. Eliot, 'Starved for Beauty', 181.
23. Kathrine Sorley Walker, 'Robert Helpmann, Dancer and Choreographer: Part One', *Dance Chronicle* 21, no. 1 (1998): 65.
24. George Bernard Shaw, 'Letter to the Editor', *The Daily Telegraph and Morning Post*, 6 February 1940, 35.
25. Shaw, 'Letter to the Editor', 35.
26. Edwin Evans, 'The Food of Love', *The Sketch*, 13 December 1939, 358.
27. Eliot, *Albion's Dance*, 137.
28. The plot is as follows: The emperor of China keeps a beautiful nightingale in captivity so that she will sing to him, but when he is given a mechanical nightingale as a gift, he and the court become fascinated by the automaton. Forgotten, the real nightingale returns to the forest. Eventually, the mechanical bird malfunctions, and the emperor becomes ill. For his health to be restored, the real nightingale must return from the forest and heal him with her song.
29. Richard Taruskin cites Dmitriy Merezhkovsky's critique of Benois and his circle: 'Our Russian Westernists have not gone all the way [to real modernism]. They are cosmopolites, not Europeans; theirs is the way of

For Benois, the realm of ballet, birthed in the court of Louis XIV and located in the exotic, magical, and otherworldly, rendered it the ideal form for the expression of *World of Art* principles. In 1908 Benois published his 'Colloquy on Ballet', in which he argued for the theatrical potential of ballet's unique synthesis of aural, kinetic, and visual artistry.[30] Above all other art forms, he claimed, ballet might exemplify the Wagnerian ideal of the *Gesamtkunstwerk*, a collective production in which every constituent artistic element contributes in equal measure to an integrated whole.[31] Benois' own collaboration with Igor Stravinsky on *Le Rossignol* would be the consummate vindication of his ballet manifesto.

Although a precocious devotee of the Ballets Russes, 'I could just manage to get to the Diaghilev Ballet on the first night and the last night, the rest of the season being spent alas at my school', as he told BBC listeners in 1946, Lambert was just too young to have attended the London premiere of *Le Rossignol* at Drury Lane in 1914.[32] While Stravinsky's 'futurist' score ruffled critical feathers, Benois's chinoiserie decor and costumes were unanimously acclaimed for their spectacular beauty.[33] *Le Rossignol* had given Benois 'an opportunity to express all my infatuation with Chinese art', as he wrote later, inspired by 'my collection of popular Chinese colour-prints, which had been brought for me from Manchuria . . . The final result was a Chinoiserie *de ma façon*, far from accurate by pedantic standards and even, in a sense, hybrid, but undoubtedly appropriate to Stravinsky's music'.[34] Neglected by the theatre management for the duration of the Great War, Benois's sets and costumes perished in the damp cellars of Drury Lane. From his wartime base in Rome, Diaghilev re-adapted the tale in 1916 as *Le Chant du Rossignol*, and commissioned the pioneering Italian Futurist Fortunato Depero to design new sets and costumes. In its juxtaposition of artifice with nature, the story's theme lent itself to Futurist treatment, although for various reasons Depero's kinetic sculpture garden of mechanical flowers peopled by geometrical maidens and mandarins was never staged.[35] After the war, and as ever in pursuit of the most cutting-edge artistic treatment, Diaghilev commissioned Henri Matisse to design two further reiterations of

endless leisure, an eternal eighteenth century, an everlasting *style Louis XV*'. Richard Taruskin, *Stravinsky and the Russian Traditions: A Biography of the Works through Mavra: Volume One* (Berkeley: University of California Press, 1996), 439n32.
30. Alexandre Benois, 'Beseda o balete', in V. Meyerhold et al., *Teatr, kniga o noveom teatr* (Saint Petersburg: Shipovnik, 1908), 100. See also Taruskin, *Stravinsky and the Russian Traditions*, 540n128.
31. After Richard Wagner employed the term in his 1849 treatises 'The Artwork of the Future' and 'Art and Revolution', promoting a theatre that unified the arts, it became associated with his aesthetic ideals.
32. Lloyd, *Constant Lambert*, 28. *Le Rossignol* premiered on 18 June 1914.
33. Stephen Walsh, *Igor Stravinsky: A Creative Spring, Russia and France, 1882–1934* (London: Jonathan Cape, 2003), 231.
34. Alexandre Benois, *Reminiscences of the Russian Ballet* (London: Putnam, 1947), 359.
35. There has been much speculation about the reasons for this. Perhaps the cardboard costumes would have obstructed the movements of the dancers; some refer to Depero's delay in finishing the work on time. Depero's landlady 'dismantled the set, selling the pieces for the back rent the artist owed her', so, once again, costumes and props from *Le Rossignol* were lost. See Selma Jeanne Cohen, 'Le Chant du Rossignol', in *Stravinsky and the Dance: A Survey of Ballet Productions, 1910–1962* (New York: New York Public Library, 1962), 44.

the chinoiserie ballet, first in 1920 with choreography by Leonide Massine and again in a 1925 Constructivist version by twenty-year-old George Balanchine, fresh from the Soviet Union. Diaghilev had always sought out the most exciting artists rather than theatre designers to work on his ballets, and in inviting a Chinese treatment from a notable and newsworthy contemporary artist to design *The Birds*, Lambert was following suit.

Chiang Yee and Ballet

Chiang first discusses ballet in *Chinese Calligraphy: An Introduction to Its Aesthetic and Technique* (1938), where he alights upon the art of the ballerina as the most instructive way to explain to non-Chinese readers the technique of Chinese calligraphy:

> After some experience of writing one begins to feel a movement springing to life under the brush which is, as it were, spontaneous . . . The sensation is really very like that aroused by a ballerina balancing upon one toe, revolving, leaping, and poising on the other toe. She has to possess perfect control of her movements and amazing suppleness. The same qualities are demanded of the writer. A dancer's movements follow the rhythm of the accompanying music: a writer's movements depend upon the length and shape of stroke of the style he is practising.[36]

During his three years in London (since 1933), Chiang continues, he had 'heard a good deal of the Russian Ballet' and had 'seen several of its performances'.[37]

After Diaghilev's death in 1929, his Ballets Russes company dispersed. Some years later, in 1932, a revived company, Ballets Russes de Monte-Carlo, was reassembled by the partnership of French artistic director René Blum and White Russian émigré Colonel Wassily de Basil. After a series of acrimonious disputes Blum finally split from de Basil in 1935 and formed a separate company, Les Ballets de Monte Carlo. This similarity of names and the fact that both companies were performing concurrently in the West End during the 1936 season is undoubtedly confusing and would explain why when Chiang came to write about his experience of seeing 'the Russian ballet' he would lump the two companies (and indeed their separate venues) together. In *The Silent Traveller in London* (1938), published in the same year as *Chinese Calligraphy*, Chiang repeats the analogy of calligraphy and ballet dancing quoted above, giving it as 'a reason special to myself for liking Russian Ballet'.[38] Here he describes attending the 'Russian Ballet Season at Covent Garden Opera House', having been 'taken there for the first time by Sir Alexander

36. Chiang Yee, *Chinese Calligraphy: An Introduction to Its Aesthetic and Technique* (London: Methuen, 1938), 129.
37. Chiang, *Chinese Calligraphy*, 129.
38. Chiang Yee, *The Silent Traveller in London* (London: Methuen, 1938), 170.

W. Lawrence and the two young Lawrences, John and George'.[39] In a later essay, 'What Can I Say About Ballet' (1948), Chiang states, 'I became interested in ballet as soon as I made the first contact with it. Its combination of three arts – dance, music and painting – appealed to me'.[40] Nevertheless, his initial experience, as he relates it in *The Silent Traveller in London*, came with some misgivings: 'I enjoyed the classical ballet *Fire Bird* [sic] particularly,' he writes, 'though I know nothing about dancing or Western music. Then came the modern one'.[41]

The Firebird (*L'Oiseau de feu*) had been created for Diaghilev by Michel Fokine back in 1910 and was revived in 1934 by Massine for de Basil's and Blum's Ballets Russes de Monte-Carlo. In 1936, after their split, De Basil's Ballets Russes de Monte-Carlo was performing *The Firebird* at Covent Garden (using the original 1926 designs by Natalia Goncharova) while the ballet Chiang Yee describes as 'the modern one' was clearly, given his detailed account of the performance, Fokine's *L'Épreuve d'amour; or, Chung Yang and the Mandarin*, staged by Blum's breakaway company, Les Ballets de Monte Carlo, at the Alhambra Theatre in nearby Leicester Square.[42]

In something of a coup Blum had managed to persuade Fokine back from the US to restage his old ballets (*Les Sylphides*, *Petroushka*, and *Scheherezade*), and to create new ones. *L'Épreuve d'amour* ('the proof of love') was Fokine's first brand new ballet for Blum, co-written and designed by veteran Ballets Russes collaborator André Derain (founder with Matisse of the Fauvist school of painting). It was the first time since 1914 that Fokine had been present in London and wide press coverage was given to the return of Diaghilev's renowned dance master. Fokine's new ballet opened on 15 May 1936 to hysterically expectant London audiences, among them the Lawrences and their guest, Chiang Yee.

The libretto of *L'Épreuve d'amour* had been loosely adapted from a French translation of a traditional Korean tale.[43] An imperious Mandarin (Jan Yazvinsky) wishes his daughter Chung Yang (Vera Nemtchinova) to marry a wealthy Ambassador from overseas (Anatole Oboukhov). Her handsome but impoverished Lover (André

39. Sir Alexander Waldemar Lawrence (1874–1939) was the Fourth Baronet of Lucknow and a politician. At the time of their visit to the ballet, his son, Sir John Waldemar, the Sixth Baronet (1907–1999), was working with the BBC, having set up their World Service European Section.
40. Chiang Yee, 'What Can I Say About Ballet?', in *The Ballet Annual*, no. 2, ed. Arnold Haskell (London: A and C Black, 1948), 113.
41. Chiang, *The Silent Traveller in London*, 169.
42. It ran for a two-month season.
43. The libretto, initially titled 'The Love Test; or, Chung-Yang the Faithful Dancer', was loosely based on the novel *Printemps Parfumé* (1892), a French translation of the well-known Korean folk tale *Chunhyangjeon* (춘향전, Ch. *Chunxiang zhuan* 春香傳), or *The Story of Chunhyang*. The story tells of the impossible love between I-Toreng, the son of a rich mandarin, and Tchounyang, the poor but beautiful and virtuous daughter of a courtesan. The translation was a collaboration between J. H. Rosny (the pseudonym of the brothers Joseph Henri Honoré Boex and Séraphin Justin François Boex) and Hong-Tjyong-Ou (Hong Jong-u), a Korean student activist then working at the Guimet Museum in Paris (from 1890 to 1893) translating Korean, Chinese, and Japanese texts. In 1894 Hong travelled to Japan on a mission orchestrated by Chinese interests to assassinate Kim Okgyun, a reform-minded Korean, whom he shot dead, arguably provoking the First Sino-Japanese War.

Eglevsky), disguised as a dragon, frightens the Ambassador away whence he is set upon and robbed by friends of the young couple disguised as bandits. Now that the Ambassador is penniless the Mandarin agrees to the marriage of Chung Yang to her Lover whereupon the friends return his wealth to the Ambassador. Once again, the Mandarin tries to broker a marriage but this time the Ambassador refuses; he would prefer to be loved for himself, hence the 'proof of love'. A chorus of playful monkeys, coy maidens, and a solo Butterfly role (Helene Kirsova) supplied conventional chinoiserie tropes while Derain's striking décor provided contemporary appeal with its modernist approach. *The Illustrated London News* devoted a full page to photographs of the mise-en-scène.[44] Derain's stylised treatment with its jauntily upswept pagoda eaves, the gaily striped jousting tents of the Ambassador's encampment, and inspired choice of a festive 'lion dance' costume for the Lover's disguise was generally received as 'his masterpiece for the stage'.[45] From Chiang's perspective, the ballet that he describes, with no little irony, as 'the modern one' was perplexing:

> In it there was a male dancer with two long bunches of whiskers attached at both ends of his mouth, and another bunch in the middle of his chin, wearing a costume partly Chinese and holding a small painted parasol, which I presume, Japanese ladies may carry. While he was dancing in peculiar contortions, the small parasol vibrated and the three long bunches of whiskers quivered in opposite directions, so that I could not stop my laughter. John suddenly said to me that that was how most Europeans imagined the Chinese. I thanked him in my mind for not using the word "Chinaman"! I nodded my head and continued the conversation: "It is very interesting to me, because I have never seen things like this before. Should we actually dress and behave like that, perhaps it would not be so laughable." Luckily I managed not to blush when the interval came and many curious eyes turned towards me.[46]

Chiang Yee's discomfited response to *L'Epreuve d'amour* anticipates that of his compatriot Hsiao Ch'ien, who described his experience of watching *Aladdin* in his wartime publication *China but Not Cathay* (1942):

> as a child I was always fond of standing before those magical mirrors in a fun-palace to see myself twisted and transformed . . . since I grew up I have long missed this secret pleasure, until I went to a Birmingham Pantomime called "Aladdin" in which my country was made out to be a Turkish bath, with my people all in fancy flowery jackets . . . The only lamentable thing was suddenly to be discovered by a fair lady sitting next to me, who screamed out, 'Look, here is one!'[47]

Accounts of Fokine's choreography suggest that he took inspiration from the pantomime tradition of the 'Oriental' villain that had transmuted into the

44. 'The World of the Theatre', *The Illustrated London News*, 23 May 1936, 912.
45. Dawn Lille Horvitz, *Michel Fokine* (Boston, MA: Twayne, 1985), 118.
46. Chiang, *The Silent Traveller in London*, 169–70.
47. Hsiao Ch'ien, *China but Not Cathay* (London: Pilot Press, 1942), 1.

stock 'Yellow Peril' characteristics of early cinematic melodrama. Judith Chazin-Bennahum writes that Fokine 'exaggerated the overweening qualities of the Mandarin' and that 'the movements for the daughter also recall the caprices of film heroines, fawning and meek, with hollow "Oriental" poses'.[48] She cites an interview with Vera Nemtchinova, who remembered the 'simpering behavior that Fokine insisted upon' in order to give her character 'a more farcical style'.[49] Dawn Lille Horwitz describes the Mandarin's ludicrous walk: 'flat-footed, with the heel hitting first, and his lower back . . . curved forward, causing his buttocks to stick out'.[50] A silent rehearsal film from the period reveals other balletic expressions of 'national character' (essentially 'Yellowface' caricature) in Fokine's choreography for *L'epreuve d'amour*.[51] Horwitz details 'steps finishing in a turned-out plié in second [position] which, tongue-in-cheek, was supposed to represent the "Chinese" element', as were 'the fast parallel runs en pointe' and 'tiny handclaps' of the maidens 'in praise of the Ambassador's virtuosity'.[52]

While London critics generally received the ballet as a charming chinoiserie fantasy—Horace Horsnell in *The Observer*, for example, described the action, with its 'detachments of bandits' and 'little bevies of maids', as 'full of mannered fun'—others expressed a similar discomfiture to Chiang.[53] Ernest Newman in *The Sunday Times* concluded that 'the invention as a whole [is] rather childish'.[54] Horwitz cites a review that, corroborating the blanket Orientalism noted by Chiang, observed that the corps de ballet 'displayed a flavour more Japanese than Chinese especially in hairstyles', which must have been particularly jarring given the current escalation of hostilities between these two nations.[55] In fact, Fokine's ballet came at a crucial point of transition for cultural representations of Chineseness in Britain, a shift taking place in no small way, as the chapters in this volume indicate, thanks to the endeavours of Chiang Yee himself.

Constant Lambert's 'Chinese Phase'

By the time he was sought out by Constant Lambert, Chiang was singularly well positioned to bridge the disconnect between theatrical Orientalism and Chinese art. Nevertheless, it was an innovative move on Lambert's part, and Chiang appreciated this:

48. Judith Chazin-Bennahum, *Rene Blum and the Ballets Russes: In Search of a Lost Life* (Oxford: Oxford University Press, 2011), 158.
49. Chazin-Bennahum, *Rene Blum and the Ballets Russes*, 158.
50. Horvitz, *Michel Fokine*, 118.
51. A silent rehearsal film of *L'Epreuve d'amour* was made by the Denham Company in New York in 1938 when the Ballets Russe de Monte Carlo performed there. See Horvitz, *Michel Fokine*, 117.
52. Horvitz, *Michel Fokine*, 117–18.
53. Horace Horsnell, *The Observer*, 17 May 1926, 19.
54. Ernest Newman, 'The Week's Music', *The Sunday Times*, 17 May 1936, 7.
55. Horvitz cites the *New English Review* but I've been unable to find this review there.

> The suggestion made by Mr Constant Lambert that I should do the décor for Mr Robert Helpmann's ballet, *The Birds* . . . was an unusual request for, from my little experience, a Chinese artist's work is not found on the Western stage even if the play or ballet has a Chinese setting. Mr Lambert foresaw that a Chinese rendering of a pictorial backcloth might be suitable for this particular ballet. He was not playing a game of curiosity or 'Chinoiserie'.[56]

Chiang appreciated that an earnest cultural eclecticism informed Lambert's creative curiosity.[57] Among Lambert's visionary critical qualities was his early appreciation of jazz, ragtime, and blues music, generally viewed by 'serious' critics with derision. An experience which profoundly influenced his own composition was seeing the African American blues singer Florence Mills perform in the revues *Dover Street to Dixie* (1923) and *The Blackbirds* (1926), each of which he attended numerous times throughout their London runs, as was the music of Duke Ellington, whom he befriended and whose genius he would champion in his polemical critique *Music Ho!: A Study of Music in Decline* (1934).[58] While commentators generally date Lambert's 'Chinese phase' back to a youthful crush on Chinese American film actress Anna May Wong, this perhaps trivialises the sincerity of what biographer Andrew Motion describes as Lambert's 'vigorous inclusiveness'.[59] Nevertheless it was around the time he first saw Wong in *The Thief of Baghdad* (1924) that Lambert became obsessed with things Chinese, a condition testified to by his friends:

> In Constant's rooms . . . there was a row of bottles of Chinese wine, earthenware bottles with large paper labels embellished with Chinese characters, and I soon discovered that these bottles of Chinese wine had a special significance for him . . . I don't think that at that time he'd ever met Miss Wong but she was his sort of Princesse Lointaine and in her honour he used to drink Chinese wine.[60]

It was Anthony Powell in the novel *Casanova's Chinese Restaurant* who first accounted for Lambert's passion in the language of courtly romance: as the knight in thrall to the unattainable lady. Hugh Moreland (based on Lambert) is described as 'a hopeless addict of a *"princesse lointaine* complex"'.[61] However, if Lambert's ardour had gone unrequited it was not for want of trying. The composer Philip Heseltine (aka Peter Warlock) attempted to help, writing to his friend the poet Robert Nichols who had, in 1927 (following a position as Professor of English Literature at the

56. Chiang, 'What Can I Say About Ballet?', 113.
57. For Lambert's discussion of exoticism in the arts see his *Music Ho!: A Study of Music in Decline* (London: Faber and Faber, 1934), 186–88.
58. Exhausted from more than three hundred performances of *Blackbirds* in London in 1926–1927, Mills became ill with tuberculosis and died from an infection after an operation back in New York City in November 1927. She was only thirty-one. Lambert composed *Elegiac Blues* in her memory, incorporating the fanfare that opened *Blackbirds*.
59. Andrew Motion, *The Lamberts: George, Constant and Kit* (New York: Farrar, Strauss, Giroux, 1986), 157.
60. Peter Quennell in *Constant Lambert Remembered*, BBC Third Network, 25 June 1966; quoted in Lloyd, *Constant Lambert*, 80–81.
61. Powell, *Casanova's Chinese Restaurant*, 14.

University of Tokyo) just returned from a two-year scriptwriting stint in Hollywood, working with Wong's co-star Douglas Fairbanks:

> Do you by any chance know an address that would find one Anna May Wong, a Chinese actress who has worked with Fairbanks? A young composer who is staying with me at present – the only Englishman under 30 with any real ability for composition that I know – is so smitten with her beauty that he wants to write and ask if he may dedicate to her two books of songs which are settings of poems by Li-Po in the excellent translation of the Japanese Obata. The songs are really very charming.[62]

The list of composers in the West who set music to translations of Chinese poetry around the turn of the twentieth century is extensive.[63] The stylistic simplicity of the eighth-century Tang poet Li Bai (Li Po) appealed to late-Victorian translators and after his inclusion in Ezra Pound's collection *Cathay* (1917) Li Bai was greatly influential on early modernist poets, especially those of Pound's Imagist school.[64] Shigeyoshi Obata's spare style of translation in *The Works of Li Po: The Chinese Poet Done Into English Verse* (1922) aligns with this development in Anglo-American poetry and would be reflected in Lambert's treatment, which continues to receive critical respect. Musicologist Deryck Cooke has commented that the 'subtle simplicity and exquisite fragility of [Li Bai's] brief poems are ... beautifully reflected in Lambert's cool, fragrant, allusive settings', an appraisal echoed by composer and critic Giles Easterbrook, who commends 'the economy of gesture, the correlation of poetic and musical image ... the intuitively exact selection and balance of emotion with material and duration'.[65] Lambert's aim had been to avoid the 'overloaded chinoiserie preciosity' of Stravinsky's *Le Rossignol*, which in *Music Ho!* he associates with a belated musical expression of Beardsleyesque fin-de-siècle Aestheticism.[66]

Between 1926 and 1928, Lambert composed seven songs for voice and piano which he would later score with an accompaniment of flute, oboe, clarinet, string quartet, and double bass. 'Knowing the personal background', remarks Easterbrook, commenting on Lambert's romantic infatuation with Anna May Wong, 'makes the

62. Letter from Philip Heseltine (Eynsford, Kent) to Robert Nichols, 6 February 1927, in *The Collected Letters of Peter Warlock* (Woodbridge: Boydell Press, 2005), 4:169. Heseltine had once done a similar favour for Nichols, writing to intercede with the unattainable object of his affections.
63. Among the best known of Lambert's immediate contemporaries in Britain were Granville Bantock, Philip Heseltine, and Arthur Bliss.
64. See Zhaoming Qian, *Orientalism and Modernism: The Legacy of China in Pound and Williams* (Durham, NC: Duke University Press, 1995).
65. Deryck Cook, sleeve note to *Concerto For Solo Pianoforte and Nine Players, Eight Poems By Li Po* composed by Constant Lambert (1955, Argo Records), see https://www.discogs.com/Constant-LambertArgo-Chamber-Ensemble-Gordon-Watson-2-Alexander-Young-Concerto-For-Solo-Pianoforte-N/release/12413336; Giles Easterbrook, sleeve note to *Eight Poems of Li-Po* composed by Constant Lambert (1994, Hyperion Records), see https://www.hyperion-records.co.uk/dw.asp?dc=W7963_66754.
66. Lambert, *Music Ho!*, 36. Lambert compares what he considers to be the exoticism of Stravinsky's score unfavourably with Claude Debussy's more productive engagement with the orchestrations of Chinese music, stating, the 'Asiatic affinities' of Debussy are 'demonstrated by the suppleness of rhythm, the richness and delicacy of colouring, and the flexibility of melodic line'.

cycle's cool aloofness enhance rather than dilute the poignancy'.[67] Lambert followed his muse on the silent screen—in *Song* (1928) and then *Piccadilly* (1929)—and finally met her in the flesh when Wong made her British stage debut in James Laver's adaptation of the Chinese play *The Circle of Chalk* (1929).[68] She and Lambert were introduced backstage at the New Theatre, St Martin's Lane, on the play's opening night (14 March 1929).[69] Mean-spirited accounts have it that Miss Wong 'spotted his flat wallet in a blink and told him to get lost'.[70] Years later Powell recalled that Lambert 'did actually get as far as giving her dinner at the Savoy'.[71] Of this period Wong would admit that 'English men pursued her avidly and she did not pay for a dinner for months'.[72]

Remaining absorbed in all things Chinese nonetheless, Lambert continued to dine regularly with Powell and other friends at Chinese restaurants in Limehouse and in Soho. In September 1929 he went to see *The Rose of Pu-Chui* at the Avenue Pavilion, an 'art' cinema on Shaftesbury Avenue.[73] Translated from the French title, *La rose de Pushui*, *The Rose of Pu-Chui* was the export title of *The Romance of the Western Chamber* (*Xixiangji*, 1927). Made by Shanghai's Minxin Motion Picture Company, this was the first film with an all-Chinese cast and direction to gain wide exposure in Europe, and the first to be shown in England.[74] The following month, Lambert added a final song, the elegiac 'The Long-Departed Lover', to complete the cycle he now titled *Eight Poems of Li Po*.[75] He had achieved a measure of closure, too, regarding his cinematic crush, having recently met fourteen-year-old Florence Chuter (aka Florence Kaye), a girl of mysterious background and striking beauty whom two years later, despite the opposition of his mother, horrified not only by her youth but by what she called the '"colour side" of Flo', Lambert would marry.[76]

67. Easterbrook, sleeve note to *Eight Poems of Li-Po*.
68. *Song* (1928, dir. Richard Eichberg) (aka *Schmutziges Geld, Dirty Money*); *Piccadilly* (1929, dir. E. A. Dupont). For this period in Wong's career see Graham Russell Gao Hodges, *Anna May Wong: From Laundryman's Daughter to Hollywood Legend* (New York: Palgrave Macmillan, 2005), 96–99.
69. Richard Shead, *Constant Lambert* (London: Simon Publications, 1973), 70.
70. John A. Gould, 'Best Friends: Constant Lambert and Anthony Powell', *Southwest Review* 91, no. 1 (2006), 99.
71. See Anthony Powell's review of Motion's *The Lamberts*: 'Self-Destruction the Lambert Way', *The Daily Telegraph*, 25 April 1986, 14. See also Lloyd, *Constant Lambert*, 89.
72. Hodges, *Anna May Wong*, 91.
73. Lloyd, *Constant Lambert*, 89.
74. Directed by May Fourth intellectuals Hou Yao and his wife Pu Shunqing (China's first female playwright to enter the world of cinema), their mission was to make stylish local films to compete with Hollywood products. The film featured swordplay and surreal dream sequences, most of which were shot on location in Suzhou and Hangzhou, while the copiously ornate interiors appealed to the current chinoiserie craze, making it a major attraction for foreign audiences. *The Spectator*'s reviewer praised 'Rose of Pu-Chui, with [its] all-Chinese cast [as] a charming and delicate piece of work', although, maybe because there was no substantial British film industry as yet, seemed unable to comprehend that China might have a film industry of its own, commenting, 'it is remarkable that the direction of this film is entirely Western, although, of course, the setting and the acting have their own Eastern character'; *The Spectator*, 5 October 1929, 438. See Kristine Harris, '"The Romance of the Western Chamber" and the Classical Subject Film in 1920s Shanghai', in *Cinema and Urban Culture in Shanghai, 1922–1943*, ed. Yingjin Zhang (Stanford, CA: Stanford University Press, 1999), 51–73.
75. Motion, *The Lamberts*, 161.
76. 'Your race', Amy Lambert told her prospective daughter-in-law, 'is an insuperable barrier to my affection for you'. See Motion, *The Lamberts*, 188.

Variously referred to in the society gossip columns and in the reminiscences of friends as a 'model from Java', 'Lambert's exquisite Chinese wife – a rare jewel', his 'most attractive oriental wife', and so on, she was, according to his friend the singer Dora Foss, a 'half Chinese half Irish girl brought up in an East End orphanage', and when Lambert met her she was working as the maid of Elsa Karen, a pianist of his acquaintance who lived in Hampstead.[77] Another friend, Myfanwy Thomas, daughter of the poet Edward Thomas, realised that this was the same girl who had captured her attention when they were at ballet school together in Tottenham Court Road and whose spectacular pirouettes had dazzled the other children. 'I thought often of the exquisite little Tamara, the octoroon whose real name was Florence', she wrote in her memoirs, 'when she grew up she became the wife of Constant Lambert the composer. He had been captivated by Anna May Wong, the film actress, and this elegant little creature closely resembled her'.[78] There is a photograph of the couple taken in July 1931, a few weeks before their wedding, standing arm-in-arm outside Lambert's favourite rendezvous, the Shanghai Restaurant, at 8 Greek Street in Soho.[79] The famed lothario Giacomo Casanova had lodged in Greek Street in 1764 (at number 47), hence the Shanghai Restaurant's literary immortalisation as *Casanova's Chinese Restaurant*, Powell's fond tribute to his friend. And it was to the Shanghai Restaurant, some ten years hence, that Robert Helpmann was directed to make that overnight dash from Manchester, breaking his hectic touring schedule to be introduced to Chiang Yee.[80] Over Chinese food they exchanged ideas for 'the "Bird" ballet', an ebullient Helpmann amusing nearby diners with his animated demonstration of the choreography.[81] In *The Silent Traveller in Oxford* there is a sketch of Helpmann next to one of Charlie Chaplin in *The Goldrush*, where the Little Tramp spears two bread rolls with forks and has them perform a 'dance', a scene which Helpmann's comic antics, demonstrating 'by movements of his fingers on the table the steps of the dancers', called to Chiang's mind.[82]

The Birds

As Beryl Grey became aware of early on in her ballet career, the 'right sets and costumes are vital for a successful production'.[83] She was barely fifteen when Helpmann chose her to star as the Nightingale, her 'first ever created role in the Company'.[84] Lambert and Helpmann rehearsed the dancers through the early autumn of 1942

77. Lloyd, *Constant Lambert*, 144. See also Gould, 'Best Friends: Constant Lambert and Anthony Powell', 99.
78. Myfanwy Thomas, *One of These Fine Days* (Manchester: Carcanet New Press, 1982), 112–15.
79. They were married on 5 August 1931 at the Kensington Registry Office.
80. The tour took in Newcastle-upon-Tyne, Liverpool, Manchester, Leeds, and Cambridge. See Grey, *For the Love of Dance*, 29.
81. Chiang, *The Silent Traveller in Oxford*, 172.
82. Chiang, *The Silent Traveller in Oxford*, 173.
83. Grey, *For the Love of Dance*, 28.
84. Grey, *For the Love of Dance*, 30.

until the 'breathtaking moment' when the company finally got to see Chiang's 'delicate scenery' and the 'amazing bird costumes and headdresses'.[85] Grey remembers their 'impatience to see it all worked out in performance' and then 'everyone's astonishment' when 'we took 15 curtain calls'.[86] *The Birds* played to packed houses throughout the season. 'During the war,' Grey recalls, '*The Birds* was to become one of the most popular and frequently performed ballets,' describing her pleasure that, 'the first role created for me should be [so] well received.'[87] James Redfern in *The Spectator* noted that the New Theatre (Sadler's Wells' wartime home, and where Lambert had seen Anna May Wong make her stage debut) was 'full to standing every night'. 'No wonder', he enthused, given 'the feast for ear and eye probably unrivalled anywhere in the world at present, including Russia'.[88] James Redfern was the byline of Walter James Redfern Turner, poet, distinguished music critic, and seasoned ballet-goer since the days of Diaghilev. He commended Helpmann for the ballet's 'complete unity of style in music, choreography and *décor*'.[89] Redfern was impressed by the 'intricacy and delicacy' of Lambert's musical arrangement, 'a delight to hear' that was 'matched and repeated in the fascinating slightly Chinese character given to the English woodland and birds'.[90] He singled out the costume of the Hen as 'a brilliant *chef-d'ouevre* of caricaturing fancy, while those of the Dove and the Nightingale', he wrote, 'are quite lovely'.[91] This was high praise from a respected commentator. *The Times* reviewer commented that Moyra Fraser had surely 'made a close study of poultry yard behaviour . . . her piquant costume and her performance provided most of the fun'.[92] Other reviews concurred that the design, with 'its ravishing garden setting and charming costumes', was a particularly strong suit of the ballet.[93] Elspeth Grant in the *Daily Sketch* thought it 'light, sweet, delicious'.[94] The addition of this 'gay capricious trifle to the Sadler's Wells repertory at the New [Theatre]', wrote Horsnell in *The Observer*, delivers 'a pretty piece of animated chinoiserie. The birds so oddly paired by the Argument are delightfully dressed by Chiang Yee, and roost, one feels, not in his decorative wallpaper trees but in cabinets of rare porcelain'.[95]

Chiang Yee's commendable achievement in response to Lambert's not undemanding commission is indicated by how precisely his original backdrop designs and costume sketches (held in The Royal Opera House Archive) correspond to their realisation on stage. Not only do we have the black-and-white stage photographs

85. Grey, *For the Love of Dance*, 30.
86. Grey, *For the Love of Dance*, 30.
87. Grey, *For the Love of Dance*, 30.
88. James Redfern, 'The Theatre', *The Spectator*, 27 November 1942, 11.
89. Redfern, *The Spectator*, 1942.
90. Redfern, *The Spectator*, 1942.
91. Redfern, *The Spectator*, 1942.
92. 'Sadler's Wells Ballet', *The Times*, 25 November 1942.
93. Walker, 'Robert Helpmann, 66.
94. Elspeth Grant, *Daily Sketch*, 25 November 1942.
95. 'The Birds', Horace Horsnell, *The Observer*, 29 November 1942, 2.

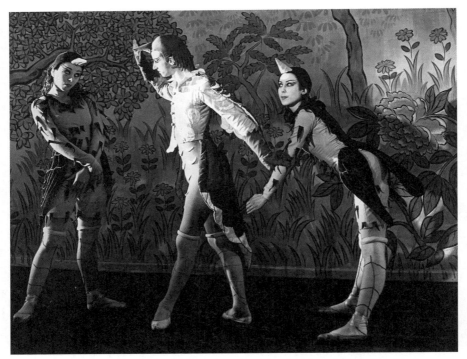

Figure 4.2: *The Birds* (1942). Cuckoo (Gordon Hamilton) and Two Cheeky Sparrows (Margaret Dale and Joan Sheldon). Courtesy of the Victoria and Albert Museum, London.

of the performance, but thanks to the exhaustive epistolary reports of balletomane Lionel Bradley, who saw *The Birds* many times throughout its run, we have detailed descriptions of the fabrics and colour schemes of the finished costumes.[96] Only the Cuckoo is missing from the sketches held in The Royal Opera House Archive, but Chiang's account of fitting Gordon Hamilton, in *The Silent Traveller in Oxford*, not only corresponds with photographs of the Cuckoo but indicates a keen sense of the practical contingencies of costume design:

> Next came the fitting of the cuckoo costume on Gordon Hamilton, who is such a contrast to Alexis Rassine, and whose short stature and witty smiling face are so suited to his part. My design for the cuckoo was intended for a more bulky bird, but the costume was adapted to fit him perfectly. The varied colors suited him, and the white feather-like collar seemed to add length to his neck and the long tail to add to his stature.[97]

96. Lionel Bradley, 'Bradley's Ballet Bulletin, 1941–1947', unpublished notebooks, Victoria and Albert Museum, Department of Theatre and Performance. Notebooks are unnumbered and unpaginated. Citing the bulletin of 24 November–16 December 1942.
97. Chiang, *The Silent Traveller in Oxford*, 173.

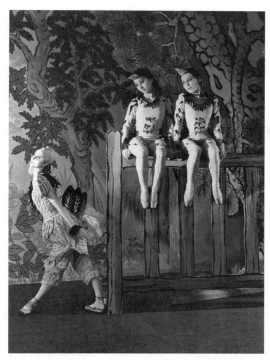

Figure 4.3: *The Birds* (1942). Hen and Sparrows (Moyra Fraser, Margaret Dale, and Joan Sheldon). Courtesy of Royal Ballet Benevolent Fund.

Bradley's detailing of Chiang's variegated colour combinations for each dancer gives a sense of why Horsnell compared the costumed 'birds' to the ornamental kind that inhabit the porcelain cabinet: 'The Cuckoo (Gordon Hamilton) has a bright blue cap with a yellow beak, red cheeks, the body covered in a mixture of a yellowish orange and a paler blue, with a variegated pattern of a different shade of the same colour, his legs continue the paler blue to the knees below which are yellow stockings and he carries behind close fitting brown wings not unlike a tailcoat'.[98] Bradley describes the costumes as 'a charming mixture of naturalism, imagination & the typical ballet costume, tho [sic] sometimes', he admits, 'they are a little unkind in obscuring the dancer's line. Most of them have close fitting "jockey" caps with a peak in the shape of a pointed beak, and a certain birdlike character is given to the face by a make up which accentuates the oval of the eyes'.[99] Much of the Hen's comic effect was achieved by her costume of 'fluffy white feathery pantaloons', which to Bradley had 'a suggestion of the female bathing costume of Victorian days.'[100] Of

98. Bradley, *Bradley's*, bulletin of 24 November–16 December 1942.
99. Bradley, *Bradley's*, bulletin of 24 November–16 December 1942.
100. Bradley, *Bradley's*, bulletin of 24 November–16 December 1942.

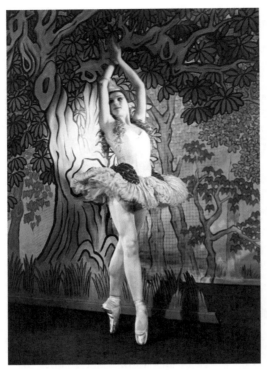

Figure 4.4: *The Birds* (1942). Nightingale (Beryl Grey). Courtesy of the Victoria and Albert Museum, London.

Chiang's scenic backdrop for *The Birds*, Bradley observes, 'the trees are chiefly of a peculiarly vivid green & the flowers large & red. These various plant forms are slightly conventionalised but are treated in a detail which verges on the practice of the pre-raphaelites [sic]'.[101]

The most difficult design challenge for Chiang had been the costume of the Nightingale because, he explains, 'the nightingale though singing beautifully at night, is a rather dull *looking* bird that has never earned distinction for the colour of its plumage . . . I was really worried about it, for the nightingale's part is one of the biggest in the ballet . . . Happily, however, after much discussion and numerous suggestions from every one, the costume finally turned out to be very pretty'.[102] Although Chiang worried that his Nightingale design was 'not very good', Bradley's description together with photographs of Beryl Grey on stage gives us an idea of the quite minimal concession that she wore 'pink tights' rather than the yellow stockings patterned with scales seen in the design; thus her costume, as Bradley describes,

101. Bradley, *Bradley's*, bulletin of 24 November–16 December 1942.
102. Chiang, *The Silent Traveller in Oxford*, 174.

was 'more like that of the conventional ballerina and less like a bird's'.[103] Just as in Chiang Yee's original sketch she has 'a brown cap with a pink beak, a pale rose bodice, without decoration, a short greyish-white tutu . . . locks of fine gold thread at either side of her face, and epaulettes of the same gold thread . . . Little brown wings going back from the side of the waist and a short brown tail are the only suggestion that she is a bird'.[104]

Bradley critiques the action of the ballet in close, step-by-step detail. Afterwards is inserted, in brackets and underlined, '(The above was written after I had seen the ballet five times)'. In early December he reflected on the 'first night hysteria', when the audience 'yelled the place down for Helpmann as though he had produced a masterpiece', while for Bradley *The Birds* improved greatly over the weeks of its performance as it 'attained to greater fluency and precision as well as to an accentuation of its humour'. His ultimate verdict on its appearance however was reserved: 'The décor is perhaps no more than pretty, therefore disappointing from an artist of Chiang Yee's calibre'.[105] Perhaps we might give the last word to Chiang, who notes that in designing for the ballet an artist 'should not give too much prominence to his own character, yet must indicate what he thinks suits the dancing and music'.[106] He had clearly thought carefully about the requirements of the *Gesamtkunstwerk* as put into practice by Benois and Bakst: 'At first I thought The Birds admirably suited to go with a flower painting or a landscape by one of our Sung [Song] masters, very simple and full of imaginative intuition. I actually tried to make use of a Sung masterpiece – "The Cranes playing by a spring" by Hsia Kuei [Xia Gui] – as a base. However after further consideration of the dancing I felt that such a backdrop would be too simple, so I painted instead a rather detailed leafy wood.'[107] (It is sad given Chiang's keen interest in stage design that he would later fall out with Robert Helpmann over a cancelled commission to design a production of *As You Like It* that Helpmann was directing in 1955 at London's Old Vic.)[108]

In 1943 Arnold Haskell put together the extensive *Exhibition of Ballet Design*. Chiang's sketches for *The Birds* were included alongside designs by his British contemporaries as well as works by Bakst, Benois, Goncharova, Derain, and Picasso, among other international luminaries. While English ballet 'is too young to have produced the scenic innovations of a Benois, Bakst or Larionov,' Haskell's introduction observes, 'the level is a high one and some of the most important work has been produced during the war years.'[109] Funded by the Council for the Encouragement of Music and the Arts (CEMA), the show toured the British Isles, opening in Leicester and culminating in 1944 at the Brighton Pavilion.

103. Bradley, *Bradley's*, bulletin of 24 November–16 December 1942.
104. Bradley, *Bradley's* bulletin of 24 November–16 December 1942.
105. Bradley, *Bradley's*, bulletin of 24 November–16 December 1942.
106. Chiang, 'What Can I Say About Ballet?', 114.
107. Chiang, 'What Can I Say About Ballet?', 113.
108. This incident is discussed in Zheng, *Chiang Yee*, 162–63.
109. *Exhibition of Ballet Design* (London: CEMA, 1943–1944).

The end of the war saw the Sadler's Wells company 'promoted' to the Royal Opera House and its subsequent incorporation as the Royal Ballet. Its Golden Jubilee was marked in 1981 with the publication *Fifty Years of the Royal Ballet*, which includes a colour plate of Chiang's design for *The Birds* backdrop, together with the Cuckoo costume (the latter was clearly not returned to the archive!).[110] Then, in 1997, Jill Anne Bowden in *The Dancing Times* reviewed *Design for Performance: From Diaghilev to the Pet Shop Boys*, a publication that accompanied the 1993 exhibition of the same name at London's Lethaby Gallery. Bowden writes that she was surprised to see that the editors' caption for 'Chiang Yee, whose enchanting design for Helpmann's *The Birds* was shown at the Lethaby Galleries' states: "'Apart from his dates of birth and death . . . it has proved impossible to obtain biographical information on this designer.'"[111] Bowden concedes that perhaps 'it is natural that research in theatre design should have yielded nothing, for it is likely that Chiang Yee never returned to stage work. . . . I thought of his illustrations, which provided one of the fascinations of my childhood, and wondered whether anybody nowadays remembers the *Silent Traveller*? Well it appears they do: I was heartened, on ringing the London Library, to be told that a number of their copies are out on loan'.[112]

Chiang's foray into the world of ballet is worth remembering not only because it demonstrates his artistic versatility and professional adaptability. *The Birds* is a landmark in the history of British stage design because Chiang's involvement makes an early intervention in the perpetuation of outdated caricatures and offensive stereotypes in ballet. This is something that troubled him, as we have seen, and that has only recently begun to be addressed with any seriousness, principally thanks to the recent activism of the Asian American dancer Phil Chan, whose book *Final Bow for Yellowface* has been making significant inroads in rethinking race representation and inclusion in ballet.[113]

110. Bland, *The Royal Ballet*, 71.
111. Jill Anne Bowden, *The Dancing Times*, January 1997, 337–38. Peter Docherty and Tim White, eds., *Design for Performance: From Diaghilev to the Pet Shop Boys* (London: Lund Humphries, 1996), 193.
112. Bowden, *The Dancing Times*, 338.
113. Phil Chan, *Final Bow for Yellowface: Dancing Between Intention and Impact* (Brooklyn, NY: Yellow Peril Press, 2020).

Figure 4.1: *The Birds* (1942) set design by Chiang Yee. Courtesy of Royal Ballet Benevolent Fund. With permission of San Edwards.

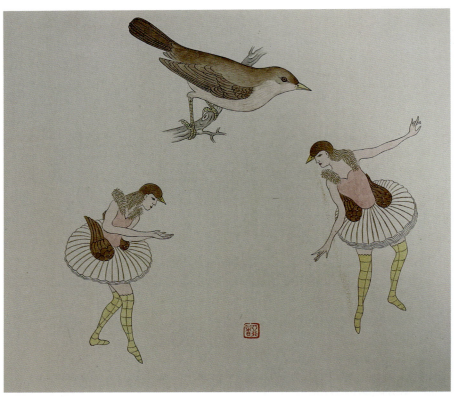

Figure 4.5: *The Birds* (1942). Nightingale costume design by Chiang Yee. Courtesy of Royal Ballet Benevolent Fund. With permission of San Edwards.

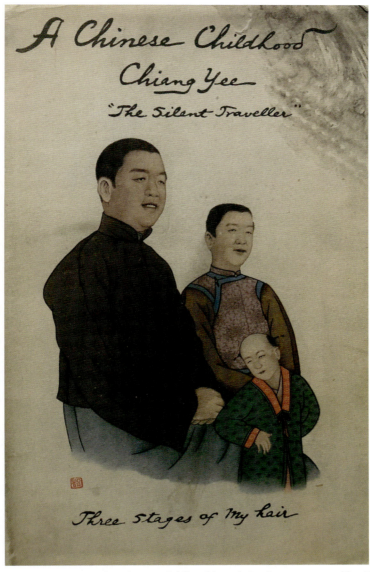

Figure 5.1: The front cover of *A Chinese Childhood* (1940). With permission of San Edwards.

Figure 6.1: 'Sleeping in a Gas Mask' from *The Silent Traveller in War Time* (1939). With permission of San Edwards.

5
The Silent Traveller at Home

Da Zheng

In May 1940, Chiang Yee's memoir *A Chinese Childhood* was published by the London-based publisher Methuen. The book received rave reviews. Many pointed out that, unlike other publications on China, which had been almost exclusively by Western authors, this was a work done by a Chinese writer in England who brought a fresh and intimate outlook.[1] A review in the *Times Literary Supplement* emphasised its authenticity, stating that the author presented the Chinese and cultural life in Jiujiang 'as they see themselves and not as others see them'.[2] 'Few books could take us farther from the upheaval and disorder of the present day than this', commented one reviewer, while another recommended it as 'a book to indulge in when anxiety needs a sedative'.[3] 'The wisdom of the Chinese—this love of little and lovely things, this passion for peacefulness, this glorying in gardens, this exalting of contemplation and appreciation over noisy aggressiveness'—could benefit anyone 'who seek a temporary escape from dismal wartime thoughts', wrote another.[4] *A Chinese Childhood* underwent several reprints in England and was subsequently published in the US, India, and China. Chiang became one of Methuen's top writers.

What intrigues me the most is the phrase 'Silent Traveller at Home', the title of a review article that appeared in the *New York Times Book Review* after John Day brought out the US edition in 1952. In that article, John Espey tries to underline the differences between *A Chinese Childhood* and other popular Silent Traveller books by Chiang. While those Silent Traveller titles, on Oxford, Edinburgh, or New York, offered the 'unexpected pleasure of seeing familiar Western scenes through Chinese eyes', *A Chinese Childhood*, according to Espey, gives a record of the author's life in China, without his signature 'contrast and surprise'.[5]

1. Maurice Collis, 'Dreaming in Armageddon', *Time and Tide*, 25 May 1940. There were only a few successful English-language publications on China by Chinese writers at the time, and *A Chinese Childhood* was unique because it was a memoir by a Chinese writer residing in Britain.
2. 'Chinese Family: Intimate Picture of a Lost Home', *Times Literary Supplement*, 11 May 1940.
3. G. A. G., 'A Chinese Looks Back', *Hong Kong Radio Review* 11, no. 14 (8 February 1941); Wilfrid Rooke Ley, 'The Man Introduces the World to You', *Catholic Herald*, 7 June 1940.
4. E. H. J., 'A Bit of Old China', *Christian World*, 30 May 1940.
5. John Espey, 'Silent Traveller at Home', *New York Times Book Review*, 16 November 1952.

There seem to me some problems in identifying this memoir as a straightforward recording and interpretation of the Chinese scene and in viewing the author as 'at home'. Espey alludes to Chiang Yee's general practice of using geographical locations in his Silent Traveller titles, such as *The Silent Traveller in London*, *The Silent Traveller in Oxford*, or *The Silent Traveller in New York*. Logically, this book, about his childhood experience in Jiujiang, China, should have been titled *The Silent Traveller in China*, or *The Silent Traveller in Jiujiang*, rather than *The Silent Traveller at Home*. Chiang could not possibly be at home. As is mentioned in the book, he had been 'in exile' in England for six years.[6] He actually used the phrase 'in exile' next to his signature in his Chinese inscription on the front page of the author's copy: 'At the beginning of the eighth year in exile in England.'[7] In other words, he was conscious of the physical distance from as well as the emotional connections with his home country on the other side of the world. Besides, the cultural environment and many of the traditional practices described in the book had disappeared forever, owing to the advent of the sociocultural revolution and the concurrent modernist movement of 1919. They existed only in memory. Aside from that, the phrase 'at home' may denote another meaning here: feeling comfortable and at ease in a place or situation. Is it possible that Chiang in fact felt 'at home' and happy in England even though it seems very unlikely?

This chapter will examine Chiang Yee's perception of and writing about home through the study of *A Chinese Childhood*. It will first highlight the feature of nostalgia in the memoir, then discuss the author's diasporic experience in England as the Silent Traveller, and finally argue that writing serves as an effective way for the author to construct a home away from home.

Nostalgia in *A Chinese Childhood*

On the dust jacket of *A Chinese Childhood* is an eye-catching colour self-portrait with the caption 'Three Stages of My Hair'. As one's hairstyle is an indicator of age, social status, or aesthetic taste, the three figures in that self-portrait represent the artist-author at three different stages: aged six, fifteen, and thirty, each marking a significant turning point in his life. At five, Chiang lost his mother, who had offered him tender maternal love as well as his childhood identity; at fifteen, he lost his father, whose care and affection had nurtured his artistic and literary identity; at thirty, he departed from his motherland which had endowed him with a cultural identity and became an exile overseas.

6. Chiang Yee, *A Chinese Childhood* (London: Methuen, 1940), 303.
7. Chiang Yee's inscription is as follows: 'This book was originally scheduled for publication in mid-November last year, but the outbreak of war caused its delay until May 2 this year. On April 15, Alan [White] came and brought me the first copy. I am touched by his kindness, and I record this in writing. Chung-ya, at the beginning of the eighth year in exile in England.' Chiang Yee, handwriting, in the author's copy of *A Chinese Childhood*.

The memoir outlines the vicissitudes experienced by Chiang's family, his early upbringing, and the cultural practices of the first two decades of the twentieth century. In a placid yet mirthful tone, Chiang delves into his childhood experiences, gently unfolding an encyclopedic and panoramic portrayal of life in Jiujiang, a port city on the Yangtze River in South China.

The history of the Chiang family can be traced back to the first century BCE, when Chiang Hsu (69 BCE–?) was appointed by Emperor Ai (26–1 BCE) to serve as government inspector and governor of Yanzhou.[8] Being 'an upright and sincere man', he was unwilling to render his service in the royal court after Wang Mang (45 BCE–23 CE) usurped the power to the throne. He resigned from the post and returned to his native place, Chang'an, to live a reclusive life. He met no one except for occasional visits from two well-known poet friends. He made three footpaths in front of his house for them to travel by. Hence the phrase 'three footpaths' became known as a poetic function in Chinese literary history.[9] In the early eighteenth century, a member of the Chiang family moved to Jiujiang on the south side of the Yangtze, built a new house, and settled there. Ten generations later, at the beginning of the twentieth century, the house had developed into a compound of two walled enclosures. The main enclosure had forty-two rooms, where Chiang and most of the family lived. It was a close-knit unit of four generations, about fifty members in total, living in that spacious family compound under the unquestioned authority of his great-grandparents. To the right side of the main enclosure stood a smaller one, which was the living quarters of his third great-uncle, with two large rooms being used as a family school, as well as a big garden.

It was a world of peace and happiness: deliberate protocols and manners, reverence for elders and ancestors, the respect paid to scholars and poets, and the joys of celebrating festivals. The family followed the Confucian tradition, caring for the young and respecting the elderly, and maintaining a harmonious relationship. There was hardly any dispute among them; if disagreements did occur, they would be settled with the advice of the elders. Throughout the year, members of the family worked hard, yet they took time to rest and enjoy themselves at the beginning of the Chinese New Year. Like all other families, the Chiangs took weeks to prepare food, clean the house, and decorate the rooms and halls with new paintings and hang red paper couplets on the entrance gate to welcome prosperity. On Lunar New Year's Eve, the family gathered to enjoy a sumptuous feast and celebrate the annual reunion. After that, the elders would take out the family genealogy in the central hall, where the ancestral shrine stood, and narrate the family history to younger generations.[10]

8. Yanzhou in the Han dynasty encompassed approximately southwest Shandong and northeast Hebei of China today.
9. Chiang, *A Chinese Childhood*, 11.
10. Chiang, *A Chinese Childhood*, 75.

It was a cultured environment. Chiang's father was an artist, known for bird-and-flower paintings. On the walls of his father's studio hung paintings by ancient masters and occasionally by his father himself. On the shelves were a large number of sketches, picture books, and bird-and-flower paintings. To Chiang, those picture books and paintings were 'like part of nature'. He loved to linger in the studio, admiring and imagining birds singing and 'flowers smiling'.[11] Or he would stand by his father's table, watching him prepare and paint. Chiang began learning to paint with his father at the age of twelve, and he often carefully studied works by ancient masters and tried to improve his technique. In addition, *A Chinese Childhood* provides vivid pictures of customs, festivals, and cultural practices in the region, such as weddings, funerals, birthday celebrations, childbirth, Lantern Festival, Qingming Festival, and Dragon Boat Festival.

The book features eight coloured plates and one hundred line drawings. These illustrations give an impressive coverage of the local socioeconomic life at the beginning of the twentieth century: bridal costumes, sedan chairs, styles of hairdressing, lanterns, and children's games. There had been a considerable number of publications by Jesuits and missionaries who recorded their travels or experiences in China, such as *The Costume of China* (1805) by William Alexander, *Pictures of the Chinese* (1860) by Robert Henry Cobbold, *Social Life of the Chinese* (1867) by Justus Doolittle, *China's Millions* (1867) by J. Hudson Taylor, and *Alone in China, and Other Stories* (1897) by Julian Ralph. When preparing his memoir, Chiang probably consulted some of the artworks in these publications, but his drawings appear different in style and are in general delightful and illuminating. On the other hand, Chiang includes no images of gambling, prostitution, torture, or violence, and there are no specific depictions of practices such as foot binding or opium smoking. The subjects depicted are characters of honour and dignity. Most interesting is the fact that half of these line drawings are of peddlers of flowers, fruit, vegetables, goldfish, silk goods, incense, brooms, or palm-fans. In Jiujiang, one of the commercial centres on the Yangtze River, business was a vital component of local social life. These peddlers, therefore, are reminiscent of the socioeconomic system that had given way to a modern and industrial society in the 1920s and 1930s.

Though apparently a eulogy, the book is an elegy in disguise. It is about the beautiful 'old days' gone forever. The phrase 'Hall of Three Footpaths' had long been used as a reference to the Chiang family, which was conscious of preserving the honour of family traditions by keeping and updating the clan genealogy register and paying tribute in the ancestral temple.[12] Even in the title deeds of their property, the ownership had been attributed as 'Hall of Three Footpaths', to a collective entity, rather than to any individuals of the family. When Chiang was writing the book in his little two-room flat in Hampstead in 1938, China was at war with Japan. His brother wrote to urge him to stay in England to gain more experience, yet a month

11. Chiang, *A Chinese Childhood*, 56.
12. Chiang, *A Chinese Childhood*, 14.

later he died of a heart attack. Two months later still, on 25 July his hometown fell, and Japanese troops occupied the city. Hundreds of local residents were slaughtered, houses burned, and the villages and towns reduced to rubble. The Chiang family compound was 'entirely destroyed'. Chiang's sister-in-law offered to take two of his four children with her to Chongqing; his wife Zeng Yun, frail and petite, took the other two children as well as her own mother, sister, and uncle, evacuating to the countryside ten miles outside the city. The six of them lived in the wild woods at the foot of Mount Lu, where the tranquility of the rustic setting was often pierced by gunfire. They were homeless and had no money to buy food or clothes for survival. Zeng's sister and uncle perished during their sojourn there. Eventually Zeng made her way to Nanjing where she lived for several years. During that short period of time, a number of family members died or were killed in the conflict, and those who survived scattered far apart from each other. Chiang Yee dedicated the memoir to 'All Members of the Hall of Three Footpaths'. The tragic undertone here is hard to miss.

The book is plagued with calamities, deaths, war, displacements, and separation. Underlying the narrative are nostalgic sentiments and painful feelings, which function as the motif of the book. Gone are the customs, friends, family members, and even favourite culinary dishes and hobbies. Nevertheless, childhood experiences and the 'happiness' of the past, while they can never be replaced, are 'surely sometimes sweet to recall'.[13] When Chiang reminisces about Chinese New Year practices, he writes:

> I am sorry to say that the New Year customs are gradually dying out. I cannot but regret it. It may be better to be practical rather than formal, but how few really joyful times one has in one's life! Looking back on the New Year Festivals of my childhood I find them very precious. What a business they were! But what pleasure and good fellowship they gave![14]

The most distressing was the loss of his mother and father. Chiang relates how he became 'a very sensitive child' after losing his mother at the age of five and how ever since he had become painfully conscious of the differences between himself and his cousins who enjoyed the 'constant care and affection of a mother'.[15] The loss of his father was another heartbreaking blow. Rather than offering a direct account of this, he recorded his first expedition with his father to Mount Lu, a most memorable experience of exploring the wonder of nature. At four o'clock, father and son set out from a small inn on the mountain to reach a site at the summit to watch the sunrise. It was pitch dark then.

> I could not distinguish where the sky ended and the water began. Everything was wrapped in a white shroud tinged with red by the first glow of the rising sun. Later

13. Chiang, *A Chinese Childhood*, 2.
14. Chiang, *A Chinese Childhood*, 78.
15. Chiang, *A Chinese Childhood*, 36.

the whole scene became bright red and sparkling. The great ball of fire rose slowly from the water, and diminished as it climbed above the horizon. Father did not speak, and I could not express my wonder and excitement.[16]

It was such a magnificent and divine moment! How he wished it could last forever. And it did, but only in his memory. His father died soon after. Chiang tells the reader poignantly that he visited the mountain a few times later, 'but never again with my dear father'.[17]

A Chinese Exile in England

Chiang Yee, when writing his memoir, was in exile. He was literally homeless, thousands of miles away from his war-torn homeland, where his former home had been burned to the ground by the Japanese. As he said years later, 'only experienced political exiles can understand what I went through'.[18] A discussion of his diasporic identity, as represented by his pen name, the Silent Traveller, may help to explain the layers of pain and lamentation registered in his memoir and other artistic and literary representations.

In 1932, around the time of his preparation for departure to England, Chiang created a pen name for himself: Zhongya 重啞. Like most of his contemporaries, he had a school name in childhood, which was Zhongya 仲雅, meaning 'second' (in order of birth) and 'grace'. Homophonous with Zhongya 仲雅, Zhongya 重啞 is loaded with multiple new meanings. *Ya* 啞 means 'mute' or 'dumb', and *zhong* 重 denotes 'heavy, weighty', 'considerable in amount or value', or 'discreet, prudent'. A combination of these two characters generates a rich variety of connotations, and probably from this came Yaxingzhe 啞行者, that is, the Silent Traveller, which later became his signature penname overseas.[19] It needs to be pointed out that, while the phrase *xingzhe* 行者 denotes a walking man, pilgrim, or traveller, it carries another meaning, that is, a monk or a Buddhist practitioner.

As indicated by the new names Zhongya and Yaxingzhe, silence, or *ya*, is emphatically valued. In China and Confucian tradition, silence has been celebrated as a virtue of elegance, grace, modesty, and steadiness. In the case of Chiang Yee, this aspect is far more complex. It underlines his disillusionment with the corrupt government and politics of China. He studied chemistry at college in China, hoping that science could effectively help make China a prosperous and powerful nation in the world. Upon graduation, however, he found that his lofty dream to 'bring prosperity to China with scientific knowledge' was shattered by reality because he

16. Chiang, *A Chinese Childhood*, 275–76.
17. Chiang, *A Chinese Childhood*, 276.
18. Chiang Yee, *China Revisited, after Forty-Two Years* (New York: W. W. Norton, 1977), 34.
19. For a full discussion of the name Silent Traveller see Da Zheng, 'The Traveling of Art and the Art of Traveling: Chiang Yee's Painting and Chinese Cultural Tradition', *Studies in Literary Imagination* 37, no. 1 (2004): 176.

did not have money to pursue advanced study in China or abroad.[20] He then joined the National Revolutionary Army to defeat the warlords in order to reunite the nation. But his patriotic dream was bluntly crushed when Chiang Kai-shek began to purge and expel his former communist allies in April 1927. He left the army and not long after began to serve as magistrate in three different counties, including his hometown, Jiujiang. Being young, educated, aspiring, and idealistic, he resolved to seize the opportunity to bring about social change and improve the lives of the local people. He supported reform, punished the rich and powerful for corruption and tax evasion, curbed nepotism, and penalized bribery. Yet he encountered numerous obstacles and met fierce resistance. To defend the national interest, he stopped the American Standard Oil Company from the unlawful construction project of an oil refinery in Jiujiang. Rather than receiving commendations from the government, he was reprimanded by the minister for foreign affairs and then the governor of Jiangxi province. He felt indignant and 'deeply depressed'.[21] He made up his mind to resign from his post. Having been freed from bureaucratic and political entanglements he no longer had to argue, command, or even talk all the time. He enjoyed the ensuing peace and silence. Soon after, he decided to go abroad to study the political system in England and observe the government in the West, hoping that he would be able to bring about reform and change in China in the future.

Yet, silence, in the case of Chiang Yee, was far more complex than simply being quiet or mute. It became a marker of alienation, uprootedness, displacement, and a new cultural identity. When he arrived in London in June 1933 he faced enormous difficulties in this entirely different environment. First of all, he knew virtually no English, except for a handful of words. If he had just celebrated freedom from endless discussions in political and bureaucratic dealings, he now found himself transformed into a virtual mute, since he could not communicate with English speakers in this foreign country. The linguistic inadequacy enhanced his sense of alienation, especially at a time when the Chinese were generally perceived to be inferior and inscrutable in popular culture in the West. Luo Changhai, his former schoolmate from Jiujiang, was the only acquaintance he had in London, yet Luo left for China a month later. Besides, he did not have much financial backing. When serving as a county magistrate in China he had bodyguards and servants, but now he had to manage entirely on his own. The Chinese phrase 'A dumb person tastes the bitter herb—suffering its bitterness in silence' was precisely Chiang's predicament. Underneath his silence were enormous emotional woes resulting from geographical displacement, linguistic impediment, and cultural estrangement. *Ya*, which had been used to denote silence, simultaneously stood for mute or dumb, with a multitude of pain and suffering underneath and unvoiced.

20. Da Zheng, *Chiang Yee: The Silent Traveller from the East – a Cultural Biography* (New Brunswick, NJ: Rutgers University Press, 2010), 23.
21. Zheng, *Chiang Yee*, 45.

Despite these overwhelming challenges and difficulties, Chiang moved on at full throttle. He tried extremely hard to learn English and improve his English writing skills.[22] He became acquainted with new friends, both Chinese and English, and launched his career as a painter and writer. With the help of Innes Jackson (later known as Innes Herdan), a student of his Chinese class at the School of Oriental Studies, he published *The Chinese Eye*, *The Silent Traveller in Lakeland*, *Chinese Calligraphy*, and *The Silent Traveller in London*, as well as some children's books by 1939. Many of these publications won high praise from critics and scholars. He grew fond of London.

While London provided him with a relatively peaceful environment for his creative activities, he was never able to stop fretting over the war situation in China, and in particular the safety of his family in Jiujiang. On 7 July 1937, the war between China and Japan broke out after the incident at Marco Polo Bridge. Chiang's hometown Jiujiang was bombarded in July 1937 and fell on 25 July 1938.

The unsettling situation in China, the loss of his beloved brother, the bombing of his hometown by the Japanese and its fall a year later, and the safety of his wife and children were things he could only bemoan to his friend Innes Jackson privately: 'There were so many miserable things happening to me nowadays, but I got nobody to talk about.'[23] For many months, he received no letters from his family. He was so worried that, as he told Jackson, he 'cried the whole day': 'I did not know what I felt. Simply I could not go living any more or even in one minute.'[24] When the news about his brother's death reached him, he was devastated. His brother had been his mentor and adamant supporter: 'The grief inside me, like a knife cutting little by little, was utterly indescribable and for many days I felt it unbearable to go on living.'[25] England, which had sheltered him, allowing him to focus on his literary and artistic pursuits, turned out to be no safe haven either. In September 1939, war was declared, and a year later, during the Blitz, Chiang's own residence in Hampstead was bombed, and nearly all his belongings were lost.

It is worth noting Chiang's artistic and poetic works related to Buddhism, especially his paintings of Budai. He held a deep interest in Buddhism all his life. Under the influence of his grandmother, he often went to Buddhist temples in his childhood. After his father's death, Chiang studied painting with Sun Moqian, a locally known artist famous for his Buddhist paintings, and in his lifetime Chiang completed a considerable number of Buddhist paintings.[26] *Calligraphy and Paintings by*

22. See Zheng, *Chiang Yee*, 53, 65.
23. From a letter from Chiang Yee to Innes Jackson, 26 July 1937, quoted in Zheng, *Chiang Yee*, 77.
24. Chiang Yee to Innes Jackson, 23 August 1937, quoted in Zheng, *Chiang Yee*, 77.
25. Zheng, *Chiang Yee*, 86.
26. One of the most notable paintings was made when Chiang Yee was the magistrate of Wuhu in Anhui province. One night, some troops led by a battalion attempted to attack the magistrate building and seize the tax money stored in Chiang's office. After sending dispatches to the provincial office for support, Chiang went to the main room, sat down at the table, and started painting *Bodhidharma Gazing at the Wall in Meditation*. Bodhidharma is the first patriarch of Zen Buddhism, and meditation is essential in Zen Buddhism and a pivotal step on the way to enlightenment. See Zheng, *Chiang Yee*, 33–34.

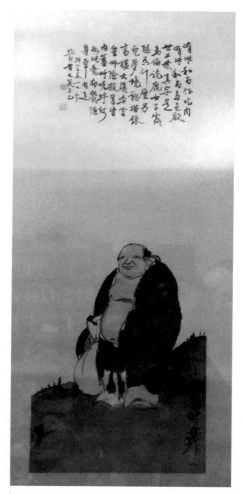

Figure 5.2: *Budai Monk*, painting, ca. 1934. With permission of San Edwards.

Chiang Yee, a collection of his artworks produced around 1970, includes as many as six Buddhist paintings.[27]

What needs to be emphasized here is the subject of Budai, whom he portrayed over the four decades of his period overseas.[28] In fact, he completed *The Budai*

27. Chiang Yee, *Calligraphy and Paintings by Chiang Yee* (n.p., ca. 1972).
28. Chiang Yee also wrote a poem in which he claims that there are three '*xingzhe*' 行者 in the world: Sun Wukong as Sun Xingzhe 孫行者 in *Journey to the West*, Wu Song as Wu Xingzhe 武行者 in *The Water Margin*, and he himself as Yaxingzhe. He is rather self-deprecating here as he confesses that he can neither 'subjugate a tiger' like Wu Song nor 'display any superpower' like Sun Wukong. See Zheng, 'The Traveling of Art and the Art of Traveling'. See also Luo Kanglie, '*Zatan Yaxingzhe qiren qihua*' 雜談啞行者其人其畫 [Some thoughts on the Silent Traveller and his paintings], *Mingbao Monthly* 77 (1972): 64.

Monk, the first such painting he ever did overseas, in the autumn of 1934. In that painting, Budai, with his signature cloth bag in his right hand, stands against the background of a mountain slope, possibly pausing for a rest from his travel and observing the surroundings. He fixes his gaze before him. His youthful face appears content and contemplative. Budai, also known as the 'cloth-bag monk', is a legendary character in Chinese popular culture dating back to the tenth century. He was said to be short and scantily clad, with a protruding belly, carrying a cloth-bag on his shoulder and holding a bowl in hand. He travelled from place to place, begging for alms. Only after his death did people come to realize that Budai was an incarnation of Maitreya, a most-respected figure among the Buddhist pantheon in many Asian countries. Since Maitreya is the Buddha of the Future, symbolising enlightenment and blissful salvation in Chinese Buddhism, Budai has become a popular subject of Chinese painting. He always carries a cloth bag and wears a disarmingly radiant smile on his face, seemingly constantly on the move.[29] Without any material possessions, he is content with life and enjoys ultimate freedom. He is an embodiment of wisdom, auspiciousness, and strength. Being displaced from Heaven, he travels incessantly, and it is in his wanderings that he enlightens the world. Apparently, Budai in Chiang's paintings was a self-reference to his new identity of Yaxingzhe, in both of its meanings, that is, as both a traveller and monk. In this sense, it was a self-portrait of the Silent Traveller.

What should be underscored here is the Buddhist principle of *ren* 忍, as embodied in Budai, who is famous for his tolerance and magnanimity. A rhyming couplet hanging in a temple in Fujian province runs, 'Greeting people with a smile, he eliminates animosity everywhere; / With a belly so enormous, he can hold the entire universe.'[30] Similarly, another couplet in Taiwan is as follows: 'The tolerance of the huge belly resolves endless issues in humanity; / The cheerfulness of the heart dissipates all the worries in the world.'[31] Chiang's *The Budai Monk* (1934) includes a long inscription condemning hypocrisy and calling for spiritual freedom. It ends, 'Oh, my, how nice it would be to become such a bald monk / Holding a cloth-bag and feeling content all the time.'[32] The very fact that Budai was Chiang's constant painting subject during his period overseas reflects the continuous strain of the difficult challenges that he had to tackle. To name just a few, he missed his wife and four children, whom, except for his two sons, he did not see until forty-two years later during his first return visit to China; his Chinese-language teaching appointment at the School of Oriental Studies was cancelled due to his regional Jiangxi accent, though he was certainly more than qualified; and he felt extremely insecure and sensitive as a published writer because of his inadequate English-language

29. See Zheng, 'The Traveling of Art and the Art of Traveling', 170–78.
30. See Weiguo Luo, *Huashuo Mile* 話說彌勒 [On Maitreya] (Beijing: Zhongguo wenlian chubanshe, 1994), 123.
31. Luo, *Huashuo Mile*, 124.
32. Chiang Yee, *The Budai Monk* (1934). This painting, which is from the author's collection, is in photographic reproduction, date unknown.

skills, since he had relied on help from Innes Jackson. While he won recognition and praise in public, those honours and accolades were secretly accompanied by loneliness, stress, discomfort, anxiety, and homesickness, which could only be temporarily and partially lessened by a stance of forbearance. That was why on his painting *The Budai Monk* (1972) Chiang inscribed the following poem: 'Budai, Budai, / With neither worries nor anxiety, / Enjoys unrestrained freedom, / Being at ease in the universe.'[33] At the end of the inscription is his signature: 'Jiujiang Silent Traveller Chiang Yee.'[34] He had cultivated a new habit: whenever he encountered something unhappy in life, he would write the character *ren* 忍 on a piece of paper and then post it on the wall as a reminder of the need for restraint from anger, disappointment, despair, and distress. Chiang had become a master in that respect for he always put on a carefree smile and cheerful image in public; nevertheless, the large number of posted sheets containing the character *ren* in his apartment testified to his self-discipline and tenacity as well as the unfathomable pain and suffering he had endured.

It was not by accident that Chiang ended his memoir with a famous classical Chinese poem by Li Yu (937–978), the ruler of the Southern Tang state. After being captured by the invading Song dynasty armies, Li was thrown from his privileged life and beautiful palace into solitary confinement and eventually poisoned to death by the Song emperor. In the poem, Li writes about his deep sadness as an exile in a foreign land away from homeland and countrymen. The poet notably underscores silence and forbearance:

> In silence I go to the Western Chamber;
> Above hangs the sickle moon;
> In the deep, lonely court of paulownia trees
> Is gaoled the chilly autumn.
> Cut it – yet unsevered;
> Order it – yet more tangled:
> Such is the parting sorrow,
> That dwells in my heart,
> Too subtle a feeling to tell.[35]

Writing as the Construction of Home

Writing and painting served as an essential means for Chiang Yee to divert his attention, to alleviate the pain in his heart, and to construct a shelter. He immersed himself in a strenuous workload. 'While I work, I keep myself aloof from most worries,' he stated. 'Perhaps my work is the only form of happiness I have.'[36]

33. Chiang Yee, *The Budai Monk* (1972). A photograph of the painting was in Chien-fei Chiang's private collection.
34. Chiang, *The Budai Monk* (1972).
35. Chiang, *A Chinese Childhood*, 304.
36. Zheng, *Chiang Yee*, 86.

And that was how his first Silent Traveller book—as well as *A Chinese Childhood* and others—was produced. In the summer of 1936, as anxiety and worries about his family in China were continually gnawing at his heart, Chiang followed his friend's suggestion and took a two-week trip to the Lake District. He visited Derwentwater, Buttermere, Crummockwater, Windermere, and Grasmere, retracing the footsteps of the romantic poets. In the surroundings of water, trees, mountains, birds, and clouds, he enjoyed tranquillity and peace, which were both energising and healing. The journey, in his own words, was 'the most agreeable period of all my English experience'.[37]

Chiang kept a journal and made sketches of local scenes on absorbent paper measuring 7″ x 9″. After returning to London, he submitted them to the manager of Country Life, a London publisher, for publication. The publisher considered the proposal but swiftly rejected it: the journal was too skimpy to make a marketable volume, and the sketches, in Chinese water-ink style, were too foreign for Western readers to appreciate. After six months, the manager of Country Life came back, reconsidered the manuscript, and agreed to publish it under the title *The Silent Traveller: A Chinese Artist in Lakeland*. To everyone's surprise, this slim volume, with only sixty-seven pages, sold out in a month. The manager of the publishing company decided to issue a reprint. Since then, nine editions have been published. The book became the first of Chiang's Silent Traveller series, which eventually numbered thirteen in total. He became, as his friend Shih-I Hsiung proclaimed, 'a Chinese H. V. Morton', referencing a popular travel writer at the time.[38]

Though the book has received a lot of critical attention, hardly anyone has paid attention to its concluding paragraph: 'The next day I returned to London at five o'clock in the afternoon. I hardly can describe my feelings during that time before and after I left Lakeland. The past days *had been a dream and not a dream*. I would like to *be dreaming forever!*' (emphasis mine).[39] By calling his fortnight stay in the Lake District both 'a dream and not a dream' Chiang stresses the idyllic and romantic elements he has observed in Wordsworth's hometown. But it is immediately followed by the assertion that he would 'like to be dreaming forever!' Does the author mean to return to this wonderland for another excursion? Or does he simply mean to resort to dreaming as a new form of travel in the future, as suggested by the phrase 'imaginary revisitings' in his own introduction to the book?[40] And, if the latter, what is the relationship between this new form of travel and his recent trip to the Lake District?

37. Zheng, *Chiang Yee*, 71.
38. Shih-I Hsiung, 'Foreword', in Lisa Lu, *The Romance of the Jade Bracelet, and Other Chinese Operas* (San Francisco, CA: Chinese Materials Center, 1980), 5–8. According to Hsiung, Chiang Yee's second book was 'a miscellaneous collection of illustrations, sketches, and anecdotes' about London, and Chiang intended to entitle it *The London Chop-Suey*. Following advice from Hsiung, Chiang switched it to *The Silent Traveller in London*, which led to the subsequent other Silent Traveller titles, covering his travel experiences in Europe, America, Asia, and Australia.
39. Chiang Yee, *The Silent Traveller: A Chinese Artist in Lakeland* (London: Country Life, 1937), 63.
40. Chiang, *Silent Traveller: A Chinese Artist in Lakeland*, 6.

As if intending to confound his reader further, Chiang narrates his subsequent winter trip to the Lake District in 'A Dream of the English Lakeland', a short essay published in the *Journal of the Fell and Rock Climbing Club* in 1938. It happens on a cold day, Chiang tells the reader, when he wanders in the valley of Wasdale Head, along the road to Wastwater, and on the summit of Scafell Pike from Sty Head Pass. He enjoys viewing the breathtaking 'Mighty Nature' under snow, recites a poem, and remembers Mount Lu in his native land. Suddenly, however, 'terrified by noises of aeroplanes and bursting bombs', he is awakened to find that the nightmarish horror and the bucolic Lake District scene were only a dream.[41] Although he is relieved to be awakened from the horrible scene, his mind is by no means free from the haunting nightmare, and reality is no peaceful haven either. He has to refrain from thinking of his family members in China. It appears that the best cure is to visit the Lake District again, but, as Chiang tells the reader, he does not dare to even try because 'the contrast' between the peaceful English Lakeland and the war-torn mountains and rivers in his native country would be unbearable. He cannot enjoy peace, even in this supposedly most peaceful environment. Silence becomes the only solution. Chiang concludes the essay with a question and a resolution: 'What more can I say about it now? I had better keep silent!'[42]

China occupied a sacred place in Chiang's heart. Writing and painting became a unique way for him to express his emotional longing for his motherland far away and to construct a new home.[43] In his presentation of personal exilic experience in England, there is a salient feature of binary elements and viewpoints, a manifestation of his nostalgic longing and personal sorrow that he attempted to harness and resolve.[44] Those binary elements—such as 'silence and presentation' or 'dreaming and reality'—underlined the effort and predicament he faced in searching for peace and settlement in this new cultural environment. Mount Lu, for example, is frequently mentioned in his poems and writings:

> After my departure, I have revisited Lu Mountain in my dreams,
> As we used to gather in the south of the city.
> There is one thing worthy of boasting in the year that has passed:
> Admiring mountains overseas can never be overindulging.[45]

41. Chiang Yee, 'A Dream of the English Lakeland', *Journal of the Fell and Rock Climbing Club* 12, no. 32 (1938), 20–23.
42. Chiang, 'A Dream of the English Lakeland', 24.
43. Several critics have noted this feature. For example, Theodor Adorno states that 'for a man who no longer has a homeland, writing becomes a place to live'. Rosemary George argues that 'the search for the location in which the self is at home' is one of the primary projects of twentieth-century fiction in English. For that reason, she reads 'all the fiction in terms of homesickness'. See Theodor Adorno, *Minima Moralia*, trans. E. F. N. Jephcott (London: NLB, 1974), 87; Rosemary George, *The Politics of Home* (Berkeley: University of California Press, 1999), 3.
44. See Da Zheng, 'Double Perspective: The Silent Traveller in the Lake District', *Mosaic* 16, no. 1 (2013): 147–78.
45. Chiang Yee, *Jiang Zhongya shi* 蔣仲雅詩 [Poems by Chiang Yee], (n.p., ca. 1935), 21.

Figure 5.3: 'Up the Lu Mountain' from *A Chinese Childhood* (1940). With permission of San Edwards.

To Chiang Yee, mountains overseas became a surrogate for Mount Lu in his homeland. And the act of 'admiring mountains overseas' allowed him to enjoy an imaginary homecoming, and helped to lessen his intense nostalgia for artistic activities and friendship in Jiujiang, even though it could never truly make him feel at home while he was overseas.[46] As he wrote, 'There is nowhere in the world comparable to Jiujiang because Jiujiang is my hometown.'[47] That was why he felt so proud of the following line from a poem he wrote in 1934: 'When spring comes, every dream takes me back to the south of the [Yangtze] River.'[48] He often recited this line and even had it carved into a seal, which he frequently applied to his calligraphic and artistic works.

46. See Zheng, 'The Traveling of Art and the Art of Traveling', 169–90.
47. Da Zheng, *Xixing huaji* 西行畫記 [Chiang Yee: A biography] (Beijing: Commercial Press, 2012), 237.
48. Chiang, *China Revisited*, 105.

Likewise, the poignant feelings registered in the concluding poem 'On Leaving Lakeland' in his Lakeland book are worth noting. The poem, a six-line regular verse in Chinese with its English translation provided in the text, seems to bring the journey to a seemingly satisfactory conclusion:

> In my native country, there is the Mountain Lu,
> It rises too beside the P'o-Yang Lake.
> And my home stands upon its shore,
> All night, and day, I see the changing colour of the mountain.
> I leave this Lakeland, and with longing seek to return,
> *With some sadness thoughts are born of my distant home!*[49] [emphasis mine]

The three couplets of the poem mark the three stages in a progressive unfolding of Chiang's emotions. The first couplet stresses the comparably beautiful setting in Chiang's own hometown in China. The word 'too' connects Mount Lu and Poyang Lake with the Lake District in England. Chiang travels back in time and space in the second couplet, recalling the pleasure he used to enjoy in his home country. In the last couplet, he vows to return, with a sudden surge of homesickness and sadness.

The poem contains the 'chief feeling' Chiang has carried away from the Lake District after the trip.[50] He mentions that he has not found any surprises in nature during the journey in the Lake District. After all, natural elements, such as rocks, trees, streams, and mountains, either in England or in China, appear to him similar, despite some superficial variations. In fact, on numerous occasions during the journey, he feels as though he has been carried back to his native country. The visit to the English lakes only 'whetted' his appetite for a return to his native land.

A comparison between this poem and one by Tao Yuanming (365–427), a great Jin dynasty poet in China, may help illustrate how Chiang invoked the ancient poet to soothe his yearning for home-returning in entirely different cultural and historical conditions.

> I built my hut beside a traveled road
> Yet hear no noise of passing carts and horses.
> You would like to know how it is done?
> With the mind detached, one's place becomes remote.
> Picking chrysanthemums by the eastern hedge
> *I catch sight of the distant southern hills*:
> The mountain air is lovely as the sun sets
> And flocks of flying birds return together.
> In these things is a fundamental truth
> I would like to tell, but lack the words.[51] [emphasis mine]

49. Chiang, *Silent Traveller: A Chinese Artist in Lakeland*, 64, 67.
50. Chiang, *Silent Traveller: A Chinese Artist in Lakeland*, 64.
51. James R. Hightower, 'T'ao Ch'ien's "Drinking Wine" Poems', in *Wen-lin: Studies in the Chinese Humanities*, ed. Tse-tsung Chou (Madison: University of Wisconsin Press, 1968), 12.

Chiang Yee admired Tao Yuanming, and on several occasions he highlighted his affinity with the ancient Chinese poet in terms of life experience and personality.[52] Tao was born near the southwest corner of Mount Lu, approximately fifteen miles from Chiang Yee's birthplace. Tao also served as the magistrate of various districts in Jiangxi. A man with a strong inclination for freedom and dignity, Tao chose to retire and became a recluse rather than being forced to endure the life of an official and compromise his principles. He built a hut in a remote area, enjoying peace away from the noise of the human world. As indicated in the poem, simple activities, such as 'picking chrysanthemums by the eastern hedge' and 'viewing the distant southern hills', became a means for him to search for the 'fundamental truth' in daily activities and the natural objects around him. He has been known as a hermit poet of nature.[53]

Both Tao and Chiang write about mountain viewing in their poems here. Interestingly, both use the same phrase, *youran* 悠然. However, their relationships to the mountains and the meaning of mountain viewing differ strikingly from each other. In the above translation of Tao's poem, the line *youran jian nanshan* 悠然見南山 has been translated as 'I catch sight of the distant southern hills', with the phrase *youran* completely left out. The meaning of the phrase, 'leisurely and pleasantly', is implied in the context of the couplet.[54] The poet is able to 'catch sight of the distant southern hills', a pleasurable view and an act of admiration that enables him to stay detached so that he can remain as a recluse with his moral integrity untainted by the world. In Chiang's poem, the line *youran sheng yuanyi* 悠然生遠憶 is rendered as 'With some sadness thoughts are born of my distant home'. The English rendition has left out the other possible meanings of the phrase *youran*, that is, leisure, pleasure, tastefulness, as well as being faraway. To Chiang, the journey of returning home itself, rather than reaching the journey's ultimate destination, carries primary importance. He could not possibly actualise a journey back to Mount Lu; and even if returning home were feasible, he would only confront a war-torn hometown, laid waste by Japanese invaders. As an exilic Chinese in the West, he could undertake a journey back to Mount Lu only in his imagination as being a perpetual dreamer of home(land) was the only option available. The medium—either language or poetry—becomes the means for him to revive, re-present, and re-invent a remote past that he can identify with. The multiple meanings denoted by the phrase *youran*—'with some sadness', 'leisurely', and 'remotely'—are in fact all applicable to Chiang's poem, orchestrating a dream-like undertone of nostalgia, creating a reverberating and even haunting effect in the reader's mind.

Finally, I would like to bring up *Chinese Children at Play*, a picture book by the young artist Yui Shufang, published in 1939, right before *A Chinese Childhood*. In

52. See, for example, Chiang, *A Chinese Childhood*, 3–4.
53. Yu-kung Kao, 'The Aesthetics of Regulated Verse', in *The Vitality of the Lyric Voice*, ed. Shuen-fu Lin and Stephen Owen (Princeton, NJ: Princeton University Press, 1986), 348–49, 369–71.
54. Different from this translation by Tse-tsung Chou, Xu Yuanchong renders the phrase as 'carefree' and 'idly'. See http://abbaenglish.blog.sohu.com/281388524.html.

addition to its charming text, the book contains sixteen delightful and vivacious drawings by Yui, illustrating popular games that children play in different seasons in China. At Yui's request, Chiang prepared an introduction to her book. It is in an epistolary form, speaking directly to Chiang's 'Dear Young Friends' in the West. Chiang comments that the drawings in *Chinese Children at Play* take him back to his childhood and remind him of the times when he played these games in China.[55] He reminisces fondly about those wonderful days when he was a child, being taught the importance of filial piety and having his hair styled by his sister and nurse. He explains that the Chinese people love peace and have a long history of civilization, and he hopes that young readers in the West will enjoy looking through the book and even try some of the Chinese games themselves. He seems to have enjoyed reimagining the happy days in the past so much so that when his tone takes a sudden dramatic shift near the end as though he has been jostled from a 'dreamlike' memory of childhood to face a cruel reality:

> I need not remind you that China has been invaded by enemies and is at war. Consequently, our children cannot continue in the peaceful enjoyment of all these games. Many of us have been living miserably for the last three years as refugees from our own country. I must thank you all for the sympathy you have shown. But I would like to end by suggesting that when peace comes to us again, you and I will go to the East and visit some beautiful Chinese city at the time of the Lantern Festival. You can wave lanterns in the shapes of doves and frogs and monkeys if you like.[56]

A Citizen of the World

Edward Said, the renowned literary critic and accomplished musician, uses the musical term 'contrapuntal' to represent the kind of reading and analysis he advocates in *Culture and Imperialism*. He stresses the need to 'move beyond insularity and provincialism and to see several cultures and literatures together, contrapuntally'.[57] To Said, counterpoint in music is a model for a new approach to critical reading, and the essence of 'contrapuntal analysis' is in its comparativity. It allows us to gain a broad perspective and deeper insights in our interpretation and appreciation of the literary text.[58]

Along the same lines, I would like to call attention to the contrapuntal features in Chiang's approach to travel writing. In his efforts to draw comparisons and search for commonalities among all peoples, or in his endeavour to cope with nostalgia and unquenchable pain during his stay overseas, contrasting elements became a prominent feature in his writing: happiness versus sadness, China versus the West, past

55. Chiang Yee, 'A Letter to Readers', in Yui Shufang, *Chinese Children at Play* (London: Methuen, 1939), n.p.
56. Chiang, 'A Letter to Readers', n.p.
57. Edward Said, *Culture and Imperialism* (New York: Vintage, 1993), 43.
58. Said, *Culture and Imperialism*, 43.

versus present, Christianity versus Buddhism, reality versus dream. Those elements complicate, enrich, and deepen Chiang's creative imagination as well as challenge the reader's responses; Chiang manages to weave them together to form the integral fabric of his literary presentation, a harmonious yet colourful narrative, taking the reader with him along the journey, transcending spatial, temporal, cultural, and linguistic boundaries. Hence, I do not agree with Espey, who claims that Chiang's signature feature of 'contrast and surprise' is absent in *A Chinese Childhood*. To me, it is there, as the key feature and motif of the book. At the same time, I also feel that 'The Silent Traveller at Home' could actually be a perfect description of that book. Chiang's Jiujiang home was nowhere to be found, his childhood life existed in his memory only, and he could never be at home again; yet he was able to bring everything back through his writing. He was in exile, yet he was able to feel at home wherever he found himself, enlightening us with his writing and cheering us with his uplifting spirit. As he wrote at the end of *A Chinese Childhood*: 'No matter what sufferings we endure, we shall find our way back to happiness.'[59] The Silent Traveller was, indeed, a citizen of the world.

59. Chiang, *A Chinese Childhood*, 304.

6
Chiang Yee in Wartime

Paul French

> When winter comes how harsh is the long night!
> This winter the night is even longer.
> Again and again I fall into brief dreams:
> Too brief to transport me to my homeland!
>
> —Chiang Yee, September 1939[1]

The Second World War in Europe (1939–1945) saw Chiang Yee's career and reputation grow with the publication of a number of books, additional invitations to speak, frequent appearances in magazines such as *Country Life* and *The Listener*, new commercial commissions, translation work, and participation in a continuing series of gallery exhibitions.[2] However, Chiang's wartime experiences also included seeing his Hampstead lodgings take a direct hit on the first day of the London Blitz and the entire contents of the house, including much of his previous work, collection of Chinese paintings and library, destroyed. Shortly afterwards he was blown unconscious by a falling bomb in Hampstead and after a hasty search relocated to new lodgings in Oxford for the duration of the war.

Throughout the war Chiang worked with both British and Chinese war propaganda entities and with Aid to China organisations, as well as on his own publishing and design commissions. Much of this was a continuation of work that Chiang had begun in the summer of 1937 when he became involved in efforts to promote awareness of the Second Sino-Japanese War to British audiences and, beginning in the autumn of 1939, awareness of the European war to Chinese readers, having become involved with multiple organisations promoting the wartime Sino-British alliance. Chiang was able to write for wartime audiences in both countries, in several instances arranging for translations into Chinese of his observations of the war in Britain to be distributed as part of Britain's war propaganda in China.

This chapter considers the work undertaken by Chiang Yee during the European war years (September 1939–August 1945), both his commercial art and writing, as well as specifically war-related commissions. Also, given the focus of this collection,

1. Chiang Yee, *The Silent Traveller in War Time* (London: Country Life, 1939), 33.
2. Several of Chiang Yee's wartime exhibitions are noted below. For his contributions see also 'Changing China', *The Listener*, 16 April 1942, 491–92.

it looks at Chiang's involvement with various organisations and events that continued, broadened, and varied his British circle of contacts. It is perhaps interesting to note that Chiang's most specifically war-related work, *The Silent Traveller in War Time* (1939), is an early contribution to a genre of what might be termed 'war morale literature': writing and film (and other artforms) showing the peculiarities of Britain at war and invariably accentuating the resilience and fortitude of the British people.

It is my contention that Chiang was able to produce such a work as *The Silent Traveller in War Time* due to the fact that he had, since the start of the Second Sino-Japanese War in the summer of 1937, been deeply aware of the worsening situation in Nationalist China brought starkly home by the death of his elder brother, Chiang Ta-ch'uan. Ideas of 'war morale literature', the fortitude of civilian populations and national unity in the face of war, had been prominent in his thinking. This was especially so after the Japanese occupation of his hometown of Jiujiang in July 1938, which he notes in the dedication of *The Silent Traveller in London*, published later that year, after the Japanese attack on China but prior to the commencement of the European war. When we look back now on the rise of British 'war morale literature' after September 1939 it is important to note that one of the first and most popular examples of this new genre was *The Silent Traveller in War Time*, published just weeks after the start of the war.

In general, we can divide Chiang's war into two phases. First, the period from September 1939 to September 1940, beginning with the outbreak of war between Britain and Germany and the aerial bombing attacks on London (the Blitz) that saw Chiang's home on the Belsize Park/Hampstead border rendered uninhabitable.[3] And, second, from December 1940 to the end of the war in 1945, a period that saw Chiang often absent from London and living in lodgings in Oxford. Despite the difficulties of transportation during the war, Chiang retained his involvement with many key London-based organisations—the British Ministry of Information, the War Artists' Advisory Committee (WAAC), and the London office of the Ministry of Information of the Republic of China. While Chiang largely maintained his London circle of friends, he also developed overlapping and additional contacts and circles in his new home of Oxford.

The Silent Traveller in War Time

In late August 1939 Chiang Yee had just finished his first children's book, *Chin-Pao and the Giant Pandas*.[4] He felt he needed a rest and, despite being aware of the probability of war between Britain and Germany breaking out, he decided to visit Geneva to see the Prado Museum in exile's *Les chefs-d'oeuvre* exhibition, which was

3. At the time, both Hampstead and Belsize Park were in the 'Borough of Hampstead'.
4. Chiang Yee, *Chin-Pao and the Giant Pandas* (London: Country Life, 1939).

about to close. Much of the Prado's collection had been sent to Switzerland during the Spanish Civil War for safekeeping.[5] Travelling by boat-train to Paris and then onwards via French railways, Chiang attended the exhibition, met an old friend, and had dinner at a Chinese restaurant. It was over dinner that he heard, from a waiter, the news that Germany had invaded Poland. Britons were encouraged to return home from the continent immediately. The next day Chiang hastily revisited the exhibition where he was disappointed by the works of Goya but was thrilled by the El Grecos.[6] Four days after having left, Chiang was back home in Parkhill Road, NW3, preparing to leave for his job at the Wellcome Historical Medicine Museum on Euston Road. His friend, the playwright Shih-I Hsiung, who lived nearby on Upper Park Road, asked if Chiang might be able to pop to Oxford Street to buy some gym shoes for Hsiung's three young children.[7] Chiang did and found himself in a department store full of mothers with their about-to-be-evacuated children all frantically shopping. He purchased the shoes and returned home to Belsize Park to drop them off. The next morning, 2 September, he read in the newspapers that war was imminent. The following day, with Shih-I Hsiung, Chiang heard the announcement that war had been declared on the radio.

Almost immediately Chiang must have contacted his publisher, Country Life, with the idea of a new book—*The Silent Traveller in War Time*. Country Life was keen but thought it should be published as quickly as possible. Chiang must have begun sketching and working on the book immediately as it was published before the year's end. The book followed the established 'Silent Traveller' format, and provides a useful record of his own activities and emotions as a Chinese man in London during the conflict and occasionally a record of what those in his circle were doing at the time. As a piece of propaganda—a Chinese view of London in the first months of the war—the book was considered unique. Chiang had begun some occasional translation tasks for the newly reformed British Ministry of Information at the start of the war and this may have encouraged the ministry to suggest that he swiftly produce a Chinese translation of the book.[8] It was renamed *Sketches About London in War Time*.[9] The plan was for the translated book to be distributed by the Far Eastern Bureau of the Ministry of Information, primarily in Hong Kong and in the International Settlement of Shanghai.[10]

5. The exhibition is often referred to as the 'Prado-loan' exhibition. In the summer of 1939 a large consignment of paintings from the Prado in Madrid was sent to Switzerland for their safety during the Spanish Civil War and exhibited in Geneva.
6. Chiang, *Silent Traveller in War Time*, 11.
7. Chiang, *Silent Traveller in War Time*, 13.
8. The Ministry of Information (MOI) had originally been formed in 1918 by pulling together disparate British organisations towards the end of the First World War. It was reformed on 4 September 1939, initially headed by Lord Macmillan (who had served as Assistant Director of Intelligence in the first incarnation of the MOI) and was headquartered in the University of London's Senate House building.
9. Chiang Yee, *Lundun zhanshi xiaoji* 倫敦戰時小記 [Sketches about London in wartime] (Hong Kong: Far Eastern Bureau, British Ministry of Information, 1940).
10. At least so suggests Horace Holder in 'Did You Hear That?', *The Listener*, 16 April 1942, 491. Holder claims a translation was made by the Ministry of Information in 1941 (at that time run by Brendan Bracken). Holder

The Silent Traveller in War Time is one of the shortest books in the Silent Traveller series. The illustration-to-word ratio is among the highest, and the font size a point or two larger than most of the other books in the series, though it follows the same design template as previous Silent Traveller volumes. Obviously, Chiang was working to a very short deadline. Assuming he began the book on or around 3 September 1939 (and allowing for the time required for editing, proofing, page layout, and typesetting, as well as printing and binding) Chiang could only have had around six to eight weeks at most to complete the work.[11] There are slightly fewer colour plates than in his previous work, *The Silent Traveller in London*, and more sketches, which presumably allowed him to work faster. Still, it was a well-produced hardback book with paper jacket and colour plates. Crucially, being published in late 1939, Chiang and his publishers just missed the introduction of paper rationing introduced in February 1940 and which saw later editions and wartime reprints of Chiang's previous works bear the 'Book Production War Economy Standard' stamp to indicate restrictions on the size and quality of paper used.[12]

Sketches about London in Wartime

The Silent Traveller in War Time is dedicated to Chiang's older brother, Ta-ch'uan. Framing the volume as a series of impressions aimed at providing his brother with a view of Britain in the early days of the war, the dedication and introductory letter to Ta-ch'uan are given additional poignancy for readers when we learn that Chiang's brother had died the previous year in Jiujiang. The brothers had communicated by letter over the years since Chiang had moved to London. Current affairs were regularly discussed—the Italian invasion of Abyssinia, the Spanish Civil War, and of course Japan's attack on China in the summer of 1937 and the resultant Japanese occupation of Jiujiang in 1938.[13] In effect, despite his brother's death, Chiang is continuing their conversation by recording his experiences in London in late 1939.

At the start of the war Chiang was working part-time at the Wellcome Historical Medical Museum (now part of the Wellcome Trust). Chiang had started working in the Museum's Japanese and Chinese section after May 1938 following a reduction in the hours he was employed in his post at the School of Oriental Studies (SOS). Initially he had begun working only on Fridays at the Wellcome and then, as SOS cut his hours further, he moved to three days a week. At the same time, he was working on another Silent Traveller book (about the Yorkshire Dales), a memoir of

was an English Quaker living in Suining, Sichuan, and with the Friends Service Council. Holder often contributed notes on aspects of Chinese life and culture to *The Listener* and was appreciative of Chiang's work. I have been unable to locate a Chinese-language edition of *The Silent Traveller in War Time*.
11. The latest actual date Chiang mentions in the book is 30 September 1939 (on page 63) when he notes the arrival of three letters from relatives in China.
12. Despite there being no restrictions at this time, it does appear that perhaps as few as eight hundred copies were printed, though the reasoning behind such a reduced print run is not entirely clear.
13. Chiang, *Silent Traveller in War Time*, 1.

his childhood, and a new idea for the first in a potential series of children's books on pandas, the most potent symbol of China in Britain at the time.[14]

Clearly Chiang was working flat out. One factor that has made *The Silent Traveller in War Time* enduringly interesting is that it is an early example of a book containing images that would subsequently become so evocative, and oft-repeated, of Britain's experience in the Second World War. Evacuation; the Blackout; gas masks; the symbolism of Winston Churchill and his trademark cigars; the patriotic songs of Gracie Fields; air-raid sirens; piles of lost gas mask boxes labelled with no more helpful identification than 'Mum' or 'Dad'; the defiant jokes and bonhomie of the pubs of Hampstead and Belsize Park; the relocation of various animals, including the pandas Ming and Tang (Sung would die in 1939), from London Zoo to Whipsnade; barrage balloons; and what later became known as the 'Blitz spirit'—a determination by the civilian population to resist attack.[15] It also contains some images that are very specific to Chiang Yee. The day after the announcement of war Chiang found himself the only remaining tenant in his apartment building and immediately started to draw comparisons between the early British political leaders in the war and various Chinese gods.

Chiang writes aesthetically, with an artist's eye, as he does in all the Silent Traveller books, conveying the beauty of Hampstead and Hampstead Heath during the Blackout, the silver, fish-like barrage balloons in Hyde Park, and the public enjoying the swans in St. James's Park; an illustration of a man sleeping beneath a tree in a gas mask, an indication of English eccentricity, was much reproduced in the British newspapers. Sad moments too are recorded, especially the evacuation of London's children to the countryside, made personal to Chiang by accompanying Shih-I Hsiung and Dymia Hsiung's three children to their assembly point as they left for evacuation to St. Albans in Hertfordshire. He then went to Paddington Station to see other groups of children being evacuated.

The book also includes many of Chiang's immediate circle of acquaintances at the start of the war—Shih-I Hsiung and his wife Dymia; Graham Shepherd (1907–1943), the illustrator and cartoonist for the *Illustrated London News*, with whom he discussed gas-mask designs and the problems of carting them around everywhere; J. W. Michieli, the photographer and water-colourist employed at the Wellcome Historical Medicine Museum, with whom Chiang was close and with whom he spent time sketching the animals at London Zoo; his friend and sometime collaborator Innes Herdan (née Jackson) and her Czech husband Gustav; and

14. *A Chinese Childhood*, which would eventually be published by Methuen in 1940. Five pandas arrived in Britain on Christmas Eve 1938, brought by an American, Floyd Tangier-Smith. They included a senior panda that Tangier-Smith named Grandma, three other adults he called Happy, Dopey, and Grumpy (in a nod to the 1937 film *Snow White and the Seven Dwarfs*), and a baby cub. Grandma died of pneumonia a couple of weeks later. Happy was sold to a German animal dealer. Grumpy and Dopey were sold to the London Zoo and renamed Tang and Sung, while the cub, also at London Zoo, was named Ming. Naturally, as a cub, it was to be Ming who caught the public, and Chiang Yee's, attention.
15. Naturally, Chiang Yee, while noting air raid sirens, blackout regulations, and barrage balloons, does not mention bombing directly as the Blitz did not begin until autumn 1940.

the publisher Noel Carrington (1895–1989), with whom Chiang would undertake moonlit walks across Hampstead Heath in the early months of the conflict and who published his children's books during the war.[16]

Chiang's war in *The Silent Traveller in War Time* provides a rather mellow, slightly humorous, and affectionate look at Britain in late 1939. The war appears more as an annoying imposition, a bothersome irritation, than a national tragedy. Of course, Chiang is writing in the first two months of the war, the very start of the 'Phoney War' (the period between September 1939 to May 1940). However, as the barrage balloons are inflated, the sandbags filled, the gas masks issued, and the children of London evacuated there is a looming sense of the much more serious conflict to come. By referring back to events in China, and his own family's sufferings in Jiujiang, Chiang is well aware that things will get worse and that this mellow atmosphere of resignation (the Phoney War being obviously a term used only later, and in hindsight) is merely an interregnum. The end of that interregnum would affect Chiang Yee in a most direct way.

The Blitz and Relocation

On 7 September 1940 Germany launched 'Black Saturday', the first serious Blitz attack on London by the Luftwaffe, ending the Phoney War. Chiang presumably would have drawn parallels with 14 August 1937 and the Bloody Saturday bombings of Shanghai that caused such civilian loss of life and devastation in the Foreign Concessions. The raids were also redolent of those on Chongqing by the Japanese bombers, which Chiang had seen reported. His Parkhill Road lodging house took a hit on 9 September, the first day the Blitz hit Hampstead, destroying the roof and upper floors of the building and causing destruction to the ground and first floors.[17]

16. Graham Shepherd (1907–1943) was the son of Ernest Shepherd, the illustrator of both *Winnie-the-Pooh* and *The Wind in the Willows* (the latter book Chiang admired greatly). Graham was friends with John Betjeman, Anthony Blunt, and Osbert Lancaster. He served in the Royal Navy and was killed in action in September 1943 in the mid-Atlantic. His daughter Mary, who Chiang also knew slightly, became known for her illustrations for the P. L. Travers Mary Poppins books. Noel Carrington was the editor, publisher, and originator of Puffin Books and the Bantam Picture Books, a small format series of lithographed books for children. In the 1920s Carrington had established the Indian office of Oxford University Press. Brother of the artist Dora Carrington, Noel lived with his wife and three children in Hampstead. Carrington published several Chiang Yee children's books under his Puffin imprint during the war, including *Lo Cheng: The Boy Who Wouldn't Keep Still* (London: Puffin Books, 1942) and *The Story of Ming* (London: Puffin Books, 1944). Both books are interesting in terms of Chiang's artistic process, in that to reduce overheads and remove the need for camera work Chiang (as with all wartime illustrators for Puffin) was required to draw direct to the plate, which often resulted in a varied texture that was often considered an improvement on camera-ready artwork.
17. Consultation of the London County Council bomb-damage maps indicates significant damage to both Parkhill Road and Upper Park Road at the start of the Blitz, with Chiang Yee's address listed as 'Total Destruction' and others close by as 'Damaged Beyond Repair', 'Seriously Damaged – Doubtful if Repairable', and 'Seriously Damaged – Repairable at Cost'. In comparison to other areas of London, Hampstead and Belsize Park were comparatively lightly bombed, making Chiang's direct hit particularly unlucky. Laurence Ward, *The London County Council Bomb Damage Maps, 1939–1945* (London: Thames and Hudson, 2015), 63.

Chiang lived on the first floor. The Fire Brigade, Air Raid Wardens, and neighbours searched the rubble assuming Chiang was dead. Fortunately, he was in Oxford that night giving a lecture to the Chinese Society on Chinese art. He did not find out about the bomb damage till the following morning, returned to London, and discovered that his lodgings were destroyed along with most of his possessions. The building was in danger of collapse. Books, paintings, sketchbooks, and letters were all destroyed. Chiang's cleaning lady lived nearby and offered him her basement as a temporary home. He found a restaurant for dinner. Returning to his temporary digs an air raid began and Chiang was blown off his feet by a bomb and knocked unconscious for a time. Eventually he awoke, groggy and wet on the pavement, and found his way to the cleaning lady's house where she provided hot tea. Chiang then stayed for several days in the Hampstead basement flat of his friend, the Chinese foreign correspondent Hsiao Ch'ien, where a few other temporarily homeless Chinese in London were also staying.[18] Eventually he decided to return to Oxford to find lodgings away from London and start all over again. Chiang was settled in several ground floor rooms with the Keene family at 28 Southmoor Road by December 1940.

Though now in Oxford, Chiang kept up his London circle of acquaintances. Wartime disruption made the train services between Oxford and London erratic and often long and much delayed, but Chiang continued to regularly visit the capital and he maintained contact with many of his pre-war and early-war friends. In London Chiang met regularly with Noel Carrington of Puffin Books at his Hampstead home. Similarly so with Alan White, the director of Methuen who had published Chiang's oft-reprinted study of Chinese art before the war as well as, later in 1942, his Burma Road novel, and had become a friend.[19] Chiang also developed contacts in Oxford. The Hsiung family moved to Oxford in 1943 which helped.[20] Hsiao Ch'ien and the literary translator Yeh Chun-chan both visited regularly, as did the deputy keeper of the British Museum's Oriental Department, Basil Gray (who had been hired at the British Museum by another acquaintance of Chiang's, Laurence Binyon), Chiang's editor and the Business Manager at Methuen, Giles Sebastian, and the rather eccentric Chiang Yee fan Sir William Milner (1893–1960).[21] Chiang

18. Exact address unknown, though close by. Hsiao Ch'ien had the basement flat of a house. There appeared to be nobody else in residence. Hsiao was told that the rest of the rooms throughout the building had been rented by a group of Soviet Russians who had not yet arrived. After the Nazi attack on the USSR in June 1941 the delegation (seemingly armaments-factory specialists) arrived and occupied the rooms. Hsiao Ch'ien, *Traveller Without a Map* (London: Hutchinson, 1990), 82–83.
19. Chiang Yee, *The Chinese Eye: An Interpretation of Chinese Painting* (London: Methuen, 1935).
20. The Hsiungs rented Iffley Turn House in Oxford. The house was sold to Graham Greene in October 1948, who gave it to his estranged wife, Vivien (who renamed it Grove House).
21. Milner, Eighth Baronet of Nun Appleton near York, was a fan of Chiang's and invited him to his stately home, Parcevall Hall, where he had restored the house and gardens. He encouraged Chiang to write his book *The Silent Traveller in the Yorkshire Dales*. According to Da Zheng, Chiang gave Milner a copy of *Chin-Pao and the Giant Pandas* to send to Queen Mary (Milner's godmother) as a gift for Princesses Elizabeth and Margaret. The book was apparently 'graciously accepted'. See Da Zheng, *Chiang Yee: The Silent Traveller from the East – a Cultural Biography* (New Brunswick, NJ: Rutgers University Press, 2010), 113.

made a few new acquaintances in Oxford, notably Tsui Chi, a lecturer in Chinese history and literature at the university who had arrived in Britain in 1937 and had also lived in Hampstead for a time before relocating to Oxford.[22]

Chiang Yee's War Effort

Chiang donated work to a Red Cross benefit exhibition held at the China Institute on Gordon Square in December 1939 and January 1940.[23] This exhibition of Chinese contemporary art included work by perhaps the three best known contemporary Chinese artists in Europe at the time, Liu Haisu, Xu Beihong, and Qi Baishi.[24] Chiang also donated works and gave lectures at the United Aid to China Fund's exhibitions in London as well as at the Municipal College in Bournemouth (where Innes Jackson was then living), and which was officially opened by Laurence Binyon.[25] Chiang's was also the only Chinese work to appear in the two Allied Artists' Exhibitions in 1941 at The Royal Society of British Artists (then on London's Suffolk Street, just off Pall Mall East), and in the Scottish National Gallery in Edinburgh. The exhibitions featured a range of art, mostly from Nazi-occupied European countries. United Aid to China also organised a children's-story-writing competition for stories 'with a Chinese background', judged by Chiang, Hsiao Ch'ien, and Shih-I Hsiung.

Chiang also held exhibitions of his own work (with proceeds going to support China), at Eton College's Drawing School and in northern England at the Graves Art Gallery in Sheffield above the city's Central Library and the City Art Gallery in Wakefield. The British landscape painter George Hamilton Constantine, originally from Sheffield, had become the director of the Graves Gallery in 1938 and Chiang appears to have been just about the first artist he invited to come and exhibit. He was to continue to loan works to exhibitions of both exclusively his own work and mixed collections throughout the war. Chiang also participated in, and lectured at, the United Aid to China Fund's art exhibition of March 1943 at London's Hertford

22. Like Chiang, Tsui Chi (Cui Ji, 1909–1950) also knew Victor Gollancz, who published his *A Short History of Chinese Civilization* (London: Gollancz, 1942) with a preface by Laurence Binyon. Puffin produced a version of the book for children, rewritten by Tsui Chi, as *The Story of China* (London: Puffin Books, 1950).
23. The China Institute in Gordon Square was created by the British government and financed from the Boxer indemnity. It was a gathering place for ethnic Chinese students in London and hosted many events open to all. In his biography of Chiang Yee, Da Zheng suggests that several of the works by Liu Haisu, Xu Beihong, Qi Baishi, and others may have been from Chiang's own personal collection.
24. Of these three artists it seems Chiang did not know Qi Baishi. However, Chiang had met Xu Beihong twice— in 1925 when he attended a talk given by Xu on Chinese painting in Jiujiang, and again in 1927 in Shanghai at the home of the artist and art historian Huang Binhong. Chiang was acquainted with Liu Haisu, a founder of the former Shanghai School of Fine Arts, who stayed with Shih-I Hsiung and Chiang Yee in Hampstead while visiting Britain before the war.
25. The United Aid to China Fund was jointly established by Lady Isobel Cripps and Dr Elizabeth Frank as a nationwide appeal to raise money to provide relief to war-torn China. Funds were distributed by a committee headed by Sir Horace Seymour, British Ambassador in China between 1942 and 1946. In 1947 the Fund was renamed the Sino-British Fellowship Trust.

House.²⁶ As well as paintings and sketches, the exhibition included jades, bronzes, lacquerware, textile embroideries, and woodcuts donated by various society figures from their personal collections, including Queen Mary and Lady Louise Mountbatten.²⁷ Chiang also described the collection in a 'news talk' for the BBC with Elspeth Huxley.²⁸

Chiang also contributed a number of simple sketches to M. P. Lee's *Chinese Cookery: A Hundred Practical Recipes*, a guide to cooking Chinese food 'on the ration'.²⁹ Lee (Li Mengbing), a seemingly enterprising Secretary in the Chinese Embassy, hoped that British cooks, despite the severe shortages, might be able to obtain a small amount of meat and stressed that Chinese cooking was ideal for those who, by necessity of rationing, would be forced to slice their meat thinly to make it go round.³⁰ Lee wrote in the introduction, 'Chinese cookery is especially suited to wartime conditions; its nutritive value is high, little meat need be used, and with limited materials great variety can be obtained'. The book was generally well reviewed as a welcome addition to the shelf of any wartime cook struggling to maintain variety on short supplies, though its popularity was probably boosted somewhat by Chiang's accompanying illustrations.

Chiang spoke regularly at charitable fundraising luncheons in late 1939 and 1940, across England, including at the Over-Seas League,³¹ where the Chinese Ambassador was in attendance.³² He spoke at an exhibition of Chinese books in London in 1942 designed to raise awareness of China's continuing struggle against Japan. Chiang also became involved in efforts to explain the struggle of Britain to the Chinese people. He became an occasional voice on the BBC Home Service and the Far East Service. Chiang himself appeared approximately five times and recommended Hsiao Ch'ien, Shih-I Hsiung, and Yeh Chun-chan to the Corporation. Chiang appeared mostly to talk about poetry and did read (in Chinese) several poems by the Tang dynasty poet Li Bai (Li Po).³³ The aim was to draw similarities between Chinese and Western poetry, as well as Chinese and Western art, to stress the supposed common values, both aesthetically and in the ongoing war.

26. Hertford House on Manchester Square. The exhibition included seven hundred works of art, objets d'art, sculpture, and painting, including several Chiang watercolours.
27. Originally Mary of Teck—who became Queen following the accession of her husband, King George V—and Edwina Mountbatten, respectively.
28. 'Chinese Art in London', *The Listener*, 8 April 1943, 414. Huxley (1907–1997) was a cousin of the better-known Aldous. She had been raised in East Africa and wrote several books on that region. She worked for the BBC throughout the war.
29. M. P. Lee, *Chinese Cookery: A Hundred Practical Recipes* (London: Faber and Faber, 1943).
30. My thanks to Frances Wood for identifying M. P. Lee.
31. Now the Royal Over-Seas League. Founded 1910.
32. Quo Tai-chi (Guo Taiqi, 1888–1952), who had served as ambassador to London since 1932 and was soon to leave to be replaced by Wellington Koo, who left Nazi-occupied Paris to take up the post. Quo returned to China, to the wartime capital of Chongqing, to act as foreign minister for the Nationalist Party.
33. In his biography of Chiang Yee, Da Zheng quotes letters from Donald Boyd, Regional Director of BBC North, reporting that he had auditioned Chiang but felt his English was not 'good enough to read translations of his poetry', but that he could read them in Chinese and this might work in 'a highbrow poetry space'; Zheng, *Chiang Yee*, 78–79.

Figure 6.2: An illustration by Chiang Yee from M. P. Lee's *Chinese Cookery: A Hundred Practical Recipes* (1943).

Even after D-Day, when victory seemed assured in Europe at least, work continued to raise awareness of China's ongoing plight. Chiang contributed to an exhibition of Chinese art at Glasgow's Kelvingrove Galleries (positioned alongside Xu Beihong), opened by the Chinese ambassador to Britain, Wellington Koo.[34] Other exhibitions were held in Rotherham and again in Wakefield.

It should also be noted that Chiang still found time to accept commercial commissions and kept on publishing. He had to make a living after all. As well as the books published during the war years, Chiang accepted a number of book jacket illustration commissions, did a frontispiece for Lady Hosie's novel of (supposedly) everyday Peking life, *The Pool of Ch'ien Lung*, accepted an invitation from the Ulster poet John Irvine (1903–1964) to write a preface to his Chinese-inspired poetry collection *Willow Leaves*, and another to design the décor for a ballet (see Chapter

34. Wellington Koo (Gu Weijun, 1888–1985), Chinese statesman and ambassador most famously known for not having signed the Treaty of Versailles at the Paris Peace Conference in 1919 over objections to the continued Japanese occupation of Shandong province. Koo, who had been Chinese ambassador to France, arrived in London to take up the post of Ambassador from Quo Tai-Chi after the Fall of France. Quo returned to China and Chongqing to become foreign minister.

4).³⁵ With a stream of new books, reprints, and these other means of income, Chiang both continued to build his audience and reputation, and maintain his bank account. The publication of *The Silent Traveller in Oxford* met with mixed reviews in that city, but was Chiang's first British bestseller, topping the sales charts for a week in November 1944, while the jacket (a watercolour of Oxford's High Street in the snow) was prominently displayed at an exhibition of the best book cover art of the year at the offices of the National Book League on Albemarle Street in Mayfair.³⁶

War Art

Chiang had been invited to visit the first War Artists' Exhibition at the National Gallery on Trafalgar Square in July 1940 by his Methuen editor, Alan White. Britain's War Artists' Advisory Committee (WAAC) had been established soon after the war in 1939 and was, chaired by Sir Kenneth Clark, then the director of the National Gallery. The WAAC technically fell under the remit of the Ministry of Information at Senate House. Chiang was impressed by the exhibition and its obvious positive effects on morale and the maintenance of culture during wartime. China had no formal tradition of war artists and so Chiang, visiting the exhibition several more times, wrote a booklet, *Visiting the British War Artists' Exhibition* (*Canguan Yingguo zhanshi huajia zuopin zhanlanhui ji* 參觀英國戰時畫家作品展覽會記, 1940), in Chinese for distribution among Chinese communities where possible.³⁷

The booklet included reproductions of works by William Rothenstein (1872–1945), Paul Nash (1889–1946), and Evelyn Dunbar (1906–1960), among others. Chiang made comments on their brushwork, formal styles, and respective traditions, but also on the role of art in understanding war. Chiang encouraged the Chinese government to support its own formal war artists movement.³⁸ Chiang also wrote another booklet in Chinese, *Britain at War* (*Zhanshi Buliedian* 戰時不列顛, 1941), which included his portrait (sketched at a Royal Society of Britush Artists—RBA—luncheon) of Winston Churchill that appeared in a number of English newspapers.³⁹

35. Lady Hosie, *The Pool of Ch'ien Lung: A Tale of Modern Peking* (London: Hodder and Stoughton, 1944). Lady Hosie being Dorothea Hosie (née Soothill), who married Sir Alexander Hosie, a retired British diplomat who had been stationed in China. John Irvine (1903–1964) published a collection of his work with the Talbot Press of Belfast in 1941. The book was subtitled, 'lyrics in the manner of the early Chinese poets'.
36. Chiang Yee, *The Silent Traveller in Oxford* (London: Methuen, 1944).
37. Though this is not to say there were not artists who commented on the war in China. Feng Zikai (1898–1975) drew cartoons depicting the horrors of war, as did the more overtly left-wing woodcut artist Li Hua (1907–1994). But there was no formal movement or organisation of artists in China akin to the War Artists' Advisory Committee. These booklets were primarily intended for Britain's overseas colonies and territories with sizeable Chinese populations—Hong Kong, Singapore, and Malaya—as well as the International Settlement of Shanghai.
38. Which, to my knowledge, it did not.
39. Chiang Yee, *Zhanshi Buliedian* [Britain at war] (1941).

Figure 6.3: 'Is He Mr. Winston Churchill?" from *The Silent Traveller in War Time* (1939). With permission of San Edwards.

Bentinck Street

Both *Visiting the British War Artists' Exhibition* and *Britain at War* were jointly supported by the MOI at Senate House and the London office of the Ministry of Information of the Republic of China. Based at 9 Bentinck Street in Marylebone, and not far from the Chinese Embassy on Portland Place, the office, run by George Kung-chao 'K. C.' Yeh, was the Republic of China's propaganda bureau in Britain during the war. Chiang had been a regular visitor since 1938 along with his friend, the war correspondent and fellow Hampstead sojourner Hsiao Ch'ien, and the translator Yeh Chun-chan. George Yeh, whose office had a relationship with the Ministry of Information, worked with Chiang on both booklets and also encouraged Chiang and Hsiao Ch'ien to collaborate on a more elaborate book publicising the Burma Road, a major plank in China's overseas wartime propaganda efforts.

George Yeh was Chiang Yee's major conduit to working with, and maintaining relations with, Republican China during the war. Born into a scholarly family in Guangzhou, Yeh left China for the US in 1919 to attend Amherst College. After graduation in 1924, Yeh moved to England and earned a master's degree in 1926 at Cambridge University in Indo-European linguistics. He then returned to China as a professor of English at universities in Peking and Shanghai. When Japan invaded China in 1937 Yeh joined the Nationalist Party government, first working as the Ministry of Information's representative in Singapore before moving to London. Yeh became a fixture on the London scene of organisations and charities sympathetic to Republican China's cause. He was good friends with the left-wing publisher Victor Gollancz, organiser of the progressive China Campaign Committee, who published several books specially prepared by Yeh's office and the head office of the Ministry of Information of the Republic of China in Chongqing, and the Chinese News Service in New York (the US-based equivalent of Yeh's London office).[40]

Hsiao Ch'ien had been appointed a lecturer at SOS in 1939. Living in Hampstead, Chiang had known Hsiao as part of the circle around himself and Shih-I Hsiung. Just prior to coming to London in 1939, Hsiao had traversed the Burma Road as a reporter. It seems that it was George Yeh's idea to put the two men together and for Chiang to develop an engaging semi-fictionalised story from Hsiao's descriptions. Chiang clearly had a British audience at this time, while Hsiao was the only Chinese war correspondent in Europe during the war. Moreover, as the major lifeline for war materiel, fuel, and medicine into Free China from British-controlled Burma, the road was a wartime legend already.

The book was a propaganda scheme dreamt up by George Yeh, Chiang, and Hsiao to engage British readers with the story of China's resistance to Japan. In 1942, Chiang's involvement guaranteed sales and reader interest and so was prioritised. The book was produced with a cover similar to those of the Silent Traveller series—a watercolour image with the English title across the top in Chiang's handwriting and in Chinese characters down the right-hand side. Alan White and Chiang certainly provided the illustrations, though the text, a novelised story of the local Chinese villagers who did so much to build the road, seems to have been more of a joint exercise by Chiang and Hsiao. Nonetheless, Methuen published and heavily marketed the book in the summer of 1942 with a sizeable advertising campaign in the press describing it as 'an inspiring story of Chinese heroism and self-sacrifice with unique illustrations by the author'.

Though the story is weak and the characterisation somewhat basic the illustrations are interesting in that they mark a change in style by Chiang, presumably conscious. Apart from several colour plates most of the drawings and sketches in the book are in a far more realistic style than the public had come to expect from the Silent Traveller series. The simple sketches show women forced to take

40. For instance, *China After Five Years of War* (London: Gollancz, 1943).

on hard manual labour while their husbands work to try and complete the Burma Road; women, children, and older people employed in supportive roles to allow the war effort to continue. It seems intentional that with this book, a piece of overt propaganda, Chiang moved consciously away from his familiar interpretations of England that employed a Chinese traditional style and that had so intrigued his British audience, instead shifting to more realistic images that would reinforce the propaganda message.

War Work

Ultimately, and despite the dislocation of moving from London to Oxford, the tragedy of his older brother's death in China, and the difficulties of maintaining contact with his family in Jiujiang, the war does seem to have been an extraordinarily productive time for Chiang. He produced three Silent Traveller books, the Burma Road illustrated novel, his memoir, five children's books, various contributions to other books, articles, speeches, works of translation, and exhibitions, while also at times working at SOS, the Wellcome Historical Medicine Museum, and both the offices of the Chinese and British Ministries of Information.[41]

Over the course of the 1939–1945 period Chiang was to regularly—whether in his writing, poetry, art, or speeches and radio broadcasts—draw parallels between China's and Britain's war experiences: the failure of Chinese and British appeasement policies towards both Japan and Germany, the horror of the bombing of Chongqing and the Blitz on Britain's major cities and industrial centres, significant defeats that tested national morale such as Republican China's loss of Shanghai in 1937 or Britain's evacuation from Dunkirk in 1940, and the awfulness of mass civilian deaths in both countries. In this way Chiang, quite consciously it seems, sought to draw parallels between the two countries and their peoples' war experiences. During the war, Chiang continued to use his traditional Chinese painting style to represent British scenes in his Silent Traveller books while also employing a more realistic style in other works—notably the Burma Road illustrated novel—to drive home ideas of the sacrifice of the entire Chinese people to the anti-Japanese war effort.

Yet throughout all his wartime work, despite the personal tragedies, Chiang remains publicly upbeat and optimistic. If the wars in both Europe and Asia depressed him at all then he did not reveal this in his published work. There is one notable exception to this characteristic optimism and enthusiasm for life. Chiang appended a preface to his own Chinese translation of *The Silent Traveller in War*

41. During the war Chiang published *The Silent Traveller in War Time* as well as *The Silent Traveller in the Yorkshire Dales* (London: Methuen, 1941) and *The Silent Traveller in Oxford* (London: Methuen, 1944). He also published the children's books *Chin-Pao and the Giant Pandas* (London: Country Life, 1939), *Chin-Pao at the Zoo* (London: Methuen, 1941), *Dabbitse* (London: Transatlantic Arts, 1944), *The Story of Ming* (London: Puffin Books, 1944), and *Lo Cheng: The Boy Who Wouldn't Keep Still* (London: Puffin Books, 1942).

Time that was intended to be read by Chinese readers in Hong Kong and China. It was dated 4 May 1940 and so was written while Chiang was still resident in Belsize Park, and had learned of his older brother's death in China:

> The pain I have suffered from the war is beyond description. My Motherland was conquered by enemies; my hometown fell; my house demolished; and my family scattered apart, thousands of miles away from me. Tormented by painful homesickness, how could it be possible for me to have a leisurely and carefree mood to compose something insignificant like this [*The Silent Traveller in War Time*]? But I did it and that was really because of something too painful to disclose.[42]

The war was to cement Chiang's place in Britain. From the very start of the Japanese attack on China he was to be a vocal and active campaigner for awareness of Republican China's struggle. Within weeks of the outbreak of the European war Chiang was to turn his eye to producing morale boosting observational propaganda. Though little mentioned now, during the Second World War Chiang Yee was constantly being read, heard, and seen by the British public, contributing, from a very early stage of the war, to the country's fight against fascism in Europe and its wartime alliance with Republican China against Japan.

42. Chiang Yee, *Lundun zhanshi xiaoji*.

Part Two: Chiang Yee's Circle

7
Navigating British Publishing and Finding an Anglophone Readership
Five Chinese Writers

Tessa Thorniley

This chapter considers a period during and shortly after the Second World War when Chinese writers in Britain enjoyed a heyday for their work and a group of publishers and editors with an interest in and sympathy towards China helped them to find new readers and achieve significant literary acclaim. In particular the chapter traces the rise to prominence of Chiang Yee, Hsiao Ch'ien (Xiao Qian, 1910–1999), Chun-chan Yeh (Ye Junjian, 1914–1999), Lo Hsiao Chien (Kenneth Lo, 1913–1995), and Tsui Chi (Cui Ji, 1909–1950) and their relationships with influential, often leftist, literary magazine editors and book publishers.[1] Such relations are often hidden from critical consideration, as literary history has a tendency to privilege friendships between individual writers or groups of writers. Yet the publishers, editors, translators, and critics under consideration here significantly shaped the careers of these five writers in Britain, the anglophone world, and beyond.

The chapter is divided into three parts. The first part is a brief account of the introduction and development of modern Chinese literature in Britain. Part Two describes some of the ways the five writers navigated British publishing in the 1940s and specifically considers the following topics: Chiang's personal and professional links with the publisher Noel Carrington (at Country Life and Puffin Books); the literary rise of Hsiao, Yeh, and Lo and the support they received from one of the finest wartime literary editors, John Lehmann (1907–1987); and Tsui's involvement with Puffin Books and his wider network. Furthermore, the novels, short stories, and children's books published by the five writers, the contribution that Hsiao, Yeh, Lo, and Tsui made to the circulation and reception of modern Chinese literature in the West through their translations, and Hsiao's literary criticism are also considered. The third and concluding part of the chapter traces the shift in publishers' responses to literature by Chinese writers during the course of the 1940s, which

1. Lo's 'prominence' was comparatively modest. Just one of his short stories is considered in this chapter.

after a tentative start gave way to Chinese stories becoming 'quite the vogue' towards the end of 1944.[2]

In Da Zheng's biography of Chiang Yee he notes that, along with Chiang, from the late 1930s, other Chinese writers who had lived in Britain, at least for a period, notably Lin Yutang (1895–1976) and Shih-I Hsiung (Xiong Shiyi, 1902–1991), had started to gain recognition: 'Though few in number, they represented a fresh voice in the West and signaled an important shift in perspective – China would no longer only be interpreted by Western authors.'[3] Less well remembered is the significant contribution of several other Chinese writers who brought ideas about China's recent societal, economic, military, and creative development to anglophone readers. The five writers considered in this chapter were all well educated and well read, including in English literature and Western literature about China.[4] Their writing pushed back against common prejudices, racism, and stereotypes about their country and its people that they had encountered. It was a 'shift in perspective' which, as we shall see, during the Second World War, became highly sought after by a select group of British publishers and editors.

What is particularly striking about several of these writers, notably Hsiao and Yeh, is how they penetrated more deeply into the networks of literary and intellectual Britain than many of their predecessors and contemporaries had or would. By foregrounding the networks within which these writers circulated, this chapter—to borrow a phrase from Pascale Casanova—comments on the 'literariness' that China's contemporary literature accumulated in 1940s Britain. In her conception of a 'world literary system', Casanova argues that the 'literariness' of a language (which she defines as its power, prestige, and accumulated linguistic and literary capital) can be measured 'not in terms of the number of writers and readers it has, but in terms of the number of cosmopolitan intermediaries—publishers, editors, critics and especially translators—who assure the circulation of texts into the language or out of it'.[5] The collective efforts of just such a network of editors, publishers, and translators aided in the circulation, promotion, and critical appreciation of modern Chinese literature in Britain and beyond, and measurably improved its standing as literature in the country. For the purpose of this chapter, modern Chinese literature refers to writing either in Chinese, in translation, or originally written in English, by Chinese authors in the first four decades of the twentieth century.

2. Typed letter from Dorothy Woodman to Lehmann, 20 September 1944. John Lehmann Collection, MS-02436, 'CCC/Dorothy Woodman', Harry Ransom Center, The University of Texas at Austin.
3. Da Zheng, *Chiang Yee: The Silent Traveller from the East – a Cultural Biography* (New Brunswick, NJ: Rutgers University Press, 2010), 104.
4. One factor linking Hsiao, Yeh, and Lo is that they all studied English literature at Cambridge University.
5. Pascale Casanova, *The World Republic of Letters* (Cambridge, MA: Harvard University Press, 2004), 20, 21. Casanova credits Abram de Swaan and Pierre Bourdieu among other sociologists for some of the ideas which inform her study.

PART ONE

Developments in Modern Chinese Literature: A 'Living Sister' Not a 'Dead Ancestor'

By the time Hsiao, already a published author and literary critic in China, arrived in gloomy wartime Britain in 1939, to teach Chinese at the University of London's School of Oriental Studies, Chinese writers had already made some notable inroads into British cultural life.[6] In an anthology of writing about China which Hsiao edited, he recalls 'the traces' that were left by the modernist poet Xu Zhimo (1897–1931) when he lived in England and fostered ties with the Bloomsbury Group of writers and artists in the 1920s.[7] From 'Essex to Devon', Hsiao wrote, he came across 'scrolls covered with his [Xu's] calligraphy,' 'books with his inscriptions,' and even 'bundles of his letters'.[8] The Chinese dramatist Hsiung, whose play *Lady Precious Stream* ran for nearly nine hundred nights between November 1934 and 1936, had enjoyed significant popular success. Furthermore, the publication of Edgar Snow's collection of modern Chinese short stories, *Living China*, in 1936 was an early suggestion that a market for modern Chinese literature might be emerging in the West. Despite many rejections by British publishers, Snow eventually published the book, bringing several Chinese writers to the attention of anglophone readers for the first time.[9] As a student in Peking, Hsiao had worked on the translations with Snow as well as contributing his own story, 'The Conversion', to the anthology. Other writers Snow published include Xiao Jun (1907–1988), Zhang Tianyi (1906–1985), and Guo Moruo (1892–1978), whose literary reputations grew further or were established during the war years in China. In a 1942 talk that Hsiao gave for the BBC's overseas service, he made the passing comment that he would have expected most of his listeners to 'have heard of' Lu Xun (1881–1936).[10]

It was following the outbreak of the Second Sino-Japanese War in July 1937 that a number of literary and general news magazines in Britain, particularly those politically inclined to the Left who viewed Japan's incursions into China as an act of fascist aggression, began to seek out and publish short stories by contemporary Chinese writers. Among them were *New Writing* and its highly successful offshoot *The Penguin New Writing*, *Left Review*, *The New Statesman and Nation*, *The Times Literary Supplement*, *The Listener*, *Life and Letters Today*, and *Time and Tide*. Shortly after the Marco Polo Bridge Incident, Chiang was invited to join Victor Gollancz's

6. The title of this section is taken from Emily Hahn, 'The China Boom', *China Heritage Quarterly* 22 (June 2010), www.chinaheritagequarterly.org/tien-hsia.php?searchterm=022_boom.inc&issue=022. Accessed 16 March 2019. Originally published in *T'ien Hsia Monthly* (ca. 1937).
7. Hsiao Ch'ien, 'Notes by the Compiler', in *A Harp with a Thousand Strings: A Chinese Anthology in Six Parts* (London: Pilot Press, 1944), xxi.
8. Hsiao Ch'ien, *A Harp with a Thousand Strings*, xxi.
9. Edgar Snow, ed., *Living China: Modern Chinese Short Stories* (London: George G. Harrap, 1936).
10. Hsaio Ch'ien, 'China's Literary Revolution', *The Listener*, 11 June 1942, 757.

Left Book Club (LBC) and gave a lecture (a rare political engagement by the writer). It was Gollancz, by this time an influential voice in Britain, who later published Tsui's *A Short History of Chinese Civilization* (1942).[11]

The introduction of modern Chinese literature to anglophone readers began in earnest in the late 1930s. Anthologies, short-story collections, translations of novels, and literary magazines from the period all contained short essays on the development of Chinese literature since the fall of the Qing empire. Writers including Hsiao, Tsui, Nym Wales (the pen name of writer and translator Helen Foster Snow who was then married to Edgar Snow), Yeh, the sinologist Harold Acton, and Robert Payne with Yuan Chia-hua (Yuan Jiahua) all contributed valuable introductions to modern Chinese poetry and prose.[12] As the Japanese swept through the coastal towns of China and took control of major rail routes in the early stages of the war and as the brutality of the Japanese occupation of China began to be reported in the West, editors and publishers sympathetic to China's cause concluded that literature had a vital role to play in bringing about China's salvation. Other forces in Britain also began to work on the perceptions of China, not least highly vociferous and influential organisations such as the China Campaign Committee (CCC) which began pressing the British government to aid China in the 1930s.

By the late 1930s, the Sino-British literary crossings of the 1920s and early 1930s between the Bloomsbury Group and the Crescent Moon Society in China had given way to transcultural friendships fostered by the second-generation Bloomsbury veterans. These included Julian Bell's friendships with both Hsiao and Yeh, Lehmann's professional and personal acquaintance with Hsiao, Yeh, and a number of other Chinese writers and China literary 'experts' in Britain, and Noel Carrington's enduring personal and professional friendship with Chiang and Tsui (until his untimely death), among others.[13] Through all of these relationships it is possible to trace the transcultural literary flows between Britain and China throughout the 1930s and well into the 1940s.

From 1937 onwards, a greater sense of urgency was attached (by those with sympathy for China's predicament) to how the country was represented in the West. In an article written in 1937, the American writer and journalist Emily Hahn unpicked for readers the 'boom' in China books of the preceding decade and argued that many of the works which had once shaped her own ideas about the country (specifically a great number by Western authors) were deeply flawed.[14] She concluded the article with an impassioned call to writers and readers of the future:

11. Tsui Chi, *A Short History of Chinese Civilization*, with a preface by Laurence Binyon (London: Gollancz, 1942).
12. John Lehmann declined to publish Yeh's introduction. It was instead published by *New Masses* in the US on 30 January 1940, under 'Cicio Mar', Yeh's name in Esperanto.
13. Carrington was a Bloomsbury veteran and his sister was the painter Dora Carrington, who worked briefly at the Omega Workshops and provided woodcuts to the Hogarth Press. Lehmann was the general manager of Hogarth Press from 1938 to 1946 and a partner with Leonard Woolf, while simultaneously editing literary journals including *New Writing*, *Folios of New Writing*, and *Daylight*, and writing his own prose. Julian Bell was the son of Clive and Vanessa Bell and was Virginia Woolf's nephew.
14. Hahn, 'The China Boom', n.p.

China is more than the old silk of a painting, faded ink brushed upon brittle paper. When will she find a voice to roar across the seas, resounding with something more than cries of anguish? When will Western brothers recognize her for a living sister, and not a dead ancestor?[15]

This sentiment is echoed by Hsiao in his correspondence with Lehmann in 1941, when he writes of his disdain for sinologists who view China as a 'heap of bones and stones'.[16] Hsiao's letter goes on to draw parallels—as Hahn had—between the West's failure to understand the new soul of China and the absence of modern Chinese literature in Europe. In wartime, Hsiao and Hahn were part of a network of literary-minded individuals around the world who recognised that literature was one of the most effective ways to bring about better 'understanding between nations' and to 'appreciate [one another's] mutual agonies'.[17] Lehmann defined this sense of shared humanity during wartime as, 'a brotherhood born between the victims of oppression'.[18] His memoir mentions that it was the Chinese writer Zhang Tianyi (whose short stories he published) who captured the essence of this spirit of writing, which Lehmann actively sought out.[19] Lehmann, a publisher, editor, novelist, and poet, is best known for the *New Writing* literary journals he published between 1936 and 1949 which sought to break down social and geographical barriers and which had a strongly leftist agenda.[20] *New Writing* had a significant literary influence and *The Penguin New Writing* and Cyril Connolly's *Horizon* are often cited as the finest wartime literary journals. Lehmann nurtured writers in whom he detected talent, particularly working-class writers and, as this chapter considers, writers from other countries.

Shortly after he arrived Hsiao began to give lectures for the CCC. As a result, he fostered close ties with the group's main organisers (Dorothy Woodman and her partner Kingsley Martin, editor of *The New Statesman and Nation* (NSN), Gollancz, and Margery Fry, among others). Woodman and Fry were both noted friends to many Chinese writers including the ones considered in this chapter. Martin regularly published news articles, short stories, and criticism relating to China and to Chinese literature in NSN, including contributions from Hsiao, Lo, and Yeh. Correspondence in Lehmann's vast editorial archive shows that he had begun seeking out Chinese stories to publish in 1937 but it was not until he encountered Hsiao (and later Yeh) in Britain that he lent his considerable editorial support to Chinese writers. This would include introducing them to his network of literary

15. Hahn, 'The China Boom', n.p.
16. Letter from Hsiao to Lehmann, 27 April 1941, John Lehmann Collection, MS-02436, 'Xiao/Hsiao Ch'ien', Harry Ransom Center, The University of Texas at Austin.
17. Hsiao Ch'ien, *Etching of a Tormented Age: A Glimpse of Contemporary Chinese Literature* (Milton Keynes: Lightning Source, ca. 1941), 48.
18. John Lehmann, *The Whispering Gallery* (London: Longmans Green, 1957), 238.
19. Lehmann, *The Whispering Gallery*, 240. Lehmann cites a review in the *The Times Literary Supplement*.
20. The New Writing series, which had several different publishers, included *New Writing, New Writing/New Series, Folios of New Writing, Daylight, New Writing and Daylight*, and *The Penguin New Writing*.

contacts, critiquing and publishing their work, negotiating foreign rights on their behalf, and even smoothing the path to Cambridge University for Hsiao.[21]

Hsiao's memoir puts the moment that 'China began to exist in the eyes of the British' after 7 December 1941.[22] He notes that he was immediately approached by publishers and film studios to work on cultural projects that might demystify China for British readers, listeners, and viewers.[23] All at once, Hsiao found that he was no longer viewed as an 'enemy alien' but instead as a 'member of the grand alliance'.[24] As this chapter notes, the Blitz was the most productive time for most of the Chinese writers. China's new Allied power status in the world had a significant influence on people's reading habits as they sought out 'great writers in foreign lands for knowledge and understanding of those places'.[25] This accounted equally for the higher demand for books about China by foreign writers, such as those offered in the Penguin Specials series of short polemical works, and many of Gollancz's LBC titles. The Second World War, then, was a moment when Chinese writers in Britain, supported by a network of editors and publishers, sought to bring their countries and their people to a place of deeper understanding through literature. Until this point, few Chinese writers had been promoted, reviewed, or critiqued in such a way as to suggest comparison with the great authors of the Western literary tradition. After all, contemporary Chinese literature was not widely available in translation in Britain in 1941 and the 'vogue' for Chinese writing had yet to emerge.[26]

It is worth briefly noting that the representations of China in literary fiction published by Chinese writers in Britain during the war became not only urgent but also somewhat united. In many of the short stories, novels, and children's books published in the period certain recurring themes can be detected, including China's heroic strides to modernise itself, the awakening of the masses to a new Chinese nationalism in the name of self-defence, the promise of a more humane and fairer society (education for all, gender equality) after the war, and the tension inherent in a society seeking to distance itself from feudal traditions and to embrace modern ways. Such themes were prevalent in much of the writing from inside China, but

21. Handwritten letter from Hsiao to Lehmann, 9 June 1942, John Lehmann Collection, MS-02436, 'Xiao/Hsiao Ch'ien', Harry Ransom Center, The University of Texas at Austin. Hsiao asks Lehmann to 'scribble a few lines' to Dadie Rylands on his behalf.
22. Hsiao Ch'ien, *Traveller Without a Map*, trans. Jeffrey C. Kinkley (London: Hutchinson, 1990), 76.
23. Hsiao, *Traveller Without a Map*, 76.
24. Hsiao, *Traveller Without a Map*, 74–75.
25. Zheng, *Chiang Yee*, 127.
26. *Village in August* by Hsiao Chün/T'ien Chün (Xiao Jun) is held up as the first contemporary Chinese novel to be published in English by Leo Ou-fan Lee. See Leo Ou-fan Lee, 'Literary Trends: The Road to Revolution, 1927–1949', in *The Cambridge History of China*, vol. 13, *Republican China, 1912–1949, Part 2*, ed. John K. Fairbank and Albert Feuerwerker (London: Cambridge University Press, 1986), 455. It was published in London by Collins and in New York by Smith and Durrell in 1942. The Chinese original was published in 1935. As this chapter will consider, Tsui Chi translated Hsieh Ping-Ying's (Xie Bingying) *Autobiography of a Chinese Girl* in 1942.

when published overseas they appear as deliberate attempts to convey to Western readers that China was an ally worth fighting for and alongside.[27]

Even though themes within the fiction suggest its proximity to Chinese overseas propaganda, the editors, publishers, and a great number of critics in Britain found more than mere propaganda value in much of the writing. That Hsiao and Yeh in particular struck up friendships with influential literary figures (George Orwell, E. M. Forster, and J. B. Priestley among them), and that their work was repeatedly held up as literature on a par with many great Russian, European, and British writers, is testament that their writing was perceived to rise above a merely political or nationalist agenda.

PART TWO

Chinese Writers Navigating Wartime British Publishing

These young, versatile Chinese writers who each attained 'a rare and distinctive mastery of English prose' and played a part in shaping twentieth-century responses to China, banded together.[28] The memoirs, biographies, and correspondence which document this period of their lives show that they shared not only their homes, family lives, and friendship, but also their professional networks. Where one writer had succeeded, another sought to follow in his path. In the mid-1930s, Hsiung introduced Chiang to his publisher, Methuen, and a decade later Chiang wrote a 'passionate letter of recommendation' on behalf of Yeh to the same publisher.[29] Methuen declined to print Yeh's short-story collection because, although 'well-written', they were not quite 'their style'.[30] Instead Methuen recommended that Yeh seek out a more 'eclectic publisher' for his collection, which proved to be good advice.[31] During the war, Chiang recommended Hsiao, Hsiung, and later Yeh to the BBC as substitutes when he was not available.[32] It was almost certainly Hsiao who introduced the aspiring writer Kenneth Lo to Lehmann, which gave Lo an early (and

27. This is not surprising as the All-China Resistance Association of Writers and Artists had been mobilising China's writers and artists against the Japanese invaders since 1938. For an analysis of the organisation see Charles A. Laughlin, 'The All-China Resistance Association of Writers and Artists', in *Literary Societies of Republican China*, ed. Kirk A. Denton and Michel Hockx (Lanham, MD: Lexington Books, 2008), 379–411. Laughlin lists some famous writers among its members, including Lao She, Wu Zuxiang, Xu Maoyong, Tian Han, Su Sueline [Su Xuelin], Mao Dun, Ling Shuhua, Chen Yuan, and Hu Feng. See Laughlin, 'All-China Resistance Association of Writers and Artists', 379–80.
28. Barbara Whittingham-Jones, *China Fights in Britain: A Factual Survey of a Fascinating Colony in Our Midst* (London: W. H. Allen, 1944).
29. Ye Junjian [Chun-chan Yeh], *Ye Junjian quanji* 葉君健全集 [The complete works of Chun-chan Yeh] (Beijing: Tsinghua University Press, 2010), 17:476. Translation from Chinese to English by Paula Jin (Jin Huiying 金慧穎).
30. Ye, *Ye Junjian quanji*, 17:476.
31. Ye, *Ye Junjian quanji*, 17:476.
32. Zheng, *Chiang Yee*, 78.

his only) taste of literary success in that period.[33] Chiang also put forward Tsui in discussions with Carrington over the publication of children's books about Chinese history for Puffin Books (part of Penguin Books) and Pilot Press (although the latter project was ultimately dropped).[34]

If the Second World War was a period when demand for stories about China rose significantly and the presence of a group of Chinese writers on British soil could to an extent meet some of this demand, this is not to suggest that the writers considered here often found the publishing market easy to navigate or anticipate. Da Zheng notes that even as a top-selling author for Methuen Chiang found the literary market 'in which he ventured, competed and eventually survived . . . unfamiliar, unpredictable, suspicious and occasionally hostile'.[35] Similarly, Yeh, who had interpreted Methuen's letter of rejection as a sign that his work was not sufficiently mainstream, admits in his memoir of his fears at that time that his work was not sufficiently modernist 'in terms of subject matter or writing style' for a major British publisher.[36] And, although Lehmann published Yeh's translations and several of his stories, he declined—or was not invited—to publish them as collected works. It was not until Yeh made contact with the Welsh short-story writer and editor Denys Val Baker that he eventually encountered Sylvan Press, which published all of his fiction.

Even editors sympathetic and committed to publishing works by Chinese writers rejected a significant quantity of their material (Lehmann's archived correspondence for example shows that he rejected poetry, prose, reportage, and criticism by Yeh, Lo, and several other Chinese writers).[37] As this chapter will consider, the Penguin Books Archive also contains evidence of the numerous disputes, disappointments, and cultural misunderstandings between Chinese writers (Chiang, Tsui, and later Han Suyin) and the publisher throughout the 1940s and beyond. Lo, too, struggled in the market. Initially buoyed by the success of his one short story, after many rejection letters he was ultimately reduced to self-publishing his collection of sketches, poetry, and short stories about Chinese seamen in Britain, *The Forgotten Wave*.[38] As well as editorial hurdles, all writers in wartime suffered the effects of paper rationing, supply problems, poor printing quality, and staff shortages at one time or another. For all of these reasons, the value of personal and pro-

33. Hsiao, *Traveller Without a Map*, 80. Hsiao's memoir notes that he briefly shared a flat with Lo (who at that time was an aspiring writer) in Cambridge.
34. Letter from Chiang to Carrington, 9 February 1944, Penguin Books Archive, University of Bristol Archive, files relating to Puffin Books, DM1107/PP15 and PP36. Chiang reminds Carrington of a conversation on 'an autumn night in 1942' when Chiang recommended that Tsui Chi write a children's book on the history of China.
35. Zheng, *Chiang Yee*, xvii.
36. Ye, *Ye Junjian quanji*, 17:476.
37. These rejection letters are contained in the John Lehmann Collection (MS-02436) at the Harry Ransom Center, The University of Texas at Austin, in the 'Chun-chan Yeh/Ye Junjian', 'Hsiao Ch'ien/Xiao Qian', and 'Lo Hsiao Chien/Kenneth Lo' correspondence files.
38. Kenneth Lo, *The Feast of My Life* (London: Transworld Publishers, 1993), 150.

fessional friendships between British publishers and editors and Chinese writers, particularly in the early stages of their careers when they were seeking endorsement, literary advice, and new readers, was of significant value. As Hsiao wrote in his anthology of literature about China (published in China and Britain): 'I have an idea that, so far as culture is concerned, a link between one or two individuals can do more than any number of conferences or commissions.'[39] With this in mind, this chapter will go on to consider each of the five Chinese writers and their links with individuals and networks, which had consequences for Chinese literature in Britain and abroad that were significant but often obscured.

Noel Carrington, Chiang Yee, and Tsui Chi

Noel Carrington first encountered Chiang while he was working as an editor at Country Life in the late 1930s. After an initial rejection and under 'humiliating terms of contract' for Chiang, Country Life published the first in the Silent Traveller series in 1937.[40] The book was an immediate success, selling out in a month and having several reprints over the next few months.[41] Carrington and Chiang became friends, exchanging ideas and prints, and Chiang became very fond of Carrington's three children. Carrington, who became Chairman of the Design and Industries Association, had an eye for 'practical design' and lettering and an evident interest in Chiang's Chinese gaze and how it was interpreted in Britain.[42] As Chiang combined both text and illustrations in his books, his appeal to a publisher who became recognised for the design and look of his books is clear. In Carrington, Chiang had found a rare publisher in twentieth-century Britain, one who was not trying to make a quick sale off China.[43]

With three children to educate, one of whom had had polio and was being homeschooled, Carrington found himself 'brooding on children's books of the informational variety'.[44] After Country Life turned his idea for a series of affordable, illustrated children's books down, he met with Allen Lane of Penguin Books, who backed his idea, agreeing that in wartime more than ever children required entertaining and informative reading materials. Once installed as the editor of the Puffin Books series, Carrington commissioned Chiang to write and illustrate two

39. Hsiao, *A Harp with a Thousand Strings*, xxi.
40. Da Zheng, 'Double Perspective: The Silent Traveller in the Lake District', *Mosaic: An Interdisciplinary Critical Journal* 36, no. 1 (2003): 164.
41. Chiang Yee, *China Revisited, after Forty-Two Years* (New York: W. W. Norton, 1977), 39–40.
42. Carrington, for example, wrote a letter to *Country Life* on 4 December 1937, published under the title 'The Chinese Idiom', in which he points out that Chiang's art of the Lake District highlights aspects of the countryside overlooked by British watercolourists.
43. Diana Yeh comments that Chiang's writing took up against 'authors pandering to an unhealthy curiosity [for China] and distributed by publishers who knew they would sell well'. 'Contested Belongings: The Politics and Poetics of Making a Home in Britain', in *China Fictions/English Language: Literary Essays in Diaspora, Memory and Story*, ed. A. Robert Lee (Amsterdam: Rodopi, 2008), 308.
44. Jeremy Lewis, *Penguin Special: The Life and Times of Allen Lane* (London: Penguin Books, 2006), 184.

books, using the technique of autolithography to enhance the quality and accuracy of Chiang's images. *Lo Cheng: The Boy Who Wouldn't Sit Still*, about a naughty boy who runs away from his tutor to adventure across China, was published in 1942, and *The Story of Ming*, based on the true story of a giant panda who is captured and brought to a British zoo, came out in 1944. These were the first books by a contemporary Chinese author to be published by Penguin Books. Sales of *Lo Cheng* were initially held up by a warehousing error but once rectified the paperback sold over 20,000 copies in the three months from January 1943.[45] In a letter to Chiang accounting for the slow start, Carrington commented that he expected similar sales going forward and described the book as 'one of best selling in the [Puffin] series'.[46] *Ming*, which was released just before Christmas when 'pandamania' in Britain was at its height, 'sold close to a quarter of a million copies'.[47]

The misstep over sales was one of several incidents which left Chiang feeling that his publisher had let him down. In another incident, Penguin failed to supply copies of Chiang's books to an Aid China exhibition where many of Chiang's paintings were on display.[48] There was also a debacle over payment for a silk scroll that Chiang had sent to Allen Lane which Lane mistook for a gift.[49] In 1944, Carrington wrote to Chiang to explain that paper rationing 'on both the British and American sides' had hampered his intention to sell *Dabbitse* (Transatlantic Arts, 1944), a story about friendship between a peasant boy named Ho Lin and his beloved water buffalo Dabbitse, and *Ming* in the US. He softened the blow by commenting 'I believe both books will have a big future in America after the war.'[50] It was an early signal that Carrington was looking for publishing opportunities on both sides of the Atlantic for Chiang.

While working on titles for Puffin, Chiang brought Tsui to the imprint to write the words for a picture book, *The Story of China* (1945), which sought to convey ideas about China to a younger readership. The original idea for the book had been put forward by Woodman, in conjunction with George Yeh at the Chinese Ministry of Information in London, although as previously indicated Carrington and Chiang had discussed a similar idea in 1942. The book caused a heated dispute between Carrington and Chiang over who would provide the illustrations and Carrington's handling of the matter with Tsui. Chiang had ruled himself out of the project and Tsui's second choice of illustrator, Diana Hsiung (Shih-I and Dymia Hsiung's

45. Letter from Noel Carrington to Chiang Yee, 5 April 1943, Penguin Books Archive, University of Bristol Archive, DM1107/PP15.
46. Letter from Noel Carrington to Chiang Yee, 7 April 1943, Penguin Books Archive, University of Bristol Archive, DM1107/PP15.
47. Zheng, *Chiang Yee*, 180.
48. Letter from Chiang Yee to Noel Carrington, 5 April 1943, Penguin Books Archive, University of Bristol Archive, DM1107/PP15.
49. Letter from Chiang to Carrington, 5 April 1943. In the letter, Chiang also refers to letters sent to Allen Lane explaining why he has been so upset.
50. Letter from Noel Carrington to Chiang Yee, 31 August 1944, Penguin Books Archive, University of Bristol Archive, DM1107/PP36.

daughter), also proved unable to take on the job.[51] During the dispute Chiang suggested that Carrington had been 'shy of' communicating with Tsui because Carrington had been unable to help publish Tsui's *A Short History of Chinese Civilization*.[52] The comment suggests that Carrington was more widely involved in publishing works by Chinese writers than just the opportunities which came from his friendship with Chiang.

The involvement of the Chinese propaganda office in the project signals that Puffin and the authors were strongly aware of the sensitivity around representations of China in wartime and that written and illustrated content was closely monitored. Correspondence between Carrington and George Yeh is telling about representations being officially sanctioned. Carrington wrote, 'We are agreed that this presentation of China as something merely decorative and static has already been over-done.'[53] The letter agrees that there is a need to include 'the many racial types that go to make up the Chinese Republic' in the book.[54] Carrington signs the letter off with the comment that works of art depicted in the book 'such as a vase or a silk screen' should be brought into a picture of a Chinese home with the function of these ornaments or pieces of furniture'.[55] That China must appear dynamic not static, and that ancient items, if illustrated, must be shown to have a practical use in contemporary daily life, are ideas that also permeated fiction written (for adults) by Chinese writers, where China is often depicted as a country on the move and modern culture is emphasised over (or in tension with) tradition. Such representations of China are also clearly in line with China's overseas propaganda in wartime.

While editor at Puffin, Carrington simultaneously worked at Transatlantic Arts, a London company set up before the war with 'an export agency specializing in exporting sheets and books from British publishers to meet the demand' in the US.[56] The company printed and published books in the US that paper shortages prevented British publishers issuing under their own imprint. These included at least seven of Chiang's books.[57] Transatlantic Arts also published children's books on both sides of the Atlantic, including *Dabbitse*. Carrington's role in the venture indicates the extent of his involvement in the global circulation of (anglophone) Chinese stories and the ways that he opened up new markets for Chiang. Through Transatlantic Arts, Carrington helped Chiang to reach American readers long

51. Letter from Tsui Chi to George Yeh, via Noel Carrington, 13 May 1943, Penguin Books Archive, University of Bristol Archive, DM1107/PP47. Tsui says Diana Hsiung, who he describes as 'an intelligent artist', is preparing for her university exams and thus is unable to help. Tsui Chi (and Carolin Jackson, illustrations), *The Story of China* (West Drayton, Middlesex & New York: Penguin Books, 1945).
52. Letter from Chiang Yee to Noel Carrington, 9 February 1944, Penguin Books Archive, University of Bristol Archive, DM1107PP15 and DM1107/PP36.
53. Letter from Noel Carrington to George Yeh, 6 May 1944, Penguin Books Archive, University of Bristol Archive, DM1107/PP47.
54. Letter from Carrington to Yeh, 6 May 1944.
55. Letter from Carrington to Yeh, 6 May 1944.
56. Zheng, *Chiang Yee*, 127.
57. Zheng, *Chiang Yee*, 127. Zheng specifically lists *Chinese Calligraphy*, *A Chinese Childhood*, and *Men of the Burma Road*.

before the Chinese writer relocated there in 1955. It is undoubtedly Carrington's enduring, if not always straightforward, friendship with Chiang that contributed to his decision to publish a collection of contemporary Chinese short stories (in translation) under the Transatlantic Arts imprint in London and New York in 1946. As the conclusion of this chapter will consider, by publishing this anthology of modern stories from China, Carrington achieved what had to several major British publishers at the start of the war seemed almost impossible.

Hsiao Ch'ien: Early publishing success

From the early 1940s, when he was newly settled in Britain, Hsiao set about establishing a literary reputation for himself. Between teaching commitments and later filing reports about the war in Europe to the *Ta Kung Pao* (*Dagong bao* 大公報) newspaper, he set to work on a series of translations and articles about Chinese literature, specifically the influence of foreign writers. It was Harold Acton who drafted Hsiao in to help polish the collection of Chinese short stories that Yeh and Donald Allen sent to Lehmann in November 1939.[58] During this time, Lehmann requested a meeting with Hsiao and his first commission followed shortly after. Not including a letter that Hsiao wrote to the NSN about a racist landlord, an article published about Ibsen in China in the summer of 1941 in the first issue of Lehmann's literary journal *Daylight* was Hsiao's first published work in Britain. Shortly after the article appeared, Hsiao successfully negotiated a book deal with George Allen and Unwin for *Etching of a Tormented Age*, a survey of contemporary Chinese literature (published later that year). The book marked Hsiao out as an authority on the literature of his country (in Britain). Hsiao's literary survey—and the series of short stories by Chinese writers that Lehmann had begun publishing in his *New Writing* journals—persuaded Eric Blair (better known by his pen name George Orwell) at the BBC that a series of talks about modern Chinese literature was overdue in Britain.[59] In Orwell's commissioning letter to Hsiao, he admits, 'how complete my ignorance of modern Chinese literature is', and he may well have assumed his readers would not have much more exposure than him.[60] Orwell was not the only leading literary figure to lament his lack of knowledge of China to Hsiao. In 1943 E. M. Forster, too, admitted to Hsiao that China was a 'subject beyond his scope' for the purposes of a new novel.[61] That Hsiao was corresponding with Orwell and Forster indicates the influential and elevated literary circles in which he circulated while in Britain.

58. Donald Allen was a translator of Japanese for the American military during the Second World War and later an editor, publisher, and translator of contemporary American literature.
59. *The Complete Works of George Orwell*, vol. 13, *All Propaganda Is Lies: 1941–1942*, ed. Peter Davison, Ian Angus, and Sheila Davison (London: Secker and Warburg, 1998), 223–35.
60. Letter from Orwell to Hsiao, 13 March 1942, in *Complete Works of George Orwell*, vol. 13, *All Propaganda is Lies*, 223.
61. Patricia Laurence, *Lily Briscoe's Chinese Eyes: Bloomsbury, Modernism, and China* (Columbia: University of South Carolina Press, 2003), 176–77.

During the war several of Hsiao's short stories, which he had written almost a decade earlier, appeared in the NSN and *Life and Letters Today*, among other newspapers and magazines.[62] These were subsequently published by George Allen and Unwin in a collection entitled *The Spinners of Silk* (1944) and became the first and only book of Hsiao's fiction to be published in English. In the same year Hsiao contributed to a collection of wartime short stories, *A Map of Hearts* (1944), published by Lindsay Drummond. The work was written at the start of 1937 when China was 'inert under the stranglehold of the Japanese'.[63] Its appearance highlights how well regarded Hsiao's writing was during the war, equivalent to contributions by Mulk Raj Anand, Alan Ross, and William Sansom which it was published alongside. Anand was already an acclaimed novelist, short story writer, and political activist by 1944, while both Ross (better known for his poetry) and Sansom would become two of Britain's finest wartime writers. The final book Hsiao published in 1940s Britain was with Pilot Press.[64] *A Harp with a Thousand Strings* (1946) was an ambitious attempt to enlighten anglophone readers about aspects of Chinese culture—with a strong emphasis on literature—observed through both Western and Chinese eyes. There is a whole section devoted to the evolution of Chinese women and Chinese men in which Hsiao publishes exemplary extracts from contemporary Chinese writers including Han Suyin and Chiang, as well as a work translated by Tsui. The book is testament to Hsiao's efforts to bring greater understanding between Britain and China through literature, including contemporary writing. It very purposefully includes passages that are 'misinterpretations' and idealisations of the country by Western writers. Hsiao left Britain in 1944 on a reporting mission about the war in Europe and did not return until the 1980s.

Chun-chan Yeh in elevated literary circles

Yeh arrived in Britain in 1944 and to a large extent took up where Hsiao had left off. Yeh had been invited by the British Ministry of Information to embark on a lecture tour to educate the military and the general public about China's War of Resistance against Japan.[65] When Yeh arrived in London, the first people to greet him were Lehmann and Woodman. Lehmann threw a party for Yeh at his flat and introduced him to many in his *New Writing* cabal, including Stephen Spender, with whom Yeh maintained a friendship well into the 1980s. Through a friendship with Kingsley Martin, Yeh regularly contributed articles and reviews to NSN throughout his time

62. In NSN Hsiao published 'Ramshackle Car' and in *Life and Letters Today* 'Galloping Legs' and 'The Epidemic'.
63. Hsiao Ch'ien, 'The Ramshackle Car', in *The Spinners of Silk* (London: George Allen and Unwin, 1944), 72.
64. Pilot Press was backed by the wealthy Hungarian Kalman Lantos, and began in the late 1930s. It was managed by Charles Madge, the South African sociologist and poet who went on to found Mass Observation. Pilot Press published Joseph Needham's *Chinese Science* (1945). The press went bankrupt shortly after Lantos died in 1948.
65. At the behest of the British Ministry of Information, Yeh gave more than six hundred speeches in factories, barracks, town halls, and military camps across the country between 1944 and 1945.

in Britain. And through Denys Val Baker, Yeh published his work in *International Stories* and connected with Sylvan Press. Outside of the *New Writing* circle, Yeh also struck up a close friendship with J. B. Priestley. According to Yeh's son, Nienlun Yeh, Priestley referred to his father as the 'Chinese member of his family' and regularly invited Yeh to spend weekends with his family at his home on the Isle of Wight while Yeh was studying at Cambridge.[66] Evidence of Yeh's wider network appeared in the author's note which accompanied his first collection of stories. It credits Arthur Waley, Beryl de Zoete, Christopher Isherwood, John Hayward, Mulk Raj Anand, Stephen Spender, and Yeh's supervisor at Cambridge, George 'Dadie' Rylands, for their invaluable criticism. The note provides valuable insight into the elevated literary circles in which he was moving by 1946.[67]

Before he set foot on British soil Yeh had already established a firm friendship with several members of the Bloomsbury Group. Yeh had been Julian Bell's best student when Bell taught English at Wuhan University from 1935 to 1937. Yeh's letters to Julian and later to Vanessa Bell in the late 1930s make no secret about his strong desire to visit Britain and particularly the Bell family and to circulate in British literary circles.[68] It was Bell who introduced Yeh to Lehmann in 1936 while the Chinese writer was still a student (of English literature) in China. Two years later Lehmann published Yeh's first short story in Britain (Yeh was in Hong Kong) in the summer of 1938, in the journal *New Writing*.[69] The following year, Yeh and Donald Allen sent Lehmann their collection of twenty stories by Chinese writers about the war against Japan. As the conclusion of this chapter notes, this collection was never published as a standalone book, but several of the stories were published in Lehmann's journals and in *Three Seasons and Other Stories*, published while Yeh was studying at Cambridge University.[70]

By the time Yeh graduated from Cambridge and returned to China he had published two novels in English, *The Mountain Village* (1947) and *They Fly South* (1948), his collected translations, and a collection of his own short stories, *The Ignorant and The Forgotten* (1946), which he had written in English in snatched moments as he toured the country for the Ministry of Information. All of Yeh's own fiction was published by Sylvan Press. Yeh's short stories and his first novel were, respectively, a Book Society recommendation and a Book Society choice, and his writing received glowing reviews in *The Times Literary Supplement*, *The Listener*, *The Observer*, NSN,

66. China Central Television (CCTV) documentary series called 'Journeys in Time'. Part 2, 'A Writer Who Reached Out to the World'. Part of a four-part documentary about Chun-chan Yeh (Ye Junjian) broadcast by CCTV in China from 20 to 23 March 2012.
67. Yeh's Chinese memoir is peppered with references to his literary friends and associates in Britain, including Denys Val Baker, Harold Acton, Cyril Connolly, Evelyn Waugh, the Sitwells, David Garnett, Walter Allen, V. S. Pritchett, and Mary Hutchinson (the short-story writer and society hostess).
68. These letters, written between 1936 and 1938, are housed in King's College Archive, Cambridge (CHA/1/125/1-2).
69. Lehmann first published one of Yeh's stories in 1938, in *New Writing*, new series, vol. 1, *Autumn 1938* (London: Hogarth Press, 1938). The story was entitled 'How Triumph Van Went Back to the Army'.
70. Chun-chan Yeh, ed. and trans., *Three Seasons and Other Stories* (London: Staples Press, 1946).

and *Life and Letters*, among others. Writing in *The Spectator*, the novelist and critic Walter Allen, for example, compared Yeh to Turgenev and Tolstoy, adding that the collection of stories 'leave behind them, as E. M. Forster has said of *War and Peace*, an effect like music'.[71] Allen is one of several critics who noted that while Yeh's short stories were about the war, their author was no mere propagandist. 'He is a poet', Allen declared.[72] Yeh left Britain to return to China in 1949; an article, written many years later, commented that he 'looked as though he was set to become an English writer but his heart, and subject matter, were in China'.[73] Yeh's legacy suggests that he was considered to be more than simply a Chinese writer and that had he stayed he would have been judged by the standards of English literature.

Kenneth Lo: Literary success and failure

Over the course of the Second World War, the number of Chinese nationals in Britain increased to about twelve thousand, including eight thousand seamen in Liverpool and forty diplomats and their families. Kenneth Lo, who had arrived in Britain in 1936 to study English literature at Cambridge University, offered his services to China's diplomatic mission in Britain shortly after the start of the war. As a result of Lo's family background he was quickly co-opted to work by the Chinese Ambassador, Wellington Koo (Gu Weijun, 1888–1985), as a 'student consul' in Liverpool. Lo was tasked with mediating in an increasingly acrimonious dispute involving thousands of Chinese seamen in the city who wanted pay parity with their British and other counterparts and wartime bonuses, given the extreme danger of their work.

In the 1970s and 1980s Lo was best known as the foremost expert in Britain on Chinese food, and the restaurateur behind the London restaurant Memories of China, but in the 1940s he was an aspiring anglophone writer who hoped to become 'one of China's front rank writers in English'.[74] In correspondence in October 1944 Lo stressed his belief that with two or three years further study, '[I should] be able to improve my writing in English to such an extent that at the end of the term it should be quite comparable to that of Ling yu-tang [*sic*] or any other Chinese authors writing in English'.[75] While Lo never realised this ambition, he did enjoy a brief moment of literary recognition after Lehmann—on the recommendation of

71. Walter Allen, 'Fiction', in *The Spectator*, 18 October 1946, 22. He is reviewing Yeh's collection of short stories. The Book Society was a subscription service which published cheaper copies of books in exchange for an agreement to buy significant copies of first editions from publishers. The books were chosen by a selection committee. It ran from 1929 to 1969.
72. Allen, 'Fiction'.
73. Michael Scammell, 'A Chinaman in Bloomsbury', *The Times Literary Supplement*, 10 July 1981, 769. A copy of the article can be found in the King's College Archive, Cambridge, LPW/8/1-8.
74. Letter from Kenneth Lo to 'Mr. Dao' (the Chinese consul in Liverpool), 8 October 1944, London Metropolitan Archives /4680/C/001, Kenneth Lo Papers, this is a private collection, as a result the box references details are likely to change in the event that it is fully archived.
75. Letter from Lo to Dao, 8 October 1944.

Kingsley Martin—published his short story 'A Chinese Seaman' in issue 24 of *The Penguin New Writing* (1945).[76] Lo had sent several stories to Lehmann from 1942 onwards, which had been rejected.

'A Chinese Seaman' was based entirely on a verbatim account by Poon Lim (Pan Lian), a Chinese seaman who had become a global celebrity after he survived for what was then a record 133 days adrift on a raft in the South Atlantic Ocean. Lo's version of the story was a narrative account written in the third person, penned after a ten-hour interview with Lim in October 1943. Lim's extreme account provided its narrator with a chance to fashion a positive role model out of a Chinese seaman who, because of his ingenuity, resourcefulness, and mental self-control (which, the story suggests, was in no small part linked to his Chinese upbringing) found that he was equipped to withstand the physical and psychological hardship of the ordeal.

The story was praised by *The Times Literary Supplement*, *The Listener*, and NSN, and Lo had several requests for translation. The success motivated Lo to push Lehmann to publish his other stories relating to Chinese seamen (a bundle of which had been passed to Martin for safekeeping). Over subsequent months and years, Lo kept up a correspondence with Lehmann, sending him poems, stories, and later a collection of essays, all of which were turned down. Undeterred, Lo sought out alternative routes to publication but found little interest. Ultimately he resorted to self-publishing the stories at the cost of two hundred pounds for two thousand copies.[77] In her review of *The Forgotten Wave*, in which she highlight's Lo's 'unusual gift for writing poetry', Woodman also noted that the collection was so badly produced that 'if I hadn't known the author, I should have passed it by thinking it was an "opium horror"'.[78] Either because of the quality of the publication, the quality of the writing, or apathy from publishers who believed that there would be little appetite for the stories about Chinese seamen (who had mostly vanished from Britain) after the Second World War, the collection flopped. Without the endorsement of Lehmann—or a literary figure of equal standing—Lo found he was unable to progress with his literary ambitions and turned his hand to selling prints of Chinese art.

Tsui Chi

Before coming to England in 1937, Tsui had been a professor of English in China. A close friend of the Hsiungs, Tsui first lived in Upper Park Road in London, not far from Chiang's home on Parkhill Road, and later they all moved to Oxford. Although Gollancz had published Tsui's first work of scholarship, *A Short History of Chinese Civilization*, in 1942, with a preface by the renowned poet Laurence Binyon, it was not until the following year that Tsui made his major contribution to the appreciation of modern Chinese literature in Britain. With his translation of Xie

76. John Lehmann, ed. *The Penguin New Writing 24* (Harmondsworth: Penguin Books, 1945).
77. Lo, *The Feast of My Life*, 150.
78. Dorothy Woodman, 'Asia Bookshelf', *Asian Horizon* 1, no. 3 (Autumn 1948): 73–74.

Bingying's (1906–2000) *Autobiography of a Chinese Girl*, Tsui brought a striking tale of female emancipation and the life of a revolutionary young woman in China to British readers. The book, based on Xie's diaries that detail her life and her time in the Nationalist Revolutionary Army (during the Northern Expedition from 1926 to 1928), had been a bestseller in China and in translation in the US in 1940.[79] In Britain the book had gone through five impressions by 1945. Tsui's translation is prefaced by the poet Gordon Bottomley, who describes how the book begins by telling the story of a young woman from a remote village who ultimately becomes much more than this as a 'symbol of her nation's new power and purpose'.[80] The experiences of a writer among the masses were evidently expected to resonate with British wartime readers. It was published by George Allen and Unwin, who had published Hsiao's first work of literary criticism in English.[81] Xie's story was accompanied by Tsui's introduction about the development of contemporary Chinese literature, in which he highlights the strong influence of English literature on writers in China, a feature that he predicts 'will serve as a cultural bond between our nations'.[82] Tsui also draws readers' attention to the works that had been written in English by Chinese writers since the start of the war, particularly two novels by Hsiung and two more by Lin Yutang, which 'explain the historical background of modern China in the making'.[83] An extract of Tsui's translation appears in part three of Hsiao's *A Harp with a Thousand Strings* (Down with Love!) about the evolution of Chinese women from the third century to 1940.[84] Tsui was afflicted with renal tuberculosis, and some of his correspondence, over the Puffin book, *The Story of China*, for example, is written from R. S. B. Hospital, Margate.[85] He died in October 1950, aged merely forty-one; Chiang and Hsiung helped to arrange his funeral in Oxford.[86] Tsui's efforts to bring about better understanding between Britain and China through literary exchange were, therefore, sadly cut short.

79. The American translation of Xie Bingying's book was made by Lin Yutang's children (Adet and Anor Lin), edited and introduced by their father, and published by John Day.
80. Hsieh Ping-ying, *Autobiography of a Chinese Girl*, trans. Tsui Chi, with a preface by Gordon Bottomley, 5th ed. (London: George Allen and Unwin, 1945), 6.
81. George Allen and Unwin also published the works of Arthur Waley, and Waley was a powerful influence on the publisher's China books of this period, as an expert, and as a reader.
82. Hsieh, *Autobiography of a Chinese Girl*, 24.
83. Hsieh, *Autobiography of a Chinese Girl*, 24.
84. Hsiao, *A Harp with a Thousand Strings*, vi. Part Three of Hsiao's book also includes an extract by Han Suyin entitled 'Ship Companions' and one by Emily Hahn (misspelled as Kahn) entitled 'Three Profiles of the Soong Sisters in the 1940s', as well as translations of traditional Chinese literature by Lin Yutang and Arthur Waley.
85. Letter from Tsui Chi to Carolin Jackson (who illustrated *The Story of China*), 5 April 1946, Penguin Books Archive, University of Bristol Archive, DM1107/PP47.
86. Zheng, *Chiang Yee*, 120. See also Da Zheng, *Shih-I Hsiung: A Glorious Showman* (Vancouver, BC: Fairleigh Dickinson University Press, 2020), 199–200.

PART THREE

Tracing the 'Vogue' for Chinese Stories

There exist several useful markers which indicate the shift in British publishers' responses to modern Chinese literature throughout the 1940s. The first is contained in correspondence between Yeh and Donald Allen in Hong Kong and Lehmann in London. In November 1939, Yeh and Allen sent a manuscript to Lehmann containing twenty short stories by Chinese writers 'written during the two years of the war [against Japan]', which the pair had translated into English and given the title *People of China*.[87] In a letter (sent under separate cover) Allen commented that he viewed the collection as a sequel to Snow's *Living China*, although only two authors appeared in both collections.[88] Yeh and Allen hoped that Lehmann would help them find a publisher in the UK or publish the collection at Hogarth Press. Lehmann approached Lane at Penguin and Gollancz, who both declined the book. Gollancz wrote, 'My dear Lehmann I'm afraid that I cannot see much possibility of selling more than a very few hundred of People of China.'[89] Evidently a standalone book of short stories about China's war effort was a difficult sell, even to publishers with strong leftist sympathies, in 1940.

That the progress of modern Chinese literature in Britain and Europe had 'not been very good' was lamented by Hsiao in a letter to Lehmann written immediately after their first meeting at the Café Royal in April 1941.[90] Even by 1942, when numerous Chinese short stories had appeared in a range of literary journals and published works by Chiang and Tsui Chi and Hsiao signalled a growing market for their wares, publishing prospects remained patchy, inconsistent, and unpredictable. In the summer of that year, Lehmann wrote a rather downbeat letter to Allen in which he commented, 'The Chinese over here are anxious to have a volume of Chinese stories from *New Writing* published in London. It seems a little doubtful whether this will be possible, but I will let you know if there are developments.'[91] Nevertheless, as Hsiao's reference to the 'Pearl Harbor effect' in Britain demonstrates, a shift in the cultural appreciation of China was already underway in 1941, even if it did not immediately penetrate every aspect of the publishing market. It was not after all until a few years later that the 'vogue' was in full swing and it was undoubtedly easier to identify in hindsight.

87. Letter from Donald Allen to John Lehmann, 10 November 1939, John Lehmann Collection, MS-02436, 'Allen', Harry Ransom Center, The University of Texas at Austin.
88. Letter from Allen to Lehmann, 10 November 1939.
89. Letter from Victor Gollancz to John Lehmann, 18 March 1940, John Lehmann Collection, MS-02436, 'Gollancz', Harry Ransom Center, The University of Texas at Austin.
90. Letter from Hsiao Ch'ien to John Lehmann, 27 April 1941, John Lehmann Collection, MS-02436, 'Xiao/Hsiao Ch'ien', Harry Ransom Center, The University of Texas at Austin.
91. Letter from John Lehmann to Donald Allen, 3 June 1942, John Lehmann Collection, MS-02436, 'Allen', Harry Ransom Center, The University of Texas at Austin.

By tracing the literary output by Chinese writers in Britain from the early 1940s, including novels, short stories, poetry, and children's books, this chapter has demonstrated that publishers were alert to the many shared Sino-British experiences in this period. Both countries had, for example, suffered national humiliation as a result of official appeasement, both were under heavy enemy attack, and both suffered significant civilian casualties. Writers too, in both countries, had responded to the war by becoming men of action who went to the front—or the home front— which brought them into contact with the people, a consequence of the war that is strongly reflected in the literature of the period in both countries.[92]

In 1946, under the Transatlantic Arts imprint, Carrington brought out *Contemporary Chinese Short Stories*, edited and translated by Yuan Chia-hua and Robert Payne.[93] The collection contained works by Lu Xun, Lao She, Shen Congwen, Zhang Tianyi, and Yao Xueyin and was accompanied by a 'valuable' introduction to twentieth-century Chinese literature by the editors.[94] It was published in London and New York and credits 'Mr. Cicio Mar' (Yeh's pseudonym in Esperanto) and 'Mr. George Yeh' for their assistance in translating and collecting materials, respectively. Its publication is an indication that what had seemed almost impossible to Lehmann, Lane, and Gollancz at the start of the decade was realised only a few short years later. The decision to publish the collection underscores not only Carrington's dedication and enthusiasm to raise the profile of modern Chinese literature in Britain but equally his awareness that China's allies on both sides of the Atlantic would respond to the gesture.

The publication of this collection firmly links Carrington to another literary figure who was engaged in the global circulation of contemporary Chinese literature, Wang Chi-chen (1899–2001), the academic and Lu Xun translator based in the US. Wang had published a collection of short stories by Chinese writers in 1944 and followed with a second book containing Chinese wartime stories (including one translated by 'Cicio Mar' and Allen) in 1947.[95] Wang had begun, unsuccessfully at the start, to promote Lu Xun's short stories to American readers as a 'more sophisticated vision' of modern China and as an antidote to Pearl Buck's easy sentimentality, which he felt had a dangerous hold on the American imagination at the

92. Almost all of the introductions to Chinese literature written in English around this time mention that Chinese writers had become more in touch with the masses since the start of the war against Japan. To give one example, Hsiao wrote, 'The war has brought the pedantic, the near-sighted, the writers who were ignorant of actual life, into the vast hinterland of China. For the first time in the social history of China, the literati class and the farmers share the same sort of life.' 'China's Literary Revolution', *The Listener*, 11 June 1942, 757.
93. *Contemporary Chinese Short Stories*, ed. and trans. Robert Payne and Yuan Chia-Hua (London: Transatlantic Arts, 1946).
94. Henry Reed, 'New Novels', *The Listener*, 16 January 1947. A review of *Contemporary Chinese Short Stories*, ed. and trans. Robert Payne and Yuan Chia-Hua.
95. Wang Chi-chen, *Stories of China at War* (New York: Columbia University Press, 1947). The story was Yao Hsueh-yin's 'The Half-Baked', also occasionally published under the title 'Half a Cartload of Straw Short'. This collection was a follow up to Wang Chi-chen, ed., *Contemporary Chinese Stories* (New York: Columbia University Press, 1944), a collection of short stories by Chinese writers written between 1918 and 1937.

time.⁹⁶ It is worth noting that Wang identified the success of Shih-I Hsiung's play *Lady Precious Stream* and Arthur Waley's abridged version of *Journey to the West* (published as *Monkey*) as suggestive of what he identified as a desire in the West to 'preserve China in amber'.⁹⁷ This comment is close in spirit to the one cited earlier in the chapter by Hsiao about the danger—especially in wartime—of those who persisted in seeing China as 'a heap of bones and stones', or in the words of Emily Hahn, as a 'dead ancestor'. By contrast, Chinese writers in the 1940s (including all of those discussed in this chapter) knew the value of representations of China as dynamic, modernising, developing, and awakening. Wang's ideas also show that Chinese intellectuals abroad around this time were putting writers in their rightful camps and choosing sides.

In *Memoir of an Aesthete*, Harold Acton similarly notes that Hsiung's play failed to usher in an era of greater and deeper cultural appreciation of Chinese novels, plays, and poetry in Britain. Having heard of the success of *Lady Precious Stream*, Acton, who was living and working in China at the time, comments that he anticipated a new dawn for China's cultural appreciation and understanding. Acton, it should be noted, had published the first English-language translation of contemporary Chinese poetry in 1936.⁹⁸ But when he arrived in Britain in 1936 he quickly concluded that his hope had been a mere 'flash in the pan'.⁹⁹ On a visit back to Europe and to London, Acton's disillusionment only grew, and he lamented that 'nobody took more than a superficial interest in China'.¹⁰⁰

Perhaps Acton was simply ahead of his time. What this chapter has considered is a period shortly after Acton's visit to Britain, when a group of Chinese writers, with the support, encouragement, and dedication of a group of interested and sympathetic editors and publishers, brought the novels, plays, and poems of China to the West and, through their published books, their speeches, and their networks, greatly improved the standing of modern Chinese literature in Britain. Moreover, the success that several of these Chinese writers enjoyed undoubtedly contributed to the 'vogue' for Chinese stories that Woodman detected in 1944, which offered anglophone readers alternative and contesting versions of China that pushed back against many of the negative stereotypes more widely associated with the country and its people as well as addressing the tendency among cultured Europeans to 'idealize China'.¹⁰¹

That the 'literariness' of Chinese literature—in particular the value ascribed to modern Chinese literature—increased in this period is beyond doubt, even if not

96. See Hua Hsu, *A Floating Chinaman: Fantasy and Failure Across the Pacific* (Cambridge Mass and London: Harvard University Press, 2016) 170. Hsu here is interpreting Chi-chen Wang's ideas about *The Good Earth* by Pearl Buck and the new market she created for breathlessly, China-loving books and articles and which so appealed to American middlebrow readers.
97. Hua Hsu, *A Floating Chinaman*, 170.
98. Harold Acton and Ch'en Shih-Hsiang, *Modern Chinese Poetry* (London: Duckworth, 1936).
99. Harold Acton, *Memoirs of an Aesthete* (London: Methuen, 1948), 391.
100. Acton, *Memoirs of an Aesthete*, 389.
101. Hsiao, *A Harp with a Thousand Strings*, xiv.

every work earned the distinction of great literature. By tracing these networks and individual relationships this chapter notes how several Chinese writers, Hsiao and Yeh in particular, penetrated into English literature and saw their work held up on a par with great English-language writers and other writers for whom English was not their first language. Ultimately, Yeh was on the cusp of becoming an 'English writer' himself by the time he left Britain.[102] All of these writers—those who survived—never abandoned the instinct to foster better understanding between East and West through literature: Hsiao and Yeh through translation and by returning to Britain in the 1980s, Chiang through his continued publishing in Britain and then the US, and Lo, who remained in Britain for the rest of his life, by introducing and explaining regional Chinese food to British cooks and diners. That both Hsiao and Yeh were welcomed back to Britain in the 1980s shows the literary esteem in which they were still held more than thirty years later. An article in *The Times Literary Supplement* ahead of Yeh's return in 1982 went so far as to write, 'In my view it would be good for both English and Chinese literature if Mr. Yeh were to come back.'[103] The ways that Chiang, Hsiao, Yeh, Lo, and Tsui contributed to the period of interest and openness towards China and its people should not be omitted from narratives of British cultural history.

102. Michael Scammell, 'A Chinaman in Bloomsbury', *The Times Literary Supplement*, 10 July 1981, 769.
103. Scammell, 'A Chinaman in Bloomsbury'.

8
Chiang Yee and the Hsiungs
Solidarity, Conviviality, and the Economy of Racial Representation

Diana Yeh

This chapter examines Chiang Yee's relationship with the Hsiungs, arguably the most famous Chinese literary couple living in Britain during the 1930s. Their relationship, though one of evident mutuality, solidarity, and conviviality as diasporic Chinese writers in Britain, was also shaped by the economy of racial representation at the time. Arguably, despite his highly popular Silent Traveller series, Chiang Yee did not achieve the level of visibility enjoyed by the Hsiungs. Shih-I and Dymia Hsiung were a couple who arrived in Britain from China in the 1930s and who, in an extraordinary twist of fate, unexpectedly shot to worldwide fame thanks to Shih-I Hsiung's play *Lady Precious Stream*. Hsiung became known as the first Chinese stage director ever to work in the West End and on Broadway. With her book *Flowering Exile* Dymia Hsiung became the first Chinese woman in Britain to publish a full-length work of either fiction or autobiography in English. During the 1930s and 1940s, such was their fame that the Hsiungs were household names in a way Chiang was not. However, it is also probably the case that Chiang Yee's legacy survives in a way that the Hsiungs' has not. For while Chiang Yee is still known to general readers today, thanks in part to the number of his books that can be found in second-hand bookshops around the UK, what is extraordinary is that, until recently, the story of the Hsiungs had been almost completely forgotten, erased from history.[1]

In this chapter I will discuss the major role the Hsiungs played in both Chiang's career and personal life as a diasporic Chinese, exiled from his home country. In doing so, I seek to navigate an interdiscplinary path between approaches to the study of transnational migration and of immigrant and racialised minority cultural production in cultural studies, art historical, and literary research. I examine Chiang's forging of ethnic ties in diaspora but also explore how, as a migrant who was also an artist, his ethnic ties were compromised by the way in which he and other diasporic

1. Diana Yeh, *The Happy Hsiungs: Performing China and the Struggle for Modernity* (Hong Kong: Hong Kong University Press, 2014).

Chinese writers at the time, including Hsiung, were inserted into the economy of British culture. The significance of ethnic ties for migrants is well recognised in social science literatures, so much so that in some, for example, culturalist accounts, it has become a taken-for-granted narrative based on an assumed pre-existing community. Critical of such accounts, this chapter seeks to render visible the significant labour required to achieve community in diaspora and then addresses an issue that has attracted less attention—the way in which these ethnic ties may be fractured by economies of racial representation.

As Paul Gilroy and Kobena Mercer have written about contemporary Black cultural production, the structures of racism that have marginalised Black artists in Britain confer upon them a burden of representation, such that they are seen as 'representatives' who speak on behalf of, and are therefore accountable to their communities.[2] As Mercer continues:

> In such a political economy of racial representation where the part stands in for the whole, the visibility of a few token black public figures serves to legitimate, and reproduce, the invisbility, and lack of access to public discourse, of the community as a whole.[3]

Chiang's relationship with Hsiung was one of mutuality, solidarity, and conviviality, and even shared calling—that of contesting dominant perceptions of the Chinese circulating in Europe and the US. Yet, in an economy of racial representation, where only a few Chinese artists or writers were admitted to visibility, but were burdened with representing their 'culture' or nation, it was also one fraught with tension, almost from the very beginning.

I first discuss the significance of Shih-I Hsiung in helping to launch Chiang Yee's career as an artist and a writer, not only through commissioning him to produce drawings to accompany his own writings but also through introducing and recommending him to significant cultural figures, both Chinese and British. I then go on to discuss the role of the Hsiungs' homes in London and Oxford in providing emotional sanctuary, a 'home away from home' through the convivial gatherings they held for Chiang and a range of other Chinese students, artist, and intellectuals. I then examine the political mission shared by Shih-I Hsiung and Chiang, who both sought to contest racialised representations of the Chinese circulating in Europe and the US. In the final section, however, I highlight how these different forms of solidarity could be ruptured as a result of the political economy of racial representation that the two writers found themselves in. In doing so, I bring to light not only a less known dimension of Chiang's life, but more broadly, illuminate how economies of racial representation can shape the everyday lives of artists who are also migrants, fracturing solidarities and rupturing even the most intimate of relations.

2. Paul Gilroy, 'Cruciality and the Frog's Perspective', *Third Text* 2, no. 5 (1988), 33–44; Kobena Mercer, *Welcome to the Jungle: New Positions in Black Cultural Studies* (London: Routledge, 1994), 240.
3. Mercer, *Welcome to the Jungle*, 240.

Becoming Artists in Diaspora: Collaborations and Cultural Connections

According to census figures, in 1931, there were fewer than two thousand China-born people in England and Wales, with just over one thousand in London, which included an elite group of intellectuals and students.[4] By the time Chiang Yee arrived in London in June 1933, Hsiung, a fellow native from Jiangxi province, had already been living there for almost a year. Chiang moved in to share Hsiung's two-storey maisonette at 50 Upper Park Road in Hampstead. Fortuitously for Chiang, it was exactly at this time that Hsiung completed his adaption of the classical Peking Opera *The Red-Maned Steed* for the English stage, which he named *Lady Precious Stream*. Hsiung found a publisher for the play first, Methuen, and invited Chiang to illustrate it, alongside Xu Beihong (1895–1953), one of the first artists to reflect the spirit of new modern China in painting. Although trained as a chemist, Chiang had developed a passion for painting, instilled in him as a child by his father, who had been an artist. When the play came out in July 1934, it boasted three colour plates by Xu and twelve monotone works by Chiang Yee.

Despite the mutual benefits of this first collaboration, however, it was to sow the early seeds of discontent between the two men and set a tone for their future relationship. For when Hsiung finally staged *Lady Precious Stream* in November 1934, the play was an overnight success, commended by theatre audiences and critics alike. It became *the* society show to see and ran for three years in the West End. Powerful figures including successive prime ministers attended, and it was critically acclaimed by literary figures such as J. B. Priestley (1894–1984) and H. G. Wells (1866–1946). Even Queen Mary went to see it, on her very first theatre visit after her Silver Jubilee celebrations. The following year, *Lady Precious Stream* even went to New York, where Hsiung met none other than First Lady Eleanor Roosevelt when she attended a performance on Broadway. Hsiung, no doubt intoxicated by this new success, exclaimed to Chiang that he might well become the illustrator for his future works. Chiang found this patronising. It was then that he resolved that he would also become an author in his own right.[5]

Nonetheless, it is through Hsiung that Chiang was able to develop relationships with significant British social, cultural, and literary figures, such as the royal academician Philip Connard (1875–1958), with whom he took motorboat and rowing trips down the River Thames. After seeing a production of *Armlet of Jade* at Westminster Theatre, Chiang also met at the Hsiungs' the Earl and Countess of Longford, who later visited his exhibition of drawings of English lakes at the Calmann Gallery and even invited him to their house in Dublin to stay. Chiang also found himself positioned within international flows of celebrated artists, writers, and performers from China and the US, some of whom would become significant

4. Figures include non-ethnic Chinese from China, but exclude ethnic Chinese born elsewhere.
5. Da Zheng, *Chiang Yee: The Silent Traveller from the East – a Cultural Biography* (New Brunswick, NJ: Rutgers University Press, 2010).

to his career. These included Xu Beihong, who had contributed the colour plates to *Lady Precious Stream*. After being introduced to him by Shih-I Hsiung, Chiang accompanied Xu to museums and galleries in London and even to see the African American star Paul Robeson (1898–1976), who was in London making a musical film, and had befriended Hsiung. Xu, together with Liu Haisu (1896–1994), the founder of the first school of fine arts in the new China, had been organising a series of major exhibitions of Chinese art in Europe. Liu arrived in London in late 1934 to mount the Modern Chinese Painting Exhibition at the New Burlington Galleries, which opened the following year. Liu invited Chiang to participate in the exhibition. It was a significant moment for Chiang to exhibit alongside some of the greatest modern artists in China and, of the ten works he displayed, he even managed to sell one small painting.

However, it was Hsiung himself who was instrumental in Chiang Yee's first major publication, *The Chinese Eye*. Methuen, which had published *Lady Precious Stream*, was seeking a Chinese writer to author a book about Chinese art in the run-up to the International Exhibition of Chinese Art at the Royal Academy of Art (28 November 1935–7 March 1936). Despite Chiang's concern that his knowledge of English would not be adequate to the task, on Hsiung's recommendation he was appointed and engaged his student Innes Jackson (later Innes Herdan) to, as he put it in his acknowledgements, 'render into lucid English my clumsy expressions'.[6] Hsiung wrote the preface for the book and it came out on 21 November 1935, a week before the International Exhibition of Chinese Art.

In his contribution, Hsiung articulates one of the major goals that he and Chiang shared, and which differentiated them from other Chinese intellectuals in Britain at the time, such as Xu Zhimo (1897–1931), Ling Shuhua (1904–1990), and other members of the Crescent Moon Society who mixed with the 'Bloomsbury set'—the desire to reach a general public and thereby educate them about China and the Chinese. He wrote,

> Books on Chinese Art already existing were all written by Western critics, whose conceptions, though valuable, would certainly give an interpretation quite different from that of Chinese artists. The author of this book treats the history and principles and philosophy of painting so deftly and yet so simply that one cannot help being instructed and entertained at the same time. It is not a big book, and thank Heavens, not an academic book! If Mr Chiang has achieved nothing else but has succeeded in writing about Chinese Art without being tiresomely academic, both the author and the reader ought to be highly congratulated.[7]

Referring to Chiang's pen name, Hsiung further observes that 'silent water runs deep,' writing that, 'whenever he shuts himself up for a certain period during which

6. Chiang Yee, *The Chinese Eye: An Interpretation of Chinese Painting* (Bloomington: Indiana University Press, 1970), vii–ix, x. Originally published by Metheun in 1935.
7. Shih-I Hsiung, preface to *The Chinese Eye*, by Chiang Yee, vii–ix. Originally published in the 1935 first edition.

you hear nothing from him, he is sure to produce a series of exquisite paintings or a volume of lovely poems'.[8] Yet, other passages are more ambiguous. Hsiung's preface begins by introducing Chiang, and explaining how he has more than one string to his bow—that he studied chemistry but is more of statesman than a scientist for his work governing districts in the Yangtze valley. But, he continues, anyone who takes him for a statesman might think they're mistaken when they hear that he is also lecturing in Chinese at the School of Oriental Studies. He continues:

> To those who saw his pictures at a *Men of the Trees* Exhibition last year and at the Modern Chinese Painting Exhibition at the New Burlington Galleries in the Spring, and at other exhibitions on the Continent, he is definitely an artist. His more intimate friends who have read his recently-published poems on English scenery will no doubt have another name for him.[9]

This passage is characteristic of Hsiung's jocular writing style, in which he pokes fun at his subjects and readers, often through creating multiple meanings or suddenly derailing expectations. It could be argued that in this game of 'mistaken identities' Hsiung is suggesting that 'the other name' for Chiang would be 'poet'. Yet, making use of the idiomatic way in which the expression 'will no doubt have another name for him' is used, Hsiung also hints at an alternative that would be disparaging. A letter from Hsiung around the same time shows how, while frequently recommending Chiang, Hsiung did so in a way that betrayed a sense of superiority and power, if not ownership over Chiang. From the lofty heights of the Hotel Edison, overlooking Times Square, during the Broadway run of *Lady Precious Stream*, Hsiung writes a letter, turning down an invitation, because, he says, 'they made a big ballyhoo here about the author directing his own play and I cannot very well give them the go-by'. But, he continues:

> I hope you will find the Chinese ambassador and Mr. Lawrence Binyon sufficient to be your main attractions, and if you like you can have Mr. Chiang Yee, the artist who has just published his book on Chinese art entitled *The Chinese Eye*, to say a few words for you. Although he is not a good speaker, and liable to be nervous on such a pompous occasion, his appearance is very attractive.[10]

With this emphasis on 'appearance', Hsiung acknowledges the way in which, during the 1930s in Britain, it was often only a limited visibility of the Chinese as a physical body and not representation of the self that is granted to the Chinese. This Hsiung knew well himself, as the embodied presence of himself and of Dymia was a constant source of attention in the press. A review of the Malvern Theatre Festival in 1938, for example, describes how Hsiung's 'neat silk-clad figure' added an 'exquisite' Chineseness to the internationalist landscape, populated by 'a tall young negro',

8. Hsiung, preface, viii.
9. Hsiung, preface, viii.
10. Letter from Shih-I Hsiung to Christine, 16 November 1935, the Hsiung family archive, Washington DC, hereafter HFA.

'a young French girl, knowing no English but expert in the universal language of dancing', 'a shy New Zealander', 'a sprinkle of Americans', and 'two young Scots in swinging kilts'.[11] Here, the presence of foreign bodies are only significant in constructing the event's aura as 'a great cosmopolitan social festival: a theatrical League of Nations'.[12] The anthropologist Arjun Appadurai has argued that nation-states manage difference 'by creating various kinds of international spectacle to domesticate difference, and by seducing small groups with the fantasy of self-display on some sort of global or cosmopolitan stage'.[13]

In assessing Chiang's value in terms of his 'attractive appearance', Hsiung's letter highlights how he consigns his 'Brother Chiang' to this economy of racial representation where Chineseness is domesticated and only circulated as a visible sign of consumable, exoticised difference. This, however, is not necessarily indicative of a fantasy of self-display or of his relations with Chiang specifically. Rather, Hsiung himself knowingly participated in this economy out of perceived necessity. Though he had arrived in London, wearing a Western suit and clutching a realist play about the class divide in modern China, his experiences in navigating the British cultural world had demonstrated that he could only gain access to visibility through crafting an aura of exoticised Chineseness.[14] By the end of his life in diaspora, he was rarely seen dressed in anything but the traditional Chinese robe that was so essential to this visibility.

Nonetheless, there remains a difference in the way Chiang wrote and spoke about Hsiung. Chiang also frequently recommended his friend for work, for example, proposing him for some film work on an 'Anglo-Chinese' story.[15] However, in Chiang's recommendations, and indeed, his wider writings on Hsiung, there is no such belittling characterisation. For example, writing about *Lady Precious Stream*, he says,

> I think anyone who has seen this play and compared it with *Chu Chin Chow* [an Orientalist musical] will not be in any doubt over their relative merits, but I should like to describe some of the difficulties Mr. Hsiung had to overcome before the play appeared. He certainly showed patience and determination. For a whole year he tried to find a manager to take it, and I think it was rejected eleven times, and among those who refused to take the risk were Sir Barry Jackson and Mr. Leon M. de Lion. It is interesting to note that after *Lady Precious Stream* had become a popular success, Mr. Lion himself played the part of the prime minister for some time, and Sir Barry Jackson took the play to Malvern Festival![16]

11. *Sussex Daily News*, 16 August 1938.
12. *Sunday Times*, 29 July 1938.
13. Arjun Appadurai, *Modernity at Large: Cultural Dimensions of Globalization* (Minneapolis: University of Minnesota Press, 1986), 39.
14. Yeh, *Happy Hsiungs*.
15. Letter from Chiang Yee to 'Mr. Browne', 16 July 1942, HFA.
16. Chiang Yee, *The Silent Traveller in London* (Signal Books: Oxford, 2002), 144. First published by Country Life in 1938.

Chiang goes on to detail Hsiung's further troubles in dealing with the British cast:

> Mr. Hsiung had to attend rehearsals faithfully for four weeks, every day from morning till evening. Not every playwright is troubled in this way, but in a play where the whole dramatic tradition was strange to the actors and actresses, there was no help for it. An actress might want to wear a man's embroidered robe, or an actor would insist on donning a lady's skirt. . . . None of them wanted to take it very seriously, and they often joked – 'Are we really going to wear these clothes on stage?' Mr. Hsiung's good humour over everything is much to be admired and his success well deserved.[17]

As these passages suggest, when writing about Hsiung, Chiang questions not his friend, for whom he has only praise, but rather the non-Chinese theatre directors and actors that Hsiung has had to deal with. This was consistent with their shared mission of educating Westerners about the Chinese, which I discuss further below. First, however, I discuss another significant aspect of the Hsiungs' role in Chiang Yee's life as a diasporic Chinese: their offer of a place like 'home'.

Living in Diaspora: Conviviality and Social Connections

Following the success of *Lady Precious Stream* and *The Chinese Eye*, the two men were united in another, much larger, common cause. As Japan continued its incursions in China, they were bound together in the resistance campaign. Both were in a position to use their fame to contribute to the ongoing resistance campaign, and both were delegates to the first International Peace Campaign Congress in Brussels in 1936. Two years later, in 1938, the Japanese army entered Jiangxi, their home province. Chiang's home was devastated and his family fled to Chongqing. The realities of the Sino-Japanese war are largely obscured in *The Silent Traveller in London*, beyond a dedication mentioning 'the entrance of the invader into my native city'.[18] Soon after, in 1939, Chiang himself escaped the London Blitz by moving to the relative safety of Oxford, where he lived in Southmoor Road. The following year, Chiang and Hsiung worked together for the Joint Broadcasting Commission on a series of talks for audiences in Malaya on the topic of 'English life and thought'. In 1943, Hsiung and his family also moved to Oxford, in the hope that sending their children to a local school would improve their chances of getting into the University of Oxford.

In Oxford, the Hsiungs rented a house in Iffley Turn. Once the childhood home of Cardinal John Henry Newman (1801–1890), Grove House was subsequently owned by the historian of India, Sir George Forrest (1845–1926), and also enjoyed the presence of Lewis Carroll (1832–1898), a regular visitor during the writing of *Alice's Adventures in Wonderland* (1865). It would later be bought by Graham Greene

17. Chiang, *Silent Traveller in London*, 144–45.
18. Chiang, *Silent Traveller in London*, vi.

(1904–1991). For the time being, however, it was the Hsiungs' new home—and to a certain extent Chiang's, since it became, according to Dymia Hsiung's autobiography *Flowering Exile*, 'the social centre of the Chinese community in England'.[19] Dymia's construction of community here is exclusively class-based, consisting only of professional and upper classes. Yet it is certainly the case that from the 1930s to the 1950s the Hsiungs' homes, first in London, and later in Oxford, became a significant site for transnational flows of students, artists, writers, intellectuals, and diplomats from China and other Chinese-speaking territories. For those only visiting, such as Xu Beihong and his wife, the Hsiungs' homes offered convenient places to stay; for those intending to stay, their homes provided, as Dymia suggests, an informal community centre, albeit class-based, where newcomers could find help with finding housing and navigating English life.

The significance of their home for diasporic Chinese was not, however, limited to practical affairs, but also had a considerable emotional dimension, offering a sanctuary from the sometimes hostile world outside and, 'whenever people felt a little homesick', a place where they could go to feel, as one visitor said, as if they were 'home in China again'.[20] In 1931, there were an estimated 450 Chinese students in British universities, 240 from China, over half of whom were studying in London, as well as 120 from Malaya and 35 from Hong Kong.[21] To cater for their needs, in London, China House in Gower Street was opened in 1933 while the University of Oxford (where the Hsiungs' three eldest children went) had the Chinese Student Union. But arguably, these more formalised institutions could not compete with the warmth of the Hsiungs' homes. Letters in the Hsiung family archive are replete with expressions of gratitude from their visitors:

> I have to confess here one thing which I would dread to tell anyone else. I have never left home for more than one week before, and so often feel homesick even in this luxurious college life. Saturday and Sunday evenings in your home, therefore, mean a lot to me as well as to many others.[22]

Chiang was also a regular visitor at the Hsiungs' home in Oxford, and was able to enjoy the lavish feasts that Dymia would prepare—of steamed egg cakes in chicken soup, roast duck, chicken 'with Chinese sauce', braised ox tongue, cabbage with dried shrimp and 'Chinese vermicelli', noodles with 'Chinese mushrooms', rice, and beer—which earned her the accolade of being 'the best cook of Chinese food in the whole of England'.[23] Separated from his own family, including his four children whom he sorely missed, Chiang also savoured his time with the Hsiungs' five children, especially their youngest child, Deh-I, and her friend Grace Lau (née Ho), whom he used to delight with his paintings of pandas. Remembering her 'Uncle

19. Dymia Hsiung, *Flowering Exile: An Autobiographical Excursion* (London: Peter Davies, 1952), 158.
20. Hsiung, *Flowering Exile*, 92. Undated letter from Tang Sheng to S. I. Hsiung, HFA.
21. Ng Kwee Choo, *The Chinese in London* (London: Institute of Race Relations/Oxford University Press, 1968).
22. Unsigned letter, 7 February 1949, HFA.
23. Hsiung, *Flowering Exile*, 202. Letter from 'Robert' to S. I. Hsiung, 1945, HFA.

Chiang' today, Deh-I recalls his loud, hearty laugh and the tricycle he once bought her:

> I was only about five, he asked me what I would like for Christmas. It must have been very hard [for him to get it] (during rationing, you could only get those things on the black market) and it was probably very expensive.

She also hints, however, at the Hsiungs' lack of attention to Chiang's kindness, saying 'I don't think our family fully appreciated how generous he was', raising another potential contributing factor to the troubled relations between the two, which I explore in the final section.[24]

Contesting Chineseness

I have so far discussed the relationship between Chiang and Hsiung in terms of their collaborations, recommendations, shared networks, and also the element of conviviality Chiang enjoyed at the Hsiungs' as a diasporic Chinese, exiled from his home. Yet what perhaps united the two men more than anything else was their shared mission to reconfigure China and the Chinese in Western eyes. By the 1930s there were abundant books that helped to spread knowledge of Chinese society, culture, and history to international audiences. However, as Chiang writes in *The Silent Traveller in London*, on the studies of Chinese literature available at the time:

> strangely enough many sinologists do not attempt to read our new type of writing which is really easier for them, though we try to read modern English rather than Chaucer. Instead they like to stick to their privilege and remain distinct, priding themselves that they can read 'classical Chinese'. How wonderful it is! But what a wrong conception of Chinese literature must be given to the whole world![25]

He also critiques the numerous travel books on China that he has read, as he says:

> I found these books unfair and irritating . . . for they laid stress on such strange sights as opium smokers, beggars, and coolies . . . it seemed to me that those writers were pandering to an unhealthy curiosity in their readers.

Indeed, it was these types of racialised misrepresentations that gave Chiang the idea to write his travel books. By taking up the pen, Chiang sought to enter the literary world and disrupt one of the technologies of power creating, sustaining, and disseminating discourses on Chineseness. His primary tactic was, as he writes, to seek 'similarities among all kinds of people not their differences or their oddities'.[26] This strategy allowed him to couch criticisms in a way that was palatable to British audiences. In the introduction to *The Silent Traveller in London*, for example, he sets

24. Deh-I Hsiung, personal correspondence with the author, 25 June 2019.
25. Chiang, *Silent Traveller in London*, 112.
26. Chiang Yee, *China Revisited, after Forty-Two Years* (New York: W. W. Norton, 1977), 38–39.

up a framework of similarity between British and Chinese misconceptions of each other's countries:

> Before I came to London, I often heard stories of it from people who had travelled there, or read of it in papers and books but these accounts were much too general and could bring no clear picture before my mind. I suppose people [in Britain] who hear and read about China must suffer in the same way.[27]

This, then, allows him to deliver a relatively pointed critique of Western accounts of the Chinese:

> Many travellers who have gone to China for only a few months come back and write books about it, including everything from literature and philosophy to domestic and social life, and economic conditions. And some have written without having been there at all. I can only admire their temerity and their skill in generalising on great questions.[28]

Hsiung was similarly irked that, as he wrote, the 'thousands of books in English trying to explain China' were written by self-established authorities, 'though many of them have never been to China or have been there for five minutes, not many of them can speak Chinese, [and] very few of them can read Chinese'.[29] Like Chiang, Hsiung also sought to humanise the Chinese with *Lady Precious Stream*, by adapting a love story with universal appeal. He was later delighted to point out that, 'Cunninghame Graham [the politician and writer] wrote to me after reading my play, that human nature is always the same, anywhere and at any time'.

However, as both men knew, misconceptions were not only spread by sinologists or travellers, but through popular culture. In his Silent Traveller books, Chiang describes how, when children saw him walk by, they would sing choruses from the Orientalist musical *Chu Chin Chow* or call out 'Charlie Chan'. These preconceptions were not only voiced by children, however. As Chiang writes of the predicament of the Chinese living in Britain: 'Some refuse to mix in circles where they would be asked many difficult questions arising from popular books and films on Chinese life'.[30] This was indeed, what continually happened to Hsiung, who wrote:

> Whenever I refused a cigarette . . . my host invariably apologised for not being able to supply me with a 'pipe of peace' [opium] . . . wherever my wife went, her feet always proved to be the chief attraction.[31]

To add insult to injury, when attempting to correct misunderstandings, Shih-I and Dymia were told that they were 'very much Westernised and could not be relied

27. Chiang, *Silent Traveller in London*, 1–2.
28. Chiang, *Silent Traveller in London*, 2.
29. Shih-I Hsiung, 'The World of Today: Youth Views the Future', undated manuscript, HFA.
30. Chiang, *Silent Traveller in London*, 8.
31. Shih-I Hsiung, 'Afterthought', in *The Professor from Peking: A Play in Three Acts* (London: Methuen, 1939), 186.

upon as good examples of *real* Chinese'.[32] As this suggests, for many, China, Chinese culture, and even Chinese people remained reified in time and space, a fixed, unchanging Other. A London critic even described Chiang, as 'one of those strange Chinese people who "belong to an age gone by"'.[33] As for Chinese culture, commenting on attitudes to paintings by Chinese artists, Chiang declared:

> If they see a picture with one or two birds, a few trees or rocks piled together, they will certainly say that that is a lovely Chinese painting. But if they find anything like Western buildings or a modern figure there, they will suddenly say 'that is not Chinese'.[34]

Little wonder, then, that in his travel books, despite all their poetic reverie, Chiang repeatedly locates himself in the urban, modern city in his illustrations. In the *Silent Traveller in London* he also describes the view of the River Thames from Richmond Park:

> Once I looked there far, far away and thought the river was like an endless ribbon of white satin spreading down from heaven and becoming wider and wider to the part where it was divided in two by a small island. The morning mist covered the island as if it were a fairyland where I would like to live for the rest of my life. It would be more than charming if I could ignore the sound of traffic![35]

The wistful contemplation ends with a sudden jolt, relocating the 'Chinese' in the here and now, in a way that punctures long-held fantasies of Cathay. As J. B. Priestley would later write in his preface to the 1950 edition of the novelisation of *Lady Precious Stream*:

> The world seems so much poorer now that the fantastic empire has gone like smoke ... and now that there is merely another vast Asiatic country filled with people clamouring for cigarettes and canned goods. So I must return to those tiny windows, through which thousands of years of noisy swarming life have shrunk to one delicate budding branch, a river in the silver rain, one slit-eyed sage fathoms deep in meditation, a slender nameless girl, a fish, a bird.[36]

In his public life Hsiung was perhaps even more audacious in his attempts to relocate China and the Chinese in contemporary global culture. In response to those who questioned his authenticity as a 'real Chinese' he would retort, citing the popularity of Hollywood movies in China, 'Why, some of our women even are becoming platinum blonds!'[37]

Hsiung also sought to educate Western audiences about modern Chinese society and politics, through works such as the play *The Professor from Peking*

32. Hsiung, 'Afterthought', 186.
33. Chiang, *Silent Traveller in London*, 1.
34. Chiang, *Silent Traveller in London*, 7.
35. Chiang, *Silent Traveller in London*, 96.
36. J. B. Priestley, preface to *The Story of Lady Precious Stream*, by Shih-I Hsiung (London: Hutchinson, 1950).
37. Hsiung, 'Afterthought', 186; *Milwaukee Sentinel*, 2 November 1935.

(1939) and the novel *The Bridge of Heaven* (1943), but had only modest success. Even the writer and dramatist Lord Dunsany (1878–1957), who wrote the preface to *The Professor from Peking*, showed ambivalence towards Hsiung's decision to replace a 'land of dragons, peach-trees, peonies, and plum-blossoms, with its ages and ages of culture, slowly storing its dreams in green jade, porcelain, and gold' with one 'complicated by telephones, bombs and Communism'.[38] Arguably, then, of the two writers, it is Chiang, through his strategy of mirroring the British and others rather than Hsiung's later strategy (after the popularity of *Lady Precious Stream*) of educating others, who had the potential for wider appeal. In Chiang's body of works, with its focus on travel writing around Britain, the 'complicated' realities of modern Chinese societies appear relatively infrequently, while Hsiung had made this a defining part of his oeuvre for many years after the success of *Lady Precious Stream*. Although Hsiung may have enjoyed far greater visibility in the 1930s, it is perhaps this that accounts for the greater enduring appeal of Chiang's works, which have, unlike Hsiung's, been republished several times over the years.

Fracture: The Economy of Racial Representation

When I interviewed the Hsiungs' second son, Deni Hsiung, about his father's relationship with Chiang Yee, he told me that Hsiung respected him because 'he saw him learning' and appreciated how 'when he first went to England, he didn't know a word of English almost, at all, and it was by sheer great effort that he made himself a writer'. Yet, in the words of Wei Hsiung, Deni's own son, during the same interview, 'towards the end of their lives they despised each other'.[39] While Deni and Wei made sense of the deterioration of their relationship with reference to their different personalities—Hsiung 'irresponsible' and Chiang 'methodical'—they also stated that Hsiung held disparaging views about his friend's works. While not directly attributing specific comments to their father but referring to wider views among Chinese intellectuals in Britain at the time, they recounted stories that Chiang 'wrote for the English people', that his works were deemed 'interesting' but that there was 'no literary genius behind' them. Together they also spoke of how Deni had attended a posthumous exhibition of Chiang's works in Beijing, where a mutual friend had said:

> It's a shame to have an exhibition *at all* here! I mean, *how* can this be called "Chinese painting"? How can these be called "Chinese art"? These are destined for a foreign public. It's a shame to have an exhibition at all, here in Beijing, in China, everybody would know it's a joke.

38. Lord Dunsany, preface to *The Professor from Peking*, by Shih-I Hsiung, viii.
39. Deni Xiong and Wei Hsiung, interview with the author, 5 March 2006, Beijing.

As I have written elsewhere, however, there were also many Chinese in Britain who were equally disparaging about *Lady Precious Stream*.[40] Interestingly, many of their reasons echo precisely those criticisms that Hsiung himself aimed at Chiang. Modernisers such as Hsiao Ch'ien (1910–1999) denounced Hsiung for creating a romanticised version of 'Old Cathay' to pander to Western tastes, and, despite Hsiung's own Nationalist Party sympathies, 'Kuomintang purists' claimed that, in doing so, he was 'indirectly helping to stultify the rebirth of the nation'.[41] Conservative artists and poets also felt ambivalent, but for different reasons. Hsiung's close friends, the calligrapher and first secretary of the embassy, Ho Sze Ko, and his wife, the poet Lily Ho, felt that his calligraphy, poetry, and knowledge of Chinese literature was not 'as high cultured as it could be'. Their views of him were also 'tinged with disapproval because he was famous for selling his work', which, they felt, contravened Confucian principles.[42] In other Chinese circles, as his son Deni acknowledged, Hsiung's cultivation of his image—wearing traditional Chinese gowns and keeping his hair long—also prompted 'nasty remarks'.[43] With the success of *Lady Precious Stream*, many became 'envious because he had all this glory, all this publicity'.[44]

It is also notable that their fractured relationship was certainly not unique among this circle of elite diasporic Chinese. For example, as Morris Gest (1875–1942), the impresario who took *Lady Precious Stream* to Broadway, wrote to Hsiung:

> What makes me mad is that when I went to see the Chinese Consul, K. C. Lee and others and begged them to take "Lady Precious Stream" and help the Chinese people, they wouldn't. I think, Dr. Hsiung, they were too jealous of you and never gave you credit for making the American people Chinese-conscious.[45]

Rivalry with Lin Yutang (1895–1976), another celebrated diasporic Chinese writer of the time who was based in the US, is also hinted at in the writings of Hsiung's friends. Proposing that Hsiung produce a book of collected autobiographical essays, the writer Benjamin Ifor Evans (1899–1982) commented, 'If you could use all your highly individual and subtle use of English we could make it the book of the season and Lin Yu Tang . . . would have to retreat to the shadows'.[46]

Though written by Hsiung's non-Chinese friend, the somewhat Machiavellian tones of this comment capture an underlying dimension of relations among this group of elite Chinese intellectuals in Britain in the 1930s and 1940s that could threaten the conviviality, collaboration, and solidarity so necessary to their lives

40. Yeh, *The Happy Hsiungs*.
41. Barbara Whittingham-Jones, *China Fights in Britain: A Factual Survey of a Fascinating Colony in Our Midst* (London: W. H. Allen, 1944), 48.
42. Grace Lau, interview with the author, 12 July 2005, London.
43. Deni Xiong and Wei Hsiung, interview with the author, 5 March 2006.
44. Grace Lau, interview with the author, 12 July 2005, London.
45. Letter from Morris Gest to S. I. Hsiung, 25 January 1939, HFA.
46. Letter from B. Ifor Evans to S. I. Hsiung, 9 January 1949, HFA.

as writers and diasporic Chinese. In a political economy of racial representation, where only a limited number of Chinese artists or writers were admitted to visibility, but were burdened with representing their 'culture' or nation, competition over who was granted access to representation and contestations over what kind of Chineseness was represented became so acute as to undo the laborious work of making a community in diaspora.

Conclusion

As this chapter has highlighted, the Hsiungs, especially Shih-I, played a significant role in both Chiang Yee's career and personal life. Sharing not only status as privileged diasporic Chinese, but also origins in the same province, and aspirations to become popular literary figures, their paths were bound together in multiple ways. From the everyday practicalities of negotiating life and a sense of belonging in a new society, to becoming embedded in the elite social and literary circles of Britain in the 1930s to the 1950s, and seeking to challenge racialised perceptions of the Chinese circulating in Europe and the US, the Hsiungs and Chiang supported one another, progressed one another's careers, and forged emotional, near-kinship ties. Despite this, the economy of racial representation of diasporic Chinese cultural producers in 1930s Britain impacted severely on their friendship, fracturing their mutuality and conviviality and even throwing into doubt the strength of their political solidarity. Instead, the few spaces granted to only those who offered specific representations of often highly exoticised Chineseness that appealed to British audiences led not only Chiang and Hsiung, but also many other diasporic Chinese literary figures in their circles at the time, to confront each other as competitors, rather than allies in a political struggle. In this sense, solidarities were ruptured, diminishing collective resistance and perpetuating the dehumanisation of the Chinese by rendering invisible highly differentiated and complex identities, and, in the end, tearing apart otherwise deep connections laboriously made from fragile ties of shared social location as diasporic Chinese.

9
Shih-I Hsiung and Anglo-Chinese Films
'An Interesting Experiment'

Paul Bevan

This chapter is composed of two parts. Part One takes the form of an introduction, and begins with a selective and brief account of the early history of Chinese film in Europe. This lays the ground for all that follows. Part Two presents the main substance of the research. It is not widely known that Shih-I Hsiung, most remembered in the West as the author of the play *Lady Precious Stream*, was involved in screenwriting in the mid-1930s. In this chapter Hsiung's role as a writer of film scripts will be explored, specifically with regard to his collaboration with the showman Lai Foun.

Along the way the chapter re-explores some tried and tested questions in the hope of throwing new light on Shih-I Hsiung. Is the image that Hsiung sought to project of himself to Western audiences—as a sophisticated Chinese playwright and intellectual—a truthful and realistic representation of his standing in Chinese intellectual circles? In much the same vein, should Shih-I Hsiung's play *Lady Precious Stream* be seen as an example of serious drama—as it was often said to be at the time—or simply as the author's own contribution to the populist, 'Orientalist' world of Fu Manchu and other sensationalist films and novels about China, as it was understood to be by a number of Hsiung's compatriots when it was performed in the 1930s?

PART ONE

A China Craze in London

> The Chinese Exhibition, the Eumorfopoulos Collection, 'Lady Precious Stream' and now Chinese films! Peacefully, delightfully, the Chinese invasion continues.

So begins the article 'Chinese Films for China' by Winifred Holmes (1903–1995), which appeared in the magazine *World Film News and Television Progress* in July

1936.¹ That year, and for much of the previous decade, a China craze had been underway in London, and the events identified by Holmes had all been a recent part of it. The International Exhibition of Chinese Art, held at the Royal Academy of Arts, Burlington House, Piccadilly, ran from 28 November 1935 to 7 March 1936, and Holmes's article was published just a few months after it came to an end. The collector George Eumorfopoulos (1863–1939) had been part of the exhibition's organising committee and in the run up to the event had sold much of his personal collection of Chinese ceramics, bronzes, jades, sculptures, and paintings to the British Museum and the Victoria and Albert Museum.² The long-running *Lady Precious Stream*, a play based on the Chinese drama *The Red-Maned Steed* (*Hongzong liema* 紅鬃烈馬), adapted by Shih-I Hsiung for an English-speaking audience, was still in progress. It began its run in the Little Theatre, London, on 27 November 1934, and continued until sometime in 1937. In 1936 it played for six months at the Savoy Theatre.³ Altogether it marked up as many as nine hundred performances. So popular was the play that after its London run came to an end, productions continued to be mounted in other parts of the country. The company of the Theatre Royal Brighton took the play to Cambridge in July 1936, the month in which Holmes's article appeared. From January to April it played on Broadway and the year before a production was mounted by an all-Chinese, English-speaking cast as far away as Shanghai.⁴ The three events singled out in *World Film News and Television Progress* were part of a China craze that had been underway in London for a number of years—but what of Chinese film, as mentioned by Holmes?

Chinese Film in Europe

The only Chinese film to have been shown commercially in Britain before the 1930s was *Xixiangji* 西廂記 (Romance of the Western Chamber), a 1927 silent film based on the classical Chinese, Yuan dynasty play of the same name.⁵ Under the title *The*

1. Winifred Holmes, 'Chinese Films for China', *World Film News and Television Progress* 1, no. 4 (July 1936): 32. Holmes also wrote an article about Japanese cinema: 'Japanese Movie Industry is Second to Hollywood', *World Film News and Television Progress* 1, no. 3 (June 1936): 19; and, later in the year, articles about Mexican, Argentinian, and Indian cinema.
2. 'The Famous Eumorfopoulos Treasure Bought for the Nation for £100,000', *The Illustrated London News*, 12 January 1935, 52–53.
3. Diana Yeh, *The Happy Hsiungs: Performing China and the Struggle for Modernity* (Hong Kong: Hong Kong University Press, 2014), 47.
4. See Yeh, *The Happy Hsiungs*. For more on the Shanghai production, see Da Zheng, '*Lady Precious Stream* Returns Home', *Journal of the Royal Asiatic Society China* 76, no. 1 (August 2016): 19–39; Paul Bevan, *A Modern Miscellany: Shanghai Cartoon Artists, Shao Xunmei's Circle and the Travels of Jack Chen, 1926–1938* (Leiden: Brill, 2015), 68–71.
5. Directed by Hou Yao (1902–1943) with Lin Chuchu (Cho-Cho Lam, 1904–1979) and Li Dandan (Lee Ya-Ching, 1910–1998), based on a play by Wang Shifu (1250–1336). The film was previously known by the promotional title *Way Down West*, possibly chosen to call to mind D. W. Griffith's film *Way Down East* (1920), which had proved so popular in Shanghai in 1924. See Yingjin Zhang, 'Chinese Film in the West', in *Encyclopaedia of Chinese Film*, ed. Yingjin Zhang and Zhiwei Xiao (London: Routledge, 2002), 66; Zhang Zhen, 'Transplanting Melodrama: Observations on the Emergence of Early Chinese Narrative Film', in *A Companion to Chinese Cinema*, ed. Yingjin Zhang (Chichester: Wiley-Blackwell, 2012), 37.

Rose of Pu-Chui, it was shown in London in 1929, just two years after its release in China.[6] Described by one English reviewer as 'a charming and delicate piece of work ... without a trace of vulgarity about it', it was shown as part of one of the 'best and most varied programmes' the reviewer had seen in London for some time.[7] The selection of films was certainly an eclectic mix. The four-part programme began with *Blind Husbands*, according to the reviewer, 'an old and rather poor' film by Erich von Stroheim. This was followed by a short comedy, *Blue Bottles*, written by H. G. Wells and directed 'in completely modern style' by the left-leaning film director Ivor Montague. This in turn was followed by another short, *Life and Death of 9413: A Hollywood Extra*, an experimental film, only eleven minutes long, described by the reviewer as 'much more modern than anything that has yet been produced in England'.[8] This was certainly no ordinary programme, with films old and new, an avant-garde short, together with 'the first Chinese picture with an all Chinese cast and direction' to be shown in London.[9]

As noted by film historian Jay Leyda (1910–1988), it was only Lai Man-Wai's (1893–1953) Minxin Film Company, then based in Shanghai, that had made any attempt to sell Chinese films to European audiences up to this point.[10] *The Rose of Pu-Chui*, *Poet from the Sea* (*Haijiao shiren* 海角詩人) and *A Reviving Rose* (*Fuhuo de meigui* 復活的玫瑰)—all directed by Hou Yao and all Minxin productions of 1927—were shown, according to Ledya, in Paris, Geneva, Berlin, London, and 'elsewhere' during the years 1928 and 1929.[11] One of the places that fits into Leyda's 'elsewhere' bracket was Spain, and the showing of at least two of these films in Madrid appears to have been a significant event in itself. *The Rose of Pu-Chui* and *A Reviving Rose* were shown in April 1929 at the Cineclub Español, an avant-garde film society that had been established the previous year. This was programmed by no lesser filmmaker than Luis Buñuel (1900–1983), his own debut film, *Un Chien Andalou*, having been released in Paris that same month.[12] The London showing of the Chinese films presented them as part of an avant-garde event and this was also

6. *The Rose of Pu-Chui* was shown in September at the Avenue Pavilion, 101 Shaftesbury Avenue, London. Advertisements for the film can be found in *Close Up* 5, no. 2 (August 1929) and *Close Up* 5, no. 3 (September 1929).
7. 'The Cinema: Some Films in London', *The Spectator*, 4 October 1929, 14.
8. 'The Cinema: Some Films in London', 14.
9. Advertisement in *Close Up* 5, no. 2 (August 1929). This American production, which one critic declared 'must be seen in order to be comprehended', was written and directed by Robert Florey and Slavko Vorkapić.
10. Jay Leyda, *Dianying: An Account of Films and the Film Audience in China* (Cambridge, MA: MIT Press, 1972), 70.
11. Zhang, *A Companion to Chinese Cinema*, 630. The showing of these films had initially been made possible through the Parisian commercial contacts of the brother of Lai Man-Wai. Leyda, *Dianying*, 70. The extant five-reel version of the film was discovered in 1981 at a film archive in the Netherlands. See Yingjin Zhang, *Chinese National Cinema* (London: Routledge, 2004), 40. *The Rose of Pu-Chui* was known in France as *La rose de Pushui* and in Spain as *La rosa de Pu-Chui*. *Poet from the Sea* was translated into French as *Le poème de la mer*. The French title of *A Reviving Rose* was *La rose qui meurt* and in Spanish it was *La rosa que muere*.
12. Jo Labanyi and Tatjana Pavlović, eds., *Companion to Spanish Cinema* (Oxford: Wiley Blackwell, 2013), 435.

the approach taken in Madrid, with Federico Garcia Lorca (1898–1936) declaiming two of his own poems during the intermission.[13]

According to Leyda, *The Rose of Pu-Chui* had 'considerable circulation' in Europe in 1928, its European history having begun with an abridged version for foreign audiences—eleven reels reduced to five.[14] It was shown at the distinguished Parisian cinema Studio 28 from 20 April to 3 June, but appears to have already been screened in Spain earlier in April.[15] By the time it reached London the following year, the China craze as identified by Holmes was already well underway in the English capital. The play *The Circle of Chalk* was mounted that year and starred the Chinese American actress Anna May Wong (1905–1961) and a youthful Laurence Olivier (1907–1989). *Piccadilly*, a film starring Wong, had been released in February and *The Rose of Pu-Chui* was shown in September at the Avenue Pavilion, Shaftsbury Avenue, close to Piccadilly Circus—the London landmark from which Wong's film took its name.[16] The composer Constant Lambert (1905–1951) is known to have seen the film and, as a great admirer of Anna May Wong, had also seen her perform in *The Circle of Chalk*. He was a follower of the China craze and by this time was one of a host of Western classical composers to have set poems by the Tang dynasty poet Li Bai (Li Po). His *Eight Poems of Li-Po* (1926–1929) was inspired by his deep admiration for Anna May Wong and was dedicated to her.[17]

By the time Holmes's article was published in 1936, Chinese cinema had already made a wider international impression. On 23 July 1935 the documentary film '*The Chinese Peasant in Spring*' (*Nongren zhi chun* 農人之春) had been awarded one of three prizes by the jury of the International Contest of Rural Cinematography held at the Exposition Universelle et Internationale, Brussels, and is said to have been the first Chinese film to win a prize at an international competition.[18] Confusingly, this accolade has also been awarded to the film *Song of the Fishermen* (*Yuguang qu* 漁光曲), directed by Cai Chusheng (1906–1968), which received an honorary prize

13. Zhang Yue, 'La evolución de las imágenes chinas en la poesía de Lorca' [The evolution of Chinese images in the poetry of Lorca], *Círculo de Lingüística Aplicada a la Comunicación* 74 (2018): 136.
14. Leyda, *Dianying*, 70.
15. Also shown in Paris at the same time were *Ben Hur* (1926, dir. Fred Niblo) and *Joyless Streets* (1922, dir. G. W. Pabst). Yingjin Zhang, 'Chinese Film in the West', 66.
16. Advertisement in *Close Up* 5, no. 2 (August 1929). The present Curzon cinema was built on the site of the Avenue Pavilion, which was destroyed by bombing in the Second World War.
17. Stephen Lloyd, *Constant Lambert: Beyond the Rio Grande* (Woodbridge: Boydell Press, 2014), 88–90. By the late 1920s English-language musical settings of the poems of Li Bai included Peter Warlock's *Along the Stream*, and Arthur Bliss's *The Ballad of the Four Seasons*. Granville Bantock's contribution was among his many compositions based on Chinese and 'Oriental' themes. Settings of Li Bai's poetry in the free German translations of Hans Bethge include those of Gustav Mahler, Richard Strauss, Karol Symanowski, Arnold Schoenberg, Anton Webern, Hanns Eisler, Ernst Krenek, Bohuslav Martinů, and Ernst Toch.
18. 'Chinese Film Wins Brussels Award: Prize in International Contest Given', *The North-China Herald*, 31 July 1935, 176; Ian Aitken, *The Concise Routledge Encyclopedia of the Documentary Film* (London: Routledge, 2013), 158. The film was directed by Sun Mingjing (1911–1992).

at the First Moscow Film Festival in February–March of the same year.[19] Cai's film is by far the better known of the two and is now considered one of the classics of left-wing cinema. As mentioned by Holmes in her article, eight films in all were sent by the Chinese government to the Moscow Film Festival, together with an official delegation. Butterfly Wu (Hu Die, 1908–1989), star of two of these films—*Twin Sisters* (*Zimei hua* 姊妹花, 1934) and *Orchid in an Empty Valley* (*Kong gulan* 空谷蘭, 1934)—was invited to the festival as the only film actress in the delegation. Afterwards, she travelled to Europe and the UK in the company of the Peking Opera actor Mei Lanfang, whose own performing schedule coincided with the film festival in the USSR.[20] Mei performed to great acclaim in several cities across the USSR, but although his tour took him to a number of other countries, he was not invited to perform in the UK. Whilst passing through London, however, Mei Lanfang, Butterfly Wu, and their colleague in the theatre world Yu Shangyuan (1897–1970) did get the chance to attend a performance of Shih-I Hsiung's *Lady Precious Stream*. The play appears to have been the source of some bewilderment to Butterfly Wu. She was clearly unimpressed by the costumes and made the suggestion to Hsiung that they be replaced with others obtained directly from China.[21] This was a mild and rather diplomatic criticism of the play; the views of other, less tactful Chinese critics will be introduced later in this chapter.

Popular Views in the UK of Chinese People in Film and Fiction

Despite the China craze and the vast number of books written by Westerners who had lived, worked, or sojourned in China since the nineteenth century, the average English person's exposure to China during the 1920s and 1930s would have been through the consumption of films and novels; but these were unlikely to have been translations of *Chinese* novels, and were almost certainly not *Chinese* films. The stories that were most familiar to the British public were the Fu Manchu novels of Sax Rohmer and other books that showed the Chinese in a less-than-complimentary light. At this time, films starring Western actors made up to look like Chinese people were common: the so-called 'Yellowface'. The general skewed view of a sinister London Chinatown, with its opium dens and low-class dives, as propagated by popular fiction and film, was on rare occasions challenged by journalists who felt a need to put things straight and even become the subject of academic research. One 'Professor Green of Aberystwyth' presented his findings to academia in 1931,

19. Zhang and Xiao, *Encyclopaedia of Chinese Film*, 105. The Moscow Festival was held four months before the Belgian Expo, so perhaps it might be more accurate to say that '*The Chinese Peasant in Spring*' was the first Chinese *documentary* film to win an international prize. Ian Christie and Richard Taylor, *The Film Factory: Russian and Soviet Cinema in Documents, 1896–1939* (London: Routledge, 2012), 346.
20. A. C. Scott, *Mei Lan-Fang: Leader of the Pear Garden* (Hong Kong: Hong Kong University Press, 1959), 119.
21. Hsiung replied to Butterfly Wu that this had been his original plan but the foreign actors were very superstitious and thought it bad luck to change costumes halfway through a run. Hu Die 胡蝶, *Hu Die huiyilu* 胡蝶回憶錄 [Memoirs of Hu Die], ed. Liu Huiqin 劉慧琴 (Beijing: Wenhua yishu chuanbanshe, 1988), 153.

concluding that, 'British boys and girls in uncounted numbers are getting a detestation of the oriental as a sly, dope-addicted, dagger-wielding criminal from the characteristic "Chinese" film that exudes from Hollywood'.[22] Films and novels, both new and old, kept the public entertained with a view into the world of the sinister 'Chinaman', seen from the cosy environment of the local cinema or read about in the comfort of their own homes.

The distorted Orientalist depictions of the Chinese people, as described in books by Thomas Burke and Sax Rohmer, were known to Chinese writers and artists in Shanghai, partly due to the popularity of Hollywood films on Chinese themes that were shown (and frequently banned by the Chinese Government) in the city's International Settlement at the time. In April 1936, the month before *Charlie Chan in Shanghai* was first shown in Shanghai, the star of the film, Warner Oland, visited China for the first time. He was apparently not there for the opening of the film, though. He had come to China because it had long been an ambition of his to 'visit the country, whose art and philosophy he has for many years studied with the keenest and deepest interest'.[23] Although Oland had many Chinese fans in China there were an equal number who took great offense at the 'Yellowface' roles he played in these films.[24] In 1933, the Shanghai pictorial magazine '*Modern Miscellany*' (*Shidai huabao* 時代畫報) published an article bemoaning the unfavourable view of Chinese people in the Western popular imagination.[25] In 'When Art Turns to Blasphemy' can be seen captioned photographs of Boris Karloff as Fu Manchu, Nils Asther in *The Bitter Tea of General Yen*, and a still from the film version of Pearl Buck's novel *The Good Earth*. As will be shown later in this chapter, in the eyes of progressive intellectuals in China, Buck's novel and Hsiung's play belonged firmly within this category of offensive and racist entertainment.

Was the world of Fu Manchu, Chu Chin Chow, and the Edwardian Music Hall—from where Christopher Frayling has so compellingly shown that these characters derived—really so far removed from that of Shih-I Hsiung, the playwright who introduced *Lady Precious Stream* to London?[26] With the marginalised position of Chinese living in London made considerably worse by depictions of the Chinese people in film and novels, it is perhaps surprising to find a company established in 1936 specifically to make films with a mixed cast of Chinese and Western actors.

22. Basil Mathews, 'The Colour Bar', *The Spectator*, 24 July 1931, 6.
23. 'Mr. Warner Oland in Shanghai', *The North-China Herald*, 25 March 1936, 532.
24. The writer and polymath Lu Xun went to see Charlie Chan films on a number of occasions. See Paul Bevan, *'Intoxicating Shanghai' – an Urban Montage: Art and Literature in Pictorial Magazines during Shanghai's Jazz Age* (Leiden: Brill, 2020), 300.
25. '*Ru Hua ju*' 辱華劇 ['When art turns to blasphemy'], *Shidai huabao* 3, no. 12 (16 February 1933), n.p.
26. Christopher Frayling, *The Yellow Peril: Dr Fu Manchu and the Rise of Chinaphobia* (London: Thames and Hudson, 2014), 137–84.

PART TWO

Lai Foun, Film Star and Contortionist: A Partnership with Shih-I Hsiung

In 1936 it was reported in *The Straits Times* of Singapore that an actress from Malaya, Diana Wong, had been chosen to play the lead role in a film to be shot in England.[27] This film, *Shadow Sweetheart*, would be the second in a series of three, and the writer of the screenplays for all these films was to be Shih-I Hsiung.[28] Indeed, it was Hsiung who was slated to write all forthcoming screenplays for the newly formed Bijou Film Company, which had its studios in the small Kentish town of Snodland.[29]

Plans for the shooting of the first film in the series were already underway in July while the London performances of *Lady Precious Stream* were in full swing, and by this time Hsiung's first screenplay had already been written.[30] According to Winifred Holmes in her 1936 article in *World Film News and Television Progress*, the story was to follow the life of a young Chinese man, the son of a wealthy family, who travels to England to receive his education. Having settled down to his studies he hears news of his father's bankruptcy, but instead of returning home he decides to join the circus. Through his newly adopted profession he makes enough money to return to China and reinstate his family to the elevated position they had once enjoyed.[31]

For a young Chinese man from a well-to-to background to join the circus in a country far from home may seem an odd twist to the story. Not so if it involves Lai Foun.[32] Lai Foun, who had recently spent a large sum of money establishing the Bijou Film Company in Snodland, came himself from such a circus background. He and his associates made up the Six Lai Founs, a music hall and vaudeville act popular throughout Europe. Lai Foun, head of the troupe, relying on the support of his fellow performers, branched out to pursue his ambition of becoming an actor and film producer. It was he who was to star in the new film as the young man who joins the circus.

The troupe is mentioned in the British press as far back as 1932. By 1934 its members were appearing under the names Lai Foun and his Chinese Wonders, or simply the Lai Foun Chinese Troupe, the latter being the name under which they

27. 'Ipoh Girl in New Film', *The Straits Times*, 27 May 1936, 13. This is the same Diana Wong who arrived in London in 1935 in the company of Dymia Hsiung. See Yeh, *The Happy Hsiungs*, 54.
28. The third film, *Violin Song*, was to star the Japanese actress Margaret Kato. 'The Answer Corner: Replies to Inquiries', *The Auckland Star*, 22 August 1936, 5, cited in *The Snodland Historical Society Newsletter* 16, no. 2 (April 2013), n.p.
29. Holmes, 'Chinese Films for China', 32; *The Evening Post* (New Zealand), 2 July 1936, cited in, *The Snodland Historical Society Newsletter* 16, n.p.
30. Holmes, 'Chinese Films for China', 32.
31. Holmes, 'Chinese Films for China', 32–33.
32. All references to 'Lai Foun' in the English-language press use this romanised form of his name. The Chinese characters for his name are never given.

Paul Bevan

performed as part of Bertram Mills Circus at Olympia Hall in London that year.[33] As a troupe of acrobats, contortionists, and plate-spinners, they would go on to astonish the world for almost thirty years.[34] In a 1936 book, writing about his own experiences in the circus, one observer appears to have been rather taken with them:

> Contortionists are received, I have noticed with mixed feelings. Some people are apprehensive of their twisting, doublings and bendings – they do not like to watch such obviously unnatural posturing. Fortunately, most contortionists (it is a very old form of entertainment) are talented in other directions. The Chinese Lai Founs troupe of apparently jointless or boneless young persons are wonderful jugglers, plate-spinners and dancers. This is one of the most graceful of circus acts, made more so by the pleasing beauty of the girls and the charm of the male members.[35]

Also in 1936 (as the China craze was well under way in London), the troupe appeared in *Variety*, the very first entertainment programme to be transmitted on British television (following directly after the official opening address and the British Movietone News on the afternoon of 20 November).[36] Subsequently, the *Radio Times* lists their participation in a number of television cabarets in 1938 and 1939.[37] Four years later they were playing themselves in a feature film, *The Dummy Talks* (1943, dir. Oswald Mitchell), as one of several speciality acts: 'A ventriloquist is murdered, leaving a show to be done. So, a midget goes undercover as the dummy. But, he always needs to find the criminal!'[38]

Throughout the 1940s the Lai Founs had a regular slot at the Bristol Hippodrome where they performed with many variety acts.[39] In 1942 a short film of their act was shot in London by Pathé and in the same year they were performing

33. Bertram Mills Circus programme, dated 1934–1935, London, Olympia Hall, private collection. See also 'Round the Halls: Last Week of Crazy Month', *The Daily Mail*, 20 December 1932, 5; Charles Graves, 'Signing Them up for the Circus', *The Sphere* 139, no. 1822 (22 December 1934): 484. The caption to a photograph in *The Sphere* is wrong to say that 1934 was their first season in the UK but does confirm that the group had its origins in Hong Kong.
34. 'Rio House Holding on to Vaude Policy', *The Billboard* 54, no. 41 (10 October 1942): 13. See also *The Billboard* 60, no. 7 (14 February 1948): 49; *The Billboard* 61, no. 47 (19 November 1949): 58; *The Billboard* 62, no. 40 (7 October 1950): 30.
35. John S. Clarke, *Circus Parade* (Huddersfield: Jeremy Mills Publishing, 2008), 68.
36. See 'Variety', Internet Movie Database, http://www.imdb.com/title/tt0402567/?ref_=nm_flmg_slf_2. Accessed 8 April 2020. *Variety* was shown at 3:30 p.m. on 2 November 1936. See *The Radio Times*, no. 683 (1–7 November 1936), 88, https://genome.ch.bbc.co.uk/page/68aba19c259d4c37ae285afae2798390. Accessed 8 April 2020.
37. 'RadiOlympia – September 1938', YouTube video, 3:56, from a performance broadcast 3 September 1938, posted by 'aptsarchive', 30 August 2008, https://www.youtube.com/watch?v=dFRoNw9K8mA. With a scene from *Cabaret Cruise*—featuring Walsh and Barker, Steve Geray and Magda Kun, the Five Lai Founs, and the Dennis Van Thal Orchestra. *The Radio Times*, no. 778 (28 August–3 September 1938), 38.
38. 'The Dummy Talks', Internet Movie Database, http://www.imdb.com/title/tt0165739/. Accessed 14 June 2014. The film took the form of a revue featuring the Ivy Benson's all-female band and the Five Lai Founs performing their usual act. See 'At the Cinemas', *The North Devon Journal-Herald*, 22 December 1943, 2.
39. The Lai Founs performed at the Bristol Hippodrome in 1940 from 25 to 30 March. They played there again from 12 to 17 August; in 1941 from 16 to 21 June; and in 1943 from 15 to 20 February in the International Circus. Information according to the website of the Bristol Hippodrome, which is no longer available.

their 'Vaudeville act' as far afield as Brazil.[40] In 1949 they were once again performing with the Bertram Mills Circus, this time in collaboration with another Chinese group—the Moy Long Troupe—making a team of ten acrobats in all. By 1950 they were playing in New York, and were still performing in the US two years later, rather diminished in number, as the Four Lai Founs.[41] Lai Foun, erstwhile contortionist and plate-spinner, now actor and film impresario, had come from this showbiz world of vaudeville, music hall, and the circus. By 1936 he was in a position to invest a considerable sum of money in his film business.[42]

The plan to make Anglo-Chinese films—'an interesting experiment' as described by Winifred Holmes—was to be the raison d'être of the Bijou Film Company. Lai Foun would be in a position to make a place for Chinese actors like himself in the ever more popular world of film and, perhaps, even shake off the scourge of the 'Yellowface' productions that were so widely accepted as the norm in Western showbiz circles. He was not only to be a partner and producer of the Bijou Film Company but, by all accounts, its main star—the romantic lead.

However, his dream of making a series of films was doomed to failure. On the website of the British Film Institute there are only two films listed as starring Lai Foun and neither mention Shih-I Hsiung as having been involved in their production. A musical entitled *Chinese Cabaret*—introduced by Holmes as a 'quota short'—was the first to be shot and was apparently made in association with Columbia Films. This is the story of the young man who travels to England and drops out of his studies to join the circus. Confusingly, elsewhere the story is said to be about a London detective's daughter unmasking a Chinatown restauranteur as a silk smuggler.[43] Shih-I Hsiung is not mentioned at all with regard to this and the 'story' is said to be written by S. E. Reynolds, a well-known television presenter and producer of the time. Another source of information from the time tells a rather different story. In a brief caption to a photograph of Dai Ailian in *The Dancing Times* the following information is found: 'Ai Lien Tai, the celebrated Chinese dancer as she appears in the Bijou Production for Columbia, *Chinese Cabaret*, starring the

40. See a clip of the Lai Founs 'probably filmed at' the Pathé Studios, London: 'Lai Founs', British Pathé Archive, 3:08, 1544.04, Canister NSP 312, Media URN 58694, 23 March 1941, http://www.britishpathe.com/video/lai-founs. See also 'Rio House Holding on to Vaude Policy', *The Billboard* 54, no. 41 (10 October 1942): 13. At the end of the war, on 21 May 1945, they were amongst the acts to appear at the Tower Circus, Blackpool, for a Grand Victory Show, according to the programme for the show.
41. *The Billboard* 62, no. 40 (7 October 1950): 30; *The Nevada State Journal*, 17 January 1952, 2.
42. 'Lai Foun announced a few months ago his decision to become a film produced himself, and acquired the new £20,000 Medway Film Studios in Kent. He will return to England in a few weeks, and will star in a second production there'; 'Hitler Honours British Star: Lai Foun at Olympic Party', *The Era*, 26 August 1936, 19. A similar story is told in 'Pictures in London', *The New York Times*, 24 May 1936, 3. Due to the large amount of money invested by him, it is tempting to think that he might have had personal contacts in the world of film—perhaps in his hometown of Hong Kong—who were able to raise money on his behalf.
43. The film, which ran for forty-four minutes, was directed by Buddy Harris, produced by Moy Long and Rae Saloman, and starred Robert Hobbs as Blackstone, Douglas Stewart as Inspector Brand, and Lilian Graham as Brand's daughter Peggy. It is Peggy who uncovers the smuggling ring. In addition, the following variety acts are listed: Lai Foun Troupe, Anne Ziegler, Hal Fox and His Band, Dinah Lee, and Grant and Moseley.

new Chinese film star, Lai Foun. Miss Tai is now working on an elaborate Chinese ballet for this film, the script for which is being written by Mr. S. I. Hsiung, author of "Lady Precious Stream".[44]

In another film produced at Snodland with the participation of Lai Foun—a film by the Medway Film Company—the contortionist is again listed among several supporting acts, simply as a member of Lai Foun and His Chinese Wonders.[45] A surviving promotional leaflet for the Medway Film Company's *International Revue* shows all the hallmarks of Orientalist music hall at its most typical.[46] This was the second film to feature Lai Foun made in 1936. Whereas the first was described as a 'story' the second is said to be a 'revue' and it is difficult to imagine what role Hsiung could have played as a writer in that context. In the illustrations to the leaflet, the orchestra—George Colborn's Musicas, playing music composed by one Marc Anthony—is shown upstage (behind where the acts perform), in a manner typical of live stage productions of the time. Colborn's name is given a prominent position, emblazoned across the set of tubular bells (a ubiquitous feature of stage bands during the 1930s) on display behind the drum kit. From the layout of the music stands, as seen in a photograph in the leaflet, it appears that the band numbered between twelve and fifteen players. What is most distinctive about the band, though, is their dress. The members who are visible in the photograph—all white males—are wearing the costume of the Chinese 'mandarin', the Manchu dress of the former Qing empire. This 'Oriental' contribution to the *International Revue*, augmented further by an 'Egyptian' comedy duo, as shown in the leaflet (again both white males, this time dressed in 'Ancient Egyptian' costume), was apparently given true authenticity by Lai Foun and his Chinese Wonders, though they are not shown in the photographs. As with the available information about *Chinese Cabaret*, it clearly states in this leaflet that the main stars were supported by a number of lesser acts, including Lai Foun's group. It is difficult to know, from the information given, exactly what format either of these films took, but it would seem that in both cases, at least one dramatic sketch was performed, probably in the manner of a televised stage show.[47] Most of the performers involved in this production have long been forgotten, but those about whom information is still available include the comedian

44. *The Dancing Times*, no. 309 (June 1936): 291. Thanks to Emily Wilcox for bringing this article to my attention. Hsiung was in the US from 31 October 1935 until 18 March 1936. In September 1936 he travelled to Brussels and at the end of December he was in China. See Yeh, *The Happy Hsiungs*, 59–61, 68.
45. An entry in the 1937 *Kinematograph Year Book* reads as follows: 'Chinese Cabaret (Mar. 16.) Lai Foun, Robert Hobbs, Lilian Graham. 4,000 ft U. "Kine." Mar 19, 1936 Rel[ease]. date not fixed. COLUMBIA'; *The Kinematograph Year Book, 1937* (London: Kinematograph Publications, 1937), 64. The office of the Bijou Film Company was at 245 Oxford Street, London. The 'directorate' was Buddy Harris, Moy Long, and Rae Saloman. See *The Kinematograph Year Book, 1937*, 350.
46. *International Revue* film programme, 1936, National Provincial Film Distributors Ltd., 32 St James's St. London SW1, in writer's own collection. The following information is recorded in *The Kinematograph Year Book, 1937*, 73: '*International Revue* (Nov. 3) Ronald Frankau, Lai Foun and his Chinese Wonders. Fred Duprez. 3,000 ft. U. "Kine." November 5, 1936. Rel. date not fixed. National Provincial.'
47. This sketch starred Fred Duprez as a manager, Edmund Dalby as an agent, the singer Winifred Bury as a secretary, and Sidney Arnold as a bartender, plus a singing duo—the Henderson Twins.

Ronald Frankau; Winifred Bury, singer and pianist; Frank Braidwood, also a singer; and Peter Bernard. Bernard was playing the following year as frontman of Peter Bernard and his Ragtimers, an act that was nothing less than an American-style minstrel show performing without makeup.[48]

This was the year of the Olympic Games in Berlin and the Lai Founs were there. Interest was apparently shown in Lai Foun and *International Revue* by none other than Adolf Hitler himself. Lai Foun had the dubious honour of meeting him in person—and not just in passing. The Lai Founs had been specifically chosen by Hitler to take part in the special entertainment that was laid on at his home in celebration of the games:

> A British film and variety star – Lai Foun – received a command from Hitler to appear with his company at a private party at his own home in honour of the champions of the Olympic Games . . . After the performance, Hitler spoke to Lai Foun for ten minutes, and warmly congratulated him on his performance. Hitler was very interested in Lai Foun's recent film appearance in 'International Revue'.[49]

Due to Hitler's racial beliefs and the notoriety of the Berlin Olympics with regard to these, it is unlikely that he would have shown more than a passing interest in a performer who did not fit in with his theories of the superiority of the Aryan race. He may, or may not, have noticed the unsuccessful fifty-four-strong Chinese Olympic team that had been sent by the Chinese Nationalist Party government to compete at the games, but he is certainly unlikely to have met any of them in person.[50] It is unlikely that Hitler would have heard of *International Revue* before he met Lai Foun and he was probably only expressing an interest in what he had been told directly about the film by Lai Foun himself—if indeed what is reported in the newspaper report holds any truth in it at all. There is no information available to say what Lai Foun thought of the meeting. No doubt, by the time war broke out this would have become an episode in his life he would have rather kept to himself.

In the scant information available about *International Revue*, Lai Foun's name is given variously as 'producer' and 'actor'. However, this is not what appears on the promotional leaflet, which states that the production was both produced and directed by Buddy Harris, who was also the director of *Chinese Cabaret*.[51] Can these films really be what Lai Foun had in mind? It seems most unlikely from an analysis of the available information that the films originally planned by Lai Foun, with screenplays by Shih-I Hsiung (that included *Shadow Sweetheart* and *Violin Song*),

48. 'Peter Bernard and His Ragtimers', British Pathé Archive, 3:22, 1160.05, Canister PT 395, Media URN 40114, 18 October 1937, http://www.britishpathe.com/video/peter-bernard-and-his-ragtimers/query/Joe.
49. 'Hitler Honours British Star', 19.
50. 'Hitler Honours British Star', 19.
51. *International Revue* film programme, 1936. Appearing to contradict this, the website of the British Film Institute gives Harris's name only as director of the film, and it is Lai Foun and the Medway Film Studios that are recognised as the producers. Lai Foun is also listed as a cast member. 'International Revue (1936)', British Film Institute, https://explore.bfi.org.uk/4ce2b72de5569.

were ever actually completed, and without the input of Hsiung perhaps Lai Foun simply reverted to the show-business environment he knew best.

Following *International Revue*—with a touch of the Orient supplied by The Lai Founs to the musical accompaniment of a band of Fu Manchu lookalikes—Lai Foun's troupe continued to perform in the distinctly Orientalist circles of the music hall and circus. In *Eastern Cabaret*, shown on BBC television in May 1938, The Five Lai Founs were again performing, in the company of a cast that included the French songstress Reine Paulet, known for her renderings of Arabic songs, and Walsh and Barker, singers of comic songs to piano accompaniment such as 'Denis the Menace from Venice'.[52] The compère of this *Eastern Cabaret* special was Nelun Devi.

Orientalist Performance

Nelun Devi and her husband, Devar Surya Sena, were by this time well known for their performances of songs collected in their travels throughout their native Sri Lanka. Their performances were most certainly not restricted to the songs of Sri Lanka, though, as they featured music from countries many thousands of miles apart. The programme for their London debut, at the Grotrian Hall in 1932, was typical of their later performances. It promised a 'Request Recital by the Sinhalese Singer Surya Sena, to be given with the assistance of Nelun Devi'. Although no complete list of the works is given, this concert was to include a diverse and eclectic mixture of 'Indian, Nepalese, Tibetan Folk-Songs, Descriptive Songs, Boatmen's Songs, Harvesting Songs of Ceylon, Recitations from Tagore, Indian Instrumental Items … and Folk Songs from Cyprus and Roumania [sic]', and even a selection of 'Negro Spirituals'.[53]

Such a concert would no doubt have appealed greatly to an English audience that yearned for their share of the mystic East, an Oriental world to which their imaginations could escape while relaxing close to home. Indeed, this was nothing less than another example of the Orientalist entertainment world so prevalent in England during the first decades of the twentieth century, here, not presented in the context of the films of Fu Manchu or the showbiz world of Lai Foun, but in a concert situation attended by a middle-class audience keen to broaden their understanding of music from far-off lands. The performers had even Orientalised their names along the way: Nelun Devi, born in Sir Lanka, was originally named Julia Pauline Winifred de Silva, and Devar Surya Sena was born Herbert Charles Jacob Pieris.

Shih-I Hsiung, as writer of *Lady Precious Stream*, should no doubt be seen in a similar way: as a purveyor of a distinctly Orientalist production for the enjoyment

52. Some of the same acts would appear together in the *Cabaret Cruise* series that began later in the year. Walsh and Barker can be seen in the following clip: 'Walsh and Barker', British Pathé Archive, 2:14, 1124.22, Canister PT 295, Media URN 39161, 18 November 1935, http://www.britishpathe.com/video/walsh-and-barker-9.
53. See 'Grotrian Hall, London (1932)', http://www.concertprogrammes.org.uk/html/search/verb/GetRecord/4758.

of the middle-class audiences of England.[54] As will be shown below, this is certainly how progressive Chinese playwrights saw his play: made for a foreign audience, or, in the case of the Shanghai English-language version, for those privileged Chinese lucky enough, or wealthy enough, to have studied English abroad or in Western-style schools in China. *Eastern Cabaret*, compared by Nelun Devi, with The Five Lai Founs, Reine Paulet, and Walsh and Barker—the latter no doubt performing songs with an Oriental twist—was the typical fare of the variety show and musical hall. It should be stressed that it was in London music hall circles that the creator of Dr. Fu Manchu enjoyed his first successes; Sax Rohmer had begun his career as a writer of sketches and songs for the music hall, and one of his closest friends was George Robey, who starred in the film version of *Chu Chin Chow* with Anna May Wong.[55]

Shih-I Hsiung and Film

As a young man, in 1922–1923 Shih-I Hsiung gained an understanding of the world of Chinese cinema working as manager of what was to become the largest Chinese-run cinema in Beijing, the 'Cheng Kwang Movie House' (Zhenguang dianyingyuan 真光電影院). This state-of-the-art cinema—rebuilt in 1921 to the highest standards after the first 'Cheng Kwang Movie House' was destroyed by fire—belonged to Hsiung's friend Lo Ming Yau (1900–1967), a Hong Kong entrepreneur who established the first Chinese-run cinemas in the city.[56] By 1927 Lo had founded Northern China Film (Huabei dianying gongsi 華北電影公司), and in the same year, while studying at university, Hsiung moved to Shanghai to act as managing director of one of the thirty-nine cinemas then in the city, 'The Pantheon Theatre' (Baixing daxiyuan 百星大戲院).[57] It will be remembered that 1927 was the year of the Chinese release of *Xixiangji* by Lai Man-Wai and the Minxin Film Company, and just three years later Lai and Lo joined forces to establish the Lianhua Film Studios.[58] The Pantheon closed in 1929 as a result of the worldwide economic crash.[59] In London's West End this was the time of the release of *Piccadilly*, the mounting of *The Circle of Chalk*, and the screening of *The Rose of Pu-Chui*.

A relationship with cinema continued throughout Hsiung's life, and *Lady Precious Stream* and his 1935 translation of *Romance of the Western Chamber* might best be seen as rare excursions into the theatre world, perhaps with a view

54. Devar Surya Sena's book proudly tells his own story in some detail but only hints at that of his wife. Devar Surya Sena, *Of Sri Lanka I Sing: The Life and Times of Devar Surya Sena O.B.E., M.A., L.L.B., A.R.C.M* (Colombo: Ranco, 1978), 78–79.
55. For more on this see Frayling, *The Yellow Peril*, 137–46.
56. Zhang, *Chinese National Cinema*, 49.
57. For more in this see Da Zheng, *Shih-I Hsiung: A Glorious Showman* (Vancouver, BC: Fairleigh Dickenson University Press, 2020), 37.
58. Kristine Harris, 'Ombres Chinoises: Split Screens and Parallel Lives in Love and Duty', in *The Oxford Handbook of Chinese Cinemas*, ed. Carlos Rojas and Eileen Cheng-Yin Chow (Oxford: Oxford University Press, 2013), 45.
59. Yeh, *The Happy Hsiungs*, 21–22.

to becoming more closely associated with higher intellectual pursuits. It was certainly as an intellectual and a member of the upper echelons of Chinese society that Hsiung sought to be recognised in the West, and to some extent he was successful in this.

Hsiung's translation of *Romance of the Western Chamber* (the play on which *The Rose of Pu-Chui* was based) met with some critical acclaim and was even chosen for inclusion in the UNESCO Collection of Representative Works published in the 1960s by Columbia University Press, the aim of which was to republish 'works that . . . any educated man should . . . read'.[60] Hsiung's translation appeared with a 'critical introduction' by the pioneering scholar of Chinese literature in the West, C. T. Hsia, who declared that Hsiung's translation had 'stood well for over thirty years', while at the same time expressing the wish that 'we may hope someday to have a translation which renders the text . . . in a more poetic fashion'.[61]

The image of Shih-I Hsiung in Europe and the US, as a product of a land of 'Oriental' mystery, was simply an imaginative creation of an overeager Western audience; his persona evolving in response to a demand for such a figure in Western theatrical circles. As previously mentioned, Butterfly Wu was quite baffled by it when she saw Hsiung's play in London.[62] In her memoirs, she comments on the two stage hands in charge of the props, reporting that they had made her and other Chinese members of the audience uncomfortable, as their clothing and sinister demeanour were reminiscent of the stereotypical 'Chinaman' seen in Western films: long formal gowns and traditional caps, hands buried in sleeves, stooped shoulders and long moustaches.[63] In fact, these figures, the 'Property Men', were very much part of the production and are named in the programme as members of the cast.[64]

Stalwarts of left-wing progressive theatrical and literary circles in China did not take kindly to Hsiung's Orientalising of Chinese theatre, seeing it as anything but forward-looking in the new intellectual atmosphere that was then flourishing at home. Two playwrights in particular, Tian Han (1898–1968) and Hong Shen (1894–1955), saw *Lady Precious Stream* as a poor translation of an old play that had no value in the forward-looking Chinese theatrical scene in which they saw themselves as pioneers. Hong Shen wrote a lengthy analysis in which he suggested that in writing the play Hsiung had insulted both China and the Chinese.[65] In another

60. Wm. Theodore de Bary, foreword to *The Romance of the Western Chamber*, by Wang Shifu, trans. S. I. Hsiung (New York: Columbia University Press, 1968), ix.
61. C. T. Hsia, 'A Critical Introduction', in *The Romance of the Western Chamber*, xxxii.
62. Hu Die, *Hu Die huiyilu*, 152–54.
63. Hu Die, *Hu Die huiyilu*, 153–55. These stagehands are also mentioned by Hong Shen in his critique. See Hong Shen 洪深, 'Ruguo de *Wang Baochuan*' 辱國的王寶川 [*Lady Precious Stream*—a national insult], in *Hong Shen wenji* 洪深文集 [Collected works of Hong Shen] (Beijing: Zhongguo xiju chubanshe, 1959), 4:248. Originally published in *Guangming* 光明1, no. 3 (July 1936). See also 'Yu Shangyuan fu Ou kaocha xiju' 余上沅赴歐考察戲劇 [Yu Shangyuan visits Europe to observe theatre], *Yifeng* 藝風 [Art trends] 3, no. 2 (1935): 122.
64. Theatre programme for *Lady Precious Stream*, Little Theatre, London, 27 November 1934–?. See also programme for *Lady Precious Stream*, Arts Theatre of Cambridge, 20 July 1936, 4.
65. Hong Shen, 'Ruguo de *Wang Baochuan*'.

anonymous article the play is said to be nothing but a Westernisation of the Chinese original, describing Hsiung as being 'fascinated by skeletal remains'.[66] Hong Shen's lengthy essay, which appeared in the left-wing periodical *Guangming*, is a scathing attack on Hsiung, his translation of the play, and the manner of its performance.[67] He begins by bemoaning two attitudes frequently exhibited by foreigners when referring to China. The first, the covert insult, he suggests can be seen in such writings as Rudyard Kipling's jingoistic, imperialist poem 'The White Man's Burden'.[68] The second could be found in Pearl Buck's novel *The Good Earth*, which represented in his view part of a widespread inclination among foreigners to praise things belonging to China's past, but to ignore, or belittle, more recent developments in modern Chinese society. Although Buck was writing about relatively recent times, in Hong's view she reduces the story to one that praises only the female virtues of China in times gone by. Additionally, he criticises a tendency among foreigners in general to praise the fragile beauty of Chinese women of the past, despite the fact that by that time great efforts had been made in China to cast off the traditional view of female beauty—as seen for example in the literary trope of the *caizi jiaren* 才子佳人 (scholar and beauty)—in favour of another type altogether: the new form of beauty inherent in the strong revolutionary woman, as represented in Chinese literature and film of recent years.[69] Both Hong Shen and Tian Han had earlier referred to themselves as Chinese Ibsens, and Nora, the protagonist of *A Doll's House*, who had been popular as a positive model for progressive Chinese womanhood for two decades already, was much more the type of character they sought to endorse.

According to Hong Shen, both faults could be seen in Shih-I Hsiung's play. Hong was particularly unhappy about Hsiung's public declarations, made in various interviews and articles, in which he claimed that everything about the play was done in accordance with the practice of traditional Chinese drama, with the sole exception of the language.[70] From reviews of the play it can be seen that London audiences were largely convinced of the play's authenticity.[71] Hong suggests that because Mei Lanfang had already performed in the US, it had not been so easy to pull the wool over the eyes of American audiences.[72] Indeed, the chasm that exists between the performances of Mei Lanfang and the bastardisation of Chinese opera as seen in

66. Ru Yu 如愚, 'Xiong Shiyi yu Tian Han Hong Shen zhiqu butong' 熊式一與田漢洪深旨趣不同 [The differing objectives of Xiong Shiyi, and Tian Han and Hong Shen], *Beiyang huabao* 北洋畫報 ['Pei-yang Pictorial News'] 31, no. 1520 (23 February 1937): 2.
67. Hong Shen, 'Ruguo de *Wang Baochuan*', 4:244–53.
68. Hong Shen, 'Ruguo de *Wang Baochuan*', 4:244–45.
69. Hong Shen, 'Ruguo de *Wang Baochuan*', 4:245.
70. Printed on the programme of the Little Theatre production were the words 'produced according to the Chinese Conventions by Nancy Price and S. I. Hsiung'. Something similar was still being said when the play was televised in 1950: 'This old Chinese play blending comedy and sentiment, is presented in the traditional manner of the Chinese theatre'; 'Lady Precious Stream', *The Radio Times*, no. 1377 (5–11 March 1950), 46.
71. See also the theatre programme for *Lady Precious Stream*, Little Theatre, London, 27 November 1934–?, front page.
72. Hong Shen, 'Ruguo de *Wang Baochuan*', 4:247. This argument does not, of course, take the success of the Broadway production into account.

Hsiung's play should have been evident to even the most uneducated viewer. Hong sees Hsiung's rewriting of *Lady Precious Stream* as no longer a Chinese play at all, but one that merely emulates the worst imitations of Chinese-themed plays and films created by foreigners.[73] Hong Shen continues his diatribe by suggesting that foreigners will gain no understanding at all of Chinese drama, nor of Chinese life, from watching the play. He tops this off with the damning declaration that not only was it not a Chinese play but it was not even a very good 'foreign' play.[74]

Hsiung had a long but not altogether fruitful relationship with the film business. His greatest triumph was as a playwright, but he never managed to repeat this success in later years. *Lady Precious Stream* was followed by his aborted adventure with Lai Foun and the film company in Snodland. In later life Hsiung continued his association with the cinema, founding his own company, the Pacific Films Corporation, in Hong Kong and acting as director of the Konin Corporation.[75] His excursion into the world of fiction, with his English-language novel *The Bridge of Heaven*, makes for turgid reading when compared, for example, to his friend and compatriot Lin Yutang's monumental *Moment in Peking*. Hsiung's biography of his 'hero' Chiang Kai-shek, published in 1948 during the time of the Chinese Civil War (1946–1949), illustrates well why left-wingers such as Tian Han and Hong Shen had no time for him intellectually or ideologically; their political views and allegiances at the time of war between the Chinese Communist Party and Nationalist Party being entirely at odds.[76] With the founding of the People's Republic of China, Hsiung's intellectual roots were severed in mainland China. His work had never been popular there but following the continued rise of the left-wing film movement, with recent films such *The Spring River Flows East* (1947) and *Crows and Sparrows* (1949), competition had become more intense. In 1950 he was still living off the back of his early success, with a BBC television production of *Lady Precious Stream*, starring Joan Painter in the title role, sixteen years after the play's extended run began in London's West End.[77] By 1956 Hsiung was working again on a Chinese version of the screenplay of the play for Pacific Films. This was completed in London in 1958 but failed to find a distributor in England, the country in which he had been so successful as a playwright, more than twenty years before.[78]

73. Hong Shen, 'Ruguo de *Wang Baochuan*', 4:247.
74. Hong Shen, 'Ruguo de *Wang Baochuan*', 4:251.
75. Miles Xian Liu, *Asian American Playwrights: A Bio-bibliographical Critical Sourcebook* (Westport, CT: Greenwood Press, 2002), 121.
76. Shih-I Hsiung, *The Life of Chiang Kai-shek* (London: Peter Davies, 1948). Hsiung refers to Chiang Kai-shek as his 'hero' a number of times in the book.
77. 'Lady Precious Stream', *Radio Times*, 46. Broadcast on 7 March and repeated 'for older children' on 12 March.
78. Yeh describes it as having been 'close to a disaster'. Yeh, *The Happy Hsiungs*, 138.

10
A 'Chinese Shelley' in 1930s Britain
Wang Lixi's Transnational Activism and Transcultural Lyricism

Ke Ren

In 1939, shortly after he moved to Oxford, Chiang Yee happened upon the Shelley Memorial in University College. Recounting his various musings from this encounter in one of the earliest chapters in *The Silent Traveller in Oxford*, Chiang comments, in his characteristic meandering style, on not only Percy Bysshe Shelley's (1792–1822) life and writings, but also his own personal associations with the Romantic poet. He concludes the chapter with a moving account of his compatriot and friend Wang Lixi (1901–1939), 'who had a great passion for the poet's work' and even called himself Shelley Wang. According to Chiang, Wang was a 'strongly revolutionary' figure with whom he had shared a London flat for a year, having arrived in Britain shortly before Chiang did. Having had some of his ideas for social reconstruction rejected in China, Wang lived in exile in Europe, 'often in poverty and sorrow'. Recalling that Wang 'wrote good poetry in Chinese classical styles as well as free verse', Chiang proceeds to quote two poems by his friend, one of which reads:

> How is one worth a bowl of rice by selling writings?
> Endangered by life yet craving to live I left my country
> But history has always been made by swords and guns,
> Those fighting on paper nothing but dogs and horses –
> The huntsman hallos them on.[1]

Chiang ends this piece by revealing that after Wang returned to China following the Japanese invasion, he died at the Henan front, having sent Chiang Yee one last volume of poems, entitled *Exile and Wars* (*Quguo cao* 去國草, 1939; the literal translation would be *Manuscripts in Exile*). With an air of regret, Chiang remarks

1. Chiang Yee, *The Silent Traveller in Oxford* (New York: Interlink Books, 2003), 13. Translated by Sylvia Townsend Warner. Chiang has mistakenly transcribed the word "haloos" in the original poem as "hallos."

that his friend 'did not devote all his energy to writing poetry' and he could not envision Wang's 'name being remembered a hundred years hence'.[2]

His predictions as to Wang Lixi's posthumous reputation aside, Chiang Yee's brief account raises a couple of intriguing questions. On the one hand, that Wang did not or could not fully commit his time to writing poetry leaves one wondering which other activities this 'strongly revolutionary' Chinese pursued in 1930s London. On the other hand, both of Wang's poems cited by Chiang were translated by Sylvia Townsend Warner (1893–1978), the well-known novelist, poet, and communist activist. Which personal, political, and literary connections linked an exiled sojourner like Wang to an established British writer like Warner? What kind of political networks and cross-cultural exchanges existed between leftist Chinese and British activists in the 1930s?

This chapter approaches these questions by examining the transnational activism and writings of Wang Lixi, a revolutionary intellectual and poet who joined his fellow Jiangxi natives Chiang Yee and Shih-I Hsiung to form a trio of displaced Chinese writers in 1930s Hampstead. The most politically engaged of the group, Wang travelled widely to gather support for China's War of Resistance against Japanese Aggression and became a key participant in transnational anti-fascist movements such as the 1935 International Congress of Writers for the Defence of Culture, the International Peace Campaign (IPC), and the China Campaign Committee (CCC). At the same time, he established close relationships with British leftist organisations and publications such as the Left Book Club and *Left Review*, while forming personal connections to writers like Sylvia Townsend Warner and especially the Ulster poet John Hewitt (1907–1987). These associations resulted in a series of transcultural encounters, such as the publication of Wang's essays and poetry in British leftist magazines, Wang's appearance in public salons in Dorset and Belfast, and Warner's reading of Wang's poems on BBC radio. Among Wang's numerous writings, the most innovative was the poetry collection *Exile and Wars*, composed as a deliberate combination of classical-style Chinese verse and modern subject matter such as peace conferences, the war in China, and encounters with fellow activists in Europe. One-third of this volume was translated into English by Wang's British friends and associates, while memories of these encounters would also resurface in several subsequent forms. Reading these moments together with Wang's travel writings and their appearance in various correspondences, memoirs, and contemporaneous newspapers, this chapter demonstrates that Wang's political activism and transcultural poetry point to an intense and innovative episode of 1930s internationalism and cross-cultural engagement extending from the circle of Chinese writers around Chiang Yee.

2. Chiang, *The Silent Traveller in Oxford*, 14.

From Editor in Shanghai to Exile in London

Born in 1901 in Anfu county, Jiangxi, Wang Lixi was raised in a family of prominent late Qing scholars and educators. After his father died when he was only six years old, Wang was first taught by his grandfather, before enrolling in a series of local schools and colleges, until their declining family fortunes forced him to leave university and take on a teaching position in a provincial agricultural school. Through his early schooling, Wang would retain a lifelong passion for classical Chinese poetry. Later, Wang's self-identification as a Chinese poet would play an important role in his overseas activism.[3]

In the aftermath of the conquest of Nanchang by the National Revolutionary Army in late 1926, Wang, who had joined the Kuomintang (KMT) sometime earlier during his days at the Ji'an Normal School, was elected to be the head of the Provincial Peasant Bureau. In January 1927, Wang also became one of the eight founding members of the provisional committee for the Hunan-Hubei-Jiangxi Peasant Movement Training Institute, working briefly alongside Mao Zedong (1893–1976).[4] In a region that by early 1927 had become a hotbed of revolutionary activity and peasant agitation promoted by the young Chinese Communist Party (CCP), as well as reactionary and anti-communist movements, Wang seemed to have made complicated political choices. While he notes vaguely in his brief autobiography that he departed Wuhan due to irreconcilable differences with Mao, other sources indicate that Wang had been a member of the so-called AB (Anti-Bolshevik) League, an anti-communist group.[5]

In 1927 Wang first met Chen Mingshu (1889–1965), a veteran of the 1911 Revolution from Guangdong and then vice-director of the KMT political department in Nanjing. Sharing intellectual interests, the two became friends.[6] In the 1930s, they collaborated on a series of influential publishing and political endeavours: the Shenzhou guoguang she 神州國光社 (Publishing House of the National Glories of the Divine Land), the Shanghai War of 1932, and the Fujian Rebellion of 1933–1934. These ventures also contributed to the conditions of Wang's exile and dictated his political outlook during his later years of activism.

Wang had begun reading Marxist materials in the early 1930s. After Chen Mingshu turned editorship of the Shenzhou guoguang she over to him, Wang

3. For biographical information on Wang Lixi see Gu Yiqun et al., *Wang Lixi zhuan* [A biography of Wang Lixi] (Chengdu: Sichuan daxue chubanshe, 1995); Gong Lianshou, 'Wang Lixi nianpu' [Chronological biography of Wang Lixi], in *Wang Lixi yanjiu ziliao* [Research materials on Wang Lixi], ed. Pan Songde (Tianjin: Tianjin shehui kexueyuan chubanshe, 1995), 22–67; and Wang Lixi, 'Wang Lixi xiaozhuan' [A brief biography of Wang Lixi], in *Wang Lixi yanjiu ziliao*, 69–70.
4. 'Wang Lixi', in *Wuchang nongmin yundong jiangxisuo renwu zhuanlüe* [Brief biographies of figures of the Wuchang Peasant Training Institute], ed. Wuchang nongjiangsuo jinianguan (Wuhan: Wuhan chubanshe, 1997), 23–26.
5. On revolutionary and counterrevolutionary politics in Jiangxi in 1926–1927 see Stephen C. Averill, *Revolution in the Highlands: China's Jinggangshan Base Area* (Lanham, MD: Rowman and Littlefield, 2006), 123–38.
6. Chen Mingshu, *Chen Mingshu huiyilu* [Memoirs of Chen Mingshu] (Beijing: Zhongguo wenshi chubanshe, 1997), 167–68.

published a number of books and translations by leftist authors and also established the influential '*The Research Monthly*' (*Dushu zazhi* 讀書雜誌), a magazine that contributed significantly to what became known as the 'social history controversy', in which writers and historians such as Hu Qiuyuan (1910–2004), Tao Xisheng (1899–1998), and Guo Moruo (1892–1978) became embroiled in a series of debates over the historical and present nature of Chinese society and the extent to which it could be defined in Marxist terms as feudal, capitalist, or 'semi-colonial, semi-feudal'.[7] The provocative stance taken by Wang, as both publisher and participant in these debates, demonstrates the receptiveness of his thought in the early 1930s as it turned to categories such as capitalism and imperialism in examining the forces that oppressed China.

On 28 January 1932, when the Japanese attacked Shanghai, Chen Mingshu, along with fellow generals Cai Tingkai and Jiang Guangnai, led the Nineteenth Route Army in the soon-to-be-mythologised defence of Shanghai, despite Chiang Kai-shek's (1887–1975) lack of support. While the Nineteenth Route Army and its leaders became popular heroes almost overnight after the Shanghai War, tensions soon arose between Chiang Kai-shek and Chen Mingshu, who had previously been a supporter of Chiang in the late 1920s.[8] Whether it was at an order by Chiang or in response to a request by Chen, the Nineteenth Route Army was soon dispatched to Fujian, ostensibly to conduct the suppression of communists in that province. Yet soon thereafter Chen and his colleagues issued a declaration of an independent government in Fuzhou, headed by Nineteenth Route Army commanders. This was the famed Fujian Rebellion, in which not only a separate government was inaugurated, but a detailed 'Political Programme' and a 'Declaration of People's Rights' were published. The revolutionaries called for overthrowing Chiang Kai-shek and countering Japanese imperialism, while protecting the rights of workers and peasants.[9] They also entered into some limited negotiations with the CCP.

While Wang did not participate directly in the military manoeuvres of either the Shanghai War or the Fujian Rebellion, he was involved in both. In 1932, through the Shenzhou guoguang she, he published *Wartime Diary* (*Zhanshi riji* 戰時日記), a journal-style account of the brief war singing the praises of Chen Mingshu and the Nineteenth Route Army.[10] This implicit critique of Chiang Kai-shek's leadership, in addition to the Marxist debates published in his journal, so alarmed the Nanjing regime that it ordered Wang to go abroad in mid-1933 on a 'investigative mission',

7. Arif Dirlik, *Revolution and History: The Origins of Marxist Historiography in China, 1919–1937* (Berkeley: University of California Press, 1978), 57–227.
8. On the 1932 Shanghai War see Donald Jordan, *China's Trial by Fire: The Shanghai War of 1932* (Ann Arbor: University of Michigan Press, 2001); Xiao Ruping, *Nanjing guomin zhengfu yu 'yi·erba' Song-Hu kangzhan yanjiu* [The Nanjing Nationalist government and the January 28 Shanghai War of Resistance] (Hangzhou: Zhejiang daxue chubanshe, 2016). The latter is especially informative on the deteriorating relationship between Chiang Kai-shek and Chen Mingshu.
9. For a classic analysis of the Fujian Rebellion see Lloyd E. Eastman, *The Abortive Revolution: China under Nationalist Rule, 1927–1937* (Cambridge, MA: Harvard University Press, 1974), 85–139.
10. Wang Lixi, *Zhanshi riji* [Wartime diary] (Shanghai: Shenzhou guoguang she, 1932).

while taking the opportunity to seize his publications. Later that year, Wang secretly travelled back to China to join Chen Mingshu in Fujian and may have had an influential hand in the crafting of the political statements issued by the People's Revolutionary Government during the rebellion. From the registers of names preserved from the Shengchan renmin dang 生產人民黨 (Productive People's Party), an inner circle organized by Chen Mingshu in December 1933, we know that Wang was active in the political centre of the Fujian Rebellion.[11] When the rebellion failed after less than two months, its leaders were forced into exile overseas, most likely with a price on their heads. For Wang, who returned to England in 1934, this was the beginning of five years of exile and activism abroad, as well as his association with the Chinese literary community in Hampstead.

'Mountain Dwelling' in Hampstead

Arriving in London in the summer of 1933, Wang Lixi and his wife, Lu Jingqing (1907–1993), a graduate of Beijing Women's Normal College and a modernist author and feminist revolutionary, first stayed in a small room in Albert Street. Later, they rented a house by Parliament Hill at the corner of Hampstead Heath, sharing three rooms with Wang's fellow writer and Fujian Rebellion leader Hu Qiuyuan and his wife, Jing Youru. To economise, the two couples shared expenses for rent and groceries. After the Hus left England at the end of 1935, Wang and Lu only kept one of the rooms and used it as a multifunctional space that served as bedroom, study, living room, and kitchen. Having lost most of their possessions in Shanghai, the room contained almost everything the couple owned, including a steady accumulation of used volumes purchased from second-hand bookshops on Charing Cross Road.[12] In 1936 Wang and Lu moved to 50 Upper Park Road, where they became flatmates with Shih-I and Dymia Hsiung as well as Chiang Yee. This trio of writers formed the 'Jiangxi circle', and their Hampstead residence soon became a hub of activity among transnational Chinese in the mid-1930s. Cultural figures who came through London during this time, including the artists Liu Haisu (1896–1994) and Xu Beihong (1895–1953), as well as younger students, such as the future translator Yang Xianyi (1915–2009), at the time a student at the University of Oxford, who often visited with Wang, Hsiung, and others in London. Yang later recalled the circle around Wang as a 'social centre' and learning much from

11. 'Shengchan renmindang dangyuan huamingce' [Registry of People's Producer Party members], in *Fujian shibian dang'an ziliao, 1933.11–1934.1* [Archival materials on the Fujian Incident, 1933.11–1934.1], ed. Fujian sheng dang'an guan (Fuzhou: Fujian renmin chubanshe, 1984), 69–77; Eastman, *Abortive Revolution*, 111–12.
12. Lu Jingqing, *Lu Jingqing shiwenji* [Collected poems and prose of Lu Jingqing] (Chengdu: Sichuan daxue chubanshe, 1997), 176–78. Wang Lixi, *Quguo cao* [Manuscripts in exile] (Chongqing: Zhongguo shigeshe, 1939), 524. On Lu Jingqing see 'Lu Jingqing,' in Amy D. Dooling and Kristina M. Torgeson, eds., *Writing Women in Modern China: An Anthology of Women's Literature from the Early Twentieth Century* (New York: Columbia University Press, 1998), 157–59.

conversations with these older figures about the complicated political situation in China.[13]

While they were materially less well off than the Hsiungs, and Wang did not hold a regular teaching job like Chiang Yee, Wang Lixi and Lu Jingqing very much embraced their life in Hampstead. Alluding to the literati tradition of writing about *shanju* 山居 ('dwelling in the mountains'), Lu Jingqing wrote a long essay fondly capturing several scenes of their early years in the neighbourhood, including summer days on the grassy areas of Parliament Hill, encounters with street artists, and amiable conversations with their landlady, Mrs. Black.[14] In addition to these simple pleasures, Hampstead's associations with the Romantic poets also featured significantly in Wang's constructed persona as the poet-in-exile 'Shelley Wang'. Wang's self-fashioning after a Romantic British poet is completely reasonable considering his cultural milieu. Having come of age in China during the May Fourth and New Culture period (1915–1925), Wang belonged to the 'romantic generation' of aspiring writers and poets who venerated and identified with a pantheon of Western literary heroes, among whom Lord Byron, Shelley, and John Keats (1795–1821) were some of the favourites.[15] Indeed, one of the key contributors to the 'social history' debates that Wang had edited was the writer and historian Guo Moruo, who was also himself a Romantic poet known for his translations of Shelley's works, notably using the conventions of classical Chinese poetry.[16] When Chiang Yee himself recalled reading Shelley's poems rendered into classical Chinese by a 'gifted poet', he was quite possibly referring to Guo's translations. Yet it is also notable that Chiang later read other translations of Shelley in vernacular Chinese.[17] The availability of multiple translations speaks to Shelley's popularity in Republican China.

In later writings that retraced his own poetic education, Wang does not emphasise any special affinity for Western poets. Nevertheless, it is evident that 'Shelley' was not merely a playful reverse transliteration of his Chinese name for use in Britain. Throughout his poetry and prose writings are suggestions of a familiarity with and admiration of not only Shelley but also Keats. In his biography of the Tang poet Li He (790–816), the only monograph he published before leaving China, Wang causally notes that Li had died at the age of twenty-seven, 'like the English poet Keats'.[18] Wang visited Shelley's and Keats's tombs in Rome in 1933, ending his travel essays by quoting from Shelley's poem 'Julian and Maddalo'.[19] Describing his

13. Yang Xianyi, *White Tiger: An Autobiography of Yang Xianyi* (Hong Kong: Chinese University of Hong Kong Press, 2002), 50–51.
14. Lu Jingqing, 'Shanju zaji' [Miscellaneous records of mountain dwelling], in *Lu Jingqing shiwenji* [Collected poetry and prose of Lu Jingqing] (Chengdu: Sichuan daxue chubanshe, 1995), 174–84.
15. Lee, Leo Ou-fan, *The Romantic Generation of Modern Chinese Writers* (Cambridge, MA: Harvard University Press, 1973), 275–79.
16. Pu Wang, *The Translatability of Revolution: Guo Moruo and Twentieth-Century Chinese Culture* (Cambridge, MA: Harvard University Asia Center, 2018), 59–68.
17. Chiang, *The Silent Traveller in Oxford*, 10–11.
18. Wang Lixi, *Li Changji pingzhuan* [Biography of Li Changji] (Shanghai: Shenzhou guoguang she, 1930), 21.
19. Wang Lixi, *Haiwai zabi* [Miscellaneous notes from overseas] (Shanghai: Zhonghua shuju, 1935), 171–72.

earliest impressions of Hampstead Heath in a series of later essays published in 1936 for a Chinese readership, Wang wrote fondly of the green fields and hills in the area. Describing children and swans around the ponds, Wang casually notes that, 'it is said that Shelley used to sail small [paper] boats there'. In the same piece, Wang later remarks that a few steps away from South End Road one could find the Keats House and Museum, on Keats Grove, where the poet had composed his 'Ode to a Nightingale'. When friends came to visit, Wang often took them to a nearby café.[20] Having established his poetic persona, 'Shelley Wang', the exiled Chinese poet and activist would venture out from Hampstead to metropolitan London, other parts of the country, and indeed to other cities in Europe over the next five years.

Transnational Activism in International Organisations

One of the major leftist magazines of the 1930s, *Left Review* was established as a publication by the British Section of the International Union of Revolutionary Writers. Edited successively by several poets and critics such as Edgell Rickword (1898–1982), Montagu Slater (1902–1956), and Randall Swingler (1909–1967), the journal aimed 'to use literature and related activities as agents of political and cultural change'. With a circulation of about three thousand copies between 1934 and 1938, *Left Review* at once praised the Soviet Union and the Communist Party, while maintaining a significant degree of editorial independence in providing for a space in which contributors could debate aesthetics, Socialist Realism, and literary theory, criticise fascism and imperialism, comment on working-class conditions, and respond to international events such as the Spanish Civil War or the war in China.[21] It was the publication with which Wang was most closely associated during his time in London.

Wang's initial foray into the pages of *Left Review* took the form of a contribution to the so-called 'Writers' International controversy' of 1934–1935. This was a forum established by the editors to elicit responses to a statement issued by the British Section of the Writers' International calling upon writers who would like to contribute to the struggle against fascism by 'joining in the struggle of the working class for a new socialist society', to develop—if they were of the working class— more effective means of articulating that struggle, or to 'use their pens and their influence against imperialist war and in defence of the Soviet Union' and to 'expose the hidden forms of war being carried on against all the Indian, Irish, African, and

20. Wang, *Haiwai zabi*, 76; Wang Lixi, *Haiwai erbi* [A second notebook from overseas] (Shanghai: Zhonghua shuju, 1936), 8–9.
21. Peter Marks, 'Art and Politics in the 1930s: *The European Quarterly* (1934–1935), *Left Review* (1934–1938), and *Poetry and the People* (1938–1940)', in *The Oxford Critical and Cultural History of Modernist Magazines*, vol. 1, *Britain and Ireland, 1880–1955*, ed. Peter Brooker and Andrew Thacker (Oxford: Oxford University Press, 2009), 632–41. See also Margot Heinemann, '*Left Review, New Writing* and the Broad Alliance against Fascism', in *Visions and Blueprints: Avant-Garde Culture and Radical Politics in Early Twentieth-Century Europe*, ed. Edward Timms and Peter Collier (Manchester: Manchester University Press, 1988), 113–36.

Chinese peoples'. This was an expansive and internationalist agenda that initiated a series of debates, over the course of several issues, on the nature of literature and the political commitment of writers.[22]

Wang's response, published in the February 1935 issue, was interestingly not a direct rejoinder to some of the other contributors, many of whom made the issue of what constituted working-class literature their focus. The opinion of Scottish writer Hugh MacDiarmid (1892–1978) expressed in the article that directly preceded Wang's piece, for instance, was that proletarian literature should not be reduced to any standardised form and must 'depend upon considerations of quality, not quantity'.[23] Whether he wished to engage with the notions of 'quality' and 'quantity', or he had entirely misunderstood the terms of debate, Wang responded to an entirely separate controversy involving a different group of writers. As Wang revealed, he had been following the debate between H. G. Wells (1866–1946) and Ernst Toller (1893–1939) on 'the subject of intellectual freedom in the U.S.S.R.'. Comparing the relative state of 'freedom' in the Soviet Union with fascist states, Wang suggested two criteria, 'quantitative' and 'qualitative', as yardsticks. Conceding that 'in Russia the intellectual is permitted to write for the toiling masses; but not against them', Wang noted that in fact the toilers were the majority in the Soviet Union. In contrast, he argued that the ruling class in China, as 'agents of imperialism', had 'complete freedom to muzzle the press . . . and to put intellectuals to death'. Their tyrannical minority rule was comparable to that exercised in Germany and Italy. Thus 'quantitative freedom' is apparently greater in the Soviet Union, as was the more recent growth in 'qualitative' freedom, in contrast to fascist and capitalist states, which only circumscribed more intellectual freedoms over time, as was evidenced in the recent passing of the Sedition Bill in Britain.[24]

As it turns out, Wang had been following a debate that arose out of heated discussions of International PEN, presided over by Wells, which had been embroiled since its 1934 Edinburgh Congress in an argument about how to defend freedom of expression as a human right and supporting exiled German writers like Toller who had been persecuted by the Nazis. While Wells supported Toller, he could not support aligning International PEN with any other political movement, including communism, in a fight against Nazism or fascism, viewing the international writers' group as a transnational rights-based organisation outside of regular politics.[25] This apolitical stance was one that frustrated Wang, who mocked Wells for his stubborn adherence to the status quo.[26] Indeed, as Wang recounted in his *Left Review* contri-

22. 'I. The Writers' International Controversy', in David Margolies, ed., *Writing the Revolution: Cultural Criticism from 'Left Review'* (London: Pluto Press, 1998), 23–25.
23. 'From Hugh MacDiarmid', *Left Review* 1, no. 4 (February 1935): 182.
24. 'From Shelley Wang', *Left Review* 1, no. 4 (February 1935): 182–83.
25. Rachel Potter, 'International PEN: Writers, Free Expression, Organisations', in *A History of 1930s British Literature*, ed. Benjamin Kohlmann and Matthew Taunton (Cambridge: Cambridge University Press, 2019), 120–33.
26. Wang, *Haiwai erbi*, 46–48.

bution, he had in fact recently resigned from the Chinese branch of International PEN (which was established in 1934) 'on account of the hostility and indifference that greeted my protest against the Japanese invasion of China and against the ruthless persecution of our writers by the present Chinese government'.[27] Even if he misread the topic, by criticizing the passivity of Wells and pointing out curbs on intellectual freedom in Britain, Wang brought an outspoken Chinese writer's concerns into an otherwise Eurocentric debate.

His mistake notwithstanding, Wang found himself welcomed by the *Left Review* editors. In the March 1935 issue, he was listed as a contributor and described as having been 'driven out of China, almost all his writings being burnt by the Nanking government'.[28] Indeed, it may have been his status as an exiled writer that accounted for his having been invited by *Left Review*, along with Shih-I Hsiung, to join the British delegation to the International Congress of Writers for the Defence of Culture, held in Paris in June 1935.[29] Headlined by André Gide and André Malraux, the congress followed the united front policy set by the Seventh World Congress of the Comintern in 1935 in gathering together 230 writers from thirty-eight countries to consider the fascist threat to peace and literature. Held in the Maison de la Mutualité with a crowd that filled its seating capacity of three thousand, the congress delegates made statements criticising limits on intellectual freedom in their own countries, generally praised the Soviet Union, and resolved to set up an Association of Writers for the Defence of Culture, presided over by such luminaries as Maxim Gorky, Sinclair Lewis, and E. M. Forster. While some of the congress discussions were overshadowed by protests over the lingering fate of Victor Serge (1890–1947), the Russian writer imprisoned by Stalin, it did establish a momentum in international solidarity and fostered some individual exchanges.[30] It also offered an opportunity for Chinese delegates to join the transnational anti-fascist movement. The official representative for China was the Moscow-based revolutionary writer Xiao San (1896–1983). When Xiao could not make it to Paris due to illness, it was Wang who spoke up for China in Paris.[31]

Taking to the podium on the evening of 25 June, during the final session of the congress, Wang occupied the stage alongside Russian writers Boris Pasternak (1890–1960) and Isaac Babel (1894–1940). The panel's theme, 'The Defence of Culture', echoed the main theme of the congress. In his short but strongly worded speech, Wang noted that China was presently threatened not only from the outside by Japan's invasion but also domestically by an 'extraordinary oppression by the fascist dictatorship', referring to Chiang Kai-shek's regime in Nanjing. Wang related

27. 'From Shelley Wang', 183.
28. *Left Review*, 1, no. 6 (March 1935): 268.
29. Wang, *Haiwai erbi*, 72.
30. Jacob Boas, *Writer's Block: The Paris Antifascist Congress of 1935* (Cambridge: Legenda, 2016); Herbert R. Lottman, *The Left Bank: Writers, Artists, and Politics from the Popular Front to the Cold War* (Chicago, IL: The University of Chicago Press, 1998), 83–98.
31. Wang, *Haiwai erbi*, 72.

that there were three movements in China: the first a purely Westernising and capitalist tendency, the second a culturally conservative group that preached loyalty to Confucian principles and held up the existing social order, and the third represented by 'proletarian writers who kept up the revolutionary struggle of the people'. Meanwhile, Chinese intellectuals were being 'arbitrarily incarcerated, tortured, and put to death without trial'. In the end, Wang suggested, the entire world and writers all over must protest about the situation in China.[32] Wang used the space afforded him on the European stage to bring attention to the persecution of intellectuals on the one hand and the resistance of Chinese left-wing writers on the other, expanding the scope of the international dimensions of the anti-fascist congress.

After the Paris writer's congress, Wang continued his participation in transnational anti-fascist movements, taking on a leading role in forming the Chinese branch of the IPC. Established by British and French activists in 1936, the IPC was a popular front-style movement in the form of a broad umbrella organisation that brought together various organisations from forty-three member states to confront the rise of fascism and to provide popular support for the weakened League of Nations collective security apparatus. Its main form of mobilisation was a series of international peace conferences through which national delegations representing a variety of social groups met to discuss key challenges and form resolutions that would serve as the agenda for national- and local-level organisational work.[33] Between 1936 and 1938, Wang was perhaps the most prominent Chinese delegate at a series of conferences in Brussels, London, and Paris.

As the first large-scale public gathering of the IPC, the World Peace Congress in Brussels, held on 3–6 September 1936, brought together more than five thousand delegates from thirty-five countries. Wang attended as one of fourteen official Chinese representatives. Rather than being sent by the KMT government, none of these delegates were affiliated with Nanjing at the time. These delegates included several representatives of Chinese students, labourers, and writers in France and Britain, but most conspicuously the former Nineteenth Route Army leader Chen Mingshu, the writer Hu Qiuyuan, and the progressive educator Tao Xingzhi (1891–1946), who headed the delegation. Many other Chinese observers, including Lu Jingqing, Chiang Yee, and the Hsiungs, also went to Brussels in support of the delegation.[34]

Stressing the themes of unity and active cooperation in the interest of collective security against war and fascism, the congress established committees in such fields as agriculture, religious faith, veterans, sports, trade unions, women, and youth.

32. 'Shelley Wong', in *Pour la défense de la culture: les textes du Congrès international des écrivains, Paris, juin 1935*, ed. Sandra Teroni and Wolfgang Klein (Dijon: Editions Universitaires de Dijon, 2005), 499–500.
33. For more on the IPC's organisation see Ke Ren, 'The International Peace Campaign, China, and Transnational Activism at the Outset of World War II', in *The Routledge History of World Peace since 1750*, ed. Christian Philip Peterson, William M. Knoblauch, and Michael Loadenthal (New York: Routledge, 2018), 359–61.
34. Da Zheng, *Shih-I Hsiung: A Glorious Showman* (Vancouver, BC: Fairleigh Dickinson University Press, 2020), 116.

While the Chinese delegation participated in several of these special committees, it was during the opening session of the congress that they announced their presence and politics most directly, in a speech given by Wang. Introduced as Professor Wang, 'a great man of letters, and a scholar', Wang took to the podium to announce China's 'hunger for peace', after decades of civil wars and foreign invasions. From the beginning, he linked the existence of civil war in China to its weakness in the face of outside threats. In an apparent dig at Chiang Kai-shek he argued that if 'every worker, peasant, and soldier refuses to fight for any military leader, under any pretext, against his countrymen, peace in our own borders will be secure.'[35] He also likened the swelling of nationalist and revolutionary movements in China to the popular front in Europe; albeit while the popular front agitated for democracy the movement in China fought for its national independence. In Wang's words, 'the elements which have combined to form the Chinese popular front are the intellectuals, youth, workers, peasants, patriotic capitalists and progressive political parties, the Chinese League of National Revolution, the Chinese Communist Party, the All-China Union for National Liberation, in a word, the whole Chinese people, except the traitors'.[36] These remarks were consistent with Wang's earlier criticism of the KMT and in particular Chiang Kai-shek, who was at this time still clinging to his policy of 'first internal pacification, then external resistance': suppressing communist and civil opposition instead of directly confronting the encroaching Japanese.

The day after the conclusion of the World Peace Congress, the Chinese delegation issued a formal request, signed by Tao Xingzhi, Chen Mingshu, Wang Lixi, and several others, to request the formation of a Chinese National Committee of the IPC.[37] In fact, shortly after the Brussels congress had been planned, the IPC had sent a representative to China to seek Chinese participation in the event. A Provisional Committee for the China Branch of the IPC was formed under the stewardship of the several leaders of the Chinese National Salvation Association, including the journalist Zou Taofen (1895–1944), the distinguished educator Ma Xiangbo (1840–1939), and the educator Li Gongpu (1902–1946). A declaration with a photograph of these figures in Shanghai as well as the European-based activists, including Wang, appeared in both the official proceedings of the World Peace Congress and the monthly bulletin of the IPC, signalling that a China committee was being formed and recognized.[38] That the efforts to organise a Chinese national committee of the IPC were undertaken by veterans of the Fujian Rebellion and the National Salvation Association who were critical of Chiang Kai-shek suggest a high degree of civic commitment to non-governmental transnational activism. With his connections to both European and Chinese activists, Wang served as an

35. International Peace Campaign, *World Peace Congress, Brussels, 3, 4, 5, 6, September 1936* (Paris: Labor Publishing, 1936), 72.
36. Ibid., 72.
37. 'Request to send representatives to China', in *Tao Xingzhi quanji* [Collected works of Tao Xingzhi] (Chengdu: Sichuan jiaoyu chubanshe, 2009), 6:338.
38. *Monthly Bulletin of the International Peace Campaign*, no. 11 (10 November 1936).

important intermediary, representing the China National Committee of the IPC in Europe until 1938, when the KMT government took over its sponsorship. By then, however, Wang and his fellow Chinese activists had already ensured that China would always be a point of focus in IPC activities, as evidenced in the two IPC conferences of 1938: the World Conference on the Boycott of Japan and Aid to China, held in London, and the World Conference for Action on the Bombardment of Open Towns and the Restoration of Peace, held in Paris in July. Wang was a leading delegate to both conferences.[39]

Over the next couple of years Wang would also become an active member of several organisations in the British Aid China movement, including the Friends of the Chinese People (FOCP) and the CCC, all of which were devoted to the cause of China's plight in the face of imperialist threats from Japan. In particular, the CCC became the most active and influential organisation in mobilising British support for China's war of resistance after Japan's full-scale invasion in 1937. Chaired by Dorothy Woodman, secretary of the Union of Democratic Control, and Victor Gollancz (1893–1967), the founder of the Left Book Club, the CCC built its momentum upon the recent public fascination with Chinese art and culture as well as more independent initiatives such as dockworkers' strikes against shipping to Japan. Between 1937 and 1939, it organised consumer boycott campaigns, raised funds for wartime relief in China, and coordinated a series of exhibitions, plays, films, and performances that showcased travelling artists such as Jack Chen (1908–1995).[40] Many of the key figures involved in the CCC recalled Wang to be a central and indefatigable presence in the campaign. In Arthur Clegg's words, Wang was characterised by a 'blandness and politeness [that] hid a revolutionary determination, a capacity for hard work and a readiness to stand up in public'.[41]

Indeed, travelling lectures on the war in China on behalf of the CCC constituted a major aspect of Wang's public activities between late 1937 and 1938. To be sure, he was still writing, contributing several articles to the leading magazines during this period, even while shifting his rhetoric to fit the new reality of the United Front between the CCP and KMT in China. As a full-scale war of resistance continued in November 1937, Wang appealed to readers of the *Labour Monthly* to recognise that the fate of China had international repercussions and that the masses could play a role in pressuring their governments to apply sanctions to Japan.[42] Wang also penned the lead article in a special supplement on 'Modern China', edited by Jack Chen, that appeared in the January 1938 issue of *Left Review*. Characterising the

39. Ren, 'International Peace Campaign', 362–64.
40. Tom Buchanan, *East Wind: China and the British Left, 1925–1976* (Oxford: Oxford University Press, 2012), 67–79; Paul Bevan, *A Modern Miscellany: Shanghai Cartoon Artists, Shao Xunmei's Circle and the Travels of Jack Chen, 1926–1938* (Leiden: Brill, 2015), 203–4.
41. Arthur Clegg, *Aid China, 1937–1949: A Memoir of a Forgotten Campaign* (Beijing: Foreign Languages Press, 2003), 7.
42. Shelley Wang, 'War in the Far East: An International Issue', *Labour Monthly* 19, no. 11 (November 1937): 682–89.

war in China as one fought on four fronts, Wang summarised for his readers the military, political and diplomatic, cultural, and mass-movement developments in China. Notably, while he acknowledged the official United Front, Wang still emphasised the role that the common people and the masses had to play. He attributed the work of the CCC and IPC in Britain to propaganda work carried on by 'Chinese students, intellectuals, religious people, merchants and workers abroad' to 'explain the case of China and to obtain sympathy and help'.[43] In a book he later published to describe to the Chinese public the various international Aid China campaigns, Wang would call this kind of activity 'citizen diplomacy' (*guomin waijiao* 國民外交), a term that suggests both an air of non-governmental autonomy and a sense of patriotic duty.[44] As we will see, it was when Wang went on the road as a 'citizen diplomat' to speak on behalf of China that some significant episodes of cross-cultural exchange took place.

Transcultural Lyricism: *Exile and Wars*

In November 1937, in collaboration with the CCC, the Left Book Club sponsored a series of public lectures, a 'China tour' around England in seventeen local meetings that highlighted visiting Chinese speakers. While Shih-I Hsiung and a couple of other Chinese figures were among the group of lecturers, the most prolific was undoubtedly Wang Lixi.[45] Established in 1936 by the publisher Victor Gollancz and supported by Harold Laski (1893–1950) and John Strachey (1901–1963), the Left Book Club sent subscribing members a monthly 'Left book' and very quickly became a leading cultural institution in the 1930s, with over forty thousand members and a network of four thousand local booksellers as distributors by 1939.[46] As Wang later recalled in an article for a wartime arts journal in China, the Left Book Club played an important role in circulating books on China, including *Red Star Over China* by Edgar Snow (1905–1972) and *China Fights Back* by Agnes Smedley (1892–1950). In the autumn of 1938, the Left Book Club also ran a subscription drive in which new members were required to donate the amount they paid for their first books to China.[47] Wang himself sometimes helped introduce fellow Chinese sojourners to become subscribers.[48] As colleagues in the CCC, Wang had formed a close relation-

43. Shelley Wang, 'China's Struggle on Four Fronts', in 'Modern China', supplement, *Left Review* 3, no. 12 (January 1938): 719.
44. Wang Lixi, *Zai guoji yuanhua zhenxian shang* [On the international aid-China front] (Chongqing: Shenghuo shudian, 1939), 3.
45. Clegg, *Aid China*, 22–23.
46. Andrew Thacker, 'Circulating Literature: Libraries, Bookshops, and Book Clubs', in *A History of 1930s British Literature*, ed. Benjamin Kohlmann and Matthew Taunton (Cambridge: Cambridge University Press, 2019), 98–102.
47. Wang Lixi, 'Yingguo wenhuajie de yuanhua yundong: Zuoshuhui ji qita' [The aid-China movement in the English cultural sphere: On the Left Book Club and other matters], in *Wang Lixi wenji* [Collected works of Wang Lixi] (Beijing: Xinhua chubanshe, 1989), 74–76.
48. Qian Gechuan, 'Yi Wang Lixi' [Remembering Wang Lixi], in *Wang Lixi yanjiu ziliao*, 321.

ship with Victor Gollancz, who at one point hosted Wang for over a month as Wang worked on a book. This may have been the volume titled *China Today*, commissioned by the Left Book Club but never actually published. Nevertheless, Gollancz fondly recalled Wang's 'gracious and gentle presence' in his memoirs.[49]

Wang began his lecture tour in early November 1937, visiting towns including Portsmouth, Taunton, and Peterborough within a couple of weeks.[50] To some extent, Wang's activities on this round of itinerary talks fell into a set routine. He would be hosted by Left Book Club supporters or affiliated bookstores and would give a talk before a local audience about the background of the Sino-Japanese War, including an account of the international ramifications, urging his audience to join the boycott of Japanese goods. The evenings would usually end with a collection of donations toward wartime aid to China. But on at least two occasions, Wang's visit resulted in extended dialogues with prominent literary hosts.

In November 1937, Wang went to Dorchester to give a talk at the Left Book Club there. His host in Dorset was the accomplished novelist and poet Sylvia Townsend Warner. Warner and her partner Valentine Ackland (1906–1969) were committed members of the Communist Party of Great Britain, activists in local rallies, and had twice gone to Spain as Red Cross volunteers and as delegates to the Second International Congress of Writers for the Defence of Culture. Both also contributed writings to leftist publications such as the *Daily Worker* and *Left Review* and helped found local affiliates of the Left Book Club. Additionally, like Wang, Warner had attended the 1936 International Peace Congress in Brussels.[51] With shared experiences and similar politics, Warner enjoyed Wang's visit, but also found him to be rather amusing. Her description of Wang, in a letter to Edgell Rickword, is one of the most colourful descriptions of Wang on tour:

> We entertained Professor Shelley Wang at the week-end. He arrived with a large suitcase held under one arm, and the handle of the suitcase in the other hand, like a talisman. The suitcase had given way under the weight of books in it, we had to go to the local leather shop to find him another ... We loved him very much, but I am afraid his Dorchester audience found him perplexing. He told them stories of the Chinese revolutionary spirit, but did not make it clear that the stories dated, many of them, from 3000 BC, and had naturally, become stylised in course of time [*sic*].
>
> One of these stories I saved for you, it was so beautifully Marxian. A Chinese dictator, determined to have peace in his dominions, took away all their weapons from the peasants. The metal thus collected he had melted down and cast into the shapes of twelve massive religious figures which adorned his palace. In the end the peasants overthrew him with sharpened bamboos.

49. Victor Gollancz, *Reminiscences of Affection* (New York: Atheneum, 1968), 136–37.
50. 'The Situation in China', *Portsmouth Evening News*, 3 November 1937; 'A Public Protest Meeting', *Peterborough Standard*, 5 November 1937; 'Boycott of Japan Urged', *Western Daily Press*, 9 November 1937.
51. On Warner's 1930s activism see Claire Harman, *Sylvia Townsend Warner: A Biography* (London: Penguin Books, 2015), 140–72.

You will see that this seemed all rather odd to the Dorchester Labour Party.[52]

A writer of historical fiction, Warner may have been especially sensitive to Wang's reference to the story of the twelve statues that China's first emperor, Qin Shihuang (259–210 BCE), had made, seemingly told as a parable of the consequences of despotic rule. The local newspaper report on Wang's talk in Dorchester does not actually mention these historical stories.[53] Yet Warner's obvious delight in Wang's bookish mannerisms and historical references suggest the possibility that, at the individual level, Wang's encounters with leftist British writers could extend beyond the political imperatives into a more profound cross-cultural dialogue. Indeed, when Wang published his book about British supporters of China, he included a moving letter from Warner entitled 'Introduction to China', sent to Wang upon his return to China in late 1938.

Wang introduces Warner as a 'famous English woman writer' who has published several volumes of poetry and novels, including the widely read *Lolly Willowes; or, The Loving Huntsman* (1926), and a passionate socialist activist involved in movements for Spain and China. He then proceeds to translate Warner's letter, in which she admitted that in her adolescence the only words she associated with China were 'Peking' and 'loot', her parents having once received a visitor who brought along stolen Chinese goods. Warner acknowledged that she now viewed China as not only an 'old curiosity shop', but a modern nation struggling for freedom, a 'living China'. Echoing the declaration of female boycotters, Warner declared that she would never purchase any Japanese silk stockings and would strive to donate medicinal supplies to China.[54] By publishing Warner's letter, Wang was trying to demonstrate to the Chinese public how conscientious Europeans were arriving at a better understanding of modern China and were willing to support China in its fight to resist Japan. Yet, as we will see, while he translated Warner's letter, he would also rely on her to help render several of his poems into English.

Wang's most intense literary encounter occurred in January 1938, when he visited Belfast on a CCC-sponsored speaking tour. His local hosts were John and Roberta Hewitt, a couple whom he had met earlier in 1933, at a summer school organised by the Independent Labour Party in Welwyn Garden City. In the late 1940s, John Hewitt would emerge as a major poet in Northern Ireland and a leading proponent of Ulster 'regionalism', but in the inter-war period he was already writing poetry even while working as the curator at the Belfast Museum and Art Gallery. Hewitt was also a committed leftist activist, involved with the Belfast Peace Council and the local branch of the Left Book Club. Before Wang's visit, Hewitt already had an interest in Chinese culture—having read Arthur Waley's *A Hundred and Seventy*

52. 'To Edgell Rickword, 10 November 1937', in Sylvia Townsend Warner, *Letters*, ed. William Maxwell (New York: Viking, 1982), 50.
53. 'China's Struggle for Freedom', *Western Gazette*, 12 November 1937.
54. 'Ouzhou ren zenyang renshi Zhongguo' [How Europeans come to understand China], in *Zai guoji yuanhua zhenxian shang*, 128–30.

Chinese Poems in his twenties—which was recently piqued again in 1936 when he visited the International Exhibition of Chinese Art at Burlington House, where he had a 'deep, compelling experience'.[55] And, as Hewitt scholar Amy Smith has shown, the Ulster poet was also very conscious of the internal political strife and the threat of Japanese imperialism in China, having composed verses with titles such as 'To China on the Fall of Shanghai' (1927) and 'Sonnet: To Japan on Her Chinese Policy' (1928).[56] Indeed, his leftist sympathies with the plight of the Chinese people can be readily seen in a passage from 'Notes to the Chinese Exhibition':

> Never for me the agate or the jade
> Til the new China or her thick rich earth
> sings with her jostling millions satisfied
> shod, fed, and shelterd like a monarch's bride.[57]

With a concern for contemporary China similar to that expressed in Warner's letter, Hewitt seemed primed to be moved by an encounter with a historically minded Marxist poet from China.

During Wang's visit to Belfast, the Hewitts put him up for ten days at their home. In between Wang's scheduled talks, including one to the Young Ulster Society, the two poets shared outings, art museum tours, and discussions of Chinese poetry and Irish history. Devoting a key section in his memoirs to his friend 'Shelley Wang', Hewitt movingly recalls details of Wang's visit, including his stubborn curiosity about the Irish Citizen Army, insistent criticism of the inadequacy of Waley's translated poems for not being able to incorporate original wordplay and not adhering to original rhythms and meters, and even conversations about the holes in Wang's shoes. For Hewitt, Wang's passion for explaining China's past and present and his 'stillness, tolerance, and single-mindedness' made him a 'good even a great man, a man wiser and richer in experience than I should ever be'. Pushed to engage cross-culturally on such an intimate level, Hewitt understood Wang's visit as an important encounter that made him more cosmopolitan: 'that span of days was one of those brief intense periods which, in life, suggest that time has depth and breadth as well as simple duration, has thickness too as well as length'.[58]

On 11 January, Hewitt's wife and brother-in-law drove Wang to County Down to see the Mourne Mountains. Stopping for a meal that evening in a Belfast café, Wang

55. John Hewitt, *A North Light: Twenty-Five Years in a Municipal Art Gallery* (Dublin: Four Courts Press, 2013), 99; Amy Beth Smith, 'On "the Edge of a Crumbling Continent": Poetry in Northern Ireland and the Second World War' (PhD dissertation, Durham University, 2014), 50–51.
56. For a fuller discussion of Hewitt's literary response to China before meeting Wang Lixi see Smith, 'On "the Edge of a Crumbling Continent"', 50–53. I am very much indebted to Amy Smith's brilliant and careful research.
57. John Hewitt, 'Notes to the Chinese Exhibition', unpublished, n.p. Notebook 21, Poems, 1935 and January–August 1936, 71, Ulster-Scots Collectors Project, John Hewitt collection, https://www.ulsterscotscollectors.com/book-21-poems-1935-to-1936-january-to-august. There is some discrepancy between the numbering in this digital archive and in the scanned notebooks. Inside the actual notebook, Hewitt has marked the volume as 'Notebook XII'.
58. Hewitt, *A North Light*, 101–3.

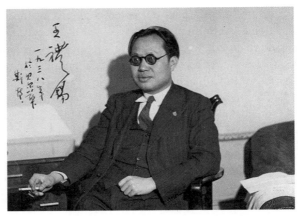

Figure 10.1: Wang Lixi. The inscription reads: 'Wang Lixi, 1938, in Belfast.' Courtesy of Keith Millar. With Permission of the John Hewitt Society.

wrote a poem about the mountains and the landscape on the inside of a packet of Kensitas cigarettes. As Hewitt's biographer relates, later the same day Wang oversaw a competition between John and Roberta and another friend to translate his poem and credited Hewitt with the victory.[59] In Hewitt's telling, 'a few evenings later with Wang's assistance I englished it [*sic*] and some months after had it published in the *New Statesman*'.[60] However, the translation seems to have been a more painstaking and collaborative process. As Amy Smith has discovered via Wang and Hewitt's correspondence several months after Wang's stay in Belfast, Wang specifically requested Hewitt to 're-english' several poems for him, a process that seems to have entailed Hewitt's polishing and rearranging a set of basic images by Wang.[61] Reading several of Hewitt's 'translations' of Wang's poems alongside Hewitt's original compositions that recalled Wang's memory, Smith convincingly argues that by combining a sensitivity to landscape images and a sense of the poet's political role in wartime, Wang provided an important model for Hewitt's own writing and persona.[62]

Yet how did Wang conceive of his own poetry—whether in Chinese or in English translation? A few clues emerge in the preface to his 1939 volume *Exile and Wars*, a copy of which he sent each to Chiang Yee and John Hewitt from Chongqing. Written in November 1938 aboard his return ship to China, Wang recalls a conversation he had with a group of young Northern Irish poets called together by John Hewitt. The late night discussion turned to the topic of Chinese *shihua* 詩話 ('poetry talks'), a genre of criticism in classical Chinese poetry formed of 'highly informal

59. W. J. McCormack, *Northman: John Hewitt (1907–1987): An Irish Writer, His World, and His Times* (Oxford: Oxford University Press, 2015), 63–65.
60. Hewitt, *A North Light*, 102.
61. Smith, 'On "the Edge of a Crumbling Continent"', 54–57.
62. Smith, 'On "the Edge of a Crumbling Continent"', 62.

compositions with numerous short sections, each consisting of lines of poetry followed (or preceded) by the author's prose comments'. One of the notable practitioners of this genre was the Qing dynasty writer Yuan Mei (1716–1798), whose *Poetry Talks from the Sui Garden* (*Suiyuan shihua* 隨園詩話) Wang had much admired in his youth.[63] According to Wang, he had promised the young Belfast poetry enthusiasts that once the 'Japanese invaders were pacified' he would devote his energy to writing a 'poetry talk from overseas' (*haiwai shihua* 海外詩話), so as to 'disseminate in China brilliant verses and literary anecdotes from abroad' (*yi haiwai jiazhang yiwen, boyu zhongtu* 以海外佳章逸聞, 播於中土). More ambitiously, perhaps he would even write a 'Chinese-Western poetry talk' in English to bring together Chinese and foreign poets. These literary plans were contingent upon victory in China's war of resistance, to which Wang was above all committed. But once the war was over, Wang resolved, 'as long as I were still alive, I would pursue this goal.'[64]

Considering these foreboding comments, it is difficult not to read *Exile and Wars* as a sort of autobiographical 'poetry talk', combining Wang's own poems, a third of which appear in English translation alongside the original Chinese in this slim volume, with brief commentaries situating the verses in the context of Wang's travels and encounters over five years of exile. Aside from a few self-translated pieces, the English versions of Wang's poems were 're-englished' translations by literary friends such as Sylvia Townsend Warner, Valentine Ackland, John Hewitt, and Innes Herdan (née Jackson), who had also helped to finesse Chiang Yee's writings.[65] Thus, in addition to presenting an account of himself, Wang was also bringing together in this anthology several of his key British and Irish interlocutors.

It must be noted that most of Wang's poetry was written in the classical style. In an era when 'new-style', vernacular poetry was being embraced, Wang held stubbornly onto what he thought of as 'beautiful' classical forms. Yet he also admits that he had been influenced by multiple late Qing writers who adapted classical poetry to incorporate modern themes and neologisms. As several recent studies have shown, classical-style poetry did not simply give way to the modern vernacular in the May Fourth period but served as a linguistically viable and aesthetically preferred form for numerous late Qing and Republican Chinese writers. Its practitioners deliberately resorted to the archaic either to contest linear agendas of cultural modernity, or to derive innovative means of self-expression.[66] More specifically, Yang Zhiyi has included Wang among a group of 1930s 'classicist' poets who continued stylistic

63. Wang, *Quguo cao*, 6; Wang, *Li Changji pingzhuan*, 176. I have borrowed this general definition of *shihua* from Jerry D. Schmidt, *Harmony Garden: The Life, Literary Criticism, and Poetry of Yuan Mei (1716–1798)* (London: RoutledgeCurzon, 2003), 153.
64. Wang, *Quguo cao*, 6–7.
65. Da Zheng, *Chiang Yee: The Silent Traveller from the East – a Cultural Biography* (New Brunswick, NJ: Rutgers University Press, 2010), 60.
66. Shengqing Wu, *Modern Archaics: Continuity and Innovation in the Chinese Lyric Tradition, 1900–1937* (Cambridge, MA: Harvard University Asia Center, 2013); Yang Haosheng, *A Modernity Set to a Pre-modern Tune: Classical-Style Poetry of Modern Chinese Writers* (Leiden: Brill, 2016); Yang Zhiyi, 'The Modernity of the Ancient-Style Verse', *Frontiers of Literary Studies in China* 9, no. 4 (2015): 551–80.

experimentations with old-style verses such as the *gexing* 歌行 form, a practice that can be traced back to the late Qing poet Huang Zunxian (1848–1905). One of his longer poems in *Exile and Wars*, 'Alas Where Shall I Go!', combines a series of rhetorical questions, seemingly inspired by the poem 'Summons of the Soul' (*Zhaohun* 招魂) in the classical anthology *Songs of Chu*, with expressions of frustration with life in exile and determination for China's salvation.[67]

Most of the poems collected in *Exile and Wars*, however, were grouped together under the heading 'Fifty Quatrains from Exile' (*Quguo wushi jueju* 去國五十絕句). These septasyllabic verses, each accompanied by a short commentary, describe Wang's travels—from his initial sea voyage abroad in 1933 to a trip to Geneva in 1938—his cultural life in London, and his responses to news from China. Together they provide a lyrical record of frustrations with exile, nostalgia for home, struggles with privations, simple pleasures of life in Hampstead, and delights of discoveries on the road. These poems also further extend Wang's fascination and identification with the Romantic poets. After seeking out the legendary resting place of Shelley's heart at St. Peter's Church in Bournemouth during a CCC trip, Wang recalled that 'Shelley and Changji [Li He] are both sad and beautiful / In my youth I loved their poems and sympathised with their style'.[68] Nor did he leave out Keats, describing his satisfaction with the green hills of Hampstead using a direct allusion to the poet's own work:

> My drifting life strays as a pilotless boat
> But this is like my village in its leafy luxury
> For half a guinea I rent lodgings together with a bill
> Under my eyes thousands of homes sparkle in the setting sun.[69]

Sometimes Wang also applied his own original imagery to well-known sites. The 're-englished' version of the poem he composed in Belfast, titled 'Mourne Mountains' in this collection and published by John Hewitt in several newspapers as well as his later collection *The Chinese Fluteplayer*, reads:

> The Mourne Mountains like a team of bears
> Tumbling into the sea
> The embroidered fields like a monk's patched cloak
> Spreading their skirts to every door
> The peasants leisurely allowing
> the chickens and dogs to wander at will
> The bare trees standing silent
> entangle the stranger's dream.[70]

67. Yang, 'The Modernity of the Ancient-Style Verse', 551–52.
68. Wang, *Quguo cao*, 38.
69. Wang, *Quguo cao*, 33–34.
70. Wang, *Quguo cao*, 66–67.

Having been told that locals referred to the rolling fields in Country Down as a patchwork quilt, Wang plucked the image of the Buddhist monk's patchwork robe (*baina* 百衲) to depict the landscape. This utopian pastoral vista at once challenges the wartime visitor's mind to wander and presents a defamiliarised yet vivid set of metaphors.

While Wang enjoyed his verdant surroundings in Hampstead and his travels around the UK, he still had to make do with a cramped flat in which he sometimes saw rodent visitors at night:

> These lean days I live in one room,
> Bedroom, study and kitchen combined;
> My books rise in formidable walls,
> But the furniture's hardly lavish.
> Allow me some sleep, good mice, in the tedious night,
> Can't you be content with books
> That smell of work and sleep and gourmandising

Continuing this imagined dialogue with the mice, Wang suggests that they do not consume his inedible books: 'Were they eatable, I'd have eaten them long ago / How can I satisfy my life with writing and selling my hard-wrung words in the market by the yard?'[71] Although the last line in the original Chinese reads 'Who would be satisfied with selling my writing by the number of words?', here, in fellow writer Innes Herdan's rendering, the difficult physical labour of writing—and perhaps of translation—for a living is represented in a more visceral manner. The amusing idea of speaking with the mouse has turned into an irritable complaint by the exiled and impoverished writer.

That Wang frequently evoked the notion of being forced to sell one's writings for a living is suggestive of his frustrations in being side-lined by the KMT regime and not being able to directly confront the national crisis in China. As seen in the poem quoted by Chiang Yee at the outset of this chapter, Wang's sense of helplessness appeared in another verse in *Exile and Wars* that ended with the lines:

> But history has always been made by swords and guns,
> Those fighting on paper nothing but dogs and horses –
> The huntsman haloos them on.[72]

As Wang's own commentary suggests, the opening line of this poem is meant to evoke the famous line by late Qing scholar-official Gong Zizhen (1792–1841), a radical poet who once critiqued the oppressive state of public opinion in the Qing with the lines 'Leaving the banquet in fear of hearing about the literary inquisition, one only writes books to earn a living' (*Bi xi weiwen wenziyu, zhushu zhiwei daoliang mou*

71. Wang, *Quguo cao*, 27–29.
72. Wang, *Quguo cao*, 25.

避席畏聞文字獄, 著書只為稻粱謀).[73] While Sylvia Townsend Warner's rendition does not quite capture this important historical allusion, she makes an important addition to the end of the poem. In her 1926 novel *Lolly Willowes; or, The Loving Huntsman*, the 'loving huntsman' is Satan, who signs a pact with the protagonist. As one literary scholar has pointed out, the novel equates Satan with the figure of Artemis who protects women and animals and has 'the power to kill assaulters'.[74] Being encouraged on by the 'huntsman', then, perhaps allows for more agency on the part of the animals or 'soldiers on paper' to confront invading enemies. Warner is voicing here her support for the Chinese writer's efforts.

By 1937, the horrifying actions of the invading Japanese became the subject of a graphic poem on the devasting effects of air raids in Guangzhou:

> Suddenly the sky is dark with metal birds
> The warning bell has rocked the town awake
> How civilised the world! A single bomb
> Can smash a thousand lives. A sea of houses
> Raised by a million hands heapt ruinous
> In a split minute; bodies scattered careless
> A child with gaping chest, his eyes appealing;
> A legless woman dying with a sigh.[75]

The juxtaposition between the ominous 'metal birds', ironically products of 'civilisation', and the ruin of both human bodies and the products of human labour, captures sharply the images shown on news reels and documented for British viewers by the CCC. Yet Wang also recognised that Chinese civilians were not alone in suffering indiscriminate bombing by fascist aggressors. In a separate entry titled 'Guernica' that he translated himself, Wang writes:

> Women and children massacred, what a world!
> We, ocean separated, fighting the same foe, are brothers.
> The boiling blood and the rays of setting sun make the ancient city red.
> Tens of thousands die, but long live Liberty![76]

This conviction that the Spanish and Chinese people were joined together in a universal struggle against fascist aggression was one of the central tenets of the IPC as well as one held by British leftist activists throughout the 1930s. It was also with the belief that Chinese and British activists were united not only through political struggle but also poetry that Wang finally left England in October 1938 to return to China and join the battlefront. On the eve of Wang's departure Kingsley Martin and

73. For Gong's original poem see 'Yong shi' [Ode to history], *Gong Zizhen shiji biannian jiaozhu* [Annotated poems of Gong Zizhen] (Shanghai: Shanghai guji chubanshe, 2013), 1:253.
74. Bruce Knoll, ' "An Existence Doled Out": Passive Resistance as a Dead End in Sylvia Townsend Warner's *Lolly Willowes*', *Twentieth Century Literature* 39, no. 3 (Autumn 1993): 359–60.
75. Wang, *Quguo cao*, 69. This version was translated by John Hewitt.
76. Wang, *Quguo cao*, 59.

Dorothy Woodman organised a farewell party, attended by many of his comrades and interlocutors over the years—Shih-I Hsiung, Victor Gollancz, Innes Herdan, the exiled German playwright Ernst Toller (whose views Wang had sided with in his 1935 *Left Review* article), and the Indian anti-imperialist leader Jawaharlal Nehru (1889–1964). For the occasion, Wang recited a long free-verse poem he composed in English, which Sylvia Townsend Warner also later read on BBC radio:

> We are parting.
> Mountains and oceans cannot divide us.
> Only language can separate people.
> Neither distance nor language can divide our spirits.
> There is not a great difference between English and Chinese,
> The distance is only in the contents of a language.
> The language of friendship is warmth;
> The language of justice is bravery;
> The language of peace is resistance.
> Real language is spelt with smiles, frowns and actions
> Not only letters and sounds.
> We cannot understand the language of invaders.
> But nothing can separate us from you.
> Neither distance nor language can divide our spirits.
> Goodbye, friends![77]

Coda

Wang Lixi died on 26 August 1939, as the leader of the newly founded Chinese Writers' Association's War Area Interview Group (Zuojia zhandi fangwentuan), an organisation of writers, literary critics, and academics who undertook a mission to travel from the wartime capital of Chongqing to the front in Henan, to compose 'guerrilla' narratives of the front experience.[78] Having returned from exile and received new autonomy under the United Front government, this was exactly the kind of collective cultural propaganda work—the sort that would rely on the mobilisation of the masses for resistance—that Wang had advocated in his earlier writings. Before the interview group could engage in serious work, Wang succumbed to a bout of jaundice. Aside from a few essays and poems he had written that year, most of his legacy as a wartime activist rested with his organisational work, writing, and lecturing in 1930s Britain.

During those years, though often associated with fellow Jiangxi natives Chiang Yee and Shih-I Hsiung, Wang often struck a more independent note. In as much as Hsiung gained fame through the global circulation of his play *Lady Precious Stream*

77. Wang, *Quguo cao*, 83–84; 'Reading of Poetry by Sylvia Townsend Warner', *Radio Times*, 15 January 1939.
78. Charles Laughlin, *Chinese Reportage: The Aesthetics of Historical Experience* (Honolulu: University of Hawai'i Press, 2002), 199–200.

and struck a position between modernism and self-exoticising Orientalism and Chiang Yee produced an innovative amalgam of Chinese poetry, calligraphy, and painting in conjunction with witty cross-cultural observations in his travel writings, both traded on their representations of China as bearers of 'cultural authenticity'. Wang, on the other hand, reached out to the British public with an increasingly resonant anti-fascist politics, especially to the Left, and, by embedding himself in several overlapping internationalist networks, helped to ensure that China and Chinese concerns were always part of the discussion. While his activism in exile expanded the social and political commitments of the Hampstead circle, his engagement with local interlocutors through poetry also suggests the range of transcultural dialogues that took place during these years between Chinese and British writers and artists. During a period of worldwide war and upheaval, these are things that cannot be readily measured, but are also not easily forgotten. As John Hewitt wrote in a widely read elegy:

> For all his greatness life could offer him
> only a little death in a vast campaign,
> a manuscript unpublished and a book
> of badly printed verse on wartime paper.
> Yet I do not think he would have understood
> that sick word failure. There are other words . . .[79]

79. John Hewitt, 'The Little Death', in *The Collected Poems of John Hewitt*, ed. Frank Ormsby (Belfast: Blackstaff Press, 1991), 44.

11
Mahjong in Maida Vale

Frances Wood

> I have had the good fortune to have known some of these distinguished exiles for many years and have always admired them for their ability both to adapt to life in the UK and to maintain a strong sense of Chinese culture at the same time. I have always hoped that their children will write about them in more detail. I am very grateful to Deh-I Hsiung, Grace Ho, Ying Chinnery and Helen Spillett for they preserve the memory of their illustrious and courageous parents.
>
> —Frances Wood

A group of Chinese ladies would meet occasionally in their North London homes to play mahjong together. A friend remembers one occasion in the early 1960s when her mother took her, along with a baffled school friend, as a 'treat', since it was her birthday. The two little girls sat and ate sunflower seeds in the front room, to the clickety-clack of the tiles. The ladies were all distinguished, and in related ways, with Chinese painting the strongest link. Two were artists of some distinction, one was responsible for most of the early acquisition of twentieth-century Chinese paintings in the Ashmolean Museum in Oxford, and the fourth was a writer and painter with close connections with the Bloomsbury Group. Two of them had lived in London since the 1940s, the other two since the 1950s. As the small sunflower-seed eater remembers: 'My parents were part of a somewhat different group connected with the Friends' Ambulance Unit which included Charles Curwen. But because there were so few "highly educated" Chinese in and around London at the time, I guess they all knew each other.'

The mahjong players on this occasion included Mary Shen, whose English husband had served with the Friends' Ambulance Unit in China. After they moved to London, Mary worked in Collet's Chinese Bookshop with Charles Curwen. Later, as a lecturer in Chinese history at the School of Oriental and African Studies, University of London, Charles Curwen would enthral his students with stories of his time in Yan'an, where he translated medical textbooks and read them aloud as Red Army doctors operated in cave hospitals. At Collet's, Mary was responsible for importing Chinese goods such as little paper butterflies, kites, and tiny, brightly coloured chenille birds. My own father worked in the British Museum on Great Russell Street, opposite Collet's, and, whenever we were ill, would bring home chenille birds

and butterflies to cheer us up. Of much greater significance was Mary's importation of contemporary Chinese paintings. Her contacts and expertise brought her to the attention of the Ashmolean Museum where, during the early 1960s, first Peter Swann and then Mary Tregear (who joined the museum in 1962 from Hong Kong) had begun to collect modern Chinese painting.[1]

One of the two painters was Auntie Fei, or Zhang Qianying (1909–2003). The second generation of these Chinese families in North London all referred to the older generation of Chinese ladies as 'Auntie': Dymia Hsiung was Auntie Hsiung; Zhang Qianying, married to the painter Fei Chengwu (1914–2001), was Auntie Fei; and, by extension, Chiang Yee was 'Uncle' Chiang.

Both Auntie Fei and Fei Chengwu had studied painting under Xu Beihong at the National Central University in Nanjing and both came to the UK on British Council scholarships in 1946. While studying with Xu, Fei Chengwu had mastered Western oil techniques but changed to painting in the Chinese style after settling in the UK. Painting birds and flowers and landscapes, he also produced charming portraits of Pekinese dogs; published a book in 1957, *Brush Drawing in the Chinese Manner*, part of the How to Do It series of the publisher Studio Publications; and produced the painting for the book jacket of Auntie Hsiung's book *Flowering Exile*.

The other Chinese painter playing mahjong was Auntie Fang, Fang Zhaoling (1914–2006), who took up painting quite late in life but achieved considerable success with her very distinctive thick, dark lines. She studied art briefly in the US, but in 1937 enrolled in a course on European History at the University of Manchester. She acted as interpreter for General Fang Zhenwu, who was travelling in Europe at the time, trying to raise funds and support for China's war against Japan. In 1938 she married his son, Fang Shin-hau, and they moved to Hong Kong in 1948. Widowed in 1950 (with eight children), she took up painting again, studying with renowned artists such as Zhang Daqian (1899–1983) and maintaining studios in both London and Hong Kong.[2]

The oldest in the group of mahjong players was Ling Shuhua (1904–1990). Born in Peking to the fourth wife of an official serving as the Mayor of Peking, she became well known in China in the early 1920s as a published short-story writer, variously described as the 'Katherine Mansfield of China'[3] and a member of the 'New Boudoir School'.[4] After studying foreign literature at Yenching University, in 1926 she married Chen Yuan (1896–1970) and in 1927 they moved to Wuhan, where he

1. 'Chinese Paintings in the Ashmolean Museum, Oxford', www.jameelcentre.ashmolean.org/collection/7/10232/1270. Accessed 16 November 2020.
2. It is interesting to note that one of Auntie Fei/Zhang Qianying's paintings in the Ashmolean was wrongly ascribed to Auntie Fang Zhaoling. This cannot have been through a confusion between their styles for Auntie Fei's style was light and delicate whilst Fang Zhaoling's paintings were characterised by immensely strong, thick, dark brush strokes.
3. Pater Stansky and William Abrahams, *Julian Bell: From Bloomsbury to the Spanish Civil War* (Stanford, CA: Stanford University Press, 2012), 190.
4. Tze-lan D. Sang, *The Emerging Lesbian: Female Same-Sex Desire in Modern China* (Chicago, IL: University of Chicago Press, 2003), 150.

had been appointed Dean of the Faculty of Arts at the University. Chen Yuan, born in Wuxi, had been sent to school in England in 1913 and studied at the Universities of Glasgow, Edinburgh, and London, achieving a PhD in 1922. Returning to China, he was appointed Professor of Foreign Languages at Peking University, and translated much foreign literature, including Turgenev, and edited the influential journal *Xiandai pinglun* 現代評論 ('Contemporary Review').

A distinguished intellectual couple, Chen Yuan and Ling Shuhua came to London in the mid-1940s. Chen Yuan was appointed Chinese representative to UNESCO in 1945; Ling Shuhua came to London a couple of years later with their daughter, Ying. The couple were distinctly estranged by this time, largely as a result of Ling Shuhua's affair with Julian Bell (1908–1937). The elder son of the painter Vanessa Bell (1879–1961) and the critic Clive Bell (1907–1961), Julian Bell had been appointed to teach English at Wuhan University in 1935. He lived in one of the many modern, Western-style red-brick houses on the thickly wooded campus, next door to Chen Yuan and Ling Shuhua. He also became friendly with some of his other neighbours, including Liao Hongying (1905–1998), an agricultural chemist, who was sharing a house with Innes Jackson (later Innes Herdan), who was studying Chinese and was later to help Chiang Yee with his books. Bell was also friendly with one of his students, Ye Junjian (Chun-chan Yeh, 1914–1999) and the British vice-consul in Chongqing, Derek Bryan (1910–2003), who was later to marry Liao Hongying. Bell, Bryan, and Ye made an epic trip in 1936 to the borders of Tibet. Before long, however, Bell was 'getting into a most complexly delicate situation with the nicest woman I've ever met … my dean's wife'.[5]

The delicate situation became increasingly fraught, with 'one threat of suicide a week'; Bell described her as 'too desperate a character for me', but the affair was only brought to an end when they were discovered in bed together. Bell, already more concerned about the rise of fascism than the nervous state of Ling Shuhua, left Wuhan (pursuing a shipboard romance with Innes Jackson) to join an ambulance brigade in Spain and was killed in July 1937.[6] Ling Shuhua made contact with Bell's family on the strength of the affair but also exchanged half a dozen letters with his aunt, Virginia Woolf, asking for support and help in publishing in the UK. In her last flat in Maida Vale there was a painting of a vase of flowers by Vanessa Bell and some cracked tiles painted by Duncan Grant.

On other occasions, the mahjong game was joined by Dymia Hsiung, wife of Shih-I Hsiung, and Lily Ho, the wife of the former diplomat Sye Ko Ho.

Many of this group of intelligent and cultured Chinese had originally come to the UK to study. In 1933, Shih-I Hsiung and Chiang Yee arrived in London. Having already translated many plays by J. M. Barrie, Shih-I Hsiung intended to study English drama. He had been inspired to do this by Ling Shuhua's husband, Chen Yuan, who had hoped to hire Hsiung as Professor of English Drama at Wuhan

5. Stansky and Abrahams, *Julian Bell*, 200.
6. Stansky and Abrahams, *Julian Bell*, 210, 216, 233.

University. Chen Yuan was disappointed to learn that Hsiung had not studied abroad, which meant that, according to the strict rules of the university, he was not eligible to take the post.[7] In January 1933, he registered as a PhD student in East London College (later Queen Mary's College).

Hsiung was able to register soon after his arrival since his English was already fluent. Chiang Yee, who shared a flat with Hsiung in Hampstead, had no English, and had come with the vague idea of studying the political system after his career in local government had come to an abrupt end when he uncovered corruption and fraud in a proposed land sale in the Jiujiang area. Despite his poor English, he managed to find employment teaching Chinese in the School of Oriental Studies of the University of London in 1934 and would subsequently survive on teaching, writing, and painting. In 1936, Hsiao Ch'ien, a journalist and writer, later to follow Chiang Yee in teaching Chinese language in the School of Oriental Studies, arrived to study at the University of Cambridge, as did Kenneth Lo (1913–1995), who later became a food writer and restauranteur. In the same year, the future translator Yang Xianyi (1915–2009) began his studies at the University of Oxford and, in 1937, Fang Zhaoling began her studies at the University of Manchester. Dymia Hsiung had studied Chinese literature at the National University in Peking, and Lily Ho, from Sichuan, had also studied Chinese literature, with a particular interest in poetry, at a women's university in Hangzhou. Her husband, Sye Ko Ho (also from Sichuan), studied political science in Chengdu before passing an exam to qualify for the diplomatic service in the US or UK, choosing the latter as he admired the country's justice system. The Hos' marriage was a modern one. Their daughter, Grace, remembers that Sye Ko Ho was

> first posted to London in 1938 after he got engaged to Lily. She was unfortunately engaged to a distant cousin, but she was a feminist and wanted to choose her own husband. She cut off her long hair when she was at university, upsetting her parents and went to Shanghai with university friends to buy American cosmetics as they only used rose petals to rouge their cheeks and lips in Sichuan. After she was introduced to Dad by another classmate, she broke off her formal engagement to her distant cousin and started a 'courtship dialogue' with Dad through writing poetry to each other, one verse at a time. Then, in 1938, after Dad's job in the Embassy was going well and he found a house to live in and had a car, he asked Mum to join him in London and get married, which they did in the Embassy. Then, World War II happened and he was asked to return to Chongqing for reassignment in 1945. With the internal conflict in China, we [including Grace and her younger brother Peter] escaped back to London in 1948. But his job as First Secretary did not last long as the UK formally recognised the People's Republic of China in 1950 and the Embassy was closed. But Dad kept his car and we had an English maid for a while

7. Da Zheng, *Shih-I Hsiung: A Glorious Showman* (Vancouver, BC: Fairleigh Dickinson University Press, 2020), 45–46.

longer (her name was Rose). We lived in grand Maresfield Gardens in Hampstead at that time.[8]

Housing

Shih-I Hsiung rented a flat in 50 Upper Park Road, Hampstead, and invited Chiang Yee to share it. The area, south of Hampstead Village itself, provided relatively cheap accommodation and was favoured at the time by writers and artists.[9] The flat was one of three in a tall white stuccoed terraced house, similar to all those that lined the street and many other roads nearby. Built in the mid-1850s, these 'large and heavy stuccoed houses with big porches, emulating the respectability of the new West End suburbs' lined many of the streets between Hampstead and Belsize Park, stretching to Swiss Cottage where Dymia Hsiung bought a flat in an identical stuccoed house with an imposing pillared porch in Buckland Crescent in the 1960s.[10] The size of the houses meant that many were divided into flats; at number 50 the landlord and his family lived in the lower half of the house with two flats above. Hsiung's flat was often full of people as he invited many distinguished Chinese visitors to stay, including the opera singer Mei Lanfang (1894–1961) and the painters Xu Beihong (who had been Fei Chengwu's teacher) and Liu Haisu. When Dymia Hsiung arrived from China in 1935 with their three eldest children, the Hsiung family lived on the second floor. They both went back to China in 1936, and then returned to UK with three children, arriving in early 1938. Another old family friend, Tsui Chi, from Hsiung's family home, Nanchang, who had come to London to study the educational system, joined another Nanchang native, Wang Lixi (Shelley Wang), and his wife, Lu Jingqing, in the top flat.

As war threatened, Chiang Yee moved out to Parkhill Road, just around the corner, and when their children were evacuated from London, the Hsiungs sought to follow them. Delan Hsiung, the oldest, was evacuated to St. Albans where she lived, apparently happily, with a bus driver and his family, a suitably proletarian experience that she described in a short story published in China in 1996.[11] The two younger boys, Deni Hsiung and Dewei Hsiung, were billeted on an elderly Anglican clergyman and his equally elderly sister. Deni recalled that their hosts were quite unprepared to deal with children. Because they were small for their age, they were given tiny meals, quite inadequate for growing boys, and were soon returned to

8. In 1949 with the establishment of the People's Republic of China, diplomatic relations were briefly broken between the UK and China. All the diplomats in post, appointed by the Republic of China which had fled to Taiwan, automatically lost their jobs. Diplomatic relations between the UK and the People's Republic were resumed at a low level in 1950, and it was not until 1972 that there was an exchange of Ambassadors.
9. See Caroline Maclean, *Circles and Squares: The Lives and Art of the Hampstead Modernists* (London: Bloomsbury, 2020).
10. Brigid Cherry and Nikolaus Pevsner, *The Buildings of England: London 4 North* (London: Penguin Books, 1998), 198.
11. Xiong Delan and Wu Guanghua, *Haiwai guiren* 海外歸人 [Those who returned from abroad] (Beijing: Beijing shiyue wenyi chubanshe, 1998).

their parents who decided to move to St. Albans to avoid the bombing of London.[12] Their home in Upper Park Road was eventually bombed, and no longer stands, but as they had moved out, they were luckier than Chiang Yee, whose flat in Parkhill Road was destroyed by a bomb, forcing him to move on overnight, choosing to go to Oxford.

In 1943, the Hsiungs also moved to Oxford, to provide a home for their three children, who all managed to obtain university places there. They first rented Iffley Turn House but had to leave when Graham Greene acquired it for his estranged wife, after which they moved to nearby Heyford Hill House. Though Shih-I Hsiung went off to Cambridge to teach, then to Singapore to help establish Nanyang University and on to Hong Kong, Dymia Hsiung remained in Oxford with her youngest daughter until she moved back to Swiss Cottage in 1966, to a flat in a tall white stuccoed house. Ling Shuhua also lived in Swiss Cottage and, eventually, nearby Maida Vale. From the late 1940s, the Feis had shared a flat with two other artists who eventually went back to China. Deh-I Hsiung remembered: 'the first time they came to stay with us, my mother told me they were not married, but they eventually decided to get married, more out of convenience, as in those days it was frowned on for unmarried people to live together. I have a photo of their wedding day with Stanley Spencer and my father attending'. Grace Ho explained that the Feis later bought a house in Finchley Central, not far from where the Ho family lived in East Finchley. The Hos' house was unusual: one of four built on Deansway, it had a green tiled roof, not unlike that of a Chinese temple, and a massive clump of bamboo planted in front. The Ho family bought the house from the famous writer Lin Yutang (1895–1976), who spent most of his time in the US, but whose daughters had lived in the house and planted the bamboo. The bamboo has now vanished from Deansway but cuttings flourish in Archway where Grace Ho used to live and in Deh-ta Hsiung's garden in West Hampstead.

Hospitality

Shih-I Hsiung was enormously hospitable, offering accommodation to visitors from his earliest days in London. He continued to entertain visitors and friends after his wife and family arrived in the UK in 1938, offering food and beds to friends and acquaintances, and Dymia Hsiung, quite unused to cooking, soon found herself catering for large numbers, often invited by her husband on the spur of the moment. As she wrote in *Flowering Exile*, her fictionalised 'autobiographical excursion', she was 'not an authority in matters connected with the kitchen' but she was forced by circumstances to master catering on a grand scale. She wrote of the differences between Chinese and English hospitality: 'with their English friends they kept to the English custom of inviting them to tea by giving reasonable notice in writing.

12. Deni Hsiung, email exchange with the author, 2019.

With their Chinese friends, they kept to the Chinese custom of never inviting them to tea, but only asking them to stay for a meal when they called. If they called in the morning, they were asked to stay for luncheon: and if they called in the afternoon, they were asked to stay for dinner'. In Oxford, this traditional hospitality, combined with sympathy for Chinese who were finding life in the UK quite hard, meant that 'whenever people felt a little homesick, they invariably came to the . . . household. They didn't need to be known to [the family]: they needn't write or telephone first; and they needn't wait for an invitation. All they had to do was stretch out one of their fingers to press on the . . . family doorbell and sure enough they were welcome'.[13]

Offering such a generous welcome must have been extraordinarily hard, particularly in wartime and the early 1950s when rationing was still in force in England. Dymia Hsiung mentioned the difficulties of rationing in her book, some of which her family managed to overcome, maintaining a good supply of eggs by keeping chickens in the garden in St. Albans and Oxford, and by their taste for items which were not rationed, such as lobster![14] She also referred to tradesmen who 'looked after' the family well, by which she must have meant turning a blind eye to rationing at times. By contrast, her 'husband' in *Flowering Exile*, based upon Shih-I Hsiung, who welcomed all-comers with no thought for his wife's struggle to make ends meet, appears to disapprove of the black market: 'I hear people in London who want to give parties have to go to the black market to get scarce food. How very dreadful!' Nonetheless, Deh-I Hsiung remembered that, 'We had a butcher who sold us meat on the black market'.[15]

All the women were intellectuals and came from families of some means and with a number of servants, so they had little or no personal experience of cooking or household management. Yet within a short time many became efficient and even good cooks. It depended to some extent upon their temperament. Ying Chinnery, daughter of Chen Yuan and Ling Shuhua, remembered that her mother 'did not want me in her kitchen':

> She could not eat pork and we had beef most of the time. She could cook nicely but did not want to do it. We had Chinese food all the time but it was very simple. My father used to cook noodles, very plain noodles. I did copy from Mrs. Zhao's cookery book but my mother threw most of her cooking away as they were like cat and dog, hating each other.[16] Most of the time we had plain rice, 'stewed beef à la Chinese', and cabbage. My mother just did not get on with my father (though I did not know until years later). My father liked the Wuxi style of food but my mother cooked very plain food.

13. Dymia Hsiung, *Flowering Exile: An Autobiographical Excursion* (London: Peter Davis, 1952), 42, 70–71.
14. Hsiung, *Flowering Exile*, 59.
15. Deh-I Hsiung, email exchange 2019.
16. Yang Buwei, the wife of the renowned linguist Zhao Yuanren (1892–1992) published *How to Cook and Eat in Chinese* in 1945. Though Zhao Yuanren and his family spent much of their life in the US, as a prominent intellectual he must have known Chen Yuan and Ling Shuhua.

Part of the explanation for the very plain food may have been the difficulty of acquiring some of the essentials of Chinese cooking, almost impossible in wartime and difficult for decades afterwards. Deh-I Hsiung remembers that, 'in wartime, we could get rice by the sackful, from the Chinese Embassy I think. Noodles we could always get, thanks to Marco Polo. . . . But since my parents were from Jiangsu and grew up on a rice diet, if my father saw days of noodles before the next sack of rice came in, he would pull a long face at the dinner table and say "noodles again". I am sure that the dried shrimp also came from the Chinese Embassy'.

In the early 1950s, Mrs. Ho had to search for Chinese ingredients in London, but the family benefitted by parcels sent from Taiwan through the diplomatic bag and family links. Grace Ho remembers her parents' 'pleasure when we received food packages from Taiwan with Chinese mushrooms, tea, dried shrimp, dried smelly fish (ugh!), dried chillies—and the rare occasions when visitors from Taiwan arrived with such delicacies as black preserved duck eggs! Such a treat, but not for us children'. A visitor who was warmly welcomed by children was Chiang Yee, who loved to please them. He found a tricycle for five-year-old Deh-I Hsiung, a rare treasure in wartime, and spent Christmas 1949 with the Ho family, enjoying the cooking and warm company whilst the children delighted in his gifts of cowboy hats and 'Red Indian' feathered headgear. In 1950 Grace Ho received an inscribed copy of *Chin-Pao and the Giant Pandas* for Easter: 'As for Uncle Chiang, I remember him mainly for the pandas he drew so well in watercolours, and he had two adopted pandas in London Zoo which he often took us to view. I guess that is why I still love pandas.'

Cooking for family and friends was an important pastime for Mrs. Ho, and Sye Ko Ho was famed for his homemade Sichuan chilli sauce. For Dymia Hsiung, with an ever-hospitable husband and an endless source of homesick Chinese students in Oxford, the situation was rather different. In *Flowering Exile*, she describes the menu for a party given for thirty student friends of the three children of the fictional Mrs. Lo:

1. Steamed egg-cakes in chicken stock soup
2. Three roasted ducks
3. Three boiled chickens, served cold, with Chinese sauce
4. Two braised ox tongues
5. Fried cabbages with dried shrimps and Chinese vermicelli
6. Fried noodles, with meat and Chinese mushrooms
7. Boiled rice
8. Beer and other drinks.[17]

It is difficult to find out how these Chinese housewives managed to find enough soya sauce for their Chinese dishes. Did it also come from the Chinese Embassy? Kenneth Lo described the one Chinese restaurant in Cambridge in the late 1930s, the Blue Barn, as one whose size belied its name, for it was 'no more than a bar,

17. Hsiung, *Flowering Exile*, 202–3.

where a dozen people sat along the length of the counter'. It 'served only three dishes: Chop Suey, Chow Mein and Fried Rice . . . the Chop Suey at the Blue Barn was a dish of stewed meat and cabbage, awash in tomato sauce; the Chow Mein was topped with a fried egg and the Fried Rice was equally substantial, stir fried with an abundance of goodies, onions, peas, chopped meat and tiny spoons of shrimp'.[18]

A solution to the shortage of soya sauce was proposed by M. P. Lee in *Chinese Cookery: A Hundred Practical Recipes*, published in 1943 by Faber and Faber with illustrations by Chiang Yee. Kenneth Lo recalled that M. P. Lee was Li Mengbing, a Secretary in the Chinese Embassy, who made the suggestion that Marmite could be used as a substitute.[19] Li Mengbing's cookbook in fact suggests that 'Bovril, Oxo or Marmite, which has a vegetable basis, can be a good substitute when soy bean sauce is unavailable . . . diluted with water in a proportion of 1 to 3'; and he states that it is 'an erroneous idea that soy sauce is indispensable to every dish of Chinese food'.[20] Li dismisses 'Chop Suey' as a dish that is 'not known or eaten in China. The nearest approach to it in the Chinese recipes is what we call "Chao Hui", a dish which contains pieces of chicken, bamboo shoots, ham, mushrooms and some minced pork balls, and which is said to have been the favourite dish of the famous statesman of the Chin [*sic*] dynasty, Li Hung Chang [Li Hongzhang]'.[21]

In the preface to *Chinese Cookery*, Li Mengbing offers part of a poem by Su Dongpo:

> Lack of bamboo makes one vulgar,
> Lack of pork makes one thin,
> In order to avoid vulgarity and slenderness,
> Have pork with bamboo shoots now and then.[22]

There is a wide variety of recognisable dishes in *Chinese Cookery*, although the names of some are unusual. *Jiaozi*, now commonly translated as 'dumplings', appear in the section 'Rice and Noodles' as 'Chinese patties', with instructions to serve them either deep-fried, boiled (*shui jiao*), or 'semi-fried' (*guotie*), and the larger buns (*baozi*) made with flour and yeast and stuffed with pork (or, for Li, alternatively, veal) and vegetables, are called 'Chinese pies'.[23] Though *baozi* would now be called 'steamed buns' in English, in her autobiographical book *Ancient Melodies*, published in 1953, Ling Shuhua also refers to *baozi* as 'meat pies'.[24] Conscious of the difficulty of obtaining some of the essential ingredients for Chinese dishes, Li Mengbing includes a list of names and addresses of Chinese restaurants and shops in London, most of which were in the Soho district, but he includes two in the old

18. Kenneth Lo, *The Feast of My Life* (London: Doubleday, 1993), 110.
19. Lo, *The Feast of My Life*, 175.
20. M. P. Lee, *Chinese Cookery: A Hundred Practical Recipes* (London: Faber and Faber, 1943), 12.
21. Lee, *Chinese Cookery*, 9.
22. Lee, *Chinese Cookery*, 7.
23. Lee, *Chinese Cookery*, 20–22.
24. Su Hua [Ling Shuhua], *Ancient Melodies* (London: Hogarth Press, 1953), 224–25.

Chinatown in Limehouse, the Chong Chu Restaurant in West India Dock Road and the emporium Sun Sam Shing Co. in Limehouse Causeway. It is possible that those who lived in London could obtain bamboo shoots, dried cuttlefish, dried Chinese mushrooms, Chinese ham, fresh ginger (for which Li proposes the very different alternative of powdered ginger), and sesame oil from Sun Sam Shing, if these items did not come from the Chinese Embassy or by post or courier from relatives in China.[25]

Very soon after the end of the war, a small Chinese supermarket, the Hong Kong Emporium, was opened in Soho's Rupert Street by the English wife of the owner of the pioneering and very successful Hong Kong restaurant on Shaftesbury Avenue, which had been catering as the 'largest and most prosperous Chinese restaurant in town' since before the war.[26] Oddly enough, my own family knew the second-floor manager there. He was a Mr. Lo, ostensibly a student studying law at the University of London, who came to live in our house as a lodger in the early 1950s. He had a huge trunk of books which he put under his bed and, according to my mother, never opened. He worked in the restaurant and, for a short while, took part in an Ava Gardner film about Asian pirates, for which he was collected every morning by a large black limousine. He left our house, in East Finchley, to lodge with the Ho family nearby where the food was certainly more to his taste. At his invitation, we went to the Hong Kong restaurant a few times where my brother and I ate egg and chips with chopsticks.

It is a truism to state that food is important in Chinese culture, but it was perhaps even more important in wartime and in the early 1950s, when it was so difficult to find and prepare. Yet apart from the family comfort it provided, like Kenneth Lo, several of the Chinese intellectuals who found themselves living in England ended up owning restaurant businesses. Sye Ko Ho had been appointed First Secretary in the Chinese Embassy in London in 1948 but his tenure did not last long, as Grace Ho recalled:

> The British government recognised the People's Republic in 1950 and the Embassy was closed. All the diplomats had to find new jobs! But they were intellectuals, not commercial men. Dad kept his car and we had an English maid for a while longer but Dad and his Embassy friends put their bald intellectual heads together and came up with the idea of opening up a high-quality Chinese restaurant in the West End, not like the scruffy Cantonese cafes in the East End. And their former chef in the Embassy was also out of a job. So, The Asiatic opened in Leicester Square in 1950–1951, selling authentic Chinese dishes with an authentic Chinese chef. It became very popular. God knows where they got their ingredients, but they did offer quality French wines as Dad had developed a keen nose for French reds and

25. Sesame oil would have been hard to find. Even after the war, we used to buy olive oil in tiny bottles from pharmacies, where it was sold for medicinal purposes, rather than cooking. In the first edition of her *A Book of Middle Eastern Food* (1968), Claudia Roden included a list of suppliers so that cooks outside London could obtain the appropriate ingredients.
26. Lo, *The Feast of My Life*, 173.

had ordered crates of the stuff from France through his former diplomatic bag. Their upper-class clients included Ernest Bevin and other politicians, plus Ava Gardner, who Dad had a slight crush on.

After The Asiatic, Sye Ko Ho and colleagues opened The Dragon, with which he was involved until he retired.

Culture

Photographs of Aunty Fei, Aunty Fang, Mary Shen, Mrs. Ho, and Dymia Hsiung (when she first arrived in the 1930s) show them wearing elegant Chinese *qipao*— close-fitting, high-necked Chinese dresses fastened with elaborate frogging. Grace Ho explained, 'Mum had her personal tailor in Taipei who had her measurements so could create beautiful, hand-sewn, silk-lined, embroidered gowns and these were brought over to her by visitors from Taiwan. I still have one or two which are too precious to give to Oxfam.'[27] When the Lin family was living in New York, Lin Yutang's wife relied on a similar source of supply: 'When we live in New York, Mother does not buy much besides shoes and stockings for she had her dresses made in China.'[28] Mrs. Ho had fine silk *qipao* for special occasions 'but also warm woolly gowns for the British winter and less formal ones'. Grace says that 'she only really adapted to the Western wardrobe in her later years when she discovered that Marks and Spencer's slacks and cardigans were really comfortable for walking in Kenwood and she didn't need garters and stockings'.

When the ladies got together to play mahjong food was often also involved, and other entertainments. There were quite a few different groupings of mahjong players amongst the women. Grace Ho remembered that after Chinese dinners in her parent's house or the Feis', 'Auntie Fei and my parents would sing Peking Opera'. When these impromptu sing-songs took place, Grace always shut her bedroom door.

Whilst the painters, the Feis, Fang Zhaoling and, to a lesser extent, Ling Shuhua, continued to work on brush paintings throughout their lives, it was particularly after his retirement that Sye Ko Ho devoted himself to calligraphy. 'Taiwan visitors brought Chinese newspapers and books and calligraphy books and brushes and ink for Dad. He preferred the expensive brushes made from the hair of the nose of the ox. I always had an image of some brave person plucking nostril hairs from a protesting ox'.[29] For Sye Ko Ho, calligraphy was important in terms of keeping Chinese traditions alive in Britain:

27. An incredible collection, including a *qipao* worn by Xu Zhimo's first wife, who spent a year in the Cambridgeshire countryside abandoned by her errant poet husband, can be seen in Song Luxia, *A Collection of Qipaos from China's Prominent Families* (Shanghai: Shanghai Scientific and Technological Literature Press, 2017).
28. Adet Lin and Anor Lin, *Our Family* (London: Jonathan Cape, 1939), 38–39.
29. Grace Ho, email exchange with the author, London 2019.

Dad always dabbled in calligraphy, acquiring his paper, proper inks to grind on proper ink-stones, and his scores of brushes in varying thicknesses, which we were never allowed to touch. Some of the items were brought over to him by friends in Taiwan, others he could eventually buy in the Guanghwa Bookshop in Soho. When he retired with more time, after his second Chinese restaurant, The Dragon, closed down, every evening after Mum cleared the supper things, he brought out his calligraphy set and took over the dining table. He had a ritual. First, he sipped a bit of whisky to release his *qi* and allow his creativity to flow like a stream. He loved the Tang poets and always chose their verses to write and if ever he made an error with a slip of the brush, the whole piece had to be thrown away. Writing a long poem of several hundreds of characters took deep concentration and skill of hand, not allowing his wrist to touch the paper, just hovering above. Some brush strokes required a powerful, heavy movement of his hand, others needed light, delicate feather strokes. Depending on how many sips of whisky he needed to release his *qi*, Dad could sometimes create pages of perfect poetry with no mistakes. Sometimes his *qi* would really flow freely and many hours of heavy silence were required to allow him to do his work. Sometimes Mum watched her favourite series on TV, so Dad required more whisky to blot out the noise. Weirdly enough, he liked to have wrestling matches on TV as background and we were not allowed to switch it off or change channels. After Mum died, Dad honoured her poems in his own calligraphy in a book which he gave to his friends in Britain and Taiwan.

On a lighter note, as much in demand as bottles of his homemade Sichuan chilli sauce were his large calligraphic 'tiger' characters.

Dymia Hsiung spent most of her time from the outbreak of war to 1966 in Oxford and so did not join the North London mahjong parties and had little contact with Ling Shuhua. Ling Shuhua's daughter remembered that her mother 'always thought she was high above those [mahjong playing] ladies. Perhaps she was spoilt by her earlier reputation. Zhang Qianying [Aunty Fei] told me years later that my mother looked down on her and her friends and she also thought for years that I had an illegitimate daughter as my mother never let on that I married'. In the early 1950s, both Dymia Hsiung and Ling Shuhua published books which achieved some success. Dymia Hsiung's *Flowering Exile* appeared first in 1952, although it is clear that Ling Shuhua had been planning to write and publish in England long before. When he was in Wuhan, Julian Bell had sent some of her short stories to his mother, Vanessa Bell, in the hope that she might be able to get them published in literary magazines. She had no success but shortly after Bell's death Ling Shuhua wrote from Sichuan where she had gone to escape the Japanese invasion, to his aunt, Virginia Woolf, who replied on 5 April 1938:

> I have not read any of your writing, but Julian often wrote to me about it . . . He said too that you had lived a most interesting life; indeed we discussed – I think in letters, the chance that you would try to write an account of your life in English. That is what I would suggest now . . . Will you make a beginning and put down

anything you remember? As no-one in England knows you, the book could be more free than usual. Then I would see if it could not be printed.[30]

Virginia Woolf sent parcels of books (mainly autobiographies) to Ling Shuhua and continued to comment upon the manuscripts she received over the next year: 'I like it very much. It has great charm ... please go on quite freely; do not mind how directly you translate the Chinese into the English ... give as many natural details of the life, of the house, of the furniture as you like.'[31]

Dymia Hsiung did not have access to such superior advice, from a writer who was also a publisher, although it was assumed by her friends that her husband had helped her greatly. As Ying Chinnery recalled: 'Mrs. Hsiung's book was written by her husband, of course. He was a real bastard.' Deh-I Hsiung remembers:

> My mother wrote the book in Chinese. My father's help consisted of translating it into English. However, mother was a more subtle writer and father did not wish to do a literal translation, so he would exaggerate some of the stories. I remember their knockdown battles over the English manuscript. My mother had been told it would be good mental therapy to write about the family as she missed my elder sister and my two brothers. She had a premonition that she would not see them for a long time. She had read my childhood book *The Family from One End Street* and that was her inspiration.[32]

Flowering Exile tells the story of an intellectual Chinese family, the Los, arriving in England just before the outbreak of war. The tribulations of wartime, the difficulties of adjusting to English customs and the solidarity felt with all other Chinese intellectual refugees are all set out, along with the family stress on education which ends with three children all studying at different colleges in Oxford and graduating to return to post-war China, hoping to participate in national reconstruction. Much of the book is clearly autobiographical, although two children left behind in China in 1935 are not mentioned, and friends are not always identified. One who was included was Tsui Chi, named Sung Hua in the book, who had shared the house in Hampstead and who had died tragically just before publication.[33] The slip cover was beautifully illustrated by Aunty Fei's husband, Fei Chengwu, with a scene of little figures walking towards the Bodleian Library, apparently inspired by the cover of Ludwig Bemelmans' children's book *Madeline*. Published in 1952, this may have been a book that Deh-I enjoyed.

The main themes of the book are the importance of education to the Hsiung family, their sympathy and consideration for fellow Chinese intellectuals in exile, and the importance of hospitality. Even in old age, these themes still played a significant part in Aunty Hsiung's life. Her sitting room was filled with books and an

30. Virginia Woolf, *Leave the Letters till We're Dead: The Letters of Virginia Woolf*, vol. 6, *1936–1941*, ed. Nigel Nicolson (London: The Hogarth Press, 1994), 221.
31. Woolf, *Leave the Letters till We're Dead*, 290.
32. Eve Garnett, *The Family from One End Street* (London: Frederick Muller, 1937).
33. Zheng, *Shih-I Hsiung*, 203–5.

alabaster model of the Acropolis, but it was also constantly filled with her grandchildren, over from China to study at universities in the UK and the US, and their friends, gathering to fill *jiaozi* and clatter in the tiny kitchen where the linoleum floor was sticky with years of stir-frying.

Ling Shuhua's *Ancient Melodies* was a very different book, recounting her life as a child in Peking, Tianjin, and Japan, based upon the advice given to her by Virginia Woolf. Vita Sackville-West provided an introduction, quoting from Virginia Woolf's letters and noting that, 'Mrs. Woolf was perhaps right in saying that one did not at first understand the different wives, who they were and which was speaking; but once one has grown accustomed to the formula of First Mother, Second Mother and even Fourth and Fifth Mothers, not to mention Ninth Sister or Tenth Brother, the picture turns into high comedy'.[34] Apart from recounting the fights and hair-pulling of her father's many wives, Ling Shuhua depicts herself as a tiny child, immensely talented as a painter, taught by imperial artists, and an accomplished student of the Chinese classics, the favourite amongst her father's dozens of children. As advised by Woolf, she describes interiors and furnishings, like the black lacquer and red lacquer tables in her room, in some detail, and her language is simple, avoiding the 'Chinese Daisy Ashford' tricks used by Lin Yutang's daughters in their memoir, *Our Family* (1939). Concentrating on her own childhood achievements, she does acknowledge one sister who had ambitions to study medicine, but passes over the mysterious deaths of two sisters who fell into a waterfall in Japan.[35] Though she received encouragement from Woolf and Sackville-West, and her daughter refers to her 'playing the daughter-in-law' to Vanessa Bell, Bell's introductions to eminent Bloomsbury figures did not help her advance a literary career in England. Bell wrote that Marjorie Strachey was 'horrified by her emotionalism' and Arthur Waley simply fled.[36]

The publication of *Flowering Exile*, a year before Ling Shuhua's *Ancient Melodies*, provoked a long estrangement between Dymia Hsiung and Ling Shuhua. When asked if there was any literary rivalry and whether the established writer, Ling Shuhua, was annoyed that a book by an amateur should encroach upon her position, both families felt that it was, in fact, the depiction of Ling Shuhua's daughter in *Flowering Exile* that caused the problem. Ling's daughter, Ying, said, 'Mrs. Hsiung was nice to me but my mother looked down on her', and Deh-I Hsiung said, 'I never thought there was any rivalry, we assumed that it [the rift] was because my mother made Ying out to be a vamp. The publishers wanted some romance and sexiness to be added. We blamed it on Peter Davies'. In *Flowering Exile*, Ying is caricatured as Yang Bin, who had been living in Paris with her parents (where Chen Yuan spent

34. Su Hua, *Ancient Melodies*, 9.
35. Sasha Su-ling Welland is the granddaughter of Ling Shuhuo, who studied medicine. See Sasha Su-ling Welland, *A Thousand Miles of Dreams: The Journeys of Two Chinese Sisters* (London: Rowan and Littlefield, 2006).
36. Welland, *A Thousand Miles of Dreams*, 303.

most of his time when he was China's representative at UNESCO) but who came over to school in Oxford where she lodged with the ever-hospitable Hsiung family. She is described as having a 'well-developed bust' and 'heavily rouged' cheeks.[37] Almost upon arrival in the Lo (Hsiung) home, she impresses all present by singing 'The March of the Volunteers', which was to become China's slightly bloodthirsty national anthem. She flirts with the two Hsiung boys, writing letters, copying poetry, and coming over from her school to see them every weekend, because, as she would put it, 'the meals in school, Aunt Lo, are too bad'. Mrs. Lo worried about her lack of interest in her studies and that 'she played too much'. Eventually, her mother comes over from France to sort out her errant daughter. The portrait of Ling Shuhua, 'Mrs. Yang' in *Flowering Exile*, is not flattering. The physical description is harsh and quite surprising in a book where few details of dress and jewellery are given. 'Mrs. Yang had had a fine figure, but now it was spreading out in all directions. She was luxuriously made up, though perhaps a little out of fashion. She was slightly powdered and carefully rouged and bejewelled in full splendour: ruby earrings, an emerald jade brooch, a pearl necklace, and a large sapphire ring with small diamonds all around it. She wore a black satin dress with a large gold pattern, which also matched the rim of her spectacles. Because she was heavily built, she had to wear flat-soled girls' shoes'.[38] She takes her daughter back to Paris and the Hsiung boys are safe from flirtation.

Whilst this literary episode may have soured relations between the Hsiungs and Ling Shuhua for a decade, Deh-I Hsiung remembers that 'Ying, as well as her mother, became good friends with my mother after we moved to Swiss Cottage in 1966', and that Ying, meeting up with Deni Hsiung (with whom she was supposed to have flirted dangerously in Oxford) in Beijing after nearly forty years, said, 'Your mother did exaggerate'. However, for Ying, the picture of her as an irrepressible flirt still rankles: 'The Hsiung boys were older than me and they were hardly able to speak Chinese . . . at the time I was hardly able to speak English'. She also still recalls that Shih-I Hsiung 'borrowed a lot of money from my father and when my father wished to have the money back, Hsiung wrote *aimo nengzhu* [爱莫能助], which meant that he was unable to help my father, meaning my father was trying to borrow money from him!'

The transformation of China after 1949 did not end the exile. Three of the Hsiung children went off from England to successful careers in China, but this did not necessarily make it easy for their parents, with relatives separated between China and Taiwan, to return. Shih-I Hsiung and Chiang Yee did make short visits to China, but Dymia Hsiung never saw China again. Sye Ko Ho and his wife, Lily, did not return, for though they had many relatives in China, Lily's brother was 'Chiang Kai-shek's personal physician'. It was left to the succeeding generations to make the journey.

37. Hsiung, *Flowering Exile*, 213.
38. Hsiung, *Flowering Exile*, 251–52.

Glossary of Chinese Names

Cai Chusheng 蔡楚生
Cai Tingkai 蔡廷鍇
Cai Yuanpei 蔡元培
Chen, Jack; Chen Yifan 陳依範
Chen Jitong 陳季同
Chen Mingshu 陳銘樞
Chen Yuan 陳源
Chiang Hsu; Jiang Xu 蔣詡
Chiang Kai-shek; Jiang Jieshi 蔣介石
Chiang Ta-ch'uan; Jiang Dachuan 蔣大川
Chiang Yee; Jiang Yi 蔣彝
Chinnery, Ying; Chen Xiaoying 陳小瀅
Di Baoxian 狄葆賢
Du Fu 杜甫
Emperor Ai 漢哀帝
Fang Shin-hau; Fang Xin'gao 方心誥
Fang Zhaoling 方召麐
Fang Zhenwu 方振武
Fei Chengwu 費成武
Fong, Wen C.; Fang Wen 方聞
Gong Zizhen 龔自珍
Gu Yuncheng 顧雲程
Guo Moruo 郭沫若
Guo Taiqi; Quo Taichi 郭泰祺
Han Suyin 韓素音
Ho, Grace; Lau Grace; He Boying 何伯英
Ho, Lily; Hsiung Hwa Lian; Xiong Hualian 熊化蓮
Ho Sye Ko; He Sike 何思可
Ho, Wai-kam; He Huijian 何惠鑒
Hong Shen 洪深
Hou Yao 侯曜
Hsia, C. T.; Xia Zhiqing 夏志清
Hsiao Ch'ien; Xiao Qian 蕭乾
Hsieh Ping-ying; Xie Bingying 謝冰瑩
Hsiung, Deh-I; Xiong Deyi 熊德夷
Hsiung, Deh-ta; Xiong Deda 熊德達
Hsiung, Delan; Hsiung Deh-lan; Xiong Delan; Hsiung, Diana 熊德蘭
Hsiung, Deni; Xiong Deni 熊德輗
Hsiung, Dewei; Xiong Dewei 熊德威
Hsiung, Dymia; Cai Daimei 蔡岱梅
Hsiung, Shih-I; Xiong Shiyi 熊式一
Hu Qiuyuan 胡秋原
Huang Zunxian 黃遵憲
Jiang Guangnai 蔣光鼐
Jing Youru 敬幼如
Koo, Wellington; Gu Weijun 顧維鈞
Lai Foun; Lei Huan 雷歡
Lai Man-Wai; Li Minwei 黎民偉
Lao She 老舍
Li, Chu-tsing; Li Zhujin 李鑄晋
Li Dandan 李旦旦
Li Gongpu 李公樸
Li He 李賀
Li Hung Chang; Li Hongzhang 李鴻章
Li Po; Li Bai 李白
Li Ruiqing 李瑞清
Li Yu 李煜
Liao Hongying 廖鴻英
Lin Chuchu 林楚楚
Lin Yutang 林語堂
Ling Shuhua 凌叔華
Liu Haisu 劉海粟
Liu Songnian 劉松年
Lo Hsiao Chien; Lo Kenneth; Luo Xiaojian 羅孝建
Lo Ming Yau; Luo Mingyou 羅明佑

Lu Ching-Ch'ing; Lu Jingqing 陸晶清
Lü Ji 呂紀
Lu Xun 魯迅
Lu Zhi 陸治
Luo Changhai 羅長海
Ma Xiangbo 馬相伯
Mao Zedong 毛澤東
Mei Lanfang 梅蘭芳
Poon Lim; Pan Lian 潘濂
Qi Baishi 齊白石
Qian Zhongshu 錢鍾書
Qin Shihuang 秦始皇
Shao Xunmei 邵洵美
Shen Congwen 沈從文
Shen, Mary; Shen Manyun 申曼雲
Shi Zhecun 施蟄存
Su Dongpo 蘇東坡
Sun Mingjing 孫明經
Sun Moqian 孫墨千
Tai Ai Lien; Dai Ailian 戴愛蓮
Tao Xingzhi 陶行知
Tao Xisheng 陶希聖
Tao Yuanming 陶淵明
Teng Gu 滕固
Tian Han 田漢
Tsui Chi; Cui Ji 崔驥
Wang Chi-chen; Wang Jizhen 王際真
Wang Mang 王莽
Wang, Shelley; Wang Li-hsi; Wang Lixi 王禮錫
Wang Shifu 王實甫
Wang Wei 王維
Wong, Anna May; Huang Liushuang 黃柳霜
Wu, Butterfly; Hu Die 胡蝶
Wu Mei 吳梅
Xiao Jun 蕭軍
Xiao San 蕭三
Xie Bingying 謝冰瑩
Xie He 謝赫
Xu Bangda 徐邦達
Xu Beihong 徐悲鴻
Xu Zhimo 徐志摩
Yang Hsien-I; Yang Xianyi 楊憲益
Yang Yuxun 楊毓珣
Yang Zhiyi 楊治宜

Yao Xueyin 姚雪垠
Ye Gongchuo 葉恭綽
Ye Nienlun 葉念倫
Yeh, Chun-chan; Ye Junjian 葉君健
Yeh, Diana 葉樹芳
Yeh, George Kung-chao; Ye Gongchao 葉公超
Yu Shangyuan 余上沅
Yuan Chia-hua; Yuan Jiahua 袁家驊
Yuan Mei 袁枚
Yui Shufang; Hsiao Shufang; Xiao Shufang 肖淑芳
Zeng Yun 曾雲
Zhang Daqian 張大千
Zhang Qianying 張倩英
Zhang Tianyi 張天翼
Zhao Buwei; Zhaoyang Buwei 趙楊步偉
Zheng Da 鄭達
Zou Taofen 鄒韜奮

Selected Bibliography

Only books and chapters from books are included in this selected bibliography. For bibliographic details of articles and essays published in newspapers, magazines, journals, and periodicals see footnotes in individual chapters. The exceptions to this are books, articles, and essays by Chiang Yee, which are listed alphabetically in their own section, below.

Writings by Chiang Yee

Chiang Yee. *Calligraphy and Paintings by Chiang Yee*. Publisher unknown, n.d., ca. 1972.
Chiang Yee. *China Revisited, after Forty-Two Years*. New York: W. W. Norton, 1977.
Chiang Yee. *Chinese Calligraphy: An Introduction to Its Aesthetic and Technique*. 2nd ed. London: Methuen, [1938] 1954.
Chiang Yee. *A Chinese Childhood*. London: Methuen, 1940.
Chiang Yee. *The Chinese Eye: An Interpretation of Chinese Painting*. London: Methuen, 1935.
Chiang Yee. 'The Chinese Painter'. *Daedalus* 86, no. 3 (May 1957): 242–52.
Chiang Yee. *Chin-Pao and the Giant Pandas*. London: Country Life, 1939.
Chiang Yee. *Chin-Pao at the Zoo*. London: Methuen, 1941.
Chiang Yee. 'A Collection of Chinese Paintings'. *The Burlington Magazine for Connoisseurs* 73, no. 429 (December 1938): 236, 262–64.
Chiang Yee. *Dabbitse*. London: Transatlantic Arts, 1944.
Chiang Yee. 'Early Chinese Painting: Nature as Viewed through the Eyes of the East'. *Country Life* (26 November 1938): lxii.
Chiang Yee. *Jiang Zhongya shi* [Poems by Jiang Zhongya (Chiang Yee)]. Publisher unknown, n.d., ca. 1935.
Chiang Yee. 'A Letter to Readers'. In Yui Shufang, *Chinese Children at Play*. London: Methuen, 1939, n.p.
Chiang Yee. *Lo Cheng: The Boy Who Wouldn't Keep Still*. London: Puffin Books, 1942.
Chiang Yee. 'Lü Chi'. In *Dictionary of Ming Biography, 1368–1644*, edited by L. Carrington Goodrich and Chaoying Fang, 1: 1005–6. New York: Columbia University Press, 1976.
Chiang Yee. 'Lu Chih'. In *Dictionary of Ming Biography, 1368–1644*, edited by L. Carrington Goodrich and Chaoying Fang, 1:960–61. New York: Columbia University Press, 1976.
Chiang Yee. *Lundun zhanshi xiaoji* [Sketches about London in wartime]. Hong Kong: Far Eastern Bureau, British Ministry of Information, 1940.
Chiang Yee. Review of *Foundations of Chinese Musical Art*, by J. H. Levis. *The Journal of the Royal Asiatic Society of Great Britain and Ireland* 70, no. 1 (January 1938): 145–48.

Chiang Yee. *The Silent Traveller: A Chinese Artist in Lakeland*. London: Country Life, 1937.
Chiang Yee. *The Silent Traveller in London*. London: Country Life, 1938.
Chiang Yee. *The Silent Traveller in War Time*. London: Country Life, 1939.
Chiang Yee. *The Story of Ming*. London: Puffin Books, 1944.
Chiang Yee, and W. W. Winkworth. 'The Paintings'. *The Burlington Magazine for Connoisseurs* 68, no. 394 (January 1936): 30–39.

Books

Acton, Harold. *Memoirs of an Aesthete*. London: Methuen, 1948.
Acton, Harold, and Ch'en Shih-Hsiang. *Modern Chinese Poetry*. London: Duckworth, 1936.
Adorno, Theodor W. *Minima Moralia*. Translated by E. F. N. Jephcott. London: NLB, 1974.
Aitken, Ian. *The Concise Routledge Encyclopedia of the Documentary Film*. London: Routledge, 2013.
Appadurai, Arjun. *Modernity at Large: Cultural Dimensions of Globalization*. Minneapolis: University of Minnesota Press, 1986.
Aston, Mark. *The Cinemas of Camden: A Survey and History of the Cinema Buildings of Camden*. London: London Borough of Camden, 1997.
Auerbach, Sacha S. *Race, Law, and 'The Chinese Puzzle' in Imperial Britain*. New York: Palgrave Macmillan, 2009.
Averill, Stephen C. *Revolution in the Highlands: China's Jinggangshan Base Area*. Lanham, MD: Rowman and Littlefield, 2006.
Baker, Phil, and Antony Clayton, eds. *Lord of Strange Deaths: The Fiendish World of Sax Rohmer*. Devizes: Strange Attractor Press, 2015.
Banton, Michael. *Racial Theories*. Cambridge: Cambridge University Press, 1998.
Benton, Gregor, and E. T. Gomez. *The Chinese in Britain, 1800–Present: Economy, Transnationalism, Identity*. Basingstoke: Palgrave Macmillan, 2007.
Bevan, Paul. *'Intoxicating Shanghai' – an Urban Montage: Art and Literature in Pictorial Magazines during Shanghai's Jazz Age*. Leiden: Brill, 2020.
Bevan, Paul. *A Modern Miscellany: Shanghai Cartoon Artists, Shao Xunmei's Circle and the Travels of Jack Chen, 1926–1938*. Leiden: Brill, 2015.
Benois, Alexandre. *Reminiscences of the Russian Ballet*. London: Putnam, 1947.
Bharucha, Rustom. *Another Asia: Rabindranath Tagore and Okakura Tenshin*. Oxford: Oxford University Press, 2006.
Bickers, Robert. *Britain in China: Community, Culture and Colonialism, 1900–49*. Manchester: Manchester University Press, 1999.
Bland, Alexander. *The Royal Ballet: The First Fifty Years*. Garden City, NY: Doubleday, 1981.
Boas, Jacob. *Writer's Block: The Paris Antifascist Congress of 1935*. Cambridge: Legenda, 2016.
Bolt, Christine. *Victorian Attitudes to Race*. London: Routledge and Kegan Paul, 1971.
Brooker, Peter, and Andrew Thacker, eds. *The Oxford Critical and Cultural History of Modernist Magazines: Volume I: Britain and Ireland, 1880–1955*. Oxford: Oxford University Press, 2009.
Buchanan, Tom. *East Wind: China and the British Left, 1925–1976*. Oxford: Oxford University Press, 2012.
Cahill, James. *An Index of Early Chinese Painters and Paintings: T'ang, Sung, and Yüan*. Berkeley: University of California Press, 1980.

Selected Bibliography

Cahill, James. *The Painter's Practice: How Artists Lived and Worked in Traditional China*. New York: Columbia University Press, 1994.
Casanova, Pascale. *The World Republic of Letters*. Cambridge, MA: Harvard University Press, 2004.
Causey, Andrew. *The Drawings of Henry Moore*. Farnham: Lund Humphries, 2010.
Chan, Pedith Pui. *The Making of a Modern Art World: Institutionalisation and Legitimisation of Guohua in Republican Shanghai*. Leiden: Brill, 2017.
Chan, Phil. *Final Bow for Yellowface: Dancing Between Intention and Impact*. Brooklyn, NY: Yellow Peril Press, 2020.
Chang, Elizabeth Hope. *Britain's Chinese Eye: Literature, Empire, and Aesthetics in Nineteenth-Century Britain*. Stanford, CA: Stanford University Press, 2010.
Chazin-Bennahum, Judith. *Rene Blum and the Ballets Russes: In Search of a Lost Life*. Oxford: Oxford University Press, 2011.
Chen Mingshu. *Chen Mingshu huiyilu* [Memoirs of Chen Mingshu]. Beijing: Zhongguo wenshi chubanshe, 1997.
Cherry, Brigid, and Nikolaus Pevsner. *The Buildings of England: London 4 North*. London: Penguin Books, 1998.
Christie, Ian, and Richard Taylor. *The Film Factory: Russian and Soviet Cinema in Documents, 1896–1939*. London: Routledge, 2012.
Clarke, John S. *Circus Parade*. Huddersfield: Jeremy Mills Publishing, 2008.
Clegg, Arthur. *Aid China, 1937–1949: A Memoir of a Forgotten Campaign*. Beijing: Xinshijie chubanshe, 1989.
Darwent, Charles. *Mondrian in London: How British Art Nearly Became Modern*. London: Double-Barrelled Books, 2012.
Davison, Peter, Ian Angus, and Sheila Davison, eds. *The Complete Works of George Orwell*. Vol. 13, *All Propaganda is Lies: 1941–1942*. London: Secker and Warburg, 1998.
Daybelge, Leyla, and Magnus Englund. *Isokon and the Bauhaus in Britain*. London: Batsford, 2019.
Delany, Paul. *Bill Brandt: A Life*. Stanford, CA: Stanford University Press, 2004.
DeRocher, Patricia. *Transnational Testimonios: The Politics of Collective Knowledge Production*. Seattle: University of Washington Press, 2018.
De Valois, Ninette. *Come Dance with Me: A Memoir*. Cleveland, OH: World Publishing, 1957.
Dirlik, Arif. *Revolution and History: The Origins of Marxist Historiography in China, 1919–1937*. Berkeley: University of California Press, 1978.
Docherty, Peter, and Tim White, eds. *Design for Performance: From Diaghilev to the Pet Shop Boys*. London: Lund Humphries Publishers, 1996.
Dooling, Amy D., and Kristina M. Torgeson, eds. *Writing Women in Modern China: An Anthology of Women's Literature from the Early Twentieth Century*. New York: Columbia University Press, 1998.
Eastman, Lloyd E. *The Abortive Revolution: China under Nationalist Rule, 1927–1937*. Cambridge, MA: Harvard University Press, 1974.
Eliot, Karen. *Albion's Dance: British Ballet During the Second World War*. Oxford: Oxford University Press, 2018.
Fairbank, John K., and Albert Feuerwerker, eds. *The Cambridge History of China*. Vol. 13, *Republican China, 1912–1949*. London: Cambridge University Press, 1986.
Finnane, Antonia. *Changing Clothes in China: Fashion, History, Nation*. London: Hurst, 2007.

Forman, Ross G. *China and the Victorian Imagination: Empires Entwined.* Cambridge: Cambridge University Press, 2013.
Frayling, Christopher. *The Yellow Peril: Dr Fu Manchu and the Rise of Chinaphobia.* London: Thames and Hudson, 2014.
Fu Guangming, ed. *Xiao Qian wenji* [Collected works of Xiao Qian]. 10 vols. Hangzhou: Zhejiang wenyi chubanshe, 1998.
Garrould, Ann. *Henry Moore: Drawings.* London: Thames and Hudson, 1988.
Garnett, Eve. *The Family from One End Street.* London: Frederick Muller, 1937.
George, Rosemary. *The Politics of Home.* Berkeley: University of California Press, 1999.
Giles, Herbert. *An Introduction to the History of Chinese Pictorial Art.* Shanghai: Kelly and Walsh, 1905.
Gollancz, Victor. *Reminiscences of Affection.* New York: Atheneum, 1968.
Gong Zizhen shiji biannian jiaozhu [Annotated poems of Gong Zizhen]. Shanghai: Shanghai guji chubanshe, 2013.
Gould, Stephen Jay. *The Mismeasure of Man.* London: Penguin Books, 1997.
Graham, Stephen. *London Nights: Studies and Sketches of London at Night.* London: John Lane, 1925.
Grey, Beryl. *For the Love of Dance: My Autobiography.* London: Oberon Books, 2017.
Grey, Beryl. *Through the Bamboo Curtain.* London: Collins, 1965.
Gu Yiqun. *Wang Lixi zhuan* [A biography of Wang Lixi]. Chengdu: Sichuan daxue chubanshe, 1995.
Hampstead at War, 1939–1945. London: Camden History Society, 1977. First edition ca. 1946 by Hampstead Borough Council (London).
Harman, Claire. *Sylvia Townsend Warner: A Biography.* London: Penguin Books, 2015.
Haskell, Arnold. *Ballet.* Harmondsworth: Penguin Books, 1945.
Hewitt, John. *A North Light: Twenty-Five Years in a Municipal Art Gallery.* Dublin: Four Courts Press, 2013.
Hockx, Michel. *Questions of Style: Literary Societies and Literary Journals in Modern China, 1911–1937.* Leiden: Brill, 2003.
Hodges, Graham Russell Gao. *Anna May Wong: From Laundryman's Daughter to Hollywood Legend.* New York: Palgrave Macmillan, 2005.
Holmes, Colin. *John Bull's Island: Immigration and British Society, 1871–1971.* London: Macmillan Education, 1988.
Hong Shen, *Hong Shen wenji* [Collected works of Hong Shen]. 4 vols. Beijing: Zhonguo xiju chubanshe, 1959.
Horvitz, Dawn Lille. *Michel Fokine.* Boston, MA: Twayne, 1985.
Hosie, Lady. *The Pool of Ch'ien Lung: A Tale of Modern Peking.* London: Hodder and Stoughton, 1944.
Hsiao Ch'ien. *China but Not Cathay.* London: The Pilot Press, 1942.
Hsiao Ch'ien. *Etching of a Tormented Age: A Glimpse of Contemporary Chinese Literature.* Milton Keynes: Lightning Source, n.d., ca. 1941.
Hsiao Ch'ien, comp. *A Harp with a Thousand Strings: A Chinese Anthology in Six Parts.* London: Pilot Press, 1944.
Hsiao Ch'ien. *Traveller Without a Map.* London: Hutchinson, 1990.
Hsieh Ping-ying. *Autobiography of a Chinese Girl.* Translated by Tsui Chi. London: George Allen and Unwin, 1945.

Hsiung, Dymia. *Flowering Exile: An Autobiographical Excursion*. London: Peter Davies, 1952.
Hsiung, S. I. *The Bridge of Heaven*. London: Peter Davies, 1943.
Hsiung, S. I. *Lady Precious Stream: An Old Play Done into English According to its Traditional Style*. London: Methuen, 1934.
Hsiung, S. I. *The Life of Chiang Kai-shek*. London: Peter Davies, 1948.
Hsiung, S. I. *The Professor from Peking: A Play in Three Acts*. London: Methuen, 1939.
Hsiung, S. I., trans. *The Romance of the Western Chamber*. By Wang Shifu. New York: Columbia University Press, 1968. First edition 1935 by Methuen (London).
Hsiung, S. I. *The Story of Lady Precious Stream*. London: Hutchinson, 1950.
Hsu, Hua. *A Floating Chinaman: Fantasy and Failure across the Pacific*. Cambridge, MA: Harvard University Press, 2016.
Huang, Yunte. *Charlie Chan: The Untold Story of the Honorable Detective and His Rendezvous with American History*. New York: W. W. Norton, 2010.
Hu Die. *Hu Die huiyilu* [Memoirs of Hu Die]. Edited by Liu Huiqin. Beijing: Wenhua yishu chubanshe, 1988.
Jenyns, Soame. *A Background to Chinese Painting*. With a preface by W. W. Winkworth. London: Sidgwick and Jackson, 1935.
Jordan, Donald. *China's Trial by Fire: The Shanghai War of 1932*. Ann Arbor: University of Michigan Press, 2001.
The Kinematograph Year Book, 1937. London: Kinematograph Publications, 1937.
Labanyi, Jo, and Tatjana Pavlović, eds. *Companion to Spanish Cinema*. Oxford: Wiley-Blackwell, 2013.
Lambert, Constant. *Music Ho! A Study of Music in Decline*. London: Faber and Faber, 1934.
Laughlin, Charles. *Chinese Reportage: The Aesthetics of Historical Experience*. Honolulu: University of Hawai'i Press, 2002.
Laurence, Patricia. *Lily Briscoe's Chinese Eyes: Bloomsbury, Modernism, and China*. Columbia: University of South Carolina Press, 2003.
Lee, Leo Ou-fan. *The Romantic Generation of Modern Chinese Writers*. Cambridge, MA: Harvard University Press, 1973.
Lee, M. P. *Chinese Cookery: A Hundred Practical Recipes*. London: Faber and Faber, 1943.
Lehmann, John, ed. *The Penguin New Writing* 24. Harmondsworth: Penguin Books, 1945.
Lehmann, John. *The Whispering Gallery*. London: Longmans Green, 1957.
Lewis, Jeremy. *Penguin Special: The Life and Times of Allen Lane*. London: Penguin Books, 2006.
Leyda, Jay. *Dianying: An Account of Films and the Film Audience in China*. Cambridge, MA: MIT Press, 1972.
Lin, Adet, and Anor Lin. *Our Family*. London: Jonathan Cape, 1939.
Lindey, Christine. *Art for All: British Socially Committed Art from the 1930s to the Cold War*. London: Artery Publications, 2018.
Liu Haisu. *Zhongguo huihua shang de liufa lun* [The theory of the Six Laws of Chinese painting]. Shanghai: Zhonghua shuju, 1931.
Liu, Miles. *Asian American Playwrights: A Bio-bibliographical Critical Sourcebook*. Westport, CT: Greenwood Press, 2002.
Liu Ruikuan. *Zhongguo meishu de xiandaihua: meishu qikan yu meizhan huodong de fenxi* [The modernisation of Chinese art: A study of art journals and art exhibitions]. Beijing: Sanlian shudian, 2008.

Lloyd, Stephen. *Constant Lambert: Beyond the Rio Grande*. Woodbridge: The Boydell Press, 2014.

Lo, Kenneth. *The Feast of My Life*. London: Transworld Publishers, 1993.

Lottman, Herbert R. *The Left Bank: Writers, Artists, and Politics from the Popular Front to the Cold War*. Chicago, IL: The University of Chicago Press, 1998.

Lu Jingqing. *Lu Jingqing shiwenji* [Collected poems and prose of Lu Jingqing]. Chengdu: Sichuan daxue chubanshe, 1997.

Luo Weiguo. *Huashuo Mile* [On Maitreya]. Beijing: Zhongguo wenlian chubanshe, 1994.

Lü Peng. *Zhongguo yishu biannianshi* ['A History of Chinese Art year by year from the year 1900 to 2010']. Beijing: Zhongguo qingnian chubanshe, 2012.

Maclean, Caroline. *Circles and Squares: The Lives and Art of the Hampstead Modernists*. London: Bloomsbury, 2020.

Margolies, David, ed. *Writing the Revolution: Cultural Criticism from 'Left Review'*. London: Pluto Press, 1998.

Martin, Rupert, ed. *Artists Design for Dance, 1909–1984*. Bristol: Arnolfini Gallery, 1984.

McCormack, W. J. *Northman: John Hewitt (1907–87): An Irish Writer, His World, and His Times*. Oxford: Oxford University Press, 2015.

Mercer, K. *Welcome to the Jungle: New Positions in Black Cultural Studies*. London: Routledge, 1994.

Mitchell, Charles P. *A Guide to Charlie Chan Films*. Westport, CN: Greenwood Press, 1999.

Morton, H. V. *H. V. Morton's London*. London: Methuen, 1940.

Motion, Andrew. *The Lamberts: George, Constant and Kit*. New York: Farrar, Strauss and Giroux, 1986.

Ne'eman, Gulie, ed. *Passing into History: Nazism and the Holocaust beyond Memory*. Bloomington: Indiana University Press, 1997.

Ng Kwee Choo. *The Chinese in London*. London: Institute of Race Relations/Oxford University Press, 1968.

Okakura Kakuzō. *The Ideals of the East: With Special Reference to the Art of Japan*. London: J. Murray, 1903.

O'Neill, Mark. *The Chinese Labour Corps: The Forgotten Chinese Labourers of the First World War*. Melbourne, VIC: Penguin Group Australia, 2014.

Payne, Robert, and Yuan Chia-Hua, eds. and trans. *Contemporary Chinese Short Stories*. London and New York: Transatlantic Arts, 1946.

Powell, Anthony. *Casanova's Chinese Restaurant*. Harmondsworth: Penguin Books, 1964.

Qian Zhaoming. *Orientalism and Modernism: The Legacy of China in Pound and Williams*. Durham, NC: Duke University Press, 1995.

Qian Zhongshu. *Guan zhui bian* [Limited views]. 4 vols. Beijing: Zhonghua shuju, 1986.

Radford, Robert. *Art for a Purpose: The Artists' International Association, 1933–1953*. Winchester: Winchester School of Art Press, 1987.

Read, Herbert. *Art in Britain, 1930–40: Centred around Axis, Circle, Unit One*. London: Marlborough Fine Art, 1965.

Read, Herbert. *Art Now*. London: Faber and Faber, 1933.

Read, Herbert [Li De]. *Jinri zhi yishu* [Art now]. Translated by Shi Zhecun. Shanghai: Shangwu yinshuguan, 1935.

Sang, Tze-lan D. *The Emerging Lesbian: Female Same-Sex Desire in Modern China*. Chicago, IL: University of Chicago Press, 2003.

Said, Edward. *Culture and Imperialism*. New York: Vintage, 1993.
Scott, A. C. *Mei Lan-Fang: Leader of the Pear Garden*. Hong Kong: Hong Kong University Press, 1959.
Schmidt, Jerry D. *Harmony Garden: The Life, Literary Criticism, and Poetry of Yuan Mei (1716–1798)*. London: RoutledgeCurzon, 2003.
Shafak, Elif. *How to Stay Sane in an Age of Division*. London: Wellcome Collection, 2020.
Shead, Richard. *Constant Lambert*. London: Simon Publications, 1973.
Smith, Amy Beth. 'On "the Edge of a Crumbling Continent": Poetry in Northern Ireland and the Second World War'. PhD diss., Durham University, 2014.
Smith, Barry, ed. *The Collected Letters of Peter Warlock*. Woodbridge: Boydell Press, 2005.
Snow, Edgar, ed. *Living China: Modern Chinese Short Stories*. London: George G. Harrap, 1936.
Song Luxia. *A Collection of Qipaos from China's Prominent Families*. Shanghai: Shanghai Scientific and Technological Literature Press, 2017.
Stansky, Pater, and William Abrahams. *Julian Bell: From Bloomsbury to the Spanish Civil War*. Stanford, CA: Stanford University Press, 2012.
Stravinsky and the Dance: A Survey of Ballet Productions, 1910–1962. New York: New York Public Library, 1962.
Su Hua [Ling Shuhua]. *Ancient Melodies*. London: Hogarth Press, 1953.
Surya Sena, Devar. *Of Sri Lanka I Sing: The Life and Times of Devar Surya Sena, O.B.E., M.A., L.L.B., A.R.C.M*. Colombo: Surya Sena, 1978.
Taruskin, Richard. *Stravinsky and the Russian Traditions: A Biography of the Works through Mavra: Volume One*. Berkeley: University of California Press, 1996.
Tcheng-Ki-Tong. *Chin-Chin; or, The Chinaman at Home*. Translated by R. H. Sherard. Fairford: Echo Library, 2019. First edition 1890 as *Les plaisirs en Chine* by Charpentier (Paris). First English edition 1895 by A. P. Marsden (London).
Thomas, Myfanwy. *One of These Fine Days: Memoirs*. Manchester: Carcanet New Press, 1982.
Townsend Warner, Sylvia. *Letters*. Edited by William Maxwell. New York: Viking, 1982.
Tsui Chi. *A Short History of Chinese Civilization*. London: Gollancz, 1942.
Tsui Chi. *The Story of China*. London: Puffin Books, 1950.
Vincent, Susan J. *Hair: An Illustrated History*. London: Bloomsbury, 2018.
Wade, Christopher, ed. *The Streets of Belsize*. London: Camden History Society, 1991.
Waley, Arthur. *An Introduction to the Study of Chinese Painting*. London: Ernest Benn, 1923.
Walsh, Stephen. *Igor Stravinsky: A Creative Spring: Russia and France, 1882–1934*. London: Jonathan Cape, 2003.
Wang Chi-chen, ed. *Contemporary Chinese Stories*. New York: Columbia University Press, 1944.
Wang Chi-chen. *Stories of China at War*. New York: Columbia University Press, 1947.
Wang, David Der-wei. *Fictional Realism in Twentieth-Century China: Mao Dun, Lao She, Shen Congwen*. New York: Columbia University Press, 1992.
Wang Pu. *The Translatability of Revolution: Guo Moruo and Twentieth-Century Chinese Culture*. Cambridge, MA: Harvard University Asia Center, 2018.
Wang Lixi. *Li Changji pingzhuan* [The biography of Li Changji]. Shanghai: Shenzhou guoguang she, 1930.
Wang Lixi. *Haiwai erbi* [A second notebook from overseas]. Shanghai: Zhonghua shuju, 1936.

Wang Lixi. *Haiwai zabi* [Miscellaneous notes from overseas]. Shanghai: Zhonghua shuju, 1935.
Wang Lixi. *Zai guoji yuanhua zhenxian shang* [On the international aid-China front]. Chongqing: Shenghuo shudian, 1939.
Wang Lixi. *Zhanshi riji* [Wartime diary]. Shanghai: Shenzhou guoguang she, 1932.
Ward, Laurence. *The London County Council Bomb Damage Maps, 1939–1945*. London: Thames and Hudson, 2015.
Welland, Sasha Su-ling. *A Thousand Miles of Dreams: The Journeys of Two Chinese Sisters*. London: Rowman and Littlefield, 2006.
Whittingham-Jones, Barbara. *China Fights in Britain: A Factual Survey of a Fascinating Colony in Our Midst*. London: W. H. Allen, 1944.
Witchard, Anne, ed. *British Modernism and Chinoiserie*. Edinburgh: Edinburgh University Press, 2015.
Witchard, Anne. *England's Yellow Peril: Sinophobia and the Great War*. Melbourne, VIC: Penguin Group Australia, 2014.
Witchard, Anne. *Lao She in London*. Hong Kong: Hong Kong University Press, 2012.
Witchard, Anne. *Thomas Burke's Dark Chinoiserie: Limehouse Nights and the Queer Spell of Chinatown*. Farnham: Ashgate, 2009.
Woolf, Virginia. *Leave the Letters till We're Dead: The Letters of Virginia Woolf, Vol. 6: 1936–1941*. Edited by Nigel Nicolson. London: The Hogarth Press, 1994.
Wu, Frank H. *Yellow: Race in America beyond Black and White*. New York: Basic Books, 2002.
Wu Shengqing. *Modern Archaics: Continuity and Innovation in the Chinese Lyric Tradition, 1900–1937*. Cambridge, MA: Harvard University Press, 2013.
Wu, William. *The Yellow Peril: Chinese Americans in American Fiction, 1850–1940*. Hamden, CT: Archon Books, 1982.
Xiao Ruping. *Nanjing guomin zhengfu yu 'yi·erba' Song–Hu kangzhan yanjiu* [The Nanjing Nationalist government and the January 28 Shanghai War of Resistance]. Hangzhou: Zhejiang daxue chubanshe, 2016.
Xiong Delan, and Wu Guanghua, *Haiwai guiren* 海外歸人 [Those who returned from abroad]. Beijing: Beijing shiyue wenyi chubanshe, 1998.
Yang Haosheng. *A Modernity Set to a Pre-modern Tune: Classical-Style Poetry of Modern Chinese Writers*. Leiden: Brill, 2016.
Yang Xianyi. *White Tiger: An Autobiography of Yang Xianyi*. Hong Kong: The Chinese University of Hong Kong Press, 2002.
Yang Yu-hsun. *La calligraphie chinoise depuis les Han*. Paris: Librairie Orientaliste Paul Geuthner, 1937.
Yeh Chun-chan [Ye Junjian]. *Ye Junjian quanji* [The complete works of Ye Junjian]. 20 vols. Beijing: Tsinghua University Press, 2010.
Yeh Chun-chan, ed. and trans. *Three Seasons and Other Stories*. London: Staples Press, 1946.
Yeh, Diana. *The Happy Hsiungs: Performing China and the Struggle for Modernity*. Hong Kong: Hong Kong University Press, 2014.
Zhang Yingjin. *Chinese National Cinema*. London: Routledge, 2004.
Zhang Yingjin, ed. *Cinema and Urban Culture in Shanghai, 1922–1943*. Stanford, CA: Stanford University Press, 1999.
Zheng Da. *Chiang Yee: The Silent Traveller from the East – a Cultural Biography*. New Brunswick, NJ: Rutgers University Press, 2010.

Zheng Da. *Shih-I Hsiung: A Glorious Showman*. Vancouver, BC: Fairleigh Dickinson University Press, 2020.
Zheng Da. *Xixing huaji* [Chiang Yee biography]. Beijing: Commercial Press, 2012.
Zheng, Jane. *The Modernization of Chinese Art: The Shanghai Art College, 1913–1937*. Leuven: Leuven University Press, 2016.
Zhongguo minghuaji ['Famous Chinese paintings collected by Ping Teng Ke']. 2 vols. Shanghai: Yu Tseng Book Company, 1930.
Zuroski Jenkins, Eugenia. *A Taste for China: English Subjectivity and the Prehistory of Orientalism*. Oxford: Oxford University Press, 2013.

Articles and Chapters in Books

Cheang, Sarah. 'Roots: Hair and Race'. In *Hair: Styling, Culture and Fashion*, edited by Geraldine Biddle-Perry and Sarah Cheang, 27–42. Oxford: Berg, 2008.
Harris, Kristine. '*Ombres Chinoises*: Split Screens and Parallel Lives in Love and Duty'. In *The Oxford Handbook of Chinese Cinemas*, edited by Carlos Rojas and Eileen Cheng-Yin Chow, 39–62. Oxford: Oxford University Press, 2013.
Heinemann, Margot. ' "Left Review", "New Writing" and the Broad Alliance against Fascism'. In *Visions and Blueprints: Avant-Garde Culture and Radical Politics in Early Twentieth-Century Europe*, edited by Edward Timms and Peter Collier, 113–36. Manchester: Manchester University Press, 1988.
Hsiao Ch'ien. 'The Ramshackle Car'. In *The Spinners of Silk*, 70–75. London: George Allen and Unwin, 1944.
Hsiung, Shih-I. Foreword to *The Romance of the Jade Bracelet and Other Chinese Operas*, by Lisa Lu, 5–8. San Francisco, CA: Chinese Materials Center, 1980.
Kao Yu-kung. 'The Aesthetics of Regulated Verse'. In *The Vitality of the Lyric Voice: Shih Poetry from the Late Han to the T'ang*, edited by Shuen-fu Lin and Stephen Owen, 332–85. Princeton, NJ: Princeton University Press, 1986.
Hewitt, John. 'The Little Death'. In *The Collected Poems of John Hewitt*, edited by Frank Ormsby, 44. Belfast: Blackstaff Press, 1991.
Holmes, Colin. 'The Chinese Connection'. In *Outsiders and Outcasts: Essays in Honour of William J. Fishman*, edited by Geoffrey Alderman and Colin Holmes, 71–93. London: Duckworth, 1993.
Inaga Shigemi. 'Okakura Kakuzō's Nostalgic Journey to India and the Invention of Asia'. In *Nostalgic Journeys: Literary Pilgrimages Between Japan and the West*, edited by Susan Fisher, 119–32. Vancouver, BC: Institute of Asian Research, University of British Columbia, 2001.
Laughlin, Charles A. 'The All-China Resistance Association of Writers and Artists'. In *Literary Societies of Republican China*, edited by Kirk A. Denton and Michel Hockx, 379–411. Lanham, MD: Lexington Books, 2008.
May, J. P. 'The Chinese in Britain, 1860–1914'. In *Immigrants and Minorities in British Society*, edited by Colin Holmes, 101–15. London: George Allen and Unwin, 1978.
Pejčochová, Michaela. 'Exhibitions of Chinese Painting in Europe in the Interwar Period: The Role of Liu Haisu as Artistic Ambassador'. In *The Reception of Chinese Art Across Cultures*, edited by Michelle Ying-Ling Huang, 179–99. Newcastle-upon-Tyne: Cambridge Scholars Publishing, 2014.

Potter, Rachel. 'International PEN: Writers, Free Expression, Organisations'. In *A History of 1930s British Literature*, edited by Benjamin Kohlmann and Matthew Taunton, 120–33. Cambridge: Cambridge University Press, 2019.

Ren Ke. 'The International Peace Campaign, China, and Transnational Activism at the Outset of World War II'. In *The Routledge History of World Peace since 1750*, edited by Christian Philip Peterson, William M. Knoblauch, and Michael Loadenthal, 359–61. New York: Routledge, 2018.

Schultz, Anna. 'John Heartfield: A Political Artist's Exile in London'. In *Burning Bright: Essays in Honour of David Bindman*, edited by Diana Dethloff, Tessa Murdoch, Kim Sloan, and Caroline Elam, 253–63. London: UCL Press, 2015.

'Shelley Wong'. In *Pour la défense de la culture: Les textes du Congrès international des écrivains, Paris, juin 1935*, edited by Sandra Teroni and Wolfgang Klein, 499–500. Dijon: Editions Universitaires de Dijon, 2005.

Thacker, Andrew. 'Circulating Literature: Libraries, Bookshops, and Book Clubs'. In *A History of 1930s British Literature*, edited by Benjamin Kohlmann and Matthew Taunton, 98–102. Cambridge: Cambridge University Press, 2019.

Vainker, Shelagh. 'Chinese Painting in London, 1935'. In *Shanghai Modern, 1919–1945*, edited by Jo-Anne Birnie Danzker, Ken Lum, and Zheng Shengtian, 118–23. Ostfildern-Ruit: Hatje Cantz Verlag, 2004.

Vainker, Shelagh. 'Exhibitions of Modern Chinese Painting in Europe, 1933–1935'. In *Chinese Painting and the Twentieth Century: Creativity in the Aftermath of Tradition*, edited by Cao Yiqiang and Fan Jingzhong, 554–61. Hangzhou: Zhejiang Art Publishers, 1997.

Vinograd, Richard. 'Patrimonies in Press: Art Publishing, Cultural Politics, and Canon Construction in the Career of Di Baoxian'. In *The Role of Japan in Modern Chinese Art*, edited by Joshua A. Fogel, 244–72. Berkeley: University of California Press, 2012.

'Wang Lixi'. In *Wuchang nongmin yundong jiangxisuo renwu zhuanlüe* [Brief biographies of figures of the Wuchang Peasant Training Institute], edited by Wuchang nongjiangsuo jinianguan, 23–26. Wuhan: Wuhan chubanshe, 1997.

Wang Lixi. 'Yingguo wenhuajie de yuanhua yundong: zuoshuhui ji qita' [The aid-China movement in the English cultural sphere: On the Left Book Club and other matters]. In *Wang Lixi wenji* [Collected works of Wang Lixi], 74–76. Beijing: Xinhua chubanshe, 1989.

Yeh, Diana. 'Contested Belongings: The Politics and Poetics of Making a Home in Britain'. In *China Fictions/English Language: Literary Essays in Diaspora, Memory and Story*, edited by A. Robert Lee, 299–325. Amsterdam: Rodopi, 2008.

Zhang Yingjin. 'Chinese Film in the West'. In *Encyclopaedia of Chinese Film*, edited by Yingjin Zhang, and Zhiwei Xiao. London: Routledge 2002.

Zhang Zhen. 'Transplanting Melodrama: Observations on the Emergence of Early Chinese Narrative Film'. In *A Companion to Chinese Cinema*, edited by Yingjin Zhang, 23–41. Chichester: Wiley-Blackwell, 2012.

Index

Note: Page numbers in bold refer to figures; page numbers in the front matter are in italics.

Anti-Bolshevik (AB) League, 160
Ackland, Valentine, 171, 175
Acton, Harold, 52, 110, 118, 120n67, 126
Aestheticism, 62
Aid to China, 89. *See also* United Aid to China
Aladdin, 59
Alhambra Theatre, 58
Alice's Adventures in Wonderland, 134
All-China Union for National Liberation, 168
Allen, Donald, 118, 120, 124
Allen, Walter, 120n67, 121
Allied Artists' Exhibition, 96
American Standard Oil Company, 77
Anand, Mulk Raj, 119–20
Ancient Melodies, 189, 194
Andersen, Hans Christian, 52
Anglo-Chinese films, 150
anti-fascism, 5, 7, 103, 106, 159, 164–67, 178, 180. *See also* fascism
Appadurai, Arjun, 113
Armlet of Jade, 130
Artists' International Association, The (AIA), 13–14
 AIA members' register, 14n21
Ashmolean Museum, 5, 181–82
Ashton, Frederick, 52–53
Asther, Nils, 147
Autobiography of a Chinese Girl, 112n26, 123
Avenue Pavilion, The, 63, 144n6, 145

Babel, Isaac, 166

Background to Chinese Painting, A, 26
Bahr, A. W., 34
Bakst, Leon, 55, 69
Balanchine, George, 57
ballet, 6, 51–70, 98, 150–51
 Royal Ballet, The, 70
Ballets Russes, 54–58
 Ballets Russes de Monte-Carlo, 57–58, 60n51
Bauhaus, 12–14
BBC (British Broadcasting Corporation) 4, 7, 55–56, 58n39, 97, 109, 113, 118, 153, 157, 159, 179
 BBC Far East Service, 97
 BBC Forces Programme, 55
 BBC Home Service, 97
 BBC Overseas Service, 109
 BBC Radio, 4, 7, 56, 97, 159, 179
 BBC Television, 153, 157
Beaton, Cecil, 52, 53n12
Belfast, 99n35, 159, 172–76
Bell, Clive, 110n13, 183
Bell, Julian, 110, 120, 183, 192
Bell, Vanessa, 52, 110n13, 120, 183, 192, 194
Belsize Park, 11–17, 90–91, 93, 94n17, 103, 185. *See also* Hampstead
Bemelman, Ludwig, 193
Benois, Alexandre, 55–56, 69
Bergson, Henri, 29–30
Bertram Mills Circus, 149–50
Bickers, Robert, 2
Bijou Film Company, 148, 150, 151n45
Binyon, Laurence, 4, 22–23, 26, 49n34, 95–96, 122, 132

Birds, The, 6, 51–53, 55, 57, 61, 64–70
Blackbirds, The, 61
Blitz, The, 5, 15, 46, 52, 54, 78, 89–90, 93n15, 94, 102, 112, 134. *See also* bombing
'Blitz spirit', 6, 93
Bloody Saturday, 94
Bloomsbury Group, The, 109–10, 120, 131, 181, 194
Blue Plaque, 5, 12n8
Blum, René, 57–58
Blunt, Anthony, 13, 94n16
bombing, 15–16, 40, 78, 90, 93n15, 94–95, 145n16, 178, 186. *See also* Blitz
 'Bombing Casualties: Spain', 14–15
 of Chongqing, 94, 102
 'Guernica', 178
 of Hampstead, 5, 15–16, 40, 52, 78, 89–90, 94–95, 134
 of Jiujiang, 78
 of London, 40, 90, 94–95, 145n16, 186
 of Shanghai, 94
Book Society, 120–21
Bottomley, Gordon, 123
Bradley, Lionel, 66–69
Brandt, Bill, 13, 16
Brandt, Rolf, 13
Breuer, Marcel, 12
Bridge of Heaven, The, 139, 157
Brighton Pavilion, The, 69
Britain at War (Zhanshi Buliedian), 99–100
British Museum, 4, 19, 21, 26–27, 30, 95, 143, 181
Broadway, 128, 130, 132, 140, 143, 156n72
Brush Drawing in the Chinese Manner, 182
Brussels, 134, 145, 151n44, 167–68, 171
Buck, Pearl, 21, 125, 126n96, 147, 156
Budai, 78–81
 Budai Monk, The (painting) (1934), 78, 80
 Budai Monk, The (painting) (1972), 78, 81
Buddhism, 24, 33, 78–81
 Buddha, 18, 20, 80
 Buddhist monk, 76, 78–81, 177
 Buddhist painting, 18, 20, 22, 78–81

Buddhist revival, 33
Buddhist temples, 78
Buddhist texts, 20n9
 Maitreya, 80
 Zen, 78n26
Buñuel, Luis, 144
Burke, Thomas, 2, 147
Burlington House, 143, 173,
Burlington Magazine, The, 34n62, 35
Burma Road, 95, 100–102
Burra, Edward, 52
Butterfly Wu (Hu Die), 146, 155
Byron, Lord, 163

Cai Chusheng, 145–46
Cai Tingkai, 161
Cai Yuanpei, 22
calligraphy, 6, 15, 19–20, 26, 34–35, 57, 84, 109, 140, 180, 191–92
 Chiang Yee, 15, 18–21, 26, 34–35, 57, 78–79, 180
 Hsiung, Shih-I, 140
 Sye Ko Ho, 191–92
 Xu Zhimo, 109
Calligraphy and Paintings by Chiang Yee, 78–79
Cambridge, 1, 114n33, 143, 188
Carrington, Noel, 94–95, 107, 110, 114–18, 125
Carroll, Lewis, 134
Casanova, Pascale, 108
Casanova's Chinese Restaurant, 52, 61, 63
Cathay, 62
census (UK), 2–3, 130
 1911, 2
 1931, 2, 130
Chan, Charlie, 40–46, 48, 137. *See also* film
 'Charlie Chan and Myself', 42
Chant du Rossignol, Le, 56
Chaplin, Charlie, 64
Chen Jitong, 25
Chen Mingshu, 160–62, 167–68
Chen Yuan, 113n27, 182–84, 187, 194–95
Chen, Jack, 13–14, 169
Cheng Kwang Movie House, 154
Chiang Hsu, 73

Index

Chiang Kai-shek, 7, 77, 157, 161, 166, 168, 195
Chiang Ta-ch'uan, 90
Chiang Yee (Jiang Yi)
 AIA, member of, 14
 ballet, 51–70
 ballet and calligraphy, analogy between, 57–58
 BBC Radio, 4, 97, 102, 113
 Buddhism, 20, 22, 24, 33, 76, 78–81
 calligraphy, 15, 18–21, 26, 34–35, 57, 78–79, 180
 Carrington, Noel, 93–95, 107, 110, 114–18
 Charlie Chan, 40–46, 48
 childhood, 72–76, 78, 87–88
 children's books, 78, 90, 93–94, 94n16, 102, 107, 112, 115–17, 125
 Chin-Pao and the Giant Pandas, 90, 94n16, 95n21, 188
 Dabbitse, 116–17, 102n41
 Lo Cheng: The Boy who Wouldn't Keep Still, 94n16, 102n41, 116
 Story of Ming, The, 94n16, 102n41, 116
 Herdan, Innes (née Jackson), 22–23, 78, 93, 131, 175, 183
 International Exhibition of Chinese Art, 21, 26, 36, 131
 Jiujiang, 19, 71–75, 77–78, 81, 84–86, 88, 90, 92, 94, 96n24, 102–3, 184
 Lake District, 82–83, 85, 115n42, 130
 Lambert, Constant, 51–52, 55, 57, 60–61, 65–66
 lectures and talks, 4, 19, 22, 35, 95–97, 109–10, 134
 London Zoo, 93–94, 116, 188
 New Burlington Galleries, 13, 21–22, 131–32
 Oxford, *xi*, 15, 37–50, 129, 134, 158, 186
 painting (and illustration), 15, 18–22, 24–36, 74, 78–81, 83, 89, 95, 96n24, 97n26, 102, 116, 130–32, 135–36, 138–40, 180, 184
 poetry, 6, 24, 79n28, 81, 83–86, 97, 102, 158–59, 163, 180

propaganda, 6, 89, 91, 100–103, 117
Read, Herbert, 14–15, 35n64
silence, 6, 38, 40–41, 49, 76, 77, 81, 83
Silent Traveller (Yaxingzhe), 38–41, 44–50, 70–72, 76–78, 80–88
Silent Traveller books. *See individual titles*
Six Laws (Six Principles), 22, 27–31
School of Oriental Studies (SOS), 19–20, 22, 34–35, 78, 80, 92, 132, 184
'Uncle' Chiang, 135–36, 182, 188
wartime, 89–103
Wellcome, 91–93, 102
Xu Beihong, 18, 96n23, 96n24, 98, 130–31
Zhongya (Chung-ya), 19, 79
China but not Cathay, 59
China Campaign Committee (CCC), 14, 101, 110–11, 159, 169–72, 176, 178
China craze, 142–43, 145–46, 149
China Fights Back, 170
China House, 135
China Institute, 96
China Today, 171
China, representation of, 180
Chinese Cabaret, 150–52
Chinese Calligraphy: An Introduction to its Aesthetic and Technique, 6, 15, 18, 35n64, 57, 78, 117n57
Chinese Childhood, A, 6, 71–76, **88**
Chinese Children at Play, 86–87
Chinese Communist Party (CCP), 157, 160–61, 168–69
Chinese Cookery: A Hundred Practical Recipes, 97–98, 189
Chinese Embassy, 97, 100, 188–90
Chinese Eye: An Interpretation of Chinese Painting, The, 5–6, 18, 21–23, 25–28, 31–33, **34**, 35, 78, 131–32, 134
Chinese film, 63, 142–50
'Chinese Peasant in Spring, The' (Nongren zhi chun), 145–46
Hsiung, Shih-I, 142–43, 152–57
Rose of Pu-Chui, The (Xixiangji), 63, 143–45

Song of the Fishermen (Yuguang qu), 145–46
Chinese Fluteplayer, The, 176
Chinese Labour Corps, 3
Chinese League of National Revolution, 168
Chinese National Salvation Association, 168
Chinese Nationalist Party (Kuomintang; Guomindang), 7, 20, 97n32, 101, 140, 152, 169
 Chiang Yee, 20
 Shih-I Hsiung, 140, 157
 Wang Lixi, 7, 160, 169
Chinese News Service, New York, 101
Chinese painting, 13, 18–36, 74, 78–81, 83, 89, 96, 111, 116, 130–32, 138, 180–82, 191
 Buddhist painting, 18, 20, 22, 78–80
 Chiang Yee (painting and illustration), 15, 18–22, 24–36, 74, 78–81, 83, 89, 95, 96n24, 97n26, 102, 116, 130–32, 135–36, 138–40, 180, 184
 Chinese Eye: An Interpretation of Chinese Painting, The, 5–6, 18, 21–23, 25–28, 31–33, **34**, 35, 78, 131–32, 134
 Exhibition of Modern Chinese Painting, 13, 21–22, 28, 131–32
 Xie He's Six Laws (aka Six Principles), 22, 27–30
Chinese Peasant in Spring, The. *See* Chinese film
Chinese Republic. *See* Republic of China, The
'Chinese Seaman, A', 121–22
Chinese Society, The, 95
Chinese Student Union, 135
Chinese Writers' Associations War Area Interview Group, 179
Chineseness, 43, 48, 52, 60, 132–33, 136, 141
Chinnery, Ying, 181, 187, 197
chinoiserie, 52, 55–62, 63n74, 65
Chin-Pao and the Giant Pandas, 90, 95n21, 102n41, 188
Chongqing, bombing of. *See* bombing
Chu Chin Chow, 13n14, 133, 137, 154
 Chu Chin Chow, 147

Chung-ya. *See* Chiang Yee
Churchill, Winston, 93, 99, **100**
Chuter, Florence (aka Florence Kaye, Florence Lambert), 63
Cicio Mar. *See* Ye Junjian
Circle of Chalk, The, 63, 145, 154
citizen diplomacy (*guomin waijiao*), 170
Clark, Kenneth, 49n34, 99
Clayden, Pauline, 53
Clegg, Arthur, 169
Cold War, 35
Collet's Chinese Bookshop, 181–82
'Colloquy on Ballet', 56
commedia dell'arte, 55
Communist Party of Great Britain, 171
Connard, Philip, 130
Connolly, Cyril, 111, 120n67
Constantine, George Hamilton, 96
Constructivist, 12n9, 57
Contemporary Chinese Short Stories, 125
Council for the Encouragement of Music and the Arts and Entertainments National Service Association (CEMA), 54–55, 69
Country Life (publishers), 82, 91, 107, 115
 also *Country Life*, 89
Covent Garden Opera House, 57–58
Crescent Moon Society, 110, 131
'Critical Review, The' (*Xueheng*), 24
oddments, 37, 50
 also cultural 'oddment' 37
Curwen, Charles, 181

Dabbitse, 116–17
Dai Ailian, 53n11, 150–51
Daily Sketch, The, 65
Daily Worker, The, 171
Dale, Margaret, 53, **66**, **67**
'Dance to the Music of Time, A', 52
Dancing Times, The, 70, 150
Daylight, 110n13, 111n20, 118
de Basil, Colonel Wassily, 57–58
de Lion, Leon M., 133
de Valois, Ninette, 51–52, 54
de Zoete, Beryl, 120
Deansway, 186

Index

Depero, Fortunato, 56
Derain, André, 52, 58–59, 69
Design and Industries Association, 115
Deva Surya Sena (Herbert Charles Jacob Pieris), 153, 154n54
Di Baoxian, 31–33
Diaghilev, Sergei, 52, 55–58, 65
Diaspora, 3, 128–30, 133–34, 141
Doll's House, A, 156
Dover Street to Dixie, 61
Driesch, Hans, 29–30
Drummond, Lindsay, 119
Drury Lane Theatre, 56
Du Fu, 25–26
Dummy Talks, The, 149
Dunbar, Evelyn, 99
Dunsany, Lord, 139

East End (London), 48–50, 64, 184, 190
 East Ender, 50
 East London College, 184
 Limehouse, 1–3, 11, 48, 63, 189–90
Eastern Cabaret, 153–54
Edinburgh Congress, 165
Edwards, Evangeline Dora, 35
Eglevsky, André, 58–59
Eight Poems of Li Po, 63, 145
Ellington, Duke, 61
Emperor Ai, 73
Emperor's Nightingale, The, 52
English Heritage, 5, 12n8, 17n33
English policemen, 37–38
Espey, John, 71, 88
Etches, Matilda, 53–54
Etching of a Tormented Age, 118
Eumorfopoulos, George, 142–43
Evans, Edwin, 55
Exhibition of Ballet Design, 69
Exhibition of Modern Chinese Painting, 13, 21–22, 28, 131–32
Exile and Wars (*Quguo Cao*), 158–59, 170, 174–77

Fairbanks, Douglas, 62
'Famous Paintings Collected by PingTeng Ke' (*Zhongguo minghuaji*), 30–31, 33

Fang Zhaoling, 182, 184, 191
fascism, 103, 109, 164–67, 178, 183
Fauvism, 58
Fei Chengwu, 182, 185, 193
'Fifty Quatrains from Exile' (*Quguo wushi jueju*), 176
film, 2–3, 7, 41–44, 60–61, 63–64, 137, 142–57, 190. *See also* Chinese film
 Bijou Film Company, 148–51
 Charlie Chan, 41–44, 147
 Charlie Chan in Panama, 41
 Charlie Chan in Shanghai, 147
 Chien Andalou, Un, 144
 Chinese Cabaret, 150–52
 Chu Chin Chow, 13n14, 133, 137, 154
 Dummy Talks, The, 149
 Fu Manchu, 2, 7, 41–42, 142, 146–47, 153–54
 Gardner, Ava, 190–91
 Good Earth, The, 126n96, 147, 156
 International Revue, 151–53
 Lai Foun, 148–52
 Leyda, Jay, 144–45
 Moscow Film Festival, 145–46
 Pacific Films Corporation, 157
 Piccadilly, 145
 Reviving Rose, A (Fuhuo de meigui), 144
 Rose of Pu-Chui, The (Xixiangji), 63, 143–45, 154–55
 Shadow Sweetheart, 148, 152–53
 Wong, Anna May, 61–65, 145, 154
Finchley, 186, 190
Firebird, The (*L'Oiseau de feu*), 58
First World War, 2–3, 29, 56, 91n8
 also Great War, The, 56
Flight of the Dragon, 4
Flowering Exile, 128, 135, 182, 186–88, 192–95
Fokine, Michel, 58–60
Fong, Wen C., 35
Forgotten Wave, The, 114, 122
Forrest, George, 134
Forster, E. M., 113, 118, 121, 166
Foss, Dora, 64
Fraser, Moyra, 53–54, 65, **67**
Friends of the Chinese People (FOCP), 169

Friends' Ambulance Unit, the, 181
Fry, Margery, 111
Fu Manchu, 2, 7, 41–42, 142, 146–47, 153–54
Fujian Rebellion, 160–62, 168
Futurism, 56

Gardner, Ava, 190–91
German
 artists and writers, 12, 13n11, 165, 179
 Bauhaus, 5, 12–14. *See also* Gropius, Walter; Breuer, Marcel
 translations of Li Bai (Li Po), 145n17
Germany
 exhibitions in, 22
 Teng Gu in, 28–29
 war with, 90–91, 94, 102
Gesamtkunstwerk, 52, 56, 69
Gest, Morris, 140
ghosts, 49–50
Gide, André, 166
Giles, Herbert, 27, 29, 36
Gilroy, Paul, 129
Goldfinger, Ernő, 12
Goldrush, The, 64
Gollancz, Victor, 96n22, 101, 109–12, 122, 124–25, 169–71, 179
 See also Left Book Club
Gomez, E. T., 3
Goncharova, Natalia, 58, 69
Gong Zizhen, 177–78
Good Earth, The, 126n96, 147, 156
Gorky, Maxim, 166
Graham, Cunninghame, 137
Grant, Duncan, 52, 183
Graves Art Gallery, Sheffield, 96
Gray, Basil, 95
Greek Street, 64
Greene, Graham, *vii*, 95n 20, 134, 186
Grey, Beryl, *ix*, 53, 54n15, 64, **68**
Gropius, Walter, 12
Grotrian Hall, 153
Gu Yuncheng, 31, 197
'Guernica', 178
Guomindang. *See* Kuomintang
Guo Moruo, 161, 163

Guo Taiqi, 97n 32
Guohua, 20n7, 21, 25
guoxue (National Studies), 30
guqin, 24

Hahn, Emily, 109n 6, 110–11, 123n84, 126
hair (Hair Raid), *ix*, 46–47, 72
'Hall of Three Footpaths', 74–75
Hamilton, Gordon, *ix*, 53, **66**, **67**
Hampstead Heath, 12, 93–94, 162, 164
Hampstead at War, 16, 202
Han Suyin, 114, 119, 123n84
Harp with a Thousand Strings, 119, 123n84
Harris, Buddy, 150n43, 151n45, 152
Harvard University, 35
Haskell, Arnold, 54, 69
Hayward, John, 120
Heartfield, John (Helmut Herzfeld), 12, 13n11
Helpmann, Robert, 53–55, 61, 64–65, 69–70
Hepworth, Barbara, 11, 13
Herdan, Innes. *See* Jackson, Innes
Hertford House, Manchester Square, 97
Heseltine, Philip (pseud. Peter Warlock) 61–62
Hewitt, John, 159, 172, 173n55 and 57, 174–76, 178n75, 180
Hewitt, Roberta, 172
Heyford Hill House, 186
Hitler, Adolf, 150n42, 152
Ho Sze Ko, 140
Ho Wai-kam, 35
Ho, Grace (aka Lau, Grace), 135, 181, 186, 188, 190–91
Ho, Lily, 140, 183–84
Hogarth Press, 110n13, 124
Hollywood, 62, 63n74, 138, 143n1, 147
Holmes, Colin, 1–2
Holmes, Winifred, 142, 143n1, 148, 150
Holocaust, 39
Homesickness, 81, 83n43, 85, 103, 135, 187–88
Hong Kong, 26, 91, 99n37, 103, 120, 124, 135, 149n33, 150n42, 154, 157, 182, 186, 190
Hong Shen, 155–57

Index

Honourable Pussy Cat, 40, 43–45
Horizon, 111
Horsnell, Horace, 60, 65, 67
Hosie, Lady, 98, 99n35
Hou Yao, 63n74, 143n5, 144
Hsiao Ch'ien (Xiao Qian), 1, 7, 14–15, 59, 95–97, 100–101, 107–15, 118n33, 119, 123–24, 125n92, 126–27, 140, 184
Hsiung Dymia (Cai Daimei), 1, 3, 93, 116, 128, 132, 135, 137, 148n27, 162, 182–88, 191–95
Hsiung Shih-I (Xiong Shiyi), *vii*, 1, 7, 11, 13–14, 21–23, 31, 36–38, 82, 91, 93, 95–97, 101, 108–9, 113, 123, 126, 128–43, 146–48, 150–57, 159, 162–63, 166–67, 170, 179, 183–87, 195
Hsiung Shih-I (Xiong Shiyi) as screenwriter, 7, 142–57
Hsiung, Deh-I, 135–36, 181, 186–88, 193–95
Hsiung, Delan (aka Hsiung, Diana), 116, 117n51, 185
Hsiung, Deni, 139–40, 185, 195
Hsiung, Dewei, 185
Hsiung, Diana. *See* Hsiung, Delan
Hsiung, Wei, 139
Hu Qiuyuan, 161–67
Huang Zunxian, 176
Hundred and Seventy Chinese Poems, A, 172–73
Huxley, Elspeth, 97

Ibsen, Henrik, 118, 156
Iffley Turn, vii, 95n20, 134
Ignorant and the Forgotten, The, 120
Illustrated London News, The, 59, 93
Independent Labour Party, The, 172
International Congress of Writers for the Defence of Culture, 159, 166–68, 171
International Exhibition of Chinese Art, 4, 21, 26, 36, 131, 143, 173
International Peace Campaign (IPC); International Peace Campaign Congress, 134, 159, 167n33, 168–70, 178
International PEN, 165
International Revue, 151–53

International Settlement, Shanghai, 91, 99n37, 147
International Stories, 120
International Union of Revolutionary Writers, 164
Irish Citizen Army, 173
Irvine, John, 98, 99n35
Isherwood, Christopher, 120
Isokon, 12–13

Jackson, Barry, 133
Jackson, Innes (*also* Innes Herdan), 22–23, 29, 34n62, 78, 81, 93, 96, 131, 175, 177, 179, 183
Japan, 7, 14, 29, 40, 44, 58n43, 74, 76, 78, 90, 92, 97, 98n34, 101, 103, 109–10, 119–20, 124, 134, 161, 166, 168–69, 171–73, 178, 182, 192, 194
Jenyns, Roger Soame (Soame Jenyns), 26
Jiang Guangnai, 161
Jiangxi province, 19, 23, 35, 36, 77, 86, 130, 134, 160
Jing Youru, 162
Jiujiang, 18–19, 72–74, 77, 84, 94, 96n24, 102
John Day, 71
Johnson, Reginald, 35
Joint Broadcasting Commission, 134
Journal of the Fell and Rock Climbing Club, 83
Journey to the West (*Monkey*), 79n28, 126
'Julian and Maddalo', 163

Karloff, Boris, 41, 147
Keats, John, 163–64, 176
Kelvingrove Galleries, Glasgow, 98
Kipling, Rudyard, 156
Kirsova, Helene, 59
Kokoschka, Oskar, 13
Konin Corporation, 157
Koo, Wellington, 44–45, 97n32, 98, 121
Kung-chao, George, 100
Kuomintang (KMT); (Guomindang, GMD), 7, 20, 22, 100, 140, 160, 167, 169, 177
Nationalist Party, 7, 20, 97n32, 101, 140, 152, 157, 161n8

Labour Monthly, 169
Lady Precious Stream, vii, 7, 21, 109, 126, 128, 130–34, 137–40, 142–43, 146–48, 151, 153, 155, 156n70, 157, 179
Lai Foun (*also* Four Lai Founs; Five Lai Founs; Lai Foun and his Chinese Wonders; Lai Foun Troupe; Six Lai Founs), 7, 142, 148–54, 157
Lai Man-Wai, 144, 154
Lake District, 82–83, 85n42
Lambert, Constant, 51–52, 55–57, 60–65, 145
Lane, Allen, 115–16
Lascelles, Anne, 53
Laski, Harold, 170
Lau, Grace. *See* Ho, Grace
Laver, James, 63
Lawn Road, 12, 14n21
Lawrence, Sir Alexander W., 57–58
Lee, M. P. (aka Li Mengbing), 97, 189
Left Book Club, 109–10, 159, 169–72
Left Review 7, 109, 159, 164–66, 169, 171, 179
Lehmann, John, 107, 110–14, 118–22, 124–25
L'Epreuve d'amour; or Chung Yang and the Mandarin, 58–59
Les Ballets de Monte Carlo, 57–58, 60n51
Lethaby Gallery, 70
Lewis, Sinclair, 166
Leyda, Jay, 144
Li Bai. *See* Li Po
Li Chu-tsing, 36
Li Gongpu, 168
Li He, 163, 176
Li Mengbing. *See* Lee, M. P.
Li Po (Li Bai), 62–63, 97, 145
Li Ruiqing, 24, 33
Li Yu, 81
Lianhua Film Studios, 154
Liao Hongying, 183
Life and Letters Today, 109, 119
Limehouse (East End Chinatown), 1–3, 11, 48, 63, 190
Limehouse Nights: Tales of Chinatown, 2

Lin Yutang, 108, 123n79, 123n84, 140, 186, 191, 194
Ling Shuhua, 113n27, 131, 182–83, 186–87, 189, 191–95
Listener, The, 89, 91n10, 109, 120, 122
Little Theatre, The, 143, 156n70
Liu Haisu, 13, 22, 25, 28, 30, 96, 131, 162, 185
Liu Songnian, 23
Living China, 109, 124
Lo Cheng: The Boy Who Wouldn't Sit Still, 94n16, 102n41, 116
Lo Ming Yau, 154
Lo, Kenneth (Lo, Hsiao Chien); (Luo Xiaojian), 7, 107, 113, 121, 184, 188–190
Lolly Willowes; or, The Loving Huntsman, 172, 178
London Zoo, 93, 188
Lorca, Federico Garcia, 145
Lord Berners, 52n4
Low, David, 14
Lu Jingqing, 1, 162–63, 167, 185
Lu Xun, 109, 125, 147n24
Luo Changhai, 77

Ma Xiangbo, 168
MacDiarmid, Hugh, 165
Madeline, 193
mahjong, 7, 181–83, 191–92
Maida Vale, 183, 186
Maitreya, 80. *See also* Buddhism
Malraux, André, 166
Malvern Theatre Festival, 132–33
Manchu dress, 151
Mao Zedong, 53n11, 160
Map of Hearts, A, 119
Marco Polo Bridge Incident, 78, 109
Martin, Kingsley, 111, 119, 122, 178
Masculinities, 37, 43
Massine, Leonide, 57–58
Matisse, Henri, 56, 58
May Fourth, 63n74, 163
McKnight Kauffer, E., 52
Medway Film Company, 150n42, 151, 152n51
Mei Lanfang, 146, 156, 185

Memories of China, 121
Men of the Trees, The, 21
 also Men of the Trees Exhibition, The, 132
Methuen, 21, 71, 95, 99, 101, 113–14, 130–31
Michieli, J. W., 93
Miller, Lee, 12
Mills, Florence, 61
Milner, Sir William, 95
Ming dynasty, 31n55
Ministry of Information of the Republic of China, 90, 100–101, 116
Ministry of Information, British, 90–91, 99–100, 119–20
Ministry of Information, Far Eastern Bureau, 91
Minxin Motion Picture Company, 63, 144, 154
Modern Chinese Painting Exhibition, 13, 21–22, 28, 131–32
Modern Miscellany, 147
Moholy-Nagy, László, 12
Moment in Peking, 157
Mondrian, Piet, 13, 16–17
Montague, Ivor, 144
Moore, Henry, 11, 13–14, 16
Moscow Film Festival, 146
Mossford, Lorna, 53
Mount Lu, 75, 83–86
Mountain Village, The, 120
Moy Long, 150
Music Hall, 54, 148, 150–51, 154
Music Ho!, 61–62

Nanjing, 75, 160–61, 166–67, 182
Nanyang University, 35
Nash, Paul, 99
National Book League, 99
National Central University, 182
National Revolutionary Army, 77
Nationalist Party (China). See Kuomintang
Nature, 21n10
Nazi persecution, 1, 12, 39n6
Nazism, 95n18, 96–97, 165
Nehru, Jawaharlal, 179

Nelun Devi (Julia Pauline Winifred de Silva), 153–54
Nemtchinova, Vera, 58, 60
'Nest of gentle artists', 11, 17
New Burlington Galleries, 13, 21–22, 25, 131–32, 143, 173
New Statesman, 109, 174
New Statesman and Nation, The, 109, 111
New Theatre, 63, 65
New Writing, 109–11, 118–20, 124, 164n21
New York, 60n51, 61n58, 71, 101, 118, 125, 130, 150, 191
New York Times Book Review, 71
Newman, Ernest, 60
Newman, John Henry, 134
Nichols, Robert, 61–62
Nicholson, Ben, 11
Nivedita, Sister (Margaret Elizabeth Noble), 29
nostalgia, 72, 84, 86–87, 176
'Notes to the Chinese Exhibition', 173

Obata, Shigeyoshi, 62
Oboukhov, Anatole, 58
Observer, The, 60, 65, 120
'Ode to a Nightingale', 164
Odeon, Haverstock Hill, 13, 16
Okakura Kakuzō, 27, 29
Oland, Warner, 42n14, 147
Olivier, Laurence, 145
Olympic Games (Berlin), 152
Orientalist (Orientalism), 7, 60, 133, 137, 142, 147, 151, 153, 180
Orwell, George, 113, 118
Over-Seas League, 97
Oxford (Oxford, University of), *vii–viii*, 1, 50, 135, 184
Oxford Union Debate, 45

Pacific Films Corporation, 157
Painter, Joan, 157
Painting in the Far East, 4
panda, 93, 116, 135–36, 188
 also pandamania, 116
Pantheon Theatre, The, 154
pantomime, 59

Paris, 26, 28, 35, 91, 144, 166–67, 169, 194–95
Parkhill Road, 11, 13, 15–17, 91, 94n17, 122, 185–86
Parliament Hill, 162–63
Pater, Walter, 29–30
Pathé, 149, 150n40
Paulet, Reine, 153–54
Payne, Robert, 110, 125
Peking Opera, 130, 146, 156–58, 191
Penguin Books, 3, 52, 112, 114–16
Penguin New Writing, The, 109, 111, 122, 124
Penrose, Roland, 12–13
People of China, 124
People's Republic of China, 36, 157, 184
People's Revolutionary Government, The, 162
Peter Bernard and his Ragtimers, 152
Phoney War, 94
Piccadilly, 63, 143, 145, 154
Pilot Press, 114, 119
poetry, 24, 62, 110, 114, 125–26
 Chiang Yee, 6, 24, 79, 81, 83–86, 97, 132, 180
 Ho, Lily, 140, 184, 192
 Ho, Sze Ko, 140
 Irvine, John, 98
 Kipling, Rudyard, 156
 Li Po, 62–63, 97, 145
 Lo, Kenneth, 122
 Lorca, Federico Garcia, 144–45
 Shi Zhecun, 14–15
 Su Dongpo, 189
 Tao Yuanming, 85–86
 Waley, Arthur, 172–73
 Wang Lixi, 7, 158–60, 163, 172–79
'poetry talks from overseas' (*haiwai shihua*), 175
Pool of Ch'ien Lung, The, 98
Poon Lim (Pan Lian), 122
Pound, Ezra, 62
Powell, Anthony, 52, 61–63, 64
Poyang Lake, 85
Priestley, J. B., 113, 120, 130, 138
Pritchard, Jack, 12

Professor from Peking, The, 139
propaganda, 6, 89, 91, 100–102, 113, 117, 170, 179
Puffin Books, 114

Qi Baishi, 24, 96
Qian Zhongshu, 30
Qin Shihuang, 172
Qing dynasty, 31, 175
qipao, 191
Queen Mary, 95n21, 97, 130

race (racism), 6, 39–40, 43n15, 46, 50, 70, 108, 129, 152
racial representation, 7, 20, 117, 129, 136, 141
Radio Times, The, 149
Rassine, Alexis, 53, 66
rationing, 54, 92, 97, 114, 116, 136, 187
 food, 54, 97, 136, 187
 paper, 92, 114, 116
Read, Herbert, 11, 13–15, 29, 35n64
Red Army, 181
Red Star Over China, 170
Redfern, James, 65
Red-Maned Steed, The, 130, 143. See *Lady Precious Stream*
Republic of China, 25, 90, 100–103, 117, 163, 175, 185n8
Republican Government. See Kuomintang
'Research Monthly, The' (*Dushu zazhi*), 161
Resphigi, Ottorino, 53
Revolution (1911), 44, 160
Reynolds, S. E., 150
Rhythmic vitality (*qiyun shengdong*), 27–30
Rickword, Edgell, 164, 171
Robeson, Paul, 131
Robey, George, 13n14, 154
Rohmer, Sax, 2, 146–47, 154
Romeo and Juliet, 52
Roosevelt, Eleanor, 130
Rose of Pu-Chui, The (*Xixiangji* [Romance of the Western Chamber]), 63, 143–45, 154–55
Ross, Alan, 119
Rossignol, Le, 55–56, 62

Rothenstein, Sir William, 99
Royal Academy of Arts, 21, 34, 131, 143
Royal Opera House, The, 52, 65–66, 70
Royal Society of British Artists, The (RBA), 96, 99
Rylands, George 'Dadie', 120

Sackville-West, Vita, 194
Sadler's Wells, 51–55, 65, 70
Said, Edward, 87
Sansom, William, 119
Savoy Theatre, 63, 143
School of Oriental Studies (SOS); School of Oriental and African Studies (SOAS), 19–20, 22, 31, 35, 78, 80, 92, 109, 132, 182, 184
Scottish National Gallery, 96
Second Sino-Japanese War. *See* War of Resistance Against Japan
Second World War, The, *viii*, 4, 40, 52, 54, 89, 93, 103, 108, 112, 114, 121–22, 145n16
Senate House, 91n8, 99–100
Serge, Victor, 166
Shadow Sweetheart, 148, 152
Shanghai, 13–14, 18, 20, 24, 26, 63–64, 91, 94, 96n24, 99n37, 101–2, 143, 143n4, 143n5, 144, 147, 154, 160–62, 168, 184
Shanghai Restaurant, 64
Shanghai War of 1932, 160–61
shanju (dwelling in the mountains), 163
Shao Xunmei, 15
Shaw, George Bernard, *vii*, 55
Shearer, Moira, 53
Sheldon, Joan, 53, **66**, **67**
Shelley Memorial, The, 10
Shelley, Percy Bysshe, 10, 158, 163–64, 176
Shelley Wang, 2, 7, 159, 163–64, 171, 173, 185. *See* Wang Lixi
Shen Congwen, 125
Shen, Mary, 182, 191
Shenzhou guoguang she, The, 160–61
Shepherd, Graham, 93, 94n16
shihua ('poetry talks'), 174–75
Shishi xinbao, 18

Short History of Chinese Civilization, 110, 122
silence. *See under* Chiang Yee
Silent Traveller in London, The, *vii*, 12, 15, 38, 49–50, 57–58, 72, 78, 82n38, 90, 92, 134, 136, 138
Silent Traveller in New York, The, 72
Silent Traveller in Oxford, The, 37, 39, 40, **42**, 46, **47**, 50, 51–52, 64, 66, 72, 99, 158
Silent Traveller in War Time, The, 6, 9, 91–94, **100**, 103
Silent Traveller, The (Silent Traveller books), *viii*, 6, 33, 35, 36, 39, 40–41, 44–50, 70, 72, 76, 80, 92–93, 101, 115, 138
Silent Traveller: A Chinese Artist in Lakeland, The, 15, 82
Singapore, 101, 148, 186
Sinophilia, 52
Sitwell, Edith, 51
Sitwell, Osbert, 51
Sitwell, Sacheverell, 51
Six Laws (Six Principals), 22, 27–30
Sketches About London in Wartime, 91
Smedley, Agnes, 170
Smith, Amy, 173–74
Snodland, 148, 151, 157
Snow, Edgar, 109–10, 124, 170
Snow, Helen Foster, 110
Socialist Realism, 5, 13, 164
Song dynasty, 23, 81
Song of the Fishermen, 145–46
Songs of Chu, 176
'Sonnet: To Japan on Her Chinese Policy', 173
Southeastern University, 19–20, 24, 30
Southmoor Road, 95, 134
Soviet Union; (Union of Soviet Socialist Republics, U.S.S.R.), 57, 164–66
Spanish Civil War, 91–92, 164, 178
Spectator, The, 13, 63n74, 65, 121
Spencer, Herbert, 29–30
Spencer, Stanley, 186, 191
Spender, Stephen, 119–20
Spillett, Helen
Spinners of Silk, The, 119
Sri Lanka, 153

St. Albans, 93, 185–87
Story of China, The, 96n22, 116, 117n51, 123
Story of Ming, The, 94n16, 102n41, 116
Strachey, John, 170
Strachey, Marjorie, 194
Stravinsky, Igor, 56, 62
Stroheim, Erich von, 144
Su Dongpo, 189
Sullivan, Michael, 35
Sun Moqian, 78
Sunday Times, The, 60
Sung Hua, 193
Surrealism (Surrealist), 12–13
Swann, Peter, 182
Swiss Cottage, 185–86, 195
Sylvan Press, 114, 120

Ta Kung Pao (*Dagong bao*), 118
Tang dynasty, 26, 28, 32, 62, 81, 97, 145, 163, 192
Tang Poetry, 62, 97, 145, 163, 192
Tao Xingzhi, 167–68
Tao Xisheng, 161
Tao Yuanming, 85–86
Tatler and Bystander, The, 54
Teng Gu, 28
theatre design, 70
Theory of the Six Laws in Chinese Painting, The, 28–29
They Fly South, 120
Thief of Baghdad, The, 61
Thomas, Myfanwy, 64
Three Seasons and Other Stories, 120
Tian Han, 113n27, 155–57
T'ien Hsia Monthly, 14
Time and Tide, 109
Times Literary Supplement, The, 71, 109, 120, 122, 127
Times, The, 65
'To China on the Fall of Shanghai', 173
Toler, Sidney, 42
Toller, Ernst, 165, 179
Tolstoy, Leo, 121
Transatlantic Arts, 117–18, 125
Tregear, Mary, 182

Tsui Chi, 1, 7, 96, 107, 110–17, 119, 122–24, 127, 185, 193

UNESCO, 155, 183, 195
Union of Democratic Control, 169
United Aid to China, 96
University of Cambridge, 101, 108n4, 112, 120, 184, 186
University of London, 19, 22, 109, 181, 184, 190
University of Manchester, 182, 184
Upper Park Road, 11–13, 14n21, 16–17, 91, 94n17, 122, 130, 162, 185–86
US (United States of America), 12, 15, 35, 58, 72, 101, 116, 117, 123, 125, 127, 129–30, 140–41, 150, 151n44, 155–56, 186, 194

Val Baker, Denys, 114, 120
Variety, 149, 152, 154
Victoria and Albert Museum, 143
Victorian, 1, 3, 16, 29, 62, 67
Vic-Wells, 51
Violin Song, 148n28, 152
Visiting The British War Artists' Exhibition, 99–100

Wade-Giles, 23, 24
Wales, Nym (Helen Foster Snow pseud), 110
Waley, Arthur, 27, 36, 120, 123n81, 126, 172–73, 194
Walton, William, 52
Wang Chi-chen, 125, 126n96
Wang Lixi, 1, 7, 14, 158–80, 185
 Shelley Wang, 2, 7, 159, 163–64, 171, 173, 185
Wang Shifu, 143n5
Wang Wei, 32
War Artists' Advisory Committee (WAAC), 90, 99
War Artists' Exhibition, 99
war morale literature, 90
War of Resistance against Japan (aka Second Sino-Japanese War), 7, 40, 89–90, 109, 119, 134, 159, 169, 171, 175

Index

Warner, Sylvia Townsend, 159, 171–73, 175, 178–79
Wartime Diary (*Zhanshi riji*), 161
Watteau, Jean-Antoine, 55
Wellcome Historical Medicine Museum, 91–93, 102
Wells, H. G., 130, 144, 165, 166
West End (London), 21, 57, 129–30, 154, 185, 190
'What Can I Say About Ballet', 58
Whistler, Rex, 52
White, Alan, 21, 23, 95, 99, 101
Willow Leaves, 98
Winkworth, W. W., 34
Wong, Anna May, 61–62, 64–65, 145, 154
Wong, Diana, 148
Woodman, Dorothy, 111, 116, 119, 122, 126, 169, 179
Woolf, Virginia, 110n13, 183, 192–94
Works of Li Po, The, 62
World Conference on the Boycott of Japan and Aid to China (London), 169
World of Art (*Mir iskusstva*), 55–56
World Peace Congress (Brussels), 167–68
Writers' International Controversy, 164
Wu Mei, 24
Wuhan University, 120, 183

Xiandai pinglun ('Contemporary Review'), 183
Xiao Jun, 109, 113n26
Xiao San, 166
Xie Bingying, 122–23
Xie He. *See* Six Laws
Xixiangji. See *Rose of Pu-Chui, The*
Xu Bangda, 36
Xu Beihong, 18, 24, 96, 98, 130–31, 135, 162, 182, 185
Xu Zhimo, 109, 131, 191n27

Yang Bin, 194
Yang Buwei, 187n16
Yang Hsien-I (Yang Xianyi), 1, 162, 184
Yang Zhiyi, 175
Yao Xueyin, 125
Yaxingzhe (Silent Traveller), 76, 19n28, 80
Yazvinsky, Jan, 58
Ye Gongchuo, 22
Ye Junjian (Yeh Chun-chan); (George Yeh), 7, 95, 97, 107–8, 113–14, 119–20, 120n66, 183
 also Cicio Mar, 110n12, 125
Yeh, Nienlun, 120
Yellow Peril, 2, 5, 43n15, 60
Yellowface, 41–43, 60, 70, 146–47, 150
Yenching University, 182
Yetts, Walter Perceval, 33–34
Youzheng shuju, 31
Yu Shangyuan, 146
Yuan Chia-hua (Yuan Jiahua), 110, 125
Yuan Mei, 175
Yui Shufang, 86–87

Zeng Yun, 75
Zhang Daqian, 182
Zhang Qianying, 182, 192
Zhang Tianyi, 109, 111, 125
Zhao Yuanren, 187n16
Zhongya, 19, 76. *See also* Chiang Yee
Zou Taofen, 168